Chinese Art II

Gold ∗ Silver ∗ Later Bronzes ∗ Cloisonné
Cantonese Enamel ∗ Lacquer ∗ Furniture ∗ Wood

by R. Soame Jenyns

&

William Watson F.S.A.

Preface and revisions to the second edition by William Watson

RIZZOLI
NEW YORK

French-language edition:
© 1966 by Office du Livre, Fribourg, Switzerland

English revised edition published 1980
in the United States of America by:

RIZZOLI INTERNATIONAL PUBLICATIONS, INC.
712 Fifth Avenue/New York 10019

Library of Congress Catalog Card Number: 79-92811
ISBN: 0-8478-0321-x

Printed and bound in Switzerland

CONTENTS

PREFACE TO THE SECOND EDITION

The death of my friend Soame Jenyns in 1976 was a loss to connoisseurs of Chinese art in West and East. He had an unrivalled knowledge of all branches of the art, which he was able to visualize in its native setting to a degree denied to those who lacked his experience of the old China and its refined society; but his main interest lay in the decorative crafts. He considered these to be the essential element in the unbroken tradition of technical and designing skills which sustained expressive fine art in its most developed forms through three millennia of Chinese history. Collecting was to Jenyns a continual adventure, from which the aura of travellers' romance never wholly faded.

In the seventeen years that have passed since this volume of the Minor Arts was first published, many collectors have died and their possessions have been variously dispersed. For the re-issue of the books it was not possible to verify the present ownership and whereabouts of every piece, particularly of pieces from the smaller collections. It may be thought that the attributions given in 1963 and 1965 have an interest in themselves, as representing a particularly enlightened passage in the history of western collecting, by both museums and private persons, so that an editor need not feel positively obliged to catch up with the fortunes of the saleroom and of bequest. The larger groups remain mostly intact or are easily traceable. Among collections now dispersed are those of Grice, Gure, Malcolm, Mayer and Low-Beer. The Fairhaven and Palmer collections are intact and those of Garner and Jenyns almost so, with some items transferred permanently or temporarily to museums. The Sedgwick collection is dispersed, but the silver has been kept together in the British Museum. The Kempe collection has a permanent home at Ekolsund near Stockholm.

Recent archaeological discovery has added to the history of decorative art in its earlier phases. By this means the known range of T'ang silverware has been considerably expanded, its various styles probably indicating the activity of different workshops or the circulation of different patterns. What has hitherto appeared to be a standard treatment (plates 20, 26), with tight scrolls on a seeded ground, is well represented among the numerous pieces discovered in two pottery jars in the Ho-chia suburb of Sian, on the site of the mansion of an imperial cousin who must have fled his home and buried his treasure on the outbreak of rebellion in 756. Similar vessels were found at Hsin-hua-fang in Kiangsu. At both of these sites the inclusion in the buried hoards of silver vessels decorated in the broader manner seen on plate 28 (there ascribed to the late 8th century) is proof that this style was already practised before the middle of the century. In this ornament, full-blooming peonies prevail and the tight scrolling is omitted. A western connection of the silver styles is made more explicit in some specimens. Such is the Sasanian-style beaded cup from Ho-chia, on which figures of exotic musicians in high relief are placed over a ground of the typical Chinese scrolling. Peony blooms pressed out in relief were sometimes accurately gilded, or gilding was applied more generally to rich repoussé ornament. The last manner is represented ideally on a dish 55 centimetres wide which was unearthed from the ruins of the West Outer Grounds of the Ta-ming palace at Sian. Although it appears in work of the earlier 8th century, especially

in a central rondel (cf. plate 25), repoussé appears to have become the main technique in the later T'ang period, for both floral motifs and animal figures. Two six-lobed dishes from Sian have respectively a bear and a large-winged ch'i-lin, in low relief and gilded, and must belong to the later group. Here the handling of the metal is quite distinct from the early closely ornamented work, and the dishes are to be classed with silverware in which much of the surface is left plain. This type is already represented at Ho-chia, and so must have at least its beginning in the earlier part of the century. A flask in the shape of a leather bottle, and the ewer of plate 32, represent this robust manner. A Ho-chia five-legged censer whose sides are decorated with floral openwork suggest that pieces of this kind were in general use in temples as much as domestically. A gold Sasanian-style cup from the same site has on its sides schematic medallions formed of soldered cloisons, lined along the outer edge with what appears to be true granulation. The application of cloisons on this cup helps to resolve a problem posed by the enamelled mirror-back of plate 85, in favour of a T'ang date. The granulation, like that of the apsarases of plate 13, may mark the reintroduction from the Iranian west of this special technique, which is not otherwise traced after the 2nd century (cf. plates 11, 12).

An initial stage of the employment of lacquer is well documented by the finds of wooden vessels of Shang date at T'ai-hsi-ts'un in Hopei, or rather of earth traces of the vessels to which the skin of lacquer paint decorating them still adhered. There is now no difficulty in accepting as lacquer mastic the substance filling the interstices of bronze ornament on many ritual vessels of the 11th century B.C. In principle the numerous large vases and boxes included in the tomb of the Lady Tai at Ch'ang-sha in Honan, in the early 2nd century B.C., mark no advance on the work of Shang lacquerers, a thousand years earlier.

It may be seen from the above instances of knowledge increased archaeologically that little has occurred in the intervening years (outside the realm of ceramics, which is not the concern of the volumes on the minor arts) to invalidate the general presentation and particular conclusions of the first edition. A comment on recent books concerning the subjects treated here as the minor arts is included in the preface to Volume III.

William Watson
London, February, 1980

INTRODUCTION

Whereas *in the West the distinction between fine art and the minor arts is clear enough, in Chinese art the line of demarcation can be debated. The Chinese look on painting as their most expressive art, and all manner of intellectual and poetic ideas were annexed to it. But through its insistence on a perfection achieved through severely limited means, even serious painting could grade, at a less creative level, into mere meticulous copying of great masterpieces or the styles of great masters. This tendency could bring even painting close to repetitive craft – such as the work of the potter and jade-carver – in which the end result was prescribed by a carefully organized workshop discipline. Moreover, whenever the products of the craftsman required pictorial ornament, he was beholden for it ultimately to the sophisticated painter, whose achievements thus passed into an impersonal or a virtually impersonal tradition. The taste of cultivated patrons, particularly of the court, set standards at all periods which the minor arts sought to satisfy. The differences we may observe between one piece of craftsmanship and another are differences of quality within a single tradition and aim, and not the distinction which in the West is often to be made between sophisticated art and folk art. All the Chinese minor arts flow from an aristocratic tradition. The bronze art of the pre-Han period, jade-carving and ceramics are usually classed with the major arts, owing to their influence in forming the quintessential character of Chinese taste. Much has been written in the West on these subjects, particularly on ceramics, as well as on painting and sculpture, so that a literature of Chinese art in its more important aspects is now easily accessible to the European public. An earlier volume in this series of publications was devoted to the major arts as we have defined them. But our knowledge of the minor arts of China, which are less richly represented in European collections, and still little known and studied, is woefully incomplete, and books dealing with them as a whole have been comparatively few.*

In S.W. Bushell's Chinese Art, published in 1904, the minor arts received closer attention than they do in the majority of later books bearing similarly comprehensive titles. An exception to this neglect of decorative art in books intended for the general reader was the Burlington Monograph on Chinese Art, published in 1925. But even here jades, lacquer and ceramics were comprehended in only one of six chapters. Meanwhile in Germany, under the concept of Kunstgewerbe ('applied art') the crafts constituting the minor arts of China received from the start more exclusive treatment. A generation ago Otto Kümmel's writings in this field were exemplary, and Martin Feddersen's Chinesisches Kunstgewerbe, published in 1939, continued the same tradition of succinct characterization and exact technological description. In America Berthold Laufer's monographs, learnedly expansive on techniques, materials, and historical connexions, added depth to the study of the minor arts.

There is need at present for a comprehensive account of Chinese craft based on material in modern collections and taking advantage of special studies published during the last thirty years. We now know more than was known a generation ago of old Chinese texts in which craft and connoisseurship are discussed, and more of the official organization of craftsmen. To do justice to the available information would absorb the energies of a dozen specialists in different branches of the minor arts. The present book and its successor can attempt only a broad review of the subject, supported

by illustrations of pieces that appear to the authors to combine the finest quality with the greatest historical interest. Our account of metalwork begins with the decorative inlaid bronze of the fourth century B.C. For later periods Gyllensvärd's book on gold and silver objects and Garner's on enamels have laid a convenient foundation for discussion. Our ignorance is deepest regarding metalwork of the Sung and Yüan periods, and what is said on this subject remains at an exploratory stage. In lacquerwork the writings of Low-Beer and Garner have taken as their aim an exact attribution of dates on which the study of the minor arts must build and which in the past has been too often avoided. Only when a closely dated account of our subject can be given will the true nature of Chinese classicism and archaism, the pervasive influences in all the minor arts, be fully revealed. The result of recent specialized studies, as of the increasing discernment of collectors in recent times in acquiring the humbler works of the Chinese artists and craftsmen, is further to enhance Hobson's conclusion to a survey of the subject written in 1927: 'In short so much of Chinese artwork is good, and so little really bad, that in a contest of artistry they would surely be acclaimed the most gifted nation of the world.'

CHAPTER I: GOLD

ALTHOUGH something can be said of gold work in China from the middle of the Chou period, there are large gaps in our knowledge of its development. The cupidity of grave robbers has probably deprived us of much gold that might have survived from ancient and mediaeval times, for gold is easily melted down and immediately negotiable. But another reason for its rarity may lie in the fact that as a craft material gold did not receive at any time the exclusive adulation bestowed upon it in the West. Distinction of this order was reserved for jade, a substance imported from beyond the confines of China proper. Aesthetic feeling, literary metaphor and antiquarian enthusiasm all went to jade. Unlike jade and even bronze, gold was not hallowed through any association with ancient sage-kings and the rites they instituted. When latter-day antiquarians considered the *chüeh* libation goblets of the ancient ritual, and the Hsia dynasty's claim to the greatest antiquity and dignity, they imagined that Hsia kings used a *chüeh* of jade, not gold.

Gold was not used in Chinese coinage until 1875, and then circulated little. Silver in standard ingots was the traditional medium of commerce, and gold did not figure even to a proportionate extent as bullion. It is characteristic that the East India Company's ships, trading to Canton in the 18th century, found it profitable until at least as late as 1785 to acquire gold by exchange for silver, for in terms of silver, gold was cheaper in China than in Europe. Being more valuable, weight for weight, gold tended even more than silver to be hoarded against emergency. Some of the cruder jewellery, nuggets, leaves and gold bars that come from the more or less recent past, seem to have served this purpose only. A notorious instance of gold hoarding is that of the Emperor Ch'ien Lung's favourite Ho Shen, who upon his execution in 1796 by Chia Ch'ing, Ch'ien Lung's son and successor, was found possessed of eighteen solid gold Lohan figures over 60 cm. high, nine hundred gold *ju-i* sceptres each weighing 48 oz, five hundred pairs of chopsticks of ivory and gold, and a gold service of 4,288 pieces.

Gold is found for the most part in the pure state, either as 'placer gold' embedded in rocks in comparatively large pieces, or as grains scattered in the alluvial deposits of river-beds. According to a famous 16th century manual, the *T'ien kung k'ai wu*, the precious metal was obtained from more than a hundred places in China. Placer gold in large nuggets was called 'horses' hooves', the medium pieces 'olives', and the smallest 'melon seeds'. Gold washed from river sand was called 'dogs' heads' or 'wheat bran' according to the size of the grains, and that obtained by 'sinking shafts in flat land' was termed 'bean' or 'flour gold'. The mines were mostly in the mountainous south-west, in Szechwan and Yünnan, while the Golden Sand river crossing the latter province owed its name to the alluvial gold found along certain stretches. The sands of the T'ung river in north Szechwan and of the middle reaches of the Yangtze, in the prefectures of Yüan Ling and Shu P'u, were worth working, but other river sands in Kiangsi

province are noted as not rewarding the cost of extraction. In Honan, on the Central Plain, gold could be mined at Ts'ai Chou and Kung Hsien. The search for gold was intense; but the statement, cited from another book, that in the appropriate districts gold could be washed from the droppings of geese and ducks, is dismissed by the author of the *T'ien kung k'ai wu* as 'reckless'.

In China superstition could interfere officially with mining as with everything else. In early times the private exploitation of mines would come under the same suspicion from government as the amassing of mercantile wealth. Confucian officials could argue that mining attracted labour from the fundamental activity of agriculture. When the crop was poor mining might be forbidden. At a later period *feng shui* geomancers could oppose mining on the grounds that it disturbed the Spirit of the Tiger, the presiding genius of the earth. At various times, alleging reasons of this kind, though, perhaps with a thought to the interests of state monopoly, the government forbade mining by decree. The last such prohibition was issued by the Emperor Tao Kuang in 1850.

The *T'ien kung k'ai wu* praises gold for its 'willow-branch flexibility'. It classes its purity by colour as shown in a streak on the touchstone: gold of seven parts purity gives green; of eight parts, yellow; of nine parts, purple; of ten parts (i.e. pure), red. The only tolerable impurity is silver, and is to be removed as follows. The gold beaten into thin foil, cut in small pieces, and encased piece by piece in clay, is heated in a crucible together with borax, whereupon the silver is drawn into the clay and gold 'of sufficient colour' (*tsu sê*) can be poured off. This method of refiring resembles the salt process practised in classical times in the West, and known there probably as early as the late third millenium B.C. The traditional Chinese method of making gold-leaf was to beat the foil, already hammered thin, between sheets of a specially strong paper made from the fibres of the inner skin of a species of giant bamboo, glossed and blackened with smoke from burning bean-oil. This paper (called *wu chin chih*), could stand up to fifty blows of the hammer. To gild an object the foil was stuck on with lacquer. In Shensi province the foil was glued to finely prepared sheepskin and, together with this backing, cut to shape for dress ornaments. The *T'ien kung k'ai wu* ends its account with the description of two methods of producing the colour of gold artifically. The golden fans of Hangchow were covered with silver foil 'gilded' by brushing with oil of hibiscus seeds and heating; and a golden surface could be produced by heating a coat of paint consisting of crushed cicada sloughs mixed with water.

Among ancient survivals of goldwork the earliest artistic pieces come from tombs at Hsin Cheng in Honan, which extend in date over the 8th–6th centuries B.C. The gold is beaten into thin sheets (but never so thin as to merit the description of gold-leaf) and decorated with comparatively coarse traced ornament, i.e. ornament rendered by grooving and punching with a blunt-nosed tool, which moves the metal without cutting or scraping it. This method required the foil to be laid on a bed of soft material. In later times both gold and silver were traced against a backing of wood, lead or pitch. The last served best for ornament executed in high relief, whether traced or raised from the under side (*repoussé*)[1]. The relief of the Hsin Cheng gold sheets is very low and follows hard, angular lines, delineating for the most part the coiled and intertwined dragons of the artistic convention current at the period, diversified

with simple striations and dog-tooth ornament. The sheets are mostly circular, some six to eight inches in diameter, and possibly were glued to wooden vessels or chests. This naïve form of ornament seems however to have been little practised.

The lavish employment of gold in metalwork proper appears in the later phase of the Huai style, beginning about the middle of the 4th century. Its purpose is to enhance the decoration of bronze and iron, being inlaid in comparatively thick foil in patterns deriving from the prevalent convention of dragon scrolling and other geometric figures. Ornament of this style painted on pottery and on lacquer differs little from the patterns inlaid on metal, and indeed the latter is often manifestly the metal worker's interpretation of motifs invented with the brush. Two trends are distinguishable in the patterns. One deals with comparatively small symmetrical units composed of straight and wavy lines running into spirals and proliferating spiral spurs, animated in the detail but with a broad effect. The other manner derives from the play of leaping dragons, with a stronger movement, more broadly static, scrolled, balanced but without obvious heraldic symmetry. Gold was hardly ever inlaid alone in bronze, but combined with similar silver foil, and usually takes the lesser rôle. The *tui* of plate 51 is a splendid example of the symmetrical style in which the larger areas are covered with silver offset by lines of gold. The inlay is inserted in shallow recesses, less than 1 mm. in depth, and held at the edges by a scarcely perceptible undercutting of the bronze. The gold threads are cut from foil; inlay of wire (whether beaten or drawn) is not found at this period, and seems not to have been practised in China before the 14th century. The gold threads are often continuous with the wider portions of the inlay. In these motifs the clean precision of the detail is essential to the effect, and the work makes of the bronzes some of the most beautiful decorated metal which has ever been produced.

While the inlay of bronze flourished, in the 4th–3rd centuries B.C., gold foil with *repoussé* ornament, and pieces of massive beaten gold or of cast gold were also produced. The jade belthook of plate 1, the harness mount of plate 8, and the dagger handle of plate 9 exemplify these methods. The terminal of the belthook of plate 1 appears to be of beaten gold with traced detail and the central portion is of *repoussé* foil. Gold casting of the greatest refinement, a *tour-de-force* of the lost-wax method, is seen in the dagger handle, which is hollow, *ajouré*, and barely touched in the cold metal. Gold inlay of decorative detail and of script characters (notably the decorative 'bird script') is found on some splendid parade weapons of the late Chou period[2], but a weapon part of solid gold such as the dagger handle is without parallel. The gold masks of the harness-mount are cast on to spigots rising from the bronze ring base. Harness-mounts of solid gold survive also from a later period, the 2nd–1st centuries B.C., in the form of plaques designed in the animal style of the Ordos art of north-west China[3]. In these the casting technique is extremely simple, being executed in an open, one-piece mould, and the temptation to the forger is proportionately greater.

The massive gold belthook of plate 7, also a unique piece, has a surface suggesting considerable work on the metal after casting. No other surviving gold object of this period has glass inlay, but glass inlaid in bronze is not uncommon, particularly on belthooks; and the central roundels of the panels of ornament in the *tui* of plate 51 formerly held glass. At this time it is unusual to find a portrayal in metal

of a mythological subject, such as the Taoist high divinity Hsi Wang Mu, represented on this gold belt-hook.

It is among belthooks and similar small ornaments that the earliest examples of gilding occur. The monster-head clasps of a multiple jade pendant found at Ku Wei Ts'un, Hui Hsien, in Honan, are described in the report as 'gilded bronze'. A large silver belthook (with inlay of jade and glass) from the same site is faced with gold foil⁴ and some small bronze belthooks have a gold surface which appears to be a foil 'burnished on'. It remains in doubt whether fire-gilding, which produces an inseparable gold surface on bronze or silver, was practised before the Han period. Lacking this technique, the craftsman was obliged to inlay his gold on bronze or to apply it as foil, with greater expenditure of the precious metal. But a gilding method which can only have been fire-gilding was in use in Han times, probably as early as the 2nd century B.C. In fire-gilding as it has been practised in the West from Roman times, fine gold powder is kneaded with an equal weight of mercury to produce an amalgam. The surface of the bronze or silver to be gilded is rubbed with a paste made of mercury and chalk, and is then ready for the application of the amalgam. The work is next gently heated so that the mercury evaporates slowly, leaving a fine film of gold adhering, which only requires to be burnished for the final effect. Both over-all gilding and parcel-gilding were practised on bronze in the Han period. Parcel-gilding was combined on bronze bowls with engraved design. On these pieces the failure to keep the areas of gold within the engraved outlines suggests an imperfect control of the process.

In the 4th and 3rd centuries B.C. inlay of precious metal is found on all manner of small bronzes, especially weapon parts and belthooks, as well as on the large ritual vessels. Similar inlay, but invariably of gold alone, is found on some iron belthooks. Iron perishes so rapidly, and the foil left detached is so fragile, that few examples of this work have reached the collector, to whom the messy rust of the iron is inevitably less attractive than cleanly patinated bronze. On iron belthooks the decorative motifs are usually small units of the geometrical type. This work appears to cease in the 2nd century B.C. Towards the end of the Han period, in the 2nd century A.D., gold is used to decorate iron mirrors, though now it seems to be 'burnished on', the gold generally taking the form of a single sheet cut in openwork and traced, depicting elaborate schemes of Taoist divinities and mythological animals in imitation of ornament more generally cast in bronze. A gold-backed mirror of this kind in the Kempe Collection, exceptionally well preserved, is dated to the late 2nd or the early 3rd century A.D.⁵.

It remains to record one singular achievement of Han goldsmiths which brings Chinese craft into touch with a Western tradition. This is granulation, a technique so specific and exacting as to merit particular description. Granulation is the decoration of a gold surface with small grains of gold, massed or arranged in lines as suits the design. The essential feature is that no solder discolours the gold or displaces the minute grains. The grains are produced by heating small fragments of gold in layers on charcoal. On melting the fragments turn to droplets and these, kept separate by the charcoal, harden as separate spherical grains. In Etruscan jewellery the grains might be as small as 0.14 mm. in diameter. Those used in Chinese granulation of the Han dynasty are larger, approximately from 0.5 mm. to 1 mm. in diameter, but the method by which they are attached can only have been the same as that used in the

14

classical West. The procedure is so particular that an independent invention of it in China is improbable to the point of impossibility. What we know of Han trade to the West makes it more plausible that the technique of granulation travelled from the Hellenistic world to China along the regular trade route.

In the West granulation was practised from about 2000 B.C. to A.D. 1000, and thereafter the knowledge of it was lost until its rediscovery in 1933[6]. In this year H.A.P. Littledale patented his colloid hard-soldering process and at last explained ancient granulation by demonstrating a method which must resemble it very closely. It depends on the fact that copper and gold, when in contact, melt at a temperature (890°C) well below their respective normal melting points. The problem is therefore to introduce a minute quantity of copper between the gold surfaces to be joined. This is done by sticking the grains in place on the ground by means of a glue mixed with a copper salt, such as the carbonate. The goldwork already in its final shape, is then heated on charcoal. The sequence of events is as follows:

"At 100°C the copper salt changes to copper oxide; at 600° the glue turns to carbon; at 850° the carbon absorbs the oxygen from the copper oxide and goes off as carbon dioxide, leavin ga layer of pure copper between the parts to be joined; at 890° the copper and gold melt and the joint is made[7]."

Ancient gold generally contains a small proportion of copper as an impurity, so that the minute layers of gold-copper alloy at the base of the grain went unnoticed until Littledale made his experiment.

The most striking evidence for the Chinese debt to the West in the matter of granulation is presented by the small scent flask illustrated at the centre of plate 11. Another such piece, virtually identical though lacking the spatula, is in the Kempe Collection[8]. Both were obtained in China. Miniature gold flasks of similar shape, with similar drop-shaped inlays (though lacking the granulation), have been found in the region lying in the east of the Black Sea, the territories of the ancient Bosporan Kingdom and the province of Colchis. The western flasks, of gold and bronze, are dated from the later 3rd to the 5th centuries A.D. The superior gold specimen with which the Chinese ones compare so closely is attributed to the tomb of the Bosporan King Riskuporis III, who reigned at the end of the 3rd century A.D.[9] Examples of skilled granulation, the latter-day representatives of a long tradition, are found also in the vicinity of the Black Sea towns of Greek foundation. Thus one might question whether the miniature gold flasks found in China were made in that country, or were imported from the West. At the period in question the Sarmatian nomads, for whom rich metalwork held a great attraction, were still occupying the territory lying to the east of the Greek cities. The relations of these people, in trade as well as warfare, with like peoples inhabiting the vast region extending to China, provide a context in which the passage of precious objects and even craft methods and styles is readily intelligible. However, the recent find of a small gold bell in a Chinese tomb at Ho Fei in Anhwei is proof that the technique of granulation was known and small ornaments such as the flasks could be manufactured in China in the later Han period[10]. The bell is 2.3 cm. high, decorated with lines of granulation, some in curves deriving from the dragon and cloud scrolling, *cloisons* for drop-shaped inlay (now missing) and three characters in filigree: *i tzŭ sun* "may you have children and grandchildren". The date of the tomb may be as late as 200 A.D., and so accords tolerably well with the earlier dates assigned to the analogous goldwork from the Black Sea coast. The flasks found in China may be the work of a goldsmith who had travelled from

a city on the Black Sea. The tradition so implanted flourished rapidly. In the buckle found at the Chinese colony of Lolang in Korea (plate 12) it was to produce, little, if at all, after 200 A.D., the crowning masterpiece of Chinese granulated gold. Here the dragon emerges from a cloud of granulation as in legend it emerges from a cloud of mist. The scatter of drop-shaped turquoise inlays resembles those of the miniature flasks.

Another type of granulated gold ornaments generally assigned to the Han period is represented by some half-dozen pieces in collections. These are small plaques of gold of rectangular or irregular, pictorial, outline, wholly Chinese in style. The decorative motifs are figures of mythological human beings (winged, mounted on dragons, bear-headed) and a stylized cicada, delineated by rows of granulated pellets, sometimes doubled by wire or combined with openwork. In an example in the Kempe Collection the openwork figure of a man on a dragon is incrusted over nearly the whole of its surface by a close irregular scatter of tiny pellets little larger than the finest known on Aegean jewellery. If the Ho Fei bell belongs to the end of the Han dynasty, the granulated plaques may be a little later, probably the 3rd or 4th century A.D.[11] Small gold rosettes and other minor ornaments with granulation have been found in tombs of the 2nd–4th centuries A.D., including simpler forerunners of the spherical beas illustrated on plate 2[12]. Granulated gold earrings found in Korea, dated to the 5th and 6th centuries, continue the same tradition. The art of granulation seems not to have survived in China after the T'ang dynasty, its demise in the East falling thus about the time when the technique of its production was forgotten in the West.

While there are records of the casting of Buddhist images in gold from the 4th century, nothing of significance in the history of goldcraft is recorded in surviving pieces after about 300 A.D. until the late 7th century, when gold and silver share in the T'ang renaissance of the arts. Some small circular and oval boxes of beaten gold in the Kempe collection are decorated with traced ornament in the new style lavishly preserved for us on silver[13]. Possibly the wide range of silver vessels which are the most characteristic products of the metalwork of this period were matched by a similar variety of gold vessels, but of these comparatively few examples have survived. In the more numerous small gold objects the skills of the earlier period continue undiminished, and miniature work of the finest quality flourished. Filigree (i.e. fine ornament of soldered wire) was added to granulation, and delicate mouldings and animal forms were cast or shaped in foil. The hairpins and earrings of plate 2 illustrate these techniques. The style of the earrings introduces the exotic note, western and barbarian, which pervades T'ang craft in precious metal. The technique of filigree itself was doubtless also due to influence derived ultimately from the classical West. The addition of the pearl to the filigree hairpin is characteristically Chinese. Some of the best work was executed on the ornament of Buddhist images and shrines, of which there is literary testimony for the T'ang and earlier periods. The lotus bearing apsarases of the Freer Gallery (plate 13) which have considerable sculptural quality, are the best surviving pieces of this kind. The Kempe collection includes examples in gold of such things as the ornaments of a silver knife scabbard, diadems and penannular bracelets of beaten gold. Cast gold does not appear among this decora-

tive work, and indeed is rarely used for ornaments after the Han dynasty. There are T'ang examples of gold plaques decorated with birds and flowers delineated by soldered wire, inlaid with turquoise, and combined with granulation (often as the ground) so fine as to give the appearance of a dust of gold[14].

In the handling of foil the T'ang goldsmiths were supreme. This work survives mostly in the form of mirror-backs, where the metal is traced and *repoussé*. The pieces illustrated on plates 16 and 17 typify contrasting styles: one in fairly high relief, exuberantly drawn and coarse in detail, the other traced with almost geometric precision, more in the manner of some of the best silver decoration. The normal bronze mirrors often have a high content of tin, which produces a silvery surface, and the ornament cast on the back copies effects of graded relief and exquisitely sharp detail, such as are most readily achieved by tracing and *repoussé* in the softer precious metal. Mirrors were also decorated with inlay of gold and silver (cf. the inlay of mother of pearl in like manner), and small separate floral and figural motifs cut from foil, with traced detail, being laid in a bed of lacquer mastic.

Between the T'ang and Ming dynasties the history of goldwork is poorly attested by surviving pieces. Attributions to the Sung and Yüan dynasties are made on stylistic grounds and have thus far received little backing from material documented by inscription or by association in tombs with better dated material. Examples of personal ornaments, some of the most exquisite filigree, can be studied in the catalogue of the Kempe collection[15]. Some rare gold dishes and cups, represented by the Kempe pieces of our plates 14 and 15, are convincingly attributed to the earlier or Northern Sung period by the style of their decoration, which is closer to the broader, fluid grace of Sung floral design (as painted for example on Tzǔ Chou porcelain) than to the crisper miniature manner of T'ang. The tracing is heavier than on the best T'ang work, and the line often careless in detail. The Sung pieces mark a decline of the tradition inherited from the T'ang, which lingered probably as late as the end of the 11th century.

The gold which has recently been excavated from tombs is of inferior workmanship. From a tomb in Szechwan assigned to the second half of the 9th century come a pair of openwork settings for pearls in the form of spiralling flames, intended as ornaments for a Buddhist shrine, and a head-dress (*kuan*) of gold sheet with coarsely traced ribbon ornament[16]. Some hairpins combining coarse filigree butterflies with jade pendants were found in an Anhui tomb dated to 946. The pins are of the kind called *pu yao*, which were intended to sway as the wearer moved.

The first sign of a new departure in the treatment of gold appears in a tomb at Wu Hsien, Kiangsu, dated to 1315[17]. The find comprises (among numerous silver vessels noticed below) five gold belt plaques with ornament of flowers and human and animal figures raised in relief to depths of 1–2 cm. A plain gold bowl bears the earliest known instance of an assay mark: *Yüan kuan tsu sê chin*, "(? Excise of the Yüan government): gold of sufficient colour". The belt plaques with high relief are rectangular or rounded, the largest measuring 15.5 × 8.2 cm. One has an elaborate version of the story of King Wen's suit to T'ai Kung Wang (cf. the silver dish of plate 31). The King is in his carriage, the future minister fishes doggedly beneath a tree, and the King's servants approach him with evident caution.

17

The high relief gives the effect of *ronde bosse* and the brief, tense characterisation of the figures is worthy of a primitive Christian ivory[18]. On another plaque mandarin ducks are enfolded in lotus petals. The remaining plaques have thick clusters of pomegranates among leaves, joined by stems separated from the ground. The subjects depicted and the generous scale of the *repoussé* are innovations in gold-work.

As these Yüan pieces suggest, gold and silver were not subject to the rigid archaising convention to which much of the finest bronzecraft was subjected from Sung times onward. In the sequel, under the Ming dynasty, we witness a surprisingly untrammelled employment of the precious metal for ostentatious work. The outstanding monument of early Ming gold is the treasure of Hsüan Tê, which was robbed from his tomb and dispersed to antique dealers some twenty-five years ago[19]. The traceable pieces from the treasure are a ewer (plate 3) and a vase with cover in the Philadelphia University Museum, two dress ornaments in the British Museum (plate 4), and a basin. The vessels are made of heavy beaten gold sheet, with traced ornament of five-clawed imperial dragons writhing in clouds. Around the neck of the ewer are stylized leaves, and simple cloud scrolls appear on the ewer lid and on the rim of the basin. An unexpected feature is the scatter of pearls and precious stones, rubies, garnets and amethysts. The stones are polished pebbles, without sign of cutting, set in cups of gold foil which hold them merely by being pressed roughly around their sides. The stones are placed irregularly, both in the design and with regard to their own differing shapes and sizes. They lend the work an adventitious air, strangely un-Chinese. Since the effect resembles the settings of turquoise common on later Tibetan metalwork, the suggestion lies ready to hand that Tibetan influence, connected with tribute and Ming patronage of the Tibetan Buddhist church, is responsible for the introduction of such barbaric ornament into China. This style was perhaps fashionable in West China, for a gold headdress with similar settings of red and green precious stones was recently excavated from a Ming tomb at Lan Chou in Kansu[20]. Porcelain ewers resembling the gold one were made from the late Yüan period onwards. The fact that a shape answering most closely to the profile of the gold ewer belongs to the Chia Ching period, a century later, perhaps points the inference, often made, that the potter copied metal forms established at an earlier time. The openwork plaques (plate 4) were probably intended for sewing to the back and front of the emperor's dragon robe. The gold sheet is thinner than that of the vessels; the edges of the perforations are bent slightly inwards, suggesting that the working method was similar to that noticed by the *T'ien kung k'ai wu* as that of Shensi goldsmiths, the foil being laid on sheepskin or leather for cutting. The effect is to be pictured against a silk of contrasting colour.

Among recently excavated pieces, gold filigree of Ming date is best represented by ornaments from the tomb in Nan Ch'eng Hsien, Kiangsu, of Chu Hou-yeh, a member of the imperial family who died in 1547[21]. These include a headdress of plaited wire set with stones *en cabochon* ground to more regular bosses and more regularly arranged than on the Hsüan Tê gold. The filigree of two phoenixes compares poorly in delicacy with T'ang and Sung work and points the way to the coarse and bedraggled filigree of gilded bronze made in Ch'ing times, which collectors sometimes flatteringly attribute to T'ang. The remaining pieces, none more than a few centimetres high, represent storeyed and many-roofed pavilions,

inhabited and embowered in vegetation. As in the tasteless carved ivory miniatures of the 19th century, the ingenuity of the craftsman provides the sole interest of this three-dimensional work.

For typical goldwork of the later Ming period we may look at the contents of the tomb of the Emperor Wan Li (1573–1620), which was officially opened in the autumn of 1955[22]. These include a headdress woven of wire, a ewer and a *chüeh* goblet on a dish with rough precious stones set around the rim in the manner of the Hsüan Tê vessels. Judging from the published photographs none of this goldwork is of high quality, the filigree, traced, and *repoussé* ornament being notably coarse. Little goldwork of Ming date and hardly more of the Ch'ing dynasty has found its way to modern collections; but some large vessels, figures of animals and mythological persons in cast gold have survived from the palace ornaments. All of these copy models, normally cast in bronze, have no claim to our attention by virtue of distinctive treatment of their material. The pieces illustrated on our plates 5, 6, 18 and 19 are exceptional. The teapots (plate 6) recapture a classical elegance (in their case owed to the pottery they imitate), while the basket (plate 18) may stand for the delight in technical mastery and the taste for ornament in regardless and insignificant profusion which infected so much of Chinese craft in its 18th century decline. The gold jewellery of the Ch'ing period is mostly shoddy, overloaded with messy filigree, loosely mounted stones and perishable addenda such as kingfisher feathers. But there is a fussing and unsubstantial quality about much Chinese jewellery, even during its zenith in the T'ang period, which does not endear it to European taste. WILLIAM WATSON

[1] Strictly speaking the raising of relief from below is termed *repoussé*, and tracing denotes work on the upper surface; but *repoussé* is often used of relatively high relief in which the two methods of working are not easily distinguished.

[2] e. g. A spearhead in the British Museum, see William Watson, *Ancient Chinese Bronzes*, London 1962, col. pl. c.

[3] Cf. Bo Gyllensvärd, *Chinese Gold and Silver in the Karl Kempe Collection*, Stockholm 1953 (hereafter 'Kempe Catalogue'), nos 22–26.

[4] *Hui hsien fa chüeh pao kao*, p. 104; William Watson, *Archaeology in China*, London 1960, pl. 82 b.

[5] Kempe Catalogue, no 32. [7] Higgins, op. cit., p. 21.

[6] See R. A. Higgins, *Greek and Roman Jewellery*, London 1961. [8] Kempe Catalogue, no 16.

[9] See K. M. Skalon, "O kulturnykh svyazyakh vostochnovo Prikaspiya v pozdnesarmatskoye vremya", *Arkheologicheskii Sbornik*, no 2 (1961), p. 114 ff.

[10] *Wen wu ts'an k'ao tzǔ liao*, 1956, no 1, p. 50, no 15.

[11] Kempe Catalogue, nos 17–20; v. H.F.E. Visser, "Some remarks on gold granulation work in China", *Artibus Asiae*, Vol xv (1952), p. 125 ff.

[12] Cf. *Wen Wu*, 1960, no 3, p. 23. [15] Kempe Catalogue, nos 54–64.

[13] Kempe Catalogue, no 39. [16] *Wen wu*, 1958, no 3, p. 65 f., figs 9, 12.

[14] Kempe Catalogue, nos 37, 38. [17] *Wen wu*, 1959, no 11, p. 19 f., fig. 4.

[18] This plaque may be compared with the silver plaques in similar high relief in the Kempe collection, Cat. no 164, which are probably also of the 14th century.

[19] An early notice of the find is in a note in the hand of George Eumorfopoulos, to whom the gold objects were offered for sale. It quotes a letter of 28th January, 1938, as follows: "About 7 weeks ago bandits broke into the Ming Ling (Ming tomb). Most of these have been plundered in former times, but in the tomb of the Emperor Hsüan Te, beneath the coffin, a treasure in massive gold was found. It consisted of: 1. A big washing jar engraved with five clawed dragon and studded with sapphires, rubies and pearls. – 2. Then his washing basin. – 3. A big box. – 4. Two smaller covered vases. – 5. His girdle with fastenings. – 6. Twelve golden hangers (a tooth pick-box, a snuff-box, a medicine-box, a case for table utensils, a box for seals etc.).
I have seen the whole treasure. In the meantime, the sellers, as usual, quarrelled and divided the find."

[20] *Kaogu*, 1960, no 3, p. 42 ff.

[21] *Wen wu*, 1959, no 1, p. 48 ff.

[22] *Kaogu Tongxun*, 1958, no 7, p. 36 ff; *Wen wu*, 1958, no 9, p. 23 ff.; *Kaogu*, 1959, no 7, p. 358 ff.; v. Ella Winter, "The Tomb of Wan-Li", *Illustrated London News*, April 11 th, 1959, p. 616–617.

1. BELTHOOK OF GOLD AND JADE

4th–3rd century B.C. *Length 12.3 cm. Freer Gallery of Art, Washington, D.C.*

Apart from some rare harness-trappings we know little of the independent use of gold in ornaments in pre-Han times. There are, however, several examples of its use in combination with jade, as in this belthook. The thin gold sheet with *repoussé* ornament is mounted on the jade at the centre, but the tiger-head terminal of the hook appears to be of solid metal beaten and traced. The carving of the white jade equals the finest quality of work dated to the end of the 4th century and the early 3rd century B.C.

2. GOLD JEWELLERY

T'ang dynasty. 8th–9th century. Length of the longest pin 16.5 cm. British Museum, London

The gold ornaments found in T'ang tombs are often of great finesse and beauty. Their filigree and granulation are of a skill comparable to that of ancient Greek jewellery. The hairpins are single or double, the former sometimes made of a narrow ribbon of gold. The filigree pin on the left has a pearl resting on petals; the ring on its right terminates in a phoenix head. The bird of the right-hand pin, the head of the middle pin, and the granulated bead and earring are hollow.

3. GOLD WINE-EWER WITH TRACED ORNAMENT AND INCRUSTATION OF SEMI-PRECIOUS STONES

Ming dynasty. Early 15th century. Height 22 cm. Philadelphia Museum of Art, Philadelphia, Pa.

This imperial piece – it has five-clawed dragons – was found together with the *ajouré* gold plaque illustrated in plate 4. It suggests the same exotic influence by its incrustation, which has the air of Tibetan work. Ewers of this type were made in porcelain from the late Yüan period onwards. The comparatively squat proportions of this piece are closer to porcelain ewers of the Chia Ching period (1522–1566) than to those of the 15th century.

4. GOLD PLAQUE *REPOUSSÉ* AND *AJOURÉ*, INCRUSTED WITH SEMI-PRECIOUS STONES

Ming dynasty. Early 15th century. Height 14.5 cm. British Museum, London

This plaque, one of an identical pair, is decorated with the imperial emblem of two five-clawed dragons squirming in clouds on either side of a flaming jewel. The jewel, probably represented by a pearl, is now missing. The incrustation, scattered in strangely un-Chinese fashion, is similar to that of the ewer of plate 3. None of the inset stones is shaped and they are only roughly polished. The contrast of the delicacy of the goldwork and the irregularity of the stones is not an effect normally sought by the Chinese craftsman, and suggests a foreign influence, possibly from Tibet. The plaques are designed to be attached to the breast and back of an imperial garment.

5. GOLD BOX INCRUSTED WITH CORAL AND PEARLS

Ch'ing dynasty. Ch'ien Lung period (1736–1795). Width 6.4 cm. Carl Kempe Collection, Ekolsund, Sweden

Incrustation of this kind is quite foreign to traditional Chinese craft, and its appearance here bespeaks the exotic and especially European tastes cultivated at the court of the emperor Ch'ien Lung. Apart from the pearled figure on the lid, which is a common conventionalized form of the character meaning long life, this box could pass as European work. The segments of coral are held by cloisons of twisted gold wire soldered on a gold body built of several sheets. The pearls are set in wax.

6. PAIR OF GOLD TEAPOTS WITH TRACED DECORATION AND IVORY HANDLES

Ch'ing dynasty. K'ang Hsi period (1662–1722). Height 6 cm. The Fairhaven Collection, Anglesey Abbey, Cambridgeshire

The design of the spouts and the handle terminals, in the form of dragon-heads and lion-heads, follows an ancient convention. This shape of teapot first appears in the fine red pottery of the I Hsing kilns towards the middle of the 16th century. The gold is likely to have been expanded and shaped by spinning. The reign-mark of K'ang Hsi is on the base together with the name of the maker, Ta Hsing. These teapots are said to have belonged to the Dowager Empress, Tz'ŭ Hsi.

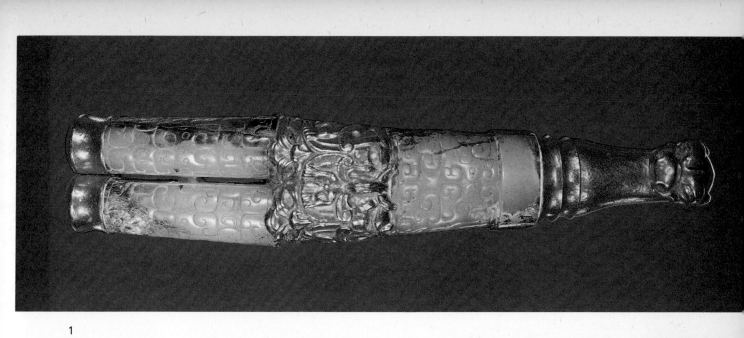

1

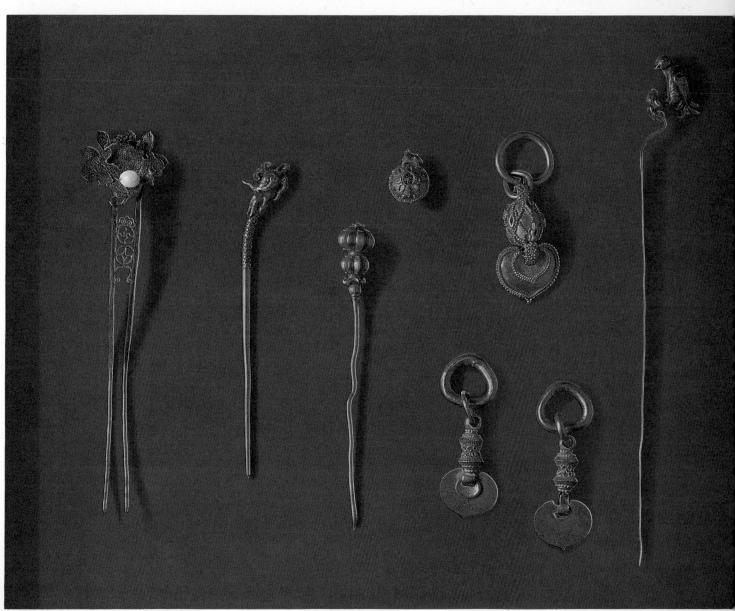

2

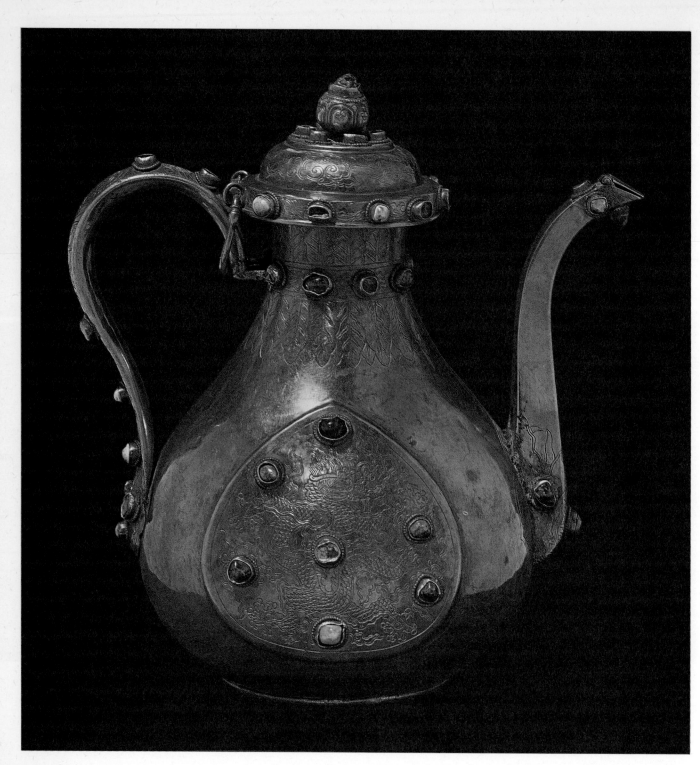

3

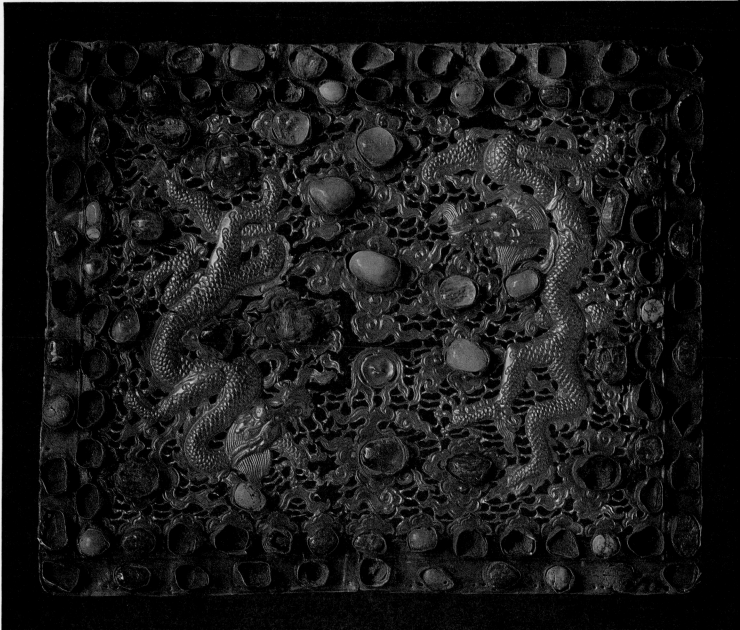

4

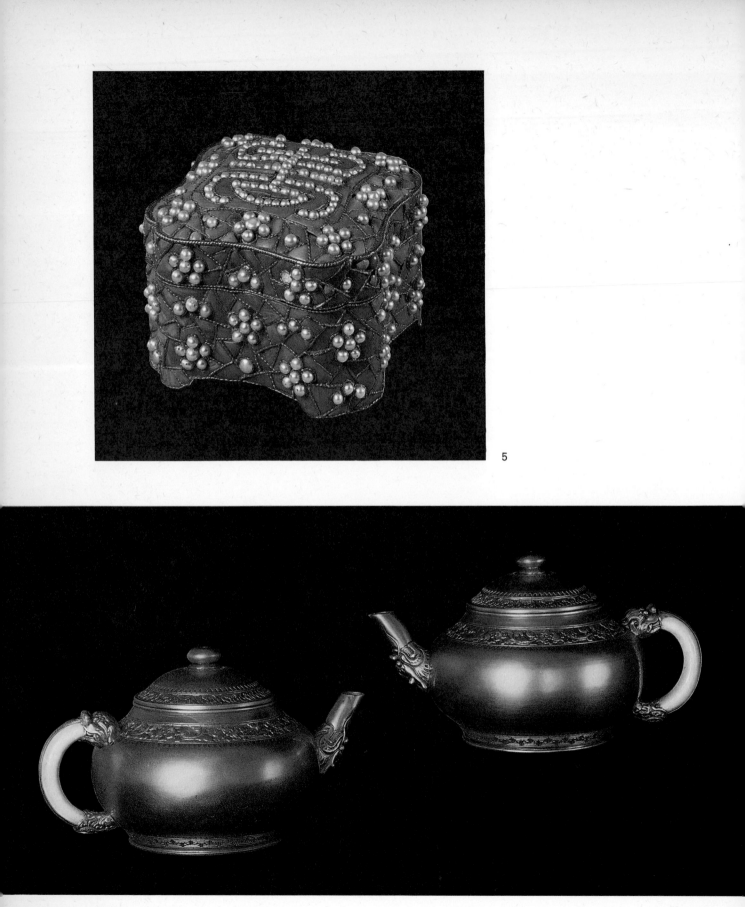

5

6

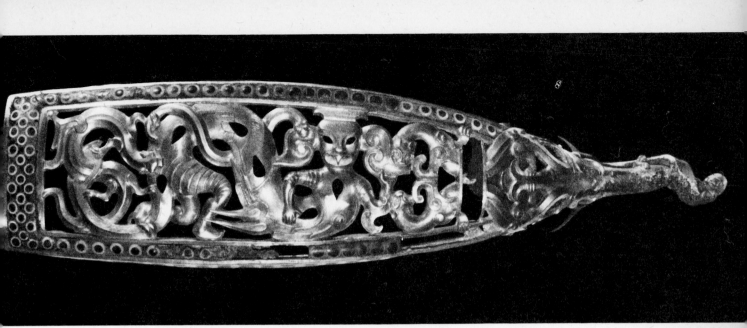

7. GOLD OPENWORK BELTHOOK WITH GLASS INLAY

2nd century B.C. *Length 8.2 cm. Fogg Art Museum, Cambridge, Mass.*

The subject depicted is Hsi Wang Mu ("Queen Mother of the West"), regent of the Taoist paradise, who is represented and designated by name on bronze mirrors of the 2nd century A.D. Unnamed she appears elsewhere in Han art. This belt-hook is the only piece attributable to the early Han period on which Hsi Wang Mu can be identified with certainty. The representation here follows the description of the goddess given in the Classic of Mountains and Rivers: "in form like a human being, with the tail of a leopard, the teeth of a tiger, good at roaring, with hair dishevelled and wearing the *sheng* headdress". The surround is of light-blue glass with inlaid white circles and spots of darker blue.

8. BRONZE HARNESS MOUNT WITH THREE GOLD T'AO T'IEH MASKS

4th century B.C. *Height 5 cm. Formerly collection Mrs. Walter Sedgwick, London*

The masks are cast onto spigots rising from the bronze ring which forms the base of the ornament. There is no sign of chiselling or engraving of the gold after casting. The tiger-like design of the traditional *t'ao t'ieh* monster-mask is that current in the 5th and 4th centuries B.C.

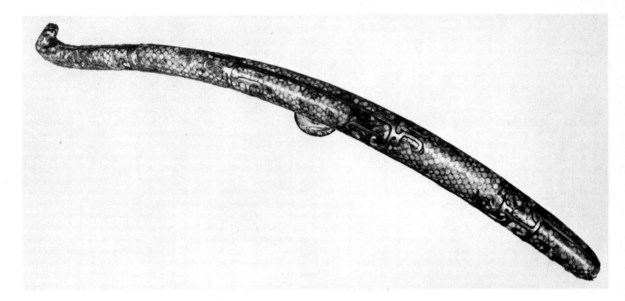

9. GOLD DAGGER HANDLE

4th century B.C. *Length 11.1 cm. British Museum, London*

The handle, composed of an openwork of repeated units derived from a winged dragon, and hollow, is a *tour-de-force* of casting skill. It can only have been produced by the lost wax process. The spirals and granulation of the dragon parts, a mass of bodies and stubby wings with a sprinkling of heads, conform to the linear style of the bronze art of the 5th–4th centuries B.C., as seen on large vessels as well as on smaller decorative pieces; but no such technically exacting work in bronze has survived. The dagger handle is unique among the antiquities of the later Chou period.

10. GOLD BELTHOOK WITH TURQUOISE INCRUSTATION

4th century B.C. *Length 18 cm. Freer Gallery of Art, Washington, D.C.*

Belthooks shaped in a curved bar are one of the earlier forms of this dress ornament. The upper terminal follows the regular convention of a dragon or snake head. From the 4th century B.C. to the 1st century B.C. belthooks are one of the most frequent finds in tombs, being the only form of personal adornment which male costume permitted. This specimen is outstanding for the accuracy and almost complete preservation of the turquoise inlay.

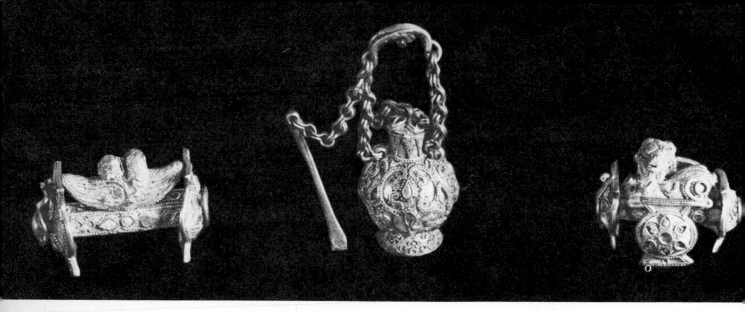

11. GOLD ORNAMENTS WITH GRANULATION AND TURQUOISE INLAY

Han dynasty (206 B.C.–A.D. 221). Height of the miniature vase 4 cm. William Rockhill Nelson Gallery of Art, Kansas City, Mo.

The technique of granulation, which requires the use of a solder with chemical action, appears at an advanced stage in the Han period. The petal-shaped inlays of turquoise resemble those found in Han ornament that is under the influence of the animal-style art of the steppe nomads. The lion and the twin doves were probably mounted on hair-pins.

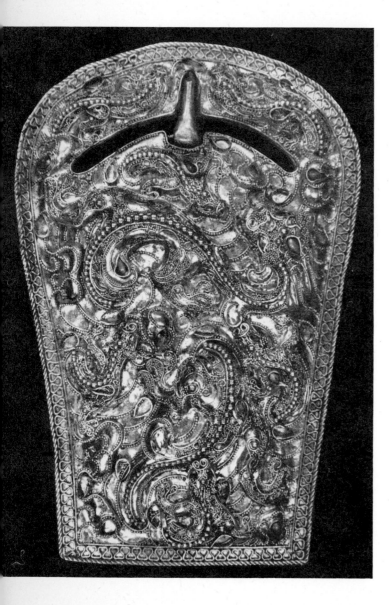

12. GOLD BUCKLE WITH GRANULATION AND TURQUOISE INLAY

1st–2nd century A.D. Found at P'yongyang, in the ancient Lolang province, Korea. Width 9.8 cm. National Museum of Korea, Seoul

This is the most splendid surviving example of Chinese gold-work of the Han period. The ground is of hammered gold. The large dragon and six smaller ones are represented in fili-gree and granulation, with a scatter of petal-shaped cells of which six still retain their inlay of turquoise. The edge of the buckle is formed of heavy twisted wire doubled by a band of loops.

28

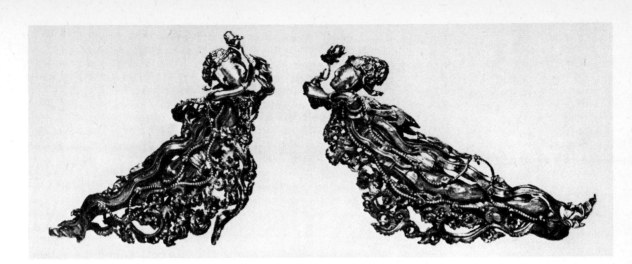

13. PAIR OF GOLD APSARASES

T'ang dynasty. 8th–96th century. Length 8.1 and 8.8 cm. Freer Gallery of Art, Washington, D.C.

Apsarases, the Heavenly Beings of the Buddhists, appear as decorative motifs in Buddhist art from the 5th century onwards. They are shown in wingless flight, sometimes resting on clouds, as in this instance, and in T'ang times might be used in ornament which had no direct connection with Buddhism or its iconography. On a mirror-back, for example, they are shown among a scatter of flowers. This pair of gold apsarases is unique in material and in its elaborate workmanship. They carry the lotus-bud, symbol of the doctrine. The gold is chased and engraved.

14. GOLD CUP WITH DRAGON-HEAD HANDLE

Northern Sung dynasty (960–1127). Found at Lo T'o Kou, Shensi province. Diameter 8.2 cm. Carl Kempe Collection, Ekolsund, Sweden

The dragon's head is hollow, made of two *repoussé* sheets soldered together. The floral decoration, all traced, is developed from the conventional lotus design, three flowers grouped on the interior and a more cursory scrolled band on the outside below the lip. The ground is marked with an irregular scatter of dots. The slacker flow of the ornament as compared with similar T'ang ornament, and the tamer look of the spiral-nosed dragon, bespeak the Sung date of the piece.

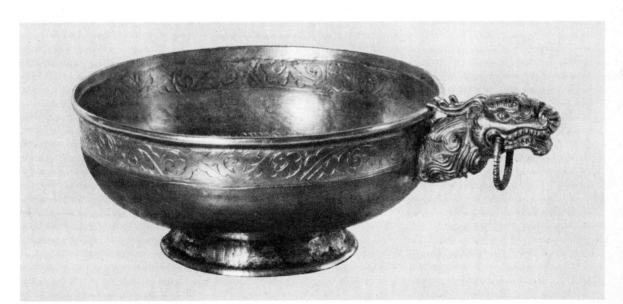

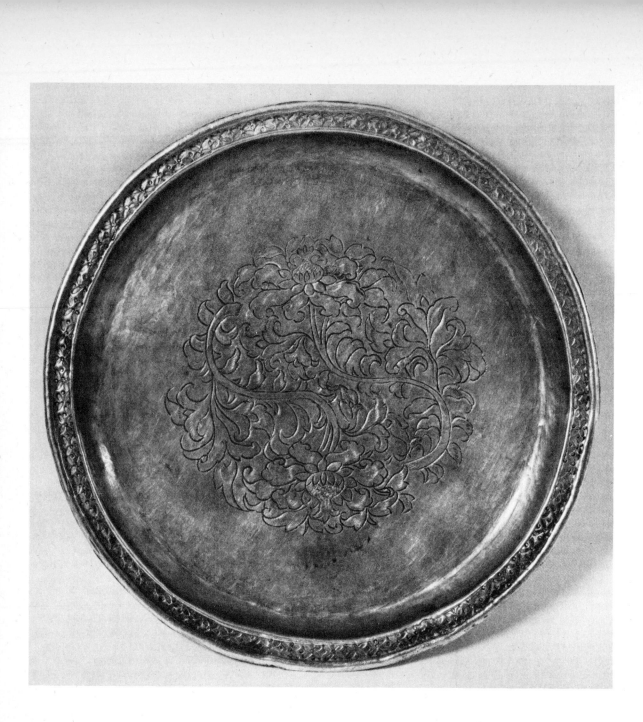

15. GOLD DISH

Northern Sung dynasty (960–1127). Diameter 13.6 cm. Carl Kempe Collection, Ekolsund, Sweden

Shallow bowls and flat dishes like the piece illustrated, of both gold and silver, decorated with broad floral designs, are characteristic of the metalwork of the early Sung period before archaic taste had come to dominate imperial craft. A less austere and heraldic arrangement, a subtler adaptation of conventional design towards realistic effect, and the shading of leaves to relieve the flatness of the ornament, agree with a newer taste for which the cooler precision of the T'ang style had lost its appeal.

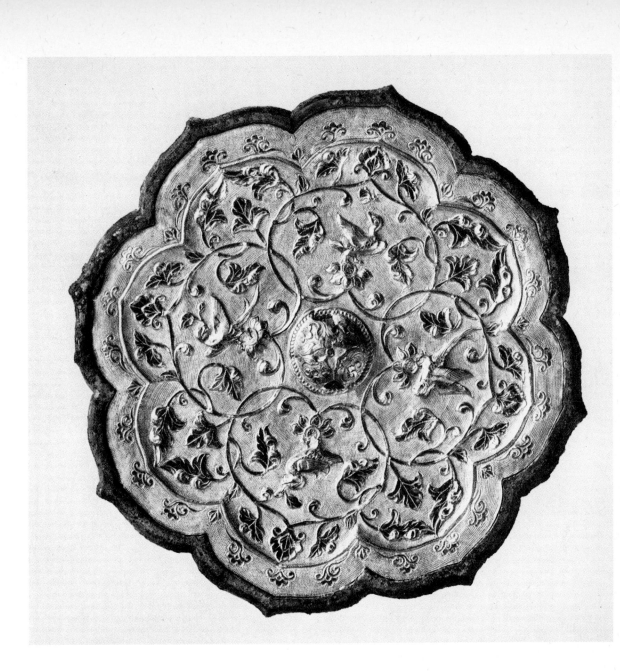

16. BRONZE MIRROR WITH GOLD BACK

T'ang dynasty. 8th–9th century. Diameter 15 cm. Freer Gallery of Art, Washington, D.C.

The scrolls with palmette-like leaves and flying and perched birds could be closely matched in the silver of the period. In an exacting framework of multiple symmetry the individual forms are rendered with a sensitivity and freshness unsurpassed in other metalwork of the T'ang period. Here, as in the mirror illustrated below it, the background is formed of small, close-set rings, as was also the practice in silver.

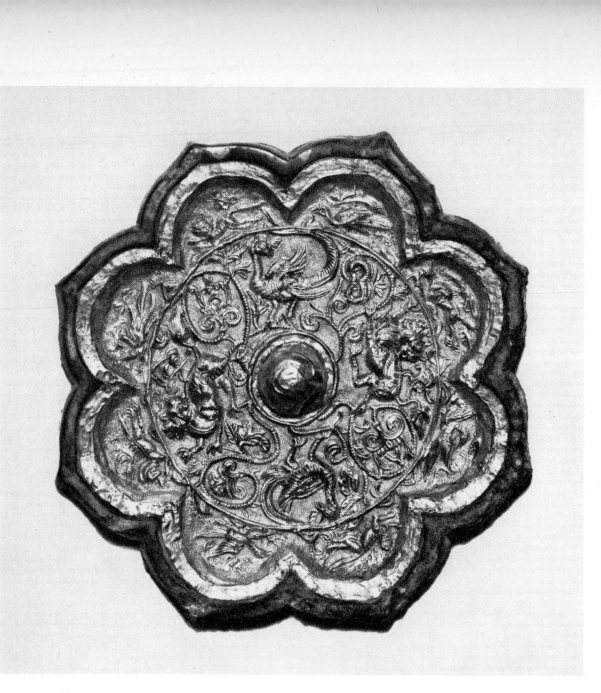

17. BRONZE MIRROR WITH GOLD BACK

T'ang dynasty. 8th–9th century. Diameter 13.3 cm. Fogg Art Museum, Cambridge, Mass.

A thin gold sheet with chased, traced or openwork ornament might be attached to the back of bronze mirrors. In general the decorative motifs are similar to those of the contemporary cast bronze mirrors, but rendered with the greater finesse which the working of the gold allowed. This mirror has alternating pairs of lions and phoenixes, the former in the style associated with Buddhist sculpture, on which they appear as temple guardians. Both motifs are frequent on bronze mirrors.

18. GOLD ORNAMENTAL BASKET DECORATED WITH BIRDS AND FLOWERS ▷

Ch'ing dynasty. 18th century. Height 28.5 cm. The Fairhaven Collection, Anglesey Abbey, Cambridgeshire

The basket is of the kind seen in Chinese colour prints of the 17th century. The flowers are executed in filigree, and the decoration of the side-panels is in *repoussé*. Purely ornamental work like this piece, not directly connected with dress, furniture, drinking utensils or the traditional accoutrement of the scholar's table, is comparatively rare among the products of Chinese craftsmen. This basket gives a hint of a western sophistication not out of place at the court of the emperor Ch'ien Lung.

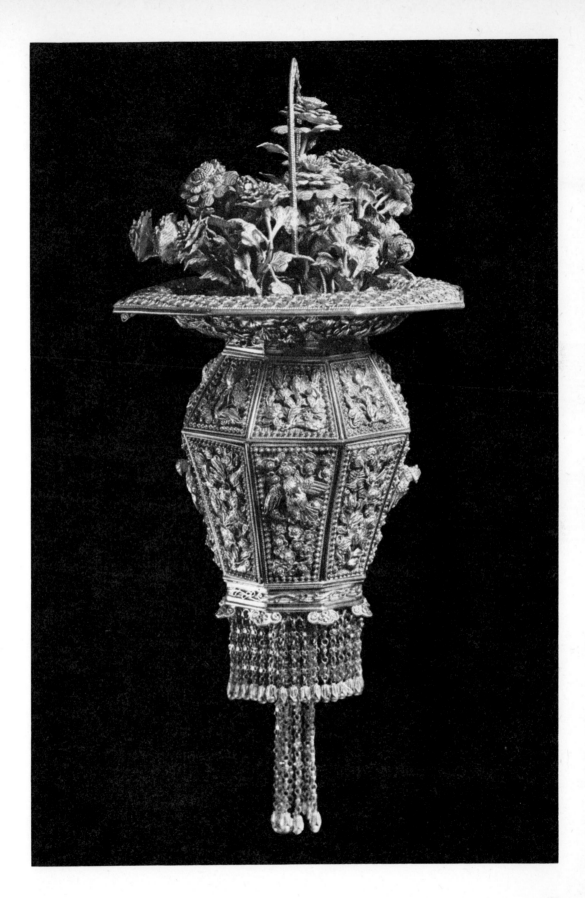

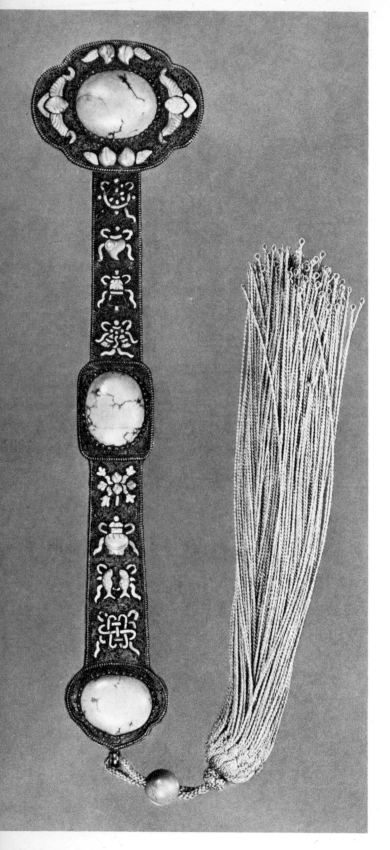

19. GOLD *JU-I* SCEPTRE, WITH FILIGREE AND INLAY OF TURQUOISE

Ch'ing dynasty. 18th century. Length (excluding the silver tassel) 21 cm. Freer Gallery of Art, Washington, D.C.

The *ju-i* (the word means "what you will") is now described as a bringer of good luck, especially suitable as a present to a senior friend or relative on an important occasion. The shape seen here may have been adopted in the Sung dynasty, though no examples of it can be dated earlier than the late Ming period. The remote ancestor of the *ju-i* appears to have been a wand held by Buddhist priests when discoursing, which more resembled a back-scratcher. This gold *ju-i* has turquoise inlay depicting bats and peaches (for happiness and long life) and the Eight Auspicious Signs which were to be seen on the sole of Buddha's foot, and which are often represented on temple altars: the wheel of the Law, a conchshell, an umbrella, a canopy, a lotus, a jar, fishes and a mystic knot.

CHAPTER II: SILVER

CHINA is very rich in silver. The *T'ien kung k'ai wu* lists places in Kiangsi, Hunan, Kuangsi, Kueichou, Honan, Szechwan, Kansu and Fukien where it was worked, but adds that the total from these eight provinces did not amount to half of the production in Yünnan. The mines at Ch'u Hsiung, Yung Ch'ang and Ta Li were the most important. Operations at the mines were controlled by the government as far as it was able. Draconian regulation of labour was inevitable, says the author, and states rather mysteriously that at the beginning of the Ming period the Fukien mines were 'in some cases exploited, in others closed up'.

Silver is less resistant to corrosion than gold, and little more so than bronze, so that its rarity in the earliest grave deposits – (cf. the few scraps of the metal reported from excavations in the site of the Shang capital at Anyang) – may not mean that the metal was rare in use. The fact that its main sources lay far beyond the limit of Shang political control need not have prevented its use, for there is other evidence of trade reaching into the barbarian South of China. But we are probably justified in assuming that before the middle of the first millenium B.C. it was not specially sought after or prized for the manufacture of artistic or ritual objects. By 400 B.C. means had been found of removing the chief impurity, lead. Probably the process of extraction by cupellation described in the *T'ien kung k'ai wu* differs little from the ancient method. The bottom of a large crucible is covered with layers of pottery fragments and charcoal ash. The ore is introduced, mixed with an equal amount of chestnut charcoal. After the whole is ignited and brought to white heat by the bellows, more charcoal is inserted into the mixture with tongs. The metal fuses in a lump, and is then melted again with pinewood charcoal to separate the lead, which falls to the bottom of the crucible. A small quantity of lead and copper is however desirable in silver, and this is deliberately added in a third melting. The ore mined at Ch'u Hsiung in Yünnan was of such purity that the smelters were obliged to buy lead 'everywhere' to use in alloying their silver.

From the 4th century B.C. comparatively thick silver sheet was inlaid on bronze in the same way as gold foil, fixed in shallow cavities slightly undercut at the edge. The silver was apparently cut almost exactly to shape before insertion in the bronze, for no trace of hammering is ever perceptible. As in the case of gold, the thinnest threads appear to be cut from foil rather than prepared as hammered wire. The aim was to achieve a perfectly smooth surface in the finished work; both in the geometric styles of late Chou times and in the realistic figural and landscape themes of some fine Han pieces, the inlaid designs copy compositions which were developed by the painter (plates 38, 51).

Cast silver of this early period, which is poorly represented in modern collections, was not uncommon, and imitated the minor ornaments which were more frequently made of bronze. The Ku Wei Ts'un belthook of cast silver faced with gold-foil was mentioned in the previous chapter (p. 12). The Kempe collection possesses some cast silver belthooks, including one outstanding specimen of the Han

period designed in openwork, with monster-mask, birds' heads and a central open knot[1]. The figure of a dwarf (plate 23), for which a pre-Han date is proposed, is exceptionally well modelled, in this respect surpassing its only compeer, a leather-jerkined soldier in the Hosokawa collection. Four shallow cups[2], of comparable age, with rims forming a heart-shape and falcon-head handles, are also of cast silver though the drop-shaped bosses on the sides (their form recalling the smaller turquoise inlays of Steppe tradition found in Han goldwork) were either raised by hammering, or imitate this work. The date of these cups is not however beyond controversy. They are said to have come from Loyang in Honan, and have been attributed to dates both earlier and (as the writer would agree) later than the Han period. Most striking of all is a scabbard of about 500 B.C. in the Frederick M. Mayer Collection, which has a front panel formed of small interlacing dragons in openwork[3]. The dull surface of the metal suggests that the silver is heavily alloyed with copper. A curiosity for its metal constituents is the turquoise inlaid belthook of plate 24: the body of the hook is apparently of bronze, but the upper surfaces are thickly plated with greenish white metal. Spectrographic analysis has shown the plating to contain silver, gold, copper and mercury. It was probably applied by the fire-gilding process. The gilding of the edge of the base is yellower, and apparently richer in gold.

The finest silverwork known from the Far East was produced in China during the T'ang dynasty. Outstanding for its artistic merit, it fascinates us no less for the evidence it gives, more precisely than any other branch of craft, of the artistic influence from the west which was attracted by the T'ang political expansion into Central Asia. By 659 Chinese power extended to the Oxus, and Ferghana, Bukhara, Samarkand and Tashkent were under Chinese control. Before the end of the 7th century Chinese craftsmen were exploiting the artistic potentialities of silver as never before. This durable and easily worked metal was abundant and cheap enough to furnish sumptuous vessels for the tables of a luxurious society with unprecedented cosmopolitan tastes.

The methods of manufacture were technically uniform and simple. The silver, alloyed with a little lead and tin, was cast to the required shape, and finished with a minimum of hammering. Handles and ring-feet were soldered; when the decoration of the outer surface appeared too noticeably in reverse on the inner side, the vessel might be constructed with a double skin, with barely visible soldering at the lip; though this procedure is followed in a relatively small proportion of the surviving pieces. Only certain multi-lobed shapes required the vessel to be constructed of several sections soldered together. The sides of the vessels are always thin, rarely exceeding one millimetre, even in pieces of comparatively large size. The ornament is almost invariably produced by tracing (see page 10). Engraving is found on a few rare ornaments[4], and there are no examples of freely chiselled relief such as occur in the silver of Sasanian Persia. The tracing leaves the sides barely roughened to the touch. Relief ornament, when it occurs (in the vessels it is confined to roundels at the bottom of the bowl) is fairly low, only some mirror backs, on which the ornament is raised from below as well as traced, display elaborate relief of differing levels.

Parcel-gilding is common, generally neatly confined to the traced figures to which it is applied.

Throughout the T'ang period there is a predilection for a ground consisting of minute, closely packed circles punched with a die, on which the lines and plain surfaces of the decorative motifs appear to great advantage. The pieces illustrated on plates 26 and 27 exhibit some contrasts in the tracing style. The box (plate 27), decorated with one of the smallest-scale versions of the floral scrolling, has a smooth, rounded line dividing the panels. The tight, static symmetry of the design, the employment of detail to variegate rather than animate the surface, are characteristic of an earlier style. The more dynamic composition of the floral ornament on the cup of plate 26 heralds the freer movement and more natural-istic trend of the 8th century designs. Here it is executed on exceptionally thick metal, and the traced line has almost the sharpness of engraving.

In his exhaustive analysis of the shapes and ornament of T'ang silver Gyllensvärd lists the designs according to his proposed derivations from Persian, Indian, and traditional Chinese sources[5]. The Per-sian group embraces a tradition which must itself be of multiple origins, going back to East Roman models. Very few of the parallels adduced can be located near the centre of Sasanian civilization, and the possibility that some characteristics cited by Gyllensvärd as Sasanian would be better described as Central Asian of Roman ancestry, related to but not directly copying Persian metropolitan work, is too great to be excluded; for the Central Asian cities were to some measure heirs to East Roman tradi-tions. But some instances of direct Sasanian influence on the T'ang silver are undeniable, and readily ex-plicable in consideration of the presence of Persian and Sogdian merchants in the T'ang capital at Ch'ang An, and of the signal fact of the retreat thither of the last Sasanian King in 675. The stricter Sasanian resemblances in the Chinese silver are 1) the ewer, a specimen particularly close to the Sasanian model being preserved in the Horyūji temple in Japan; 2) elongated lobed cups; 3) stemmed cups like that of plate 20 (but those called Sasanian lack the moulding at the top of the stem, which probably goes back to Roman models); 4) hunting scenes and the associated conventions of horsemen, vegetation and animals (though such ornament probably had wide currency in Central Asia); and 5) the palmette scroll and the half-palmette scroll. The palmette, along with the vine-leaf, was to furnish the chief theme of Chinese veg-etable ornament in the earlier T'ang period; but it is never the dry scrolling known on Persian silver. From the start the Chinese artist made graceful additions. Essentially similar designs were however used in Chinese Buddhist ornament from the 4th century. It is clear that the Sasanian suggestion, if it indeed had the influence we suppose, fell on willing eyes.

The element in the silverware designated 'Indian' by Gyllensvärd comprises Buddhist objects and their ornament, which originated remotely in India. The forms of the bowls, bottle-shaped vases (kun-dika) and reliquaries of the temples were rarely reproduced in silver (a notable exception is the bowl of Buddhist form in the Shōsō-in, Japan, which is quite inappropriately decorated with a hunting land-scape in the Persian style). More important, the Buddhist decorative theme par excellence, the lotus bloom, now entered into secular art, singly or in scrolls, with a freshness that belies its long familiarity in religious ornament. How far its emergence from the temples marks an appreciable 'Indian' influence on T'ang art is open to question. Its use in secular ornament may also be, more directly, a contribution from Central Asian civilization to the receptive artists of T'ang China (plate 21).

When all acknowledgement is made to foreign inspiration, clearly demonstrable and guessed at, the character of T'ang silver remains thoroughly Chinese. It issues from the native tradition at a moment when the apprehension of both form and ornament is refreshed. The new style is controlled but not yet inhibited by the formalism into which Chinese invention ever declines, and by which, with subtle though sensible loss, it is gracefully preserved. In the T'ang ornament spirals, frets, chequers etc. of Chinese ancestry appear, together on occasion, with the phoenixes, tigers, birds, demons and other creatures of the Chinese bestiary (cf. plate 25). The landscape with figures may be borrowed from Chinese painting (plate 31). Elaborate floral scrolls (plates 20, 22, 30, 32), bands of flowers and birds in comparatively naturalistic style (plates 27, 28), rich floral medalions and roundels (plate 25) – all these are T'ang inventions. The most original and pleasing of vessel shapes, the petalled and lobed bowls and boxes (plates 22, 25, 33), the platters with lobed outline (plate 31), are no less certainly the creation of the Chinese craftsman. Boxes in the shape of shells and goats, and a tray in the form of a leaf, are other imaginative designs to be found in modern collections[6].

Within the T'ang period a broad succession of styles can be guessed at, though the exact dates of the transitions elude us, and the possibility that earlier styles continued in use alongside the newer makes the dating of individual pieces insecure. Gyllensvärd speaks of a 'revival of the archaic style at the end of the period'; and the possibility of an archaising trend continuing throughout the period, perhaps at a distinct centre of silverwork, is not to be excluded. The clearest elements of Sasanian style – the shapes of pronounced Persian type and the hunting *décor* with its characteristic forms – are to be placed near the beginning of the development, possibly as early as the middle of the 7th, and probably not later than the opening decades of the 8th century. The bowl with this decoration in the Shōsō-in was deposited there in 767 A.D. A comparison with the decoration of bronze mirrors of the 7th century suggests that the stiffer kind of symmetrical scrolls of clear construction appearing on the silver are no later (cf. plate 20). But before the beginning of the 8th century a tendency to overload the scrollery with leaves and flowers, and to combine vine leaves and palmettes on the same stems, comes to dominate in the designs. The tight, heraldic treatment of small flowers and tendrils, as seen on the bowl of plate 25, echoed in the multiple symmetry of the scrollery on the box of plate 27, was evolved probably not later than 700. The freer scrollery of the box illustrated on plate 22, and especially the broad treatment seen on the cup of plate 26, escape from the severe convention and mark a later development, probably occupying the first half of the 8th century. The cup is close in shape and decoration to a piece found at the Kōfukuji temple at Nara, Japan, which may be dated to about 710. The still broader style of the bowl of plate 28 and the cup of plate 29 appear to denote a further stage, to be assigned provisionally to the second half of the 8th century. The bucket illustrated on plate 30 has an archaic stiffness in all the elements of its decoration which warrant its being placed earliest among the pieces we illustrate.

Only the discovery of pieces dated by inscription, or from tombs so dated, can add the desirable precision to this dating of stages in the development of silver ornament. The progress and interplay of styles was complex. Not all the 7th century work was treated with geometricising restraint. A

round platter in the Minneapolis Institute of Art is reputed to come from a Loyang tomb dated to 664, a date which places it among the very earliest examples of T'ang silver[7]; but its rich, loosely scrolled designs of flowers and birds display all the inventive freedom, though not the structural principle, of designs which we allot above to the period after 800.

The only certain attribution to be made to the 9th century is that of the pieces from Pei Huang Shan in Shensi province (plates 31–33), which are dated to 877 by an inscription on one of them. The floral scrolls seen here have something of the rigidity of the early scrolling, though with a different effect, and raised in a kind of relief not seen on early T'ang work. The figural scene (plate 31) now introduces a subject from Chinese legend. An elongated lobed cup, also in the British Museum, is unusual in having on the inside a decoration consisting of flowered diapers, poorly drawn tendrils with stark symmetrical flowers; and, in clearly demarcated panels on the wider lobes, an urgently striding woodcutter with his load and two men in conversation. This cup and the Pei Huang Shan vessels are of beaten silver, and much inferior in craftsmanship to the best work of the 7th and 8th centuries.

Very little silver of post-T'ang date can be studied in modern collections, and we owe our main information to a few groups of vessels excavated in recent years. Sung silver compares badly with work of the T'ang period. It is no longer the medium for the most original craft, and the palm has passed to porcelain. A few small pieces with traced floral decoration on a ground of rings, all coarser than on the best T'ang silver, continue the T'ang tradition, but the more careful small-scale ornament is worked in *repoussé* on thin foil. Two combs in the Kempe collection, belonging probably to the Northern Sung period, represent the best of this work[8], but they have dry repetitiveness and neglect of detail which now robs the miniature style of its charm. Some platters with traced flowers like those of the gold piece illustrated on plate 15, and some bowls with sides of imbricated petals filled with similar tracing[9], represent a new, broader floral style, rescued from banality by a certain unstudied grace.

The tomb of Wang Chien (A.D. 901–925), king of the shortlived state of Former Shu in modern Szechwan, contained lacquered boxes inlaid with openwork silver panels[10]. These depict phoenixes and lions amid formalized foliage and flowers in a manner quite distinct from the T'ang tradition of central China, lacking the symmetry and scrolled effects, and yet unaffected by the Sung naturalism. A bowl from this tomb is constructed of a sheet of silver inlaid with flowers and birds of gold foil, doubled by an outer sheet of lead and lacquered. In this case the ornament is tightly scrolled; one gains the impression of a provincial attempt to copy the ornament of metropolitan silver by curious methods. A tomb at Tê Yang in the same province, dated by coins to the opening decades of the 12th century, contained a variety of new shapes of silver boxes and vessels[11]. The former are round, with flat lids rounded at the edge, the whole divided into numerous lobes. Both pieces have a pair of phoenixes at the centre, surrounded by rather angular floral scrolls which imitate the old style but quite miss its elegance. The body and lid of one box consist of minute openwork. The vessels, of beaten silver (Fig. 1), differ from any made before of this metal, though most of the shapes are familiar in Sung porcelain. On the bases

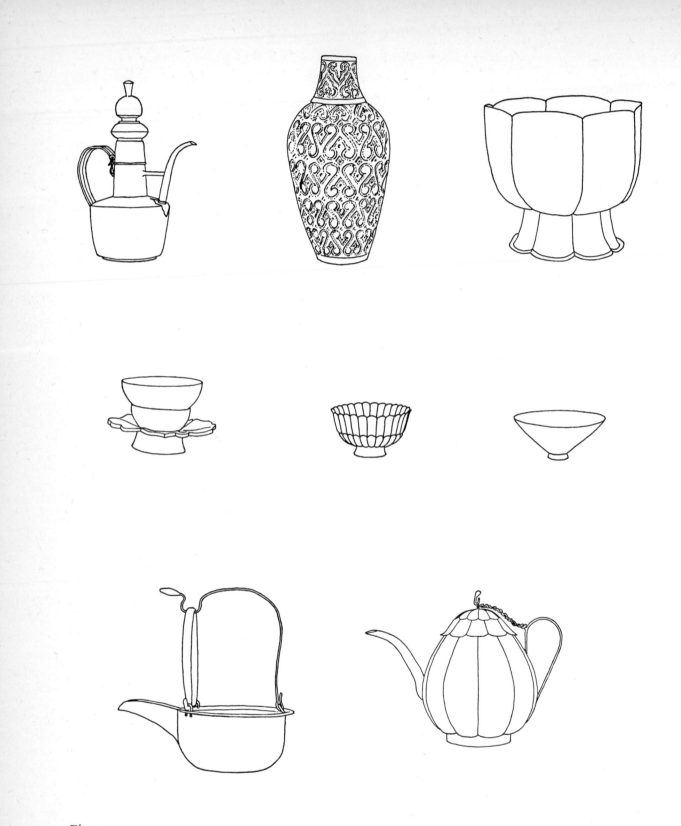

Fig. 1
Silver vessels found at Tê Yang, Szechwan province. Early 12th century.
Scale 1:4. (After *Wen wu ts'an k'ao tzŭ liao*, 1961, no 11)

of some of the pieces, the makers' names are written in ink: the Chou and P'ang families working at Hsiao Ch'üan (a township near Tê Yang). The words 'ten parts' (i.e. pure silver) guarantee the work of the Chou silversmiths. Other inscriptions record the names of women for whom the pieces were made. There is no evident provincialism in this Tê Yang silver: the evolved shapes of the finest porcelain were available to copy in any part of the country. For a record of provincial taste during the Northern Sung period we may look at silver produced in the Liao territory bordering the northern frontier. Some heavy *repoussé* relief of complicated animals and birds from a tomb in Liaoning, made as ornaments for the person and for harness, proclaim a taste quite alien to the Chinese, although the motifs used are based (like the Liao pottery) on sophisticated Chinese models[12].

Silver work is not documented again by dated finds until the early 14th century, when two tomb groups of vessels illustrate very fully the context in which the two pieces of plate 34 are to be placed. The tomb of Lü Shih-meng in Wu Hsien, Kiangsu, which was dated to 1304 by the funerary inscription, contained four boxes of beaten silver[13]. The most elaborate of them has the rim and sides moulded in the shape of eight pointed petals. The lid is recessed from the lip and decorated with a large traced roundel of a pair of phoenixes in clouds. The traced floral medalions on another is much in the style we have ascribed to the Sung period, but with less harmonious curves. An unusual and amusing piece is a water-dropper in the exact shape of a persimmon, with a lid of four petals and a stalk. That these medalions of flowers and phoenixes and, apart from these, the marked preference for the plain surface of beaten silver, were characteristics of late Yüan silver in general, is demonstrated by a hoard of gold and silver numbering 102 pieces found buried in an earthenware pot at Ho Fei in Anhui province (Fig.2)[14]. One vase in this hoard is marked with a date corresponding to 1333, and a platter is inscribed 'made by Chang Chung-ying'. The platter is also marked as 'nine parts' silver. The most numerous shapes are those of the spouted bowl and bottle illustrated on plate 34. The place of manufacture, as indicated on four of the small hemispherical cups, was 'No 4 shop' at Lu Chou, the modern Ho Fei.

In the subsequent history of silvercraft, as far as broad developments of technique are concerned, it remains only to recognise the shift to chiselling which occurred at the end of the Yüan dynasty. This innovation is associated with the name of Chu Pi-shan, a silversmith of Chia Hsing in Chekiang province, whose signature appears on the cup illustrated on plate 35. Chu Pi-shan used also the names Hua Yü, Chê Chih Hsiu Shui Jen, Wu T'ang Jen. His is the only name of a Yüan silversmith that has been found inscribed on surviving pieces. He specialized in elaborate cast and chiselled pieces, and was famous for his crab, shrimp and raft wine-cups, the last of which is the kind represented by the piece of plate 35. He never used solder, and his vessels were noted for their neat pouring. There is a record of a figure signed Pi-shan, representing Wang Chao-chün, the lady whom the Han emperor Yüan Ti gave in marriage to a barbarian: Chao-chün was shown mounted, holding a lute (*p'i p'a*), 'her eyebrows and hair and the collar of her garment decoratively treated, with varied detail in the horse's mane. Only one flaw, on the horse's belly, had been filled with metal'[15].

The cup of plate 35, now in the David Collection and formerly in the possession of General Sir Robert Biddulph, was acquired from loot taken from the Summer Palace in 1860[16]. It is closely matched

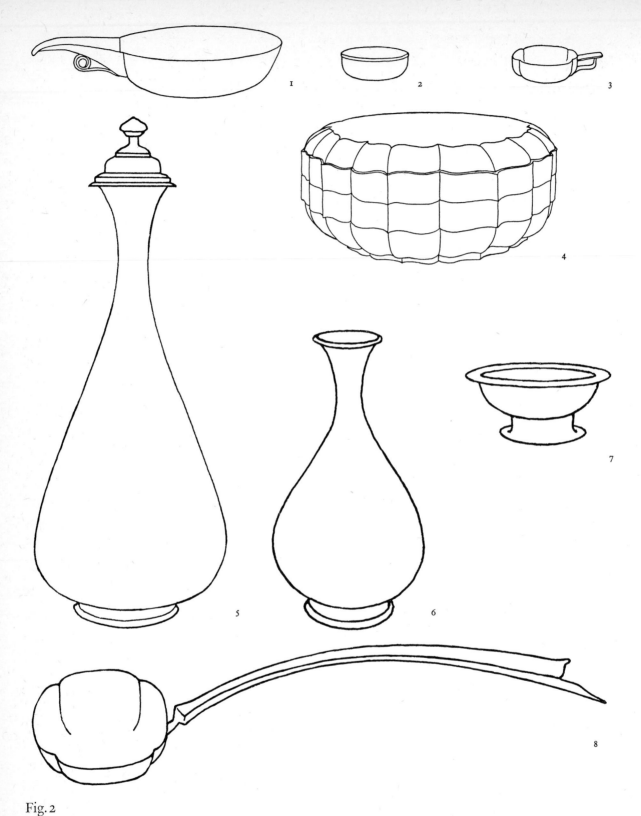

Fig. 2

Silver vessels found at Ho Fei, Anhui province, dated to A.D. 1333.

Scale: 1:4. (After *Wen wu ts'an k'ao tzǔ liao*, 1957, no 2)

by another cup in the Peking Palace collection which is inscribed with the same date (corresponding to A.D. 1345) although the maker seems not to be named on it[17]. The former existence of a third example of a cup of this design is attested by an illustration in the *Chin shih so*. This cup is dated to A.D. 1361[18], and the figure seated in the hollow log is evidently intended to be the Sung poet Li Po, to whom verses inscribed on the cup refer. The verses about Chang Ch'ien which are engraved on the David cup appear in the same seal characters also on the cup in the Palace collection. On the box which holds the David cup are engraved various long inscriptions, one of which was composed by an owner of the cup, Kao Shih-ch'i (1645–1703), a literary man and Hanlin academician who was a close friend of the emperor K'ang Hsi. The cup is said to be the work of Chu Pi-shan, and to have been made for the Examination Hall. It came into Kao Shih-ch'i's hands in 1689 when he bought it from a boatman who claimed to have dredged it up from a river-bed. From Kao's possession it probably passed to K'ang Hsi and so descended to Ch'ien Lung. The text attributed to Kao is followed by the date corresponding to 1777. Three other laudatory inscriptions on the box end with the names of eminent contemporaries of the academician. It is a justifiable inference that the inscribed texts were copied at the order of Ch'ien Lung from documents preserved with the cup. This cup and its compeer in the Palace collection have a good claim to be the only surviving works of Chu Pi-shan, and so perhaps afford us a glimpse of the splendid metalwork used in the palaces of the Yüan emperors. In a famous passage Marco Polo speaks of tables loaded with gold and silver vessels at the court of the great Khan.

The inferiority of silver dated to the Ming and Ch'ing periods in public and private collections both in the East and the West is perhaps more than fortuitous, reflecting a real decline of Chinese interest in fine silverware which followed soon after the revival of the craft in Yüan times. The tomb of Wan Li contained no silver vessels to match the gold bowls and dishes, and no silver was included among the pieces reported to have come from the tomb of Hsüan Tê. One may suppose that for imperial use gold served all the purposes that silver might have fulfilled. In his catalogue of silver in the Kempe collection Gyllensvärd has attributed a variety of pieces to the Ming period. Some of these are dated on general grounds which might be questioned: the hairpins and filigree ornaments (including a very elaborate hairdress of silver-gilt) have no marked period character, representing types which may well have continued to be made into Ch'ing times[19]. A cup in beaten silver in the form of a half-peach with leaves and stalk holds greater interest and is certainly earlier than the Ch'ing dynasty. It attests the survival of the T'ang-Sung tradition of traced ornament, combined with bolder plastic ornament of the kind ascribed to Chu Pi-shan[20]. Two ornamental plaques with crowds of human figures and buildings raised in very high relief resemble the style of the gold buckles from the tomb at Wu Hsien dated to 1315 (see above, p. 50) and are possibly not much later in date.

The most striking embodiment of Ming taste in silver is to be seen however in the elegant ewer illustrated on plate 36, on which cast, engraved, traced and *repoussé* ornament are combined. One may suppose that such ewers were in common use in rich households; but the Kempe piece appears to be the only one that has survived from the Ming period. The shape is well known in porcelain, the silver ewer comparing most closely with porcelain ones of the 16th century. The few pieces of Ming silver

that have been discovered in recent excavations include a teapot for wine-pouring of rather inelegant profile and a box shaped like a segmented gourd, both from a tomb dated to 1553[21], and a ritual goblet of the *chüeh* form in a tomb of 1589 (Fig. 3).

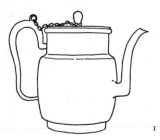

Fig. 3
Silver vessels of the Ming period. 1, 2 found in Ch'i Ch'un Hsien, Hupei province, in a tomb dated to A.D. 1553. 3 found near Shanghai, in a tomb dated to A.D. 1589.
Scale: 1:4. (After *Wen wu ts'an k'ao tzŭ liao*, 1958, no 5; and *Kaogu*, 1961, no 8)

Comparatively few names of silversmiths have been recorded in literature. In the late Yüan period Chu Pi-shan at Chia Hsing is mentioned as one of a number of silversmiths working in the western part of Chekiang province; Hsieh Chün-yü and Hsieh Chün-ho worked at P'ing Chiang in Hunan, and T'ang Chün-ch'ing at Sung Chiang in Kiangsu. The painter Tai Chin of Chekiang, active in the mid 15th century and founder of a school of painting, is said to have made flowers, hairpins, animals and human figures of silver; but he desisted when he saw some of his own work in the hands of a silver-melter, and took to painting. He is also credited with some exercises in artistic iron-work. P'an Mou, also of Chekiang, had a remarkable history. He was captured by pirates and taken to Japan, where he remained for ten years and learned to work metal in the Japanese manner, eventually excelling in chiselled gold and silver and inlays of these metals, designing in the 'Japanese flower style'. On his return to China he made writing accessories, scissors, boxes, vases, ritual vessels and censers. P'an Mou's signature is not known on surviving silver and his dates are not recorded. But perhaps his hand, or that of a successor in his line of work, is to be divined in such a piece as the box illustrated

on plate 37. Here the relief ornament is chiselled, and there is a hard clarity in the design in which it may not be too fanciful to discern the influence of P'an's Japanese training. One Chang Ch'i-ku, a contemporary of Pan Mou, was also famed for his silver. With these names, apart from some seal-makers who could work in silver, the record of silversmiths ends. Through the Ming and Ch'ing periods silver was inlaid in the ornament of bronze vessels as is related in the next chapter, but this skill was not necessarily combined with the practice of silvercraft in its own right.

<div align="right">WILLIAM WATSON</div>

[1] Bo Gyllensvärd, *Chinese Gold and Silver in the Carl Kempe Collection*, Stockholm 1953 (hereafter 'Kempe Catalogue'), no. 82.

[2] One in the Kempe Collection (Cat. No. 76), two in the Fogg Art Museum and one in the Freer Gallery of Art.

[3] Chinese Art Society of America, *The Art of Eastern Chou* (A Loan Exhibition), 1962: Cat. No. 4.

[4] e.g. The diadem in the Kempe Collection, Cat. No. 42. It is used also on the bull, Cat. No. 132, but I hesitate to accept a T'ang date for this figure or for the figure of a woman (Cat. 130), of both of which virtual duplicates exist also in the British Museum Collection.

[5] Bo Gyllensvärd, *T'ang Gold and Silver*, Stockholm 1957.

[6] e.g., respectively, the Freer Gallery of Art, the William Rockhill Nelson Gallery of Art, and the Frederick Mayer Collection.

[7] Gyllensvärd, *T'ang Gold and Silver*, pl. 9a.

[8] Kempe Catalogue, nos. 142, 143.

[9] e.g. Hakkaku Art Museum, *Selected Specimens*, pl. 40; Kempe Catalogue, no. 117 (attributed to late T'ang).

[10] *Wen wu ts'an k'ao tzŭ liao*, 1957, no. 7, p. 24f.; *Wen wu*, 1961, no. 11, p. 4, 46f.

[11] *Wen wu*, 1961, no. 11, p. 8ff., 48ff.

[12] *Kaogu*, 1960, no. 2, pl. 1, p. 15ff.

[13] *Wen wu*, 1959, no. 11, pp. 19ff.

[14] *Wen wu*, 1957, no. 2, p. 52ff; also Laurence Sickman, "Chinese Silver of the Yüan Dynasty", *Archives of the Chinese Art Society of America*, XI (1957).

[15] Quoted from *Ni yu lu* in Li Wu-fang, *Chung kuo i shu chia cheng lüeh*, Tientsin 1915. To this valuable anthology of notices on craftsmen the author is much indebted.

[16] R.L. Hobson, "A silver cup of the Yüan dynasty", *Burlington Magazine*, Vol. XXII, 1912–13, p. 153ff.

[17] International Exhibition of Chinese Art, London 1936, *Chinese catalogue, Vol. IV*, no. 61.

[18] For description and illustration see S.W.Bushell, *Chinese Art*, London 1906, p. 107, fig. 72.

[19] Kempe Catalogue, nos. 153–163.

[20] Kempe Catalogue, no. 152.

[21] *Wen wu*, 1958, no. 5, p. 55ff.

20. SILVER STEM-CUP WITH TRACED DECORATION

T'ang dynasty. Second half of the 7th century. Height 6.3 cm. Formerly collection Mr. Desmond Gure, London

The stem-cup is one of several vessel-shapes adopted by the Chinese from Sasanian Persia. In outline the cup differs from the Persian type in having taller, more vertical sides, only slightly flared between the cord moulding and the lip. The ring moulding on the stem follows the Persian model, but the stepped base of the cup is a Chinese innovation. The taut plant scrolls with palmette-like flowers is the T'ang version of a motif originally derived from the Near East, but already established in the Chinese tradition for some three centuries. The background of the scrollwork is formed of the usual small, close-set rings. The cup is made with a double skin.

21. SILVER GLOBULAR BOX AND LID WITH TRACED DECORATION

T'ang dynasty. Early 8th century. Height 6.5 cm. Carl Kempe Collection, Ekolsund, Sweden

The ornament consists of four lotus flowers framed in oval scrolls of stems and leaves on the bowl, and petals on the lid around the knob. The vessel is similar in shape to the one which frequently appears as an attribute of Bhaishajyaguru, the Bodhisattva of medicine. The foot-rim is formed separately and soldered on.

22. SILVER SIX-LOBED BOX WITH PARCEL-GILT AND TRACED ORNAMENT

T'ang dynasty. Early 8th century. Diameter 10.2 cm. Formerly collection Captain Dugald Malcolm, London

Such boxes were a Chinese form without parallel among the Persian silver vessels to which in general much of T'ang metalwork resembles. The ornament of birds in a flowered scroll, repeated symmetrically in each segment and gilded against a ground of small punched circles, is in the finest style of the 8th century. The purpose of these small boxes, whether comfits or cosmetics, has not been elucidated. They are found also in ingenious shapes, such as a reclining ram or a bivalve shell.

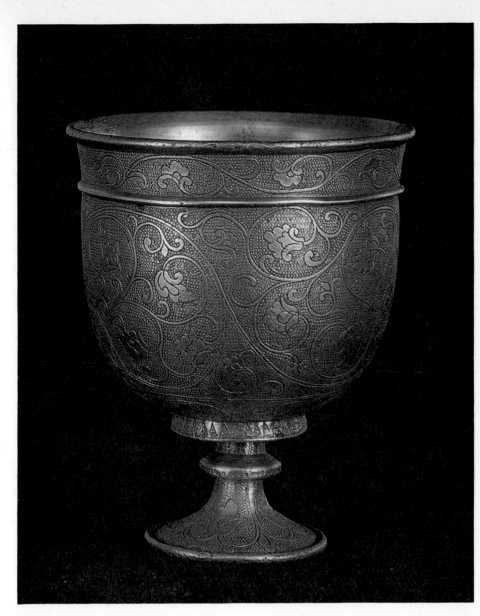

20

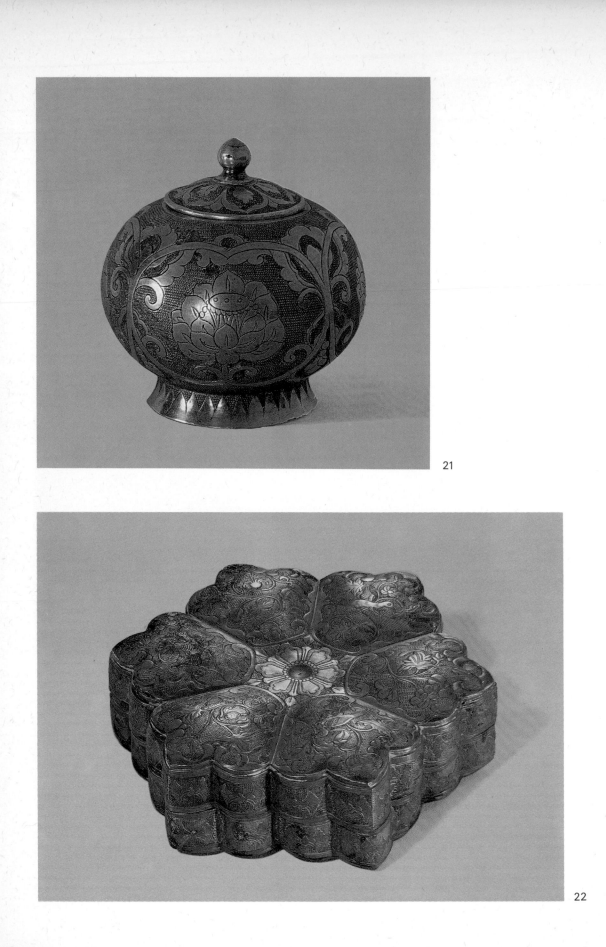

21

22

23. SILVER FIGURE OF A DWARF

5th–3rd century B.C. *Height 15.7 cm. Fogg Art Museum, Cambridge, Mass.*

Only a handful of human figurines from the pre-Han period are preserved. The majority of these represent kneeling servants and some evidently were intended as supports for trays and lamp-holders. The figure here illustrated, and another of a leather-clad soldier attributed to the Han period, are the only examples of silver statuary surviving from early times. The dating of the dwarf rests on the treatment of the face, which relates it to some of the bronze figurines datable to the 5th–3rd centuries B.C.

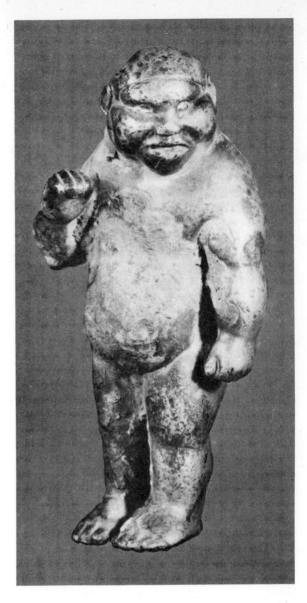

24. GILDED BRONZE BELTHOOK WITH TURQUOISE INLAY

2nd century B.C. *Length 10.2 cm. British Museum, London*

The upper surface of the belthook, with the animals, is greenish-white and may be described as "green-gold" applied by the mercury gilding process. This plating is unusually thick, and proved on analysis to contain silver, gold, copper and mercury. The underside of the belthook is plated with richer gold and is therefore of a yellower colour. Turquoise is inlaid along the dragon's back. The dragon is fighting with a monster, represented by only a head and two arms, one of which grips the dragon by the neck while the other pushes its left jaw. This style of sinuous dragon and the openwork relief in which it is rendered are characteristic of the early Han period.

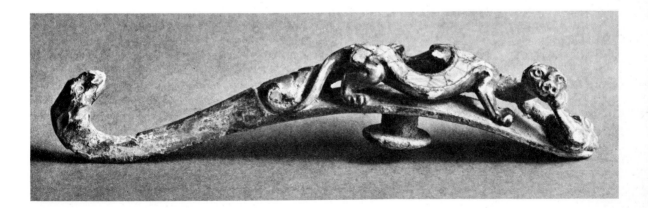

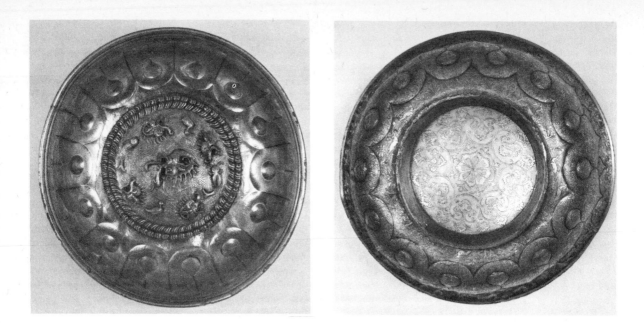

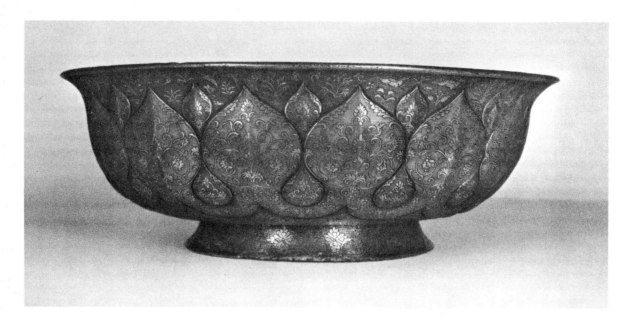

25. SILVER LOTUS-SHAPED BOWL, WITH TRACED AND PARCEL-GILT DECORATION

T'ang dynasty. 7th century. Diameter 16.2 cm. William Rockhill Nelson Gallery of Art, Kansas City, Mo.

This most splendid of the lobed silver bowls of the T'ang silversmiths exemplifies one of their happiest inventions. The circlet of lotus petals was already long familiar in Buddhist art, but it had not hitherto in China, or elsewhere, been so successfully adapted to the bowl form. Unlike the majority of such bowls the sides of this piece are fashioned into a double line of petals. These are filled with floral medallions scrolled symmetrically on a ground of small circles. Above and below is a medley of plants, rocks, clouds, birds, animals and insects. Each principal flower or creature is gilded. The base of the interior, decorated in high relief, shows ducks swimming among waves from which emerge the heads of dragons and catfish.

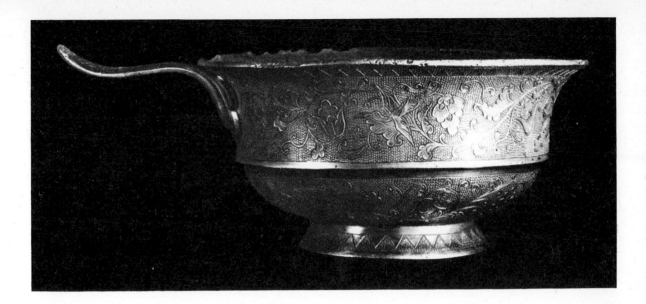

26. SILVER CUP WITH TRACED DECORATION

T'ang dynasty. Width, with handle, 13 cm. Formerly collection Mrs. Walter Sedgwick, London

The silver is exceptionally thick, as may be seen at the rim. The ornament, traced on a ground of punched rings, consists of two bands of floral scrolling, in the upper of which three flying birds are interspersed. An open flower is drawn under the foot. The tracing is unusually emphatic, the edges of the main lines standing slightly proud and sharp. The handle is riveted.

27. SILVER BOX WITH TRACED DECORATION

T'ang dynasty. Diameter 4.3 cm. Formerly collection Mrs. Walter Sedgwick, London

The decoration of the box represents the finest and closest tracing found on T'ang silver. The two halves of the box have different arrangements of the grape and vine-leaf scroll, designed with perfect symmetry in each quarter of the circle. The tight curves of the stems and the density of the design are characteristic of the ornament of the late 7th and early 8th centuries.

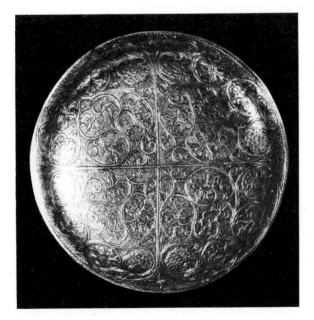
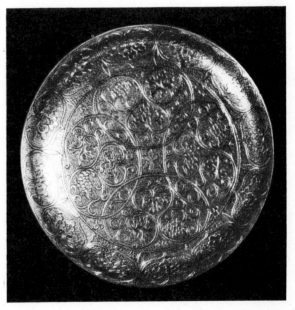

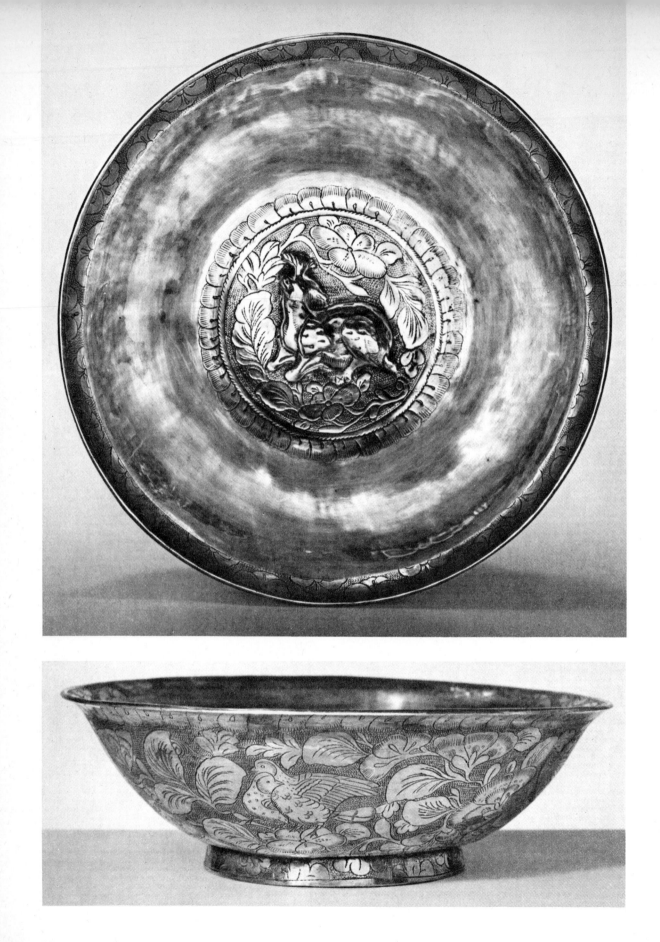

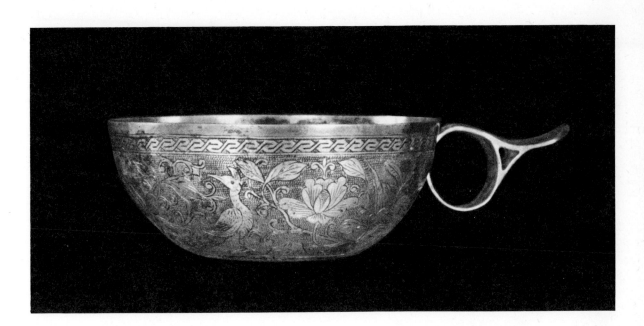

28. SILVER BOWL, PARCEL-GILT, WITH TRACED AND *REPOUSSÉ* ORNAMENT

T'ang dynasty. Late 8th century. Diameter 18 cm. Formerly collection Mr. Frederick M. Mayer, New York

A goat or gazelle set among trees or flowers is a decorative convention which finds parallels in Persian art. Examples may be found on Persian seals of the Sasanian period of a schematized treatment of the animal's horns which may account for the curious shape they are given on this bowl. Ornament rendered with the degree of relief seen here, though common on Persian silver, is comparatively rare on Chinese work. The small lunate figures scattered on the animal's coat follow a convention of long standing, in China traceable as far back as the Han dynasty. The other elements of the ornament, floral border, petals, flower sprays and the ground of small circles, are all more typical of the Chinese silversmith's repertoire than the large central motif. Gilding is used only on the outside of the bowl, which is decorated with mandarin ducks, partridges, flowers and leaves on a punched parcel-gilt background.

29. SILVER CUP OR SCOOP WITH TRACED DECORATION

T'ang dynasty. Second half of the 8th century. Width, with handle, 9 cm. Formerly collection Mrs. Walter Sedgwick, London

The approximate form of this cup and handle are known in bronze before T'ang, in the 5th–6th centuries A.D. This cup has a purely Chinese ancestry, although in T'ang times it joined a repertoire of silver vessels in which foreign, especially Persian, forms were much copied and adapted. The decoration of birds and peonies is traced on a ground of close-set, punched circles.

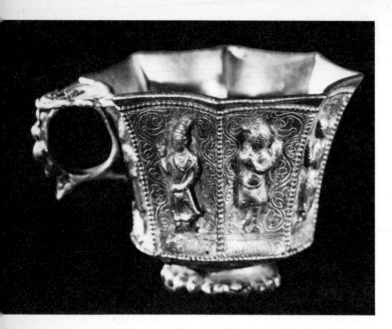

30. SILVER WINE-CUP WITH FIGURES OF MUSICIANS

T'ang dynasty. First half of the 8th century. Height 6.5 cm.

Sogdiana, the north-eastern province of the Iranian empire, appears to have supplied the models for some silver vessels manufactured in China in the first half of the 8th century. Iranian features are seen here in the beaded foot-rim, the faceted sides and the decoration of the handle escutcheon with a human face (replacing the royal head of Iranian pieces). The figures on the side hold musical instruments, standing against a ground of floral scrolling.

31. SILVER DISH WITH *REPOUSSÉ* AND TRACED ORNAMENT, PARCEL-GILT

T'ang dynasty. 877. Length 23.4 cm. British Museum, London

This dish was found at Pei Huang Shan, near Sian in Shensi province, in a group of vessels of which one bears the inscription "Made to the order of the great officer Wang in the 4th year of the Ch'ien Fu period (i.e. A.D. 877). Weight, according to the standard of the public office of the municipality, 2½ oz". This piece appears, therefore, to fall comparatively late in the history of T'ang silver. The floral scrolls have lost the taut precision of the 8th century and look forward to the more relaxed, graphic style of the Sung dynasty. The scene represents the approach made by Wen, father of Wu Wang the founder of the Chou dynasty, to T'ai Kung Wang, whom he wished to make his minister. T'ai Kung Wang is found fishing and Wen has dismounted to speak to him.

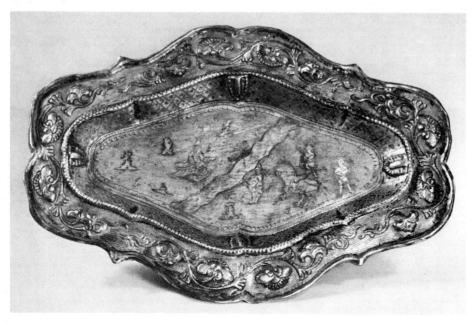

32. SILVER WINE-EWER

T'ang dynasty. 877. Height 25 cm. British Museum, London

This piece was included in the find of vessels made at Pei Huang Shan in Shensi province to which the dish illustrated on plate 31 also belongs. Another piece in the group is dated to A.D. 877 by an inscription. The wine-ewer was one of the Persian forms which became popular in the T'ang dynasty. No close western parallel can, however, be found for this version, though it sufficiently resembles ceramic ewers made in the T'ang and Sung times to suggest that it represents a common metal form in China. The body shows signs of turning which possibly indicate that the metal was shaped by spinning.

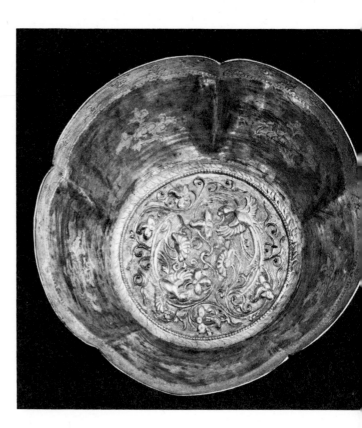

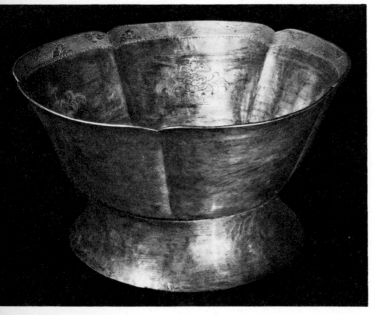

33. SILVER BOWL WITH TRACED AND PARCEL-GILT DECORATION

T'ang dynasty. 877. Diameter 16.2 cm. British Museum, London

A bowl with seven shallow lobes in the sides is found also in the white procelain of the late T'ang period. The form was probably an invention of the Chinese silversmith, owing nothing to the T'ang taste for exotic western objects. High-relief decoration of the silver appears mostly on the bottom of bowls of this type. Here two parakeets are shown flying among the flowers. This bowl is another piece from the find of silver made at Pei Huang Shan in Shensi. The gilding is on the ornament at the bottom of the bowl, the border at the rim and the flower sprays on the sides.

34 a, b. SILVER SPOUTED BOWL AND BOTTLE

Yüan dynasty. Early 14th century. William Rockhill Nelson Gallery of Art, Kansas City, Mo.

These plain vessels, of a simplicity of design akin to Sung porcelain rather than the T'ang tradition of decorated silver, can be closely dated by comparison with a treasure of silver found in 1955 at Ho Fei in Anhui Province. This included pieces virtually identical with those illustrated here. One of the bottles was inscribed with the date: *"knei yu year of the regnal period Chih Shun"*, corresponding to A.D. 1333. The treasure consists mostly of bottles (the larger ones with lids like the one shown here), spouted bowls and small hemispherical cups. This combination appears to constitute a wine service, the spouted bowls probably serving to mix the wine before pouring it into the cups for drinking. Spouted bowls similar to these silver ones, even to the loop under the spout, are found in blue-and-white porcelain of the 14th century.

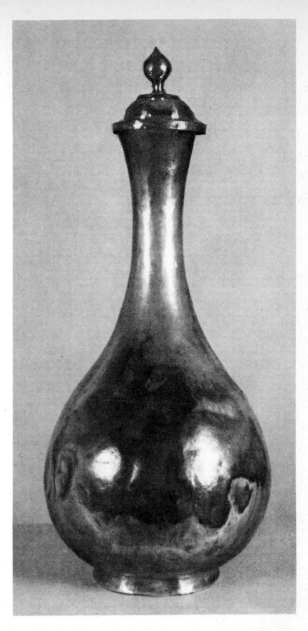

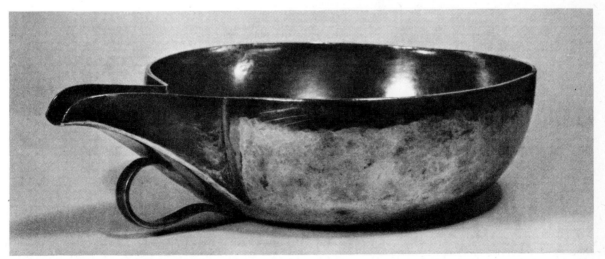

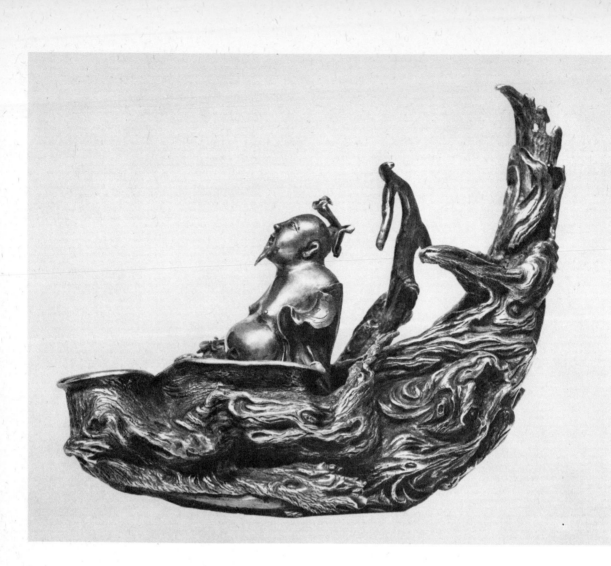

35. SILVER CUP IN THE SHAPE OF A MAN IN A HOLLOW LOG

Yüan dynasty. Made by Chu Pi-shan. Dated to 1345. Length 20.5 cm. Formerly David Collection, London

Chu Pi-shan, also called Hua Yü, was the most notable silversmith of the Yüan dynasty. He is said to have made "crab cups" and "shrimp cups", and this so-called "raft cup" is of the same fanciful design. A closely similar cup illustrated in the *Chin shih so* and ascribed to Chu Pi-shan, names the man seated as Li Po, the T'ang poet and prince of drinkers. A poem inscribed on the bottom of the cup illustrated here refers to one who "wished to reach the Milky Way and . . . crossed the Silver Sea". This is an allusion to Chang Ch'ien, who travelled across Asia as far as Ferghana in the 2nd century B.C. In later legend he is said to have sought the source of the Yellow River, which was fabled to flow from the Milky Way. This cup was formerly in a palace collection. The novelty of Chu Pi-shan's work was the elaboration of cast and chiselled ornament.

36. SILVER WINE-EWER WITH TRACED AND CHASED DECORATION ▷

Ming dynasty. 16th century. Height 27 cm. Carl Kempe Collection, Ekolsund, Sweden

The spout of the ewer rises from a dragon head and the handle terminates in a dragon head and a lily medallion. Ewers of this design were made throughout the Ming period in porcelain. The shape seen here, with its exquisitely balanced profile, marks the last refinement of the vessel type. The medallions on the body portray scenes evidently taken from Taoist lore, but they have not been identified. The lid is a later replacement.

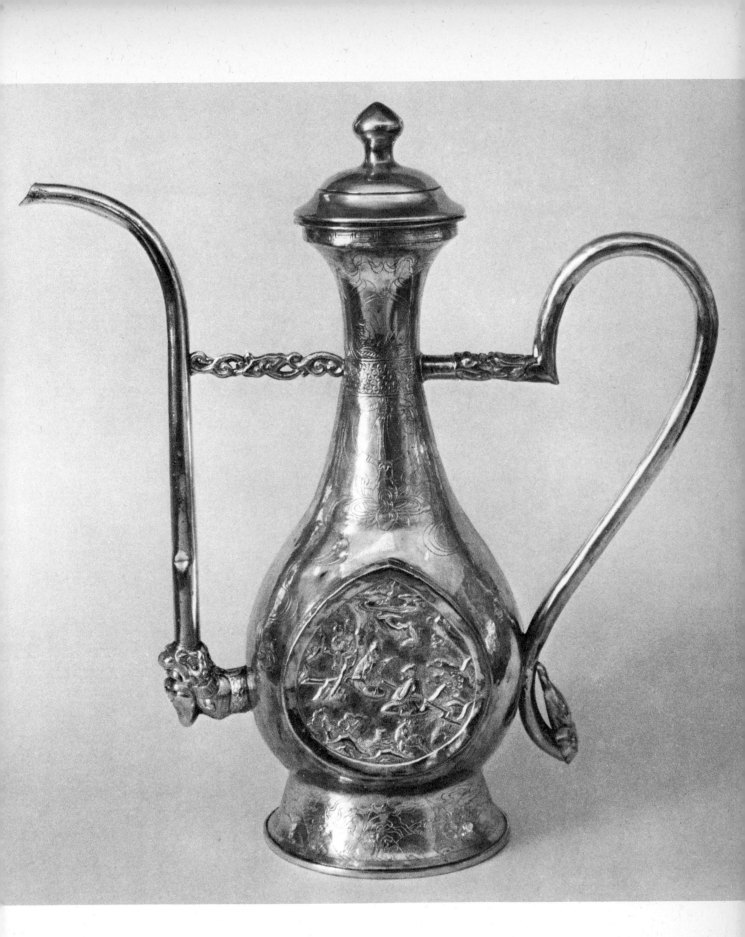

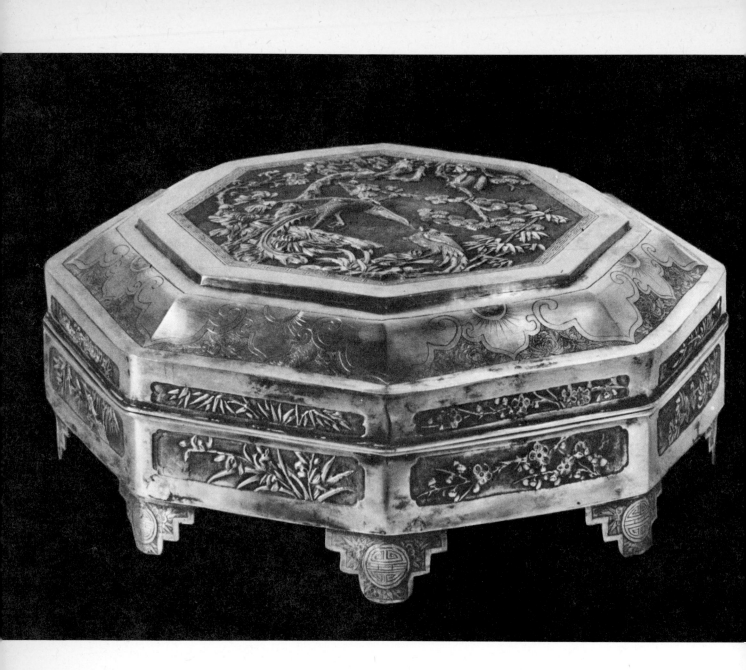

37. SILVER BOX WITH TRACED DECORATION

*Late Ming or early Chi'ng dynasty. 16th or 17th century. Art
Institute of Chicago (S. M. Nickerson Fund purchase), Chicago
Ill.*

The bamboo, pine and plum of the lid and side panels are
the common symbols of longevity which dominate Ming and
Ch'ing ornament. The character *Shou*, longevity, is placed on
each foot. The relief is in the carving style used on lacquer.
Both the relief ornament and the flat floral designs are on
the traditional ground of small, circular punch-marks.

CHAPTER III: BRONZE, IRON AND PEWTER

THE MOST difficult problem in the study of mediaeval Chinese bronzecraft, over a period embracing the Sung, Yüan and Ming dynasties, is the dating of archaistic work. These pieces copy ancient bronze vessels, hallowed in Chinese eyes by their antiquity, and more especially by their ritual purposes. They are described in the ancient ritual manuals, which to Confucians were almost sacred texts. The importance of these archaistic bronzes lies in the fact that through them, more than through any other branch of craft, the adaptations and transmogrifications of ancient decorative motifs came to permeate much of Chinese art. They constituted a language of ornament both complicated in a manner appealing to the Chinese eye and well-suited as a foil to the traditional floral patterns. Above all, the archaistic style bore a highly respected symbolism which flattered scholarly taste. In the early decades of the present century, both in China and the West, bronzes now recognizable as mediaeval were still accepted as ancient, and figured in books alongside true products of the Shang and Chou periods. Once the copying of the antique had begun a line could hardly be drawn between pieces designed in an avowed archaistic spirit and those intended to deceive the collector as truly ancient. It was the effort to imitate even the adventitious effects of patina on bronze vessels recovered from tombs that lead to the techniques of variegating the colour of the metal, a special feature of the later Chinese bronzecraft. One such method is described in the *Tung t'ien ch'ing lu chi* (Conspectus of Criticism of Antiques) by Chao Hsi-ku, a member of the Sung Imperial house (and thus presumably well acquainted with the imperial collection of bronze vessels) who wrote in the 13th century:

"In imitating ancient bronze objects their method is to mix mercury with powdered tin, which is the preparation used at the present time to polish mirrors. First this preparation is spread evenly on the new bronze. Then a solution of powdered sal ammoniac (*nao sha*) in strong vinegar is applied with a brush. After waiting till the colour becomes that of wax tea (a rich brown) the bronze is plunged into freshly drawn water and soaked in it, whereupon the metal acquires this colour. If one waits for the surface to turn to the colour of lacquer before soaking in fresh water, the metal then assumes this colour. Further delay affects the change of colour. If the treated metal is not placed in water, its colour turns to pure kingfisher blue"[1].

The shapes and ornament of ancient vessels were imitated with no less fidelity than was observed in copying the patinated surface.

The antiquarian interest to which such copies of the antique appealed was stimulated by the revival of Confucianism in the later, or Southern, Sung period[2]. Inevitably this interest was directed in the first place to the inscriptions cast on the ancient ritual bronzes, which witnessed to ancient piety. But there is evidence too at an early time of scholarly interest taken in the shapes and ornament of the bronzes. With the move of the government southwards following upon the invasion of the Kin Tar-

tars in the North, the great imperial collection was dispersed. Its loss eventually prompted the manufacture of imitations of ancient vessels and so helped to establish the archaistic tradition.

It was a long-standing custom that excavated bronze vessels of importance should be presented to the emperor. Chen Tsung (998–1022) ordered two scholars to study an excavated rectangular *ting* which had been brought to his notice. In the mid-eleventh century we hear that the official Liu Ch'ang obtained eleven bronze vessels recovered from a tomb near Yung Hsing in Kansu (where he was posted) and had the text and drawings of the vessels reproduced in the form of stone-rubbings for distribution to his antiquarian friends. But his interest lay chiefly in the inscriptions and the identity of the Chou king in whose reign the bronzes were cast. The custom of printing illustrated albums of the bronzes begins about a century later with the publication in 1092 of Lü Ta-lin's *K'ao ku t'u* (Pictures for the Study of Antiquity), which records, by description and drawing, bronze vessels in the imperial collection and in thirty-seven private collections. The most famous of these catalogues was the *Hsüan ho po ku t'u lu* (The Hsüan Ho album of antiquities) in thirty volumes, commissioned by the emperor Hui Tsung as a record of his own collection, and completed early in the 12th century.

There can be no doubt that the diffusion of these illustrated works gave capital assistance to the copyist of antique bronze. In practice he was as likely to be working from a drawing as from the ancient original. The peculiarities of the wood-block illustration, with its odd perspective and tendency to simplify bothersome detail, had an influence of its own in determining the archaistic style. At the same time one may suspect that not every piece figured even in the *Hsüan ho po ku t'u lu* was of genuine antiquity. Some of the illustrations so strongly suggest the archaistic rather than the true ancient manner that we may suspect the compilers of having accepted an occasional contemporary fake as ancient. Even as a guide to Sung archaism, as distinct from that of Yüan and later times, the *Hsüan ho po ku t'u lu* is unfortunately unreliable. The Sung date of the book in the form in which it survives has been questioned. Since the first edition no longer survived in print, the second edition, which appeared in the Ta Chih period (1308–1311), was based on a manuscript copy of it, to which illustrations of additional, possibly post-Sung, archaistic vessels may have easily been added. The subsequent editions of the book, which are those now generally available, are based on the second edition.

We are at present on good ground in distinguishing Ming and Ch'ing bronzes from those of the preceding two dynasties, but the distinction between Sung and Yüan remains speculative. Some evidence for pre-Ming date is furnished by the ingredients of the alloy. By early Ming times the use of zinc in appreciable quantities was generally established. While it is not known when the deliberate addition of zinc to the metal began, it may be presumed that its presence in a large proportion (more, say, than 8 or 9%) is an indication of Ming or later date. On the other hand many post-Yüan bronzes were cast with tin only.

Among the bronze vessel types of established Ming date are those of the characteristic Hsüan Tê style (plate 58), those with Arabic inscriptions (plate 59), pieces with ornament of identifiable later style (plate 60) and pieces datable by the maker's signature, such as the work of Hu Wen-ming (plate 47). When these are eliminated there remains to be considered an important group of bronzes, of superb

quality, in which the ornament is inlaid in gold and silver with great fidelity to ancient designs (plates 39–42, 55, 56). It is among these that pieces representing the first flush of Sung antiquarian metalwork must be sought. It is noticeable at once that the ornament copies that of the late Chou and early Han periods, rather than earlier styles which through their association with Shang emperors and the early Chou kings would be expected to commend themselves more strongly to Confucian antiquarians and collectors. It is significant therefore that Chao Hsi-ku says that in his time inlaid bronze was mistakenly held to be of Shang date. It may not have been known in the Sung period that inlay of precious metal in bronze did not go back before the 4th century B.C. and that it continued into the Han period. To the eye of the Sung connoisseur the splendour of the inlaid bronze made a greater appeal than the cast bronze ornament, and the designs associated with it were after all a little more akin to his own flowery vision. Arguments for dating the pieces noted above to the later Sung rather than the Yüan period, are their high quality and meticulous archaism. Neither this degree of craftsmanship nor such evident antiquarianism can be found in any bronze attributed to the Yüan period. It is on the other hand at home in the age which copied the shapes of ancient ritual vessels in the perfected porcelain of the imperial kilns. Nor can the motives of Confucian piety, or of the desire to replace the lost collections of the Northern Sung emperors, be attributed with like force to the Yüan rulers and their courts.

For all its fidelity to the inlay style of the late Chou period, the ornament of the *hu* of plate 39 is composed into an over-all pattern not quite paralleled in ancient work. The frame of inlay around the *t'ao t'ieh* monster-mask escutcheon, the three shield-shaped projections from the lower edge of each decorated field and this precise species of interlacery are variations introduced by the Sung master. The shape is a shade unclassical in the proportions of neck and bulging sides and in the splay of the foot. The motifs inlaid on the *hu* of plate 40 depart equally from ancient examples in the filling of the triangles with closer designs, threads of gold giving outlines where the ancient styles would require a proportion of wider elements. The wider lines of gold are inlaid more deeply than was the practice in Chou and Han times. But the ornament is treated sensitively, with no tendency towards the emphatic and grotesque style which appears on many archaistic vessels of Ming date (cf. plate 46). The winged lion of plate 41 is a work of exceptional merit, both for its plastic quality and the excellence of the inlay. It does not copy any ancient model. In Chou and Han times inlaid ornament was seldom used on animal figures modelled with this degree of realism. The ornament of the miniature bucket illustrated on plate 43 does no more than recapture the general effect of the old style. The most remarkable example of fidelity to the past is to be seen in the detail of ornament on the perfume-still (plate 55), in the inlay around the edges of the central tray, and in the gilded bear feet, which would do credit to any Han work.

The method of inlay used on these pieces is tolerably similar to that of ancient times (see page 11) except for the greater weight of gold on the *hu* (plate 40) and the generous chiselling visible in the strap-work of the inlay (now lost) on the bowl of the perfume-still (plate 55). Inlay of this kind had probably ceased by the beginning of the Yüan dynasty. To this period hardly any bronzes can be attributed on sure grounds. If the existing palace collections in Taiwan and Peking (the National Museum) include bronze vessels of Yüan date, as seems probable, they cannot yet be distinguished

with certainty from those of the Ming period. No Yüan inscriptions are found on bronze vessels.

An interesting innovation is found on some Korean Buddhist pedestal bowls which are dated to the latter part of the dynasty, bearing inscriptions yielding years extending from 1214 to 1397[3]. The inlay on these is executed entirely with wire inserted in deep grooves, without any of the transitions from narrow to broad so beloved of the ancient style and copied in China in the Sung period. The place of origin of this method of inlay, whether Korea, Central Asia or the Islamic West, is uncertain. It cannot be positively attributed to China of the Yüan period, but it is much used on Chinese bronzes of the Ming period and may yet be traced to the preceding dynasty; and the possibility that it originated in China itself cannot be excluded (cf. plates 46, 58, 60).

In the Ming period interest centres on a large group of palace bronzes, bearing the mark of the Hsüan Tê reign (1426–1435), which introduce new shapes and new methods of variegating the surface of the metal. As happened also with the Hsüan Tê imperial blue-and-white porcelain, the bronzes of this reign acquired such fame that they were imitated for long afterwards, the reign mark cast on them proclaiming their style rather than their date of manufacture. It follows that the exact dating of pieces bearing the Hsüan Tê mark is problematical. The finest work is judged to belong to the Hsüan Tê period, but enfeebled descendants, still bearing the classical reign title, certainly continued to be made until the end of the Ming dynasty, and possibly were still produced in the earlier decades of the Ch'ing period.

The lasting fame of certain reigns for particular arts is a recurrent feature of the history of Chinese crafts, and the reason for it is not always apparent. But the reputation of the Hsüan Tê bronzes arises plainly from the response of the palace workshops to an imperial decree of 1428. Although there is no mention of this decree and its consequences in the official Ming history, a record of its exact wording and of the measures taken to implement it is preserved in the *Hsüan Tê i ch'i t'u p'u* (Illustrated catalogue of the ritual vessels of the Hsüan Tê period)[4]. It is stated there that in 1427 the emperor received from the King of Siam a tribute of 39,000 catties of copper. In the following year he ordered that this metal was to be used for the manufacture of ritual vessels for the imperial altars (*chiao t'an* and *tsung miao*) and for all places within the palace where such vessels were displayed. The Board of Rites and the Board of Works were directed to proceed with this work, taking as models the drawings in the *K'ao ku t'u* and the *Hsüan ho po ku t'u lu* (see p. 85 above) and the forms of the ritual vessels made in the imperial porcelains of the Southern Sung period; for the emperor's heart was saddened to see that 'the ritual vessels now displayed are of shapes bequeathed by preceding dynasties and are not true to antiquity'. The palace offices were ordered also to make a survey of existing pieces and to list the exact quantities of materials available in store for casting the new bronzes.

The *Hsüan Tê i ch'i t'u p'u* contains illustrations of the principal vessel types that were cast in obedience to the decree. In spite of the instructions, comparatively few pieces imitated existing bronze vessels then believed to be genuinely ancient, or were based on the drawings of such to be found in the *Po k'u t'u lu*. The great majority reproduce shapes to be found among the imperial Sung porcelains, treating them rather freely. Even when an antique piece was imitated there seems to have been no

attempt at deceptive accuracy. The report notes differences of colour in the copies, reddish-yellow replacing brown ('wax tea colour') and a 'light blue' replacing a green-red mottled surface. Great attention was given to special effects of colour, though there is no indication how these were achieved. It is noted that one reproduction of an ancient model received silver inlay and was marked with the reign title Hsüan Tê in seal characters. The few drawings of pieces intended as faithful copies of the antique give no sure clue whether the originals were truly ancient or were Sung archaistic pieces. The incense burners based on Sung porcelain shapes were cast in much larger numbers, and were given new names. The main types were:

1. With millipede handles (Fig. 4 no. 2)
2. With heaven-soaring handles and breast-like projections (Fig. 4 no. 3)
3. With fish handles (Fig. 4 no. 4)
4. With rope handles and lobate body (Fig. 4 no. 5)
5. With phoenix or elephant handles (Fig. 4 no. 6)
6. With halberd-blade handles (Fig. 4 no. 7)

The colours of these pieces are described as deep yellow, wax tea colour, ripe crab-apple, splashed with gold like rain drops and snow-flakes. The shapes with millipede and heaven-soaring handles were frequently gilded at the upper half of their surface (including the handles) or the lower half (including the base), the gold ending at an undulating margin on the shoulder or the lower part of the side.

The problem of distinguishing the true products of the palace foundries of the Hsüan Tê period from imitations of them made later in the Ming dynasty (invariably bearing the Hsüan Tê mark) has exercised the wits of connoisseurs for centuries, and is perhaps today, as it probably was already long ago, past any sure solution. It is the incense burners, with their marvels of gilding and colouring, that have always attracted the greatest interest. The 16th century collector Hsiang Yüan-pien is said to have accepted as genuine those with surfaces of hibiscus yellow, chestnut brown, and yellow gold like the peaches of the immortals; and the true Hsüan Tê bronze was compared to the beauty of a girl's skin. Later critics have sought the genuine pieces among those of superb workmanship and rich surface colour, including a dark purplish-red. All these criteria are supported by the *Hsüan Tê i ch'i t'u p'u* as far as its brief descriptions allow. Marks of two, four and six characters, in seal script or the square hand, are similarly vouched for. But none of the criteria is exclusive, and the imitation of the Hsüan Tê style outside the palace flourished openly and is on record. The 'Hsüan Tê' incense burners made in Suchow were yellow ('Tripitaka-paper colour') and brown ('wax tea'), or as red as dates or chestnuts. Of the copies it is said that long wear could remove the attractive colour and reveal ordinary bronze; but this can be no less true of the palace products. In the early years of Wan Li, one Kan Wen-t'ang of Nanking made incense burners in the now classic shapes, but his colour was merely that of pig's liver. Better success in colour attended the work of another metal-worker of Suchow, by surname Chou, who discovered methods of imitating the colour effects correctly. For bronzes with parcel-gilding, openwork

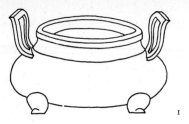

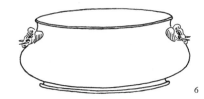

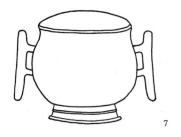
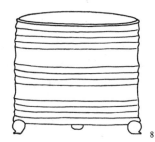

Fig. 4

Bronze censers of the Hsüan Tê period (A.D. 1426–1435). (The wavy line in nos 2–4 marks the edge of the gilding)

Scale: 1:4. (After *Hsüan Tê ch'i t'u p'u*)

66

and complicated gilded relief, examples of all of which have at one time or another been attributed to the Hsüan Tê period, the *Hsüan Tê i ch'i t'u p'u* gives no explicit support. The manufacture of bronze vessels in these styles in the Hsüan Tê period, not necessarily in the palace workshops, cannot be excluded (pieces of this kind were recently exhibited as of Hsüan Tê date in the National Museum, Peking), but a more convincing context for them is the later Ming period, with the work of bronze-casters such as Hu Wen-ming. The most that can be said positively, at present, is that the mark of Hsüan Tê appearing on these bronzes is no guarantee of early Ming date. On degenerate brass versions of the incense burners this reign mark was cast at least as late as the 17th century[5].

Our illustration of bronze judged to be of Hsüan Tê date is unfortunately confined to the single piece of plate 58. It is a variant of the traditional ritual *kuei*, closer in shape to the Sung porcelain versions than to ancient or archaistic form. The reddish-brown surface, the two-character mark *Hsüan Tê* and the decoration of silver inlay all answer to a description in the *Hsüan Tê i ch'i t'u p'u*. The inlay imitates the *t'ao t'ieh* monster mask and other conventionalized themes of the ancient vessels, and is executed in the technique described above (pages 86–87) for Korean bronzes of the 13th and 14th centuries. Similar inlay of silver-wire in bronze vessels continued through the Ming period. It is found applied with great delicacy to the incense-burner of the Ch'eng Hua era, illustrated on plate 60, and continues in the bronzes of Hu Wen-ming, who was active at least as late as 1613.

The *ting* illustrated in plate 46 introduces a style which was adopted probably not before the middle Ming period, for it cannot be connected with the Hsüan Tê group. The essential feature is the heavy relief of rounded forms representing the *disjecta membra* of the ancient *t'ao t'ieh* mask, which even in the Shang phase of its life showed a tendency to be dissolved into the spiral pattern of the ground. Gold and silver sheet is laid over the relief and the ground is filled with silver 'wire inlay' of *lei wen*, the thunder pattern. The effect of this style is generally farouche and gaudy in a taste far removed from the Hsüan Tê elegance. It is used both on small pieces like the one illustrated, and on larger and still more extravagant vessels, for the most part of the *ting* and *kuei* forms. The origin of the style is not far to seek: it arises from a too literal interpretation of the woodcuts illustrating the *Hsüan Ho po ku t'u lu* (see page 85 above), the models enjoined on bronze workers by the imperial decree of 1428, but apparently not thus slavishly obeyed until a century or more later. The stylistic disunity created by the discordant detail in the *ting* of plate 46 reflects the progressively summary treatment of the drawing in successive editions of the famous Sung manual.

The activity of Hu Wen-ming, whose work is well identified by signature, lay mostly between 1583 and 1613, in the Wan Li period. Both dates are inscribed (inlaid in silver) on a *kuei*:

a) 'Made in the chrysanthemum (ninth) month of the *kuei wei* year of the Wan Li era (1583) by Hu Wen-ming from Yün Chien.'[6]

b) 'Made in the autumn of the *kuei ch'ou* year of the Wan Li era (1613) by Hu Wen-ming for the use of the Shih Yü Chai (Studio of the Conversation of Stones).'[7]

Yün Chien is an old name for Sung Chiang Hsien in Kiangsu province, a famous centre of metalcraft. According to the *Yün Chien tsa chih* (local history) Hu Wen-ming was celebrated for his bronze ritual

vessels and the high prices he could charge for them. His inlaid relief, while deriving from the bookish tradition represented by the piece of plate 46, is treated with a subtler sense of style, avoiding the bizarre and creating a better unified design. The savagery of the grotesque *t'ao t'ieh* is tamed to decorative ends. But much of Hu Wen-ming's work, if not the greater part, appears to have relied on finely cast relief and parcel-gilding. The box, probably a plant-holder, illustrated on plate 47, is among the finest of such pieces, decorated with a notably original version of the traditional theme of dragon and leviathan.

Another name often seen inlaid as signature on bronze is that of Shih Sou. He is said to have been a monk who lived at the end of the Ming dynasty. His work is less elaborate than that of Hu Wen-ming, being generally confined to simple inlays of silver on vessels of the ritual shapes.

The Hsüan Tê practice of fine bronze-casting, giving broad, plain surfaces sufficiently attractive to dispense with inlay, reappears in a group of vessels distinguished by their large inscriptions in Arabic, of that most decorative of scripts (plate 59)[8]. This surprising acceptance of allusion to an alien religion in palace ornament is ascribed to the interest taken in Islam by the Emperors Hung Chih (1488–1505) and Cheng Tê (1506–1521). The latter is known to have studied Arabic and is even rumoured to have adhered secretly to the Muslim religion; and most of the palace eunuchs came from the Muslim communities of West China. The problem of dating the Muhammedan bronzes joins with that presented by the Hsüan Tê pieces. A censer decorated with Arabic writing in the Field Museum, Chicago[9] is of the kind illustrated in fig. 4 no. 3, with heaven-soaring handles. It bears an inscription proclaiming it the work of one Wu Pang-tso of the Board of Works in the year 1430. But this Hsüan Tê mark on a Muhammedan piece appears to be an isolated instance, and possibly, as often happened, the bowl was cast long after the Hsüan Tê period. Commonly the mark found on Muhammedan bronzes is that of Cheng Tê, and many pieces have strongly the air of work executed after rather than before this reign. Some tall-necked vases with ring handles or zoomorphic handles, decorated on the belly with the pious Muslim formulas, are certainly of the 17th or 18th century.

A discussion of the history of Buddhist bronze lies outside the scope of this chapter. The gilt bronze images of the Northern Wei and T'ang dynasties have been much collected and studied. Artistically and technically they have had little in common with lay bronzework, since neither exceptional virtuosity of casting nor surface embellishment were called for. Buddhist work of quality comparable to the best of the T'ang could still be executed in the Sung period, as witnessed by the Kuan Yin of plate 44. The surface of this piece shows little if any trace of the chisel. After the close of the Sung dynasty, a decline of standards is reflected in Buddhist bronze images both small and life size, and first-class work of this kind is hardly to be found again before the early Ming period. To the reign of Yung Lo (1403–1424) are assigned a few gilt images in a style approximating to that of Tibet and Nepal[10]. Our plate 71 presents an 18th century piece in the same exotic tradition. In the reigns of K'ang Hsi (1662–1712) and Ch'ien Lung (1736–1795) the official establishment of Tibetan lamaistic temples in Peking led to a large production of small gilt-bronze images of the deities of the vast esoteric pantheon, in a style barely distinguishable from the Tibetan and Nepalese. The lotus-shaped altar of plate 71 almost equals the

best of the Western work of like date. Tibetan monks as well as their Chinese pupils were no doubt engaged in image-making in Peking from the K'ang Hsi period onwards.

The history of the casting of secular figures in bronze is poorly documented before the 17th century. The Ladies Reading illustrated on plate 57 is a piece of a rare kind, which may be attributed by style reasonably, though not quite positively, to the Sung period. We may surmise that, in comparison with ivory and porcelain, bronze was less frequently used in Ming times as a medium for decorative small-scale sculpture, at least for work of sufficiently high quality to ensure its preservation. The impressive Lohan of plate 45, which hovers between the ecclesiastical image-making and lay sculpture, issues from a long tradition of Lohan portraiture in the temples. The vast number of secular bronze figures to be seen today, with few exceptions of mediocre merit, representing immortals, Lao-tzŭ, the gods of literature and wealth, Confucian dignitaries etc, and, of animals, chiefly tigers, *ch'i lin*, water buffalo and Buddhist lions, rarely give grounds for dating before the late 16th or the 17th century, and belong in the bulk to the 18th and 19th centuries. The examples of this work which we have chosen from the collection of the British Museum (plates 62, 63, 65, 66) represent the better quality to be found among them. The comparison of the lion of plate 62 with the *ch'i lin* of plate 61, made a thousand years earlier, makes clear how little power was added to the sculptural form by the greater concern for realism which characterizes the recent tradition.

Among the ornamental bronze vessels the achievement of the age of Ch'ien Lung is epitomized by the pieces illustrated on plates 50 and 67, the former compact of sentimental archaism, even to the imitation of eruptions in decaying bronze by inlay of gold grains, the latter a playful combination of austere traditional elements with an unusual species of floral ornament. Bronze vessels of the 18th century cast more deliberately as versions of the old ritual vessels often present a bewildering medley of exactly copied motifs arranged with little feeling either for the antique pattern or the Ming variations of it. They have a dry disorder that, to our eyes, robs them of the charm of the older archaism[11]. According to literary record the best imitators of the antique in Ch'ing times were all in Kiangsu: members of the Kan and Wang families in Wu Hsien, whose work confounded experts; Ch'ien Ta-tien of Chia Ting Hsien whose *hu* and *chüeh* were indistinguishable from those of Shang and Chou; and Feng Hsi-yü, who inlaid gold and silver on ritual vessels, and made *ju-i* sceptres, belthooks and bells. But the work of these men seems not to have been signed, and cannot now be identified[12].

IRON AND PEWTER

An early use of iron for artistic purposes was mentioned in the first chapter of this book: iron belt-hooks, inlaid with gold foil, which are found in graves of the 4th and 3rd centuries B.C. Thereafter, until mediaeval times, evidence is quite lacking for the employment of iron in fine craft. Buddhist images were cast in iron in the T'ang period (possibly even earlier) and a few statues of some sculptural quality survive from the 10th century; but it is not until the 17th century that the names of

artists working in this medium are recorded. Chang Ao-ch'un, the author of the *ju-i* illustrated on plate 70, is said to have specialized in these objects, which are strangely associated with Chao Nan-hsing, a Grand Censor of the early 17th century. We are told that "all Chao Nan-hsing's *ju-i* of iron inlaid with silver were the work of Chang Ao-ch'un".[13] We can now only guess at the nature of the patronage, or incident or anecdote which led to the attribution of the iron *ju-i*, or of poems inscribing them, to this minister celebrated for his integrity. The *ju-i* may have been made of the stubborn material to underline a personal allusion, and did not necessarily issue from an established tradition of small-scale decorative craft in iron. Such intrinsic merits as the piece of plate 70 possesses are the neat forging of the shape, and the lustrous surface, on which no file-marks appear. The 'inlay' is illusory, the silver wire being hammered on to a surface roughened by a close reticulation of scored lines, and not laid in specially prepared recesses[14]. Chao Ao-ch'un's work has no recorded sequel.

Greater interest attaches to the 'iron pictures' in the tradition established by Liang Ying-feng and T'ang P'eng (called T'ien-ch'ih). They both worked in the latter half of the 17th century[15], in Wu Hu Hsien, Anhui. It is said that T'ang was a neighbour of the painter Hsiao Yün-ts'ung, and finding his craft rated lower than Hsiao's, undertook to produce in iron landscape paintings as fine as the painter's. In the iron pictures the wires and leaves of forged iron imitating the brush strokes of black ink painting are fixed in the frame only at the edges, the whole appearing as openwork. T'ang seems not to have signed his work, but several iron landscapes with the signature of Liang Ying-feng have survived[16]. The majority of existing pieces, landscapes, closer views of bamboos and rock, flower sprays etc. are unsigned. Some flower pieces, like that of plate 72 representing autumn, are in sets of four as symbols of the seasons. Decorative ironwork of this kind has continued until the present time, but apart from Liang's signed pieces, no close dating of them can be attempted.

The iron jar illustrated on plate 68 is treated in yet another manner, the pattern being obtained wholly by drilling through the metal, which had an original thickness of about five millimetres. Great care has been taken to simulate the effect of interlacing branches. The shape of the jar suggests that it may be of the Wan Li period, or earlier, and so antedates the rise of the Liang-T'ang school of ironcraft.

Still more casually documented than ironwork are the products of the pewter worker. The metal was chiefly employed in the manufacture of tea-caddies, and prized for the quality of the engraving. The earliest recorded name is that of Huang Yüan-chi of Chia Hsing Hsien in Chekiang, whose pewter 'was indistinguishable from silver'[17]. Chu Shih-mei of Shan Yin Hsien, Shantung, engraved his caddies with poems, and most famous of all were the 'cloud caddies' of the trio Wang Shan-ts'ai, Chu Chen-shih and Liu Jen-shan. In Chiang Tu Hsien, Kiangsu, fine pewter caddies were given away by tea-shops and thrown away by insensitive customers. Those who prized them exchanged them with each other in token of friendship. But pewter was used also for incense-stick holders, pricket candlesticks, jars with covers (some with pottery linings), opium boxes, wine ewers and teapots. Some of the ewers were made the vehicle of elaborate ornament of *laque burgautée* (plate 49), and pewter teapots were made at I Hsing in Kiangsu in the forms of the pottery teapots for which this centre was famous. Some fine pieces of this description are marked with the names of I Hsing potters (cf. plate 69). Pewter was sometimes

inlaid with copper or brass, especially the larger pieces, or decorated with parcel-gilding, as in the case of the large altar piece illustrated on plate 48[18].

WILLIAM WATSON

[1] Quoted by Jung Keng, *Yin chou ch'ing t'ung ch'i t'ung lun*, p. 133.

[2] Cf. William Watson, "Sung Bronzes", *Transactions of the Oriental Ceramic Society*, Vol. 32, 1959–60, pp. 33 ff.

[3] Basil Gray, "The Inlaid Metalwork of Korea", *British Museum Quarterly*, Vol. 20, no. 4, June 1956, p. 92.

[4] According to a preface dated to 1526 this text was printed from a manuscript obtained in 1437 from a senior officer (*t'ai chien*) of the Board of Rites, in which the decree of 1428 and the report of the action taken upon it are presented by Lü Chen, the President of the Board of Works. The text now available is a reprint of the 1526 edition made in 1928.

[5] It is unfortunate that the history of the *Hsüan Tê i ch'i t'u p'u*, as given in the preface of 1526, does not put it beyond every question as a text unaltered from the time of its composition in the Hsüan Tê reign; but the official language and the arrangement of the report have the marks of authenticity, and anything approaching a travesty of an imperial decree and of so high-ranking a report so comparatively soon after the event is on general considerations improbable.

[6] The piece is published and this translation given by Aschwin Lippe, "Two archaistic bronzes of the Ming dynasty", *Archives of the Chinese Art Society of America*, XI, 1957, p. 78f.

[7] A *kuei* with parcel-gilt *t'ao t'ieh* ornament, bearing this inscription, is in a private collection.

[8] The *locus classicus* is Berthold Laufer, "Chinese Muhammedan Bronzes", *Ars Islamica*, vol. I (1934), pp. 133 ff.

[9] Laufer, *op. cit.*, figs 1, 2.

[10] Douglas Barrett, "The Buddhist Art of Tibet and Nepal", *Oriental Art*, Vol II, no. 3, Autumn 1957, pp. 90ff. The Chinese tradition may derive from one A-ni-ko, a Nepalese, who reached China in the Yüan dynasty and was celebrated for his casting of Buddhist images.

[11] e.g. Aschwin Lippe, *op. cit.*, fig. 3, a *tou* of undecorated bronze dated to 1724.

[12] Li Fang-wu, *Chung kuo i shu chia cheng lüeh*.

[13] Li Fang-wu, *op. cit.*

[14] This technique is found on Japanese iron-work of the 16th and 17th centuries, and in Japan termed *nunome* (cloth-texture). It may have been introduced into both China and Japan by the Portuguese.

[15] According to Yao Weng-wang (The iron pictures of T'ang T'ien-ch'ih and Liang Ying-feng, *Wen wu ts'an k'ao tzŭ liao*, 1957, no. 3, pp. 22ff.) Liang Ying-feng was considerably the older of the two.

[16] Yao Weng-wang, *loc. cit.*, figs. on pp. 22, 24.

[17] The names of pewter workers are cited from Li Fang-wu, *op. cit.*

[18] John Alexander Pope, "A Chinese Buddhist Pewter with a Ming date", *Archives of the Chinese Art Society of America*, vol. XVI, 1962, p. 88ff.

38. BRONZE CENSER OF THE *PO SHAN* TYPE, INLAID WITH GOLD, SILVER, TURQUOISE AND CORNELIAN

2nd–1st century B.C. *Height 17.9 cm. Freer Gallery of Art, Washington, D.C.*

Censers with a lid shaped to represent a many-peaked mountain were made in Han times in bronze and pottery. The *po shan*, or "vast mountain", represents the home of immortals, who are sometimes represented on it in the form of men with feathery wings. Bears, tigers and other animals lurk in the folds and caves of the mountain, while huntsmen pursue them. Here a huntsman with drawn bow can be seen on the right. In the centre a wolf or tiger attacks its prey. Above these a villager leads a buffalo pulling a cart. The metallic inlay is in a modified version of the style seen on inlaid bronze of the 4th and 3rd centuries B.C. and probably already had an archaic air at the time when it was executed. The composition of animals and hills, here rendered in bronze, represents the conventionl landscape of Han painters. Such pieces are among the finest examples of Han metalcraft.

39. BRONZE VASE INLAID WITH GOLD AND SILVER

Sung dynasty. 11th–12th century. Height 50 cm. Victoria and Albert Museum, London

Like the vase illustrated on plate 40, this *hu* betrays its date in the proportions of the profile and the inclination of the foot, although in general it follows the style of the 4th–3rd centuries B.C. The decoration superficially resembles that of inlaid bronzes of this period, but is really a free invention in the terms of the ancient convention. The scrolled forms, with slender spirals, sudden changes of direction and changes from broad to narrow line, are quotations from the old idiom. A free and inventive treatment of ancient motifs is characteristic of Sung archaism, which shared the vitality of other branches of Sung craft. The casting and technique of inlay equal the quality of the best work of the earlier period.

40. BRONZE VASE INLAID WITH GOLD

Sung dynasty. 11th-12th century. Height 42.5 cm. Victoria and Albert Museum, London

This superb example of Sung work in the antique style is inlaid with massive gold in unusually deep channels. It purports to be in the style of about 300 B.C., but the design is treated freely, with a result that cannot be paralleled with ancient bronzes. The continuous, serpentine line of much of the detail and the disposition of the spur-like projections on the main figures betray the more decorative trend of Sung ornament as compared to the cool geometricism of late Chou art.

41. BRONZE WINGED LION INLAID WITH GOLD AND SILVER

Sung dynasty. 11th–12th century. Height 21.5 cm. British Museum, London

Like much of the archaistic inlay on metal of the Sung dynasty, the motifs here rendered in gold and silver are copied closely from those used on bronzes of the 4th–3rd centuries B.C. Its geometric character, the spirals and alternation of widths, and the bird-head terminals are all true to the antique. But in the ancient work these motifs are not seen applied to animal form so freely modelled.

42. BRONZE RITUAL VESSEL INLAID WITH GOLD AND SILVER

Sung dynasty. 12th–13th century. Height 32 cm. Victoria and Albert Museum, London

The forms of bronze vessels made in the Sung period in archaic styles were often very different from the ancient pieces they in general professed to copy. This vase, which combines the body of a phoenix with the head of a dragon, has no ancient parallel, although the forms of animal-masks and the triangles and spirals of the inlaid ornament are inspired more or less closely by the work of the 4th and 3rd centuries B.C. The placing of a vase on the back of the animal is a Sung conceit.

43. MINIATURE BRONZE BUCKET WITH GOLD AND SILVER INLAY

Sung dynasty. 12th–13th century. Height 4 cm. Formerly collection Mrs. Walter Sedgwick, London

Like the miniature vessels made in the fine porcelain of the Southern Sung period, this small bronze is a collector's toy. The style of the inlaid ornament is an adaptation of the pre-Han designs, which are copied with fair fidelity in the detail, though the total effect is quite unlike the ancient models.

44. GILDED BRONZE FIGURE OF THE BODHISATTVA KUAN YIN (AVALOKITÉSVARA)

Sung dynasty. 12th–13th century. Height 20 cm. British Museum, London

In post-T'ang times, Kuan Yin is the Buddhist deity most frequently portrayed in sculpture. Here the flask held in the left hand is a regular attribute, but the *stūpa* placed in the headdress takes the place of the small image of Kuan Yin's spiritual progenitor, A Mi T'o (Amitābha). The exaggeratedly tall headdress is found on this image in sculpture and painting in China from the 12th century. At a period when Buddhist image-making on this small scale was in decline, the quality of modelling and casting makes this figure outstanding.

45. GILDED BRONZE FIGURE OF A SEATED LOHAN

Ming dynasty. Height 15.2 cm. Formerly collection Mrs. Walter Sedgwick, London

The naturalistic trend taken by monumental sculpture in the Sung dynasty was continued in Ming times in small bronzes. The artist devoted notable powers of characterization to representing legendary sages and heroes, and in particular revelled in the extravagant personalities of Taoist and Buddhist worthies. The figures of Lohan, the eccentric and supernaturally endowed Buddhist ascetics who enjoyed a growing cult in the temples, are often portrayed with vigour and an evident attempt at psychological realism.

46. BRONZE CENSER OF *TING* FORM, INLAID WITH GOLD AND SILVER

Ming dynasty. ca. 1600. Height 12 cm. Garner Collection

The *ting* is a ritual vessel made in Shang and Chou times, which, together with the *kuei*, was among the august shapes made in the imperial porcelain of the Southern Sung period. The appropriate decoration is the monster mask called *t'ao t'ieh*, of which the version seen on this vessel copies the ancient design in its chief parts: eyes, eyebrows, lateral extension to the mask, clawed feet and an upper jaw which lacks a lower one; but each of these elements betrays its Ming date in the easy, curving lines of the design, as well as the character of the high relief. Nor were vessels of this kind in ancient times inlaid with gold or silver. The background of squared spiral is a coarse rendering of the "thunder pattern" which forms the ground of the ancient ornament.

47. BRONZE VESSEL, PARCEL-GILT, WITH DRAGON AND FISH

Ming dynasty. Made by Hu Wen-ming. ca. 1600. Length 11.1 cm. Garner Collection

The feet of the vessel are shaped into animal-masks, and lion-heads hold the ringhandles. The four-clawed dragons play either side of a flaming jewel between clouds and water. Parcel-gilt relief of this style is characteristic of the work of Hu Wen-ming, whose activity, as shown by dated pieces with signature, extended at least from 1583 to 1613.

48. PEWTER VASE WITH TRACED AND GILDED DECORATION

Ch'ing dynasty. 18th century. Height 20 cm. Formerly collection Dr. Grice, London

The use of pewter was largely confined to utilitarian vessels and boxes, of which certain rectangular tea-caddies with short cylindrical necks became well-known in Europe in the 18th century. The piece illustrated here is intended as an incense-burner for an altar. The shape derives ultimately from one of the ancient ritual bronze vessels. Similar pieces were made in porcelain at the end of the Ming period. The traced ornament of the pewter vase consists of a lotus scroll, dragons chasing a flaming pearl – both having Buddhist associations – and a group of figures in court costume representing the Taoist Emperor of Heaven and his attendants.

49. PEWTER TEAPOT DECORATED WITH *LAQUE BURGAUTÉE*

Ch'ing dynasty. K'ang Hsi period (1662–1722). Height 21 cm. Formerly collection Mrs. Walter Sedgwick, London

The fragments of mother of pearl with which the ornament is rendered are set in lacquer adhering directly to the pewter body of the vessel. The form of the teapot, with tall body and handle, is typical of the K'ang Hsi period, when it was also made in *famille verte* porcelain. The panels show ladies in a garden. The ornaments around the neck include a book and a fan. The knob of the lid is made of jade.

50. BRONZE TWIN VASES WITH GOLD INLAY

Ch'ing dynasty. Ch'ien Lung period (1736–1795). Height 8.5 cm. Collection Mr. W. W. Winkworth, London

No better example could be found of the fantastic treatment of traditional elements of bronze ornament. A pre-Han convention survives in the spirals which pervade the design, though no single major form is copied from the antique. Twin vases of this type were first made in the Ming period, often in jade and other hardstones. The surface of the bronze is pale yellow. The patches of apparent corrosion are elaborately simulated, the rough projecting parts consisting of pure gold, resembling unworked nuggets and grains, inserted into the bronze.

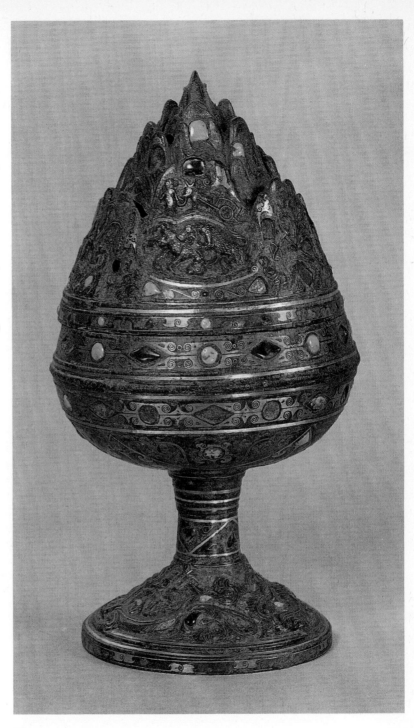

38

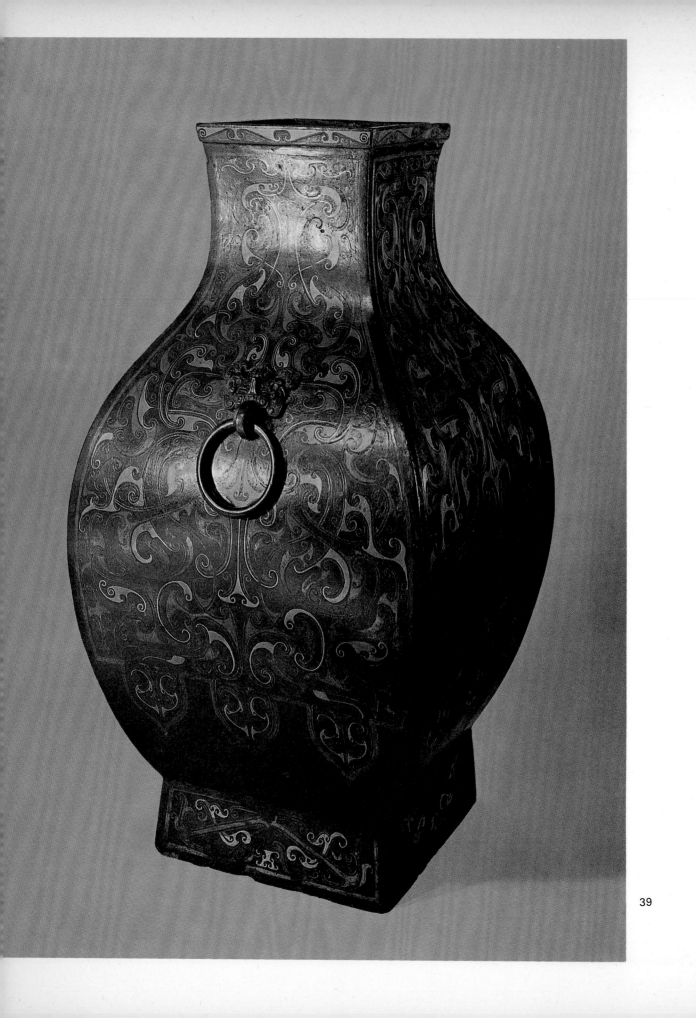

39

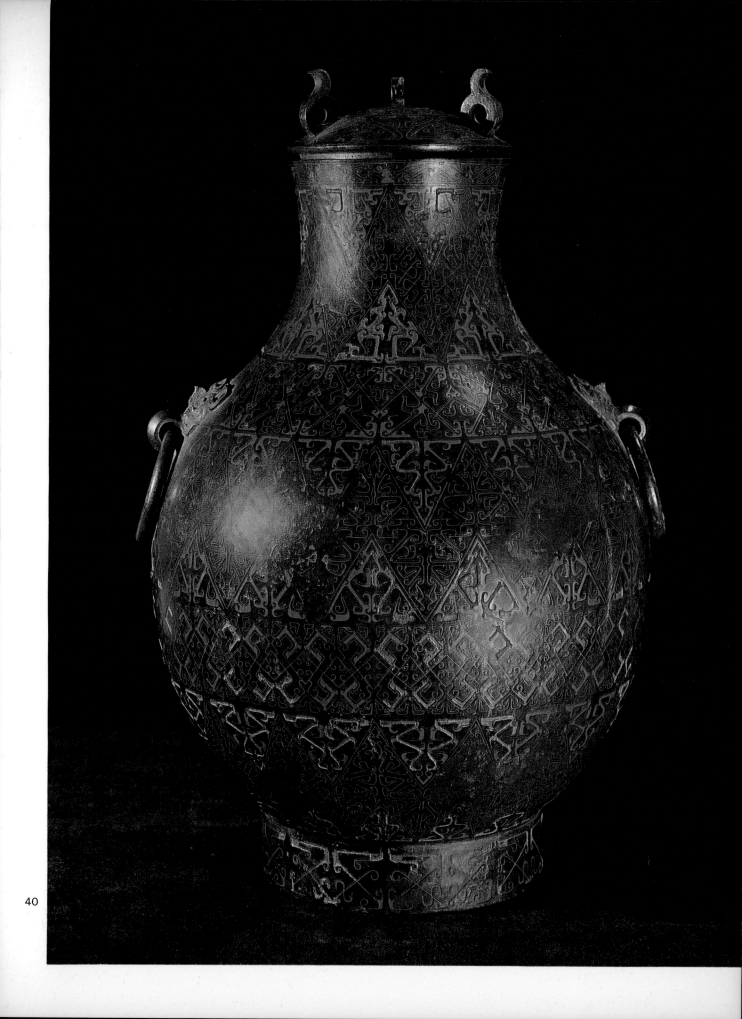

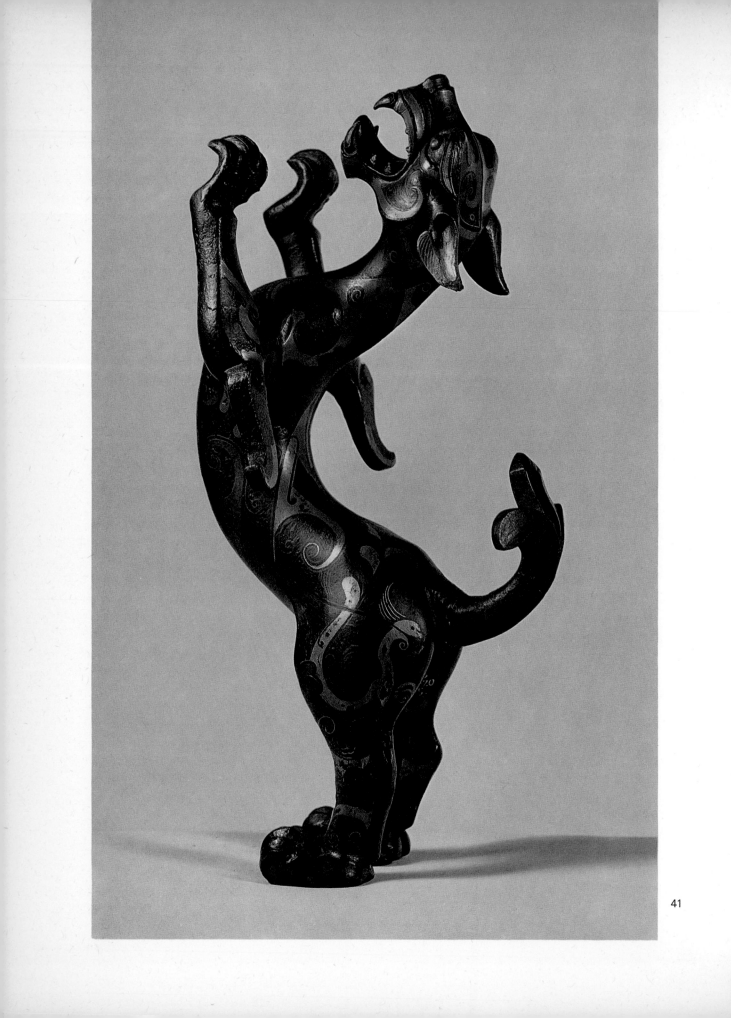

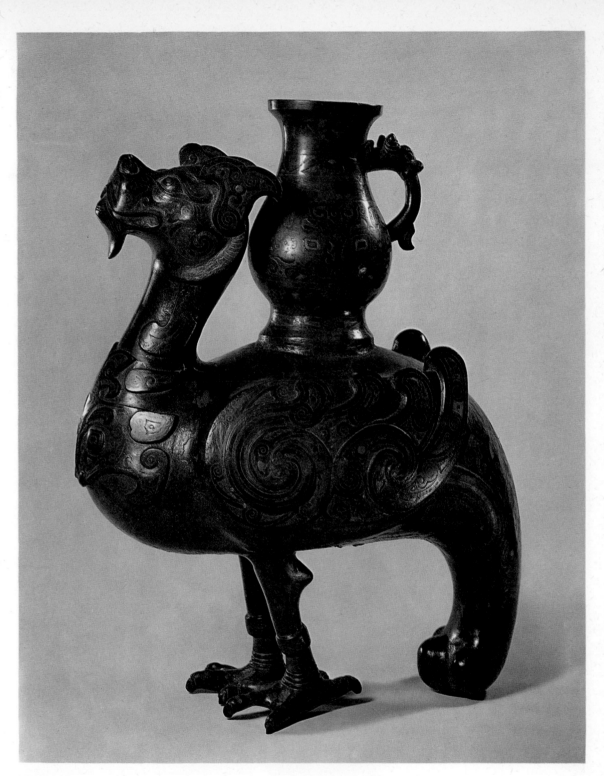

42

43

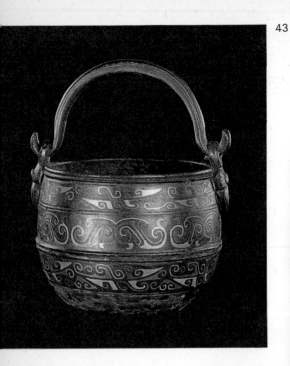

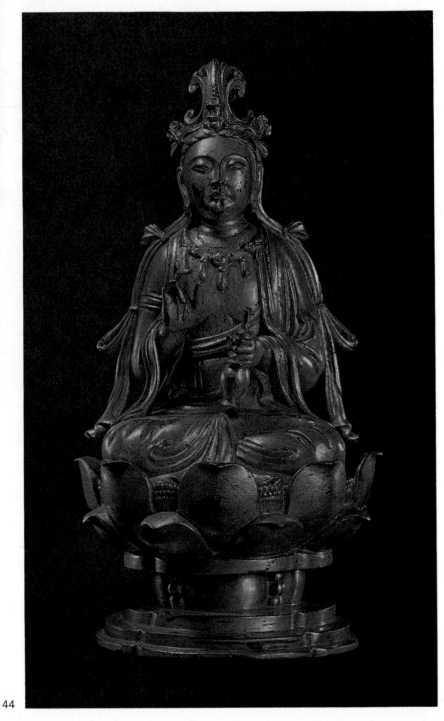

44

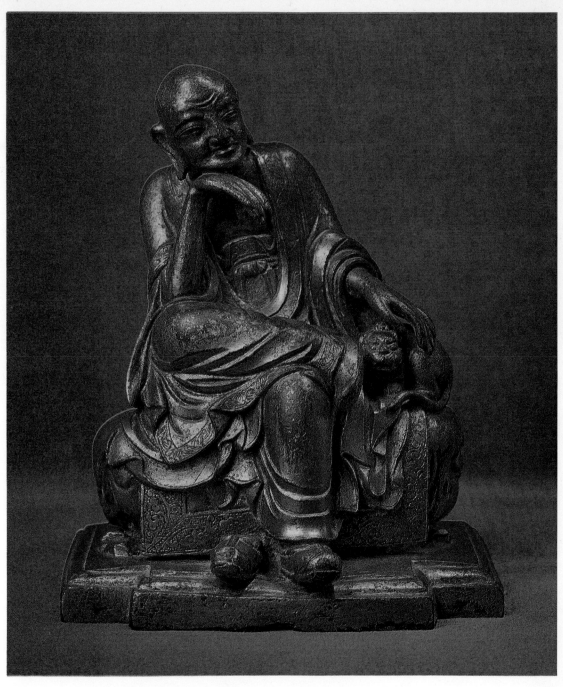

45

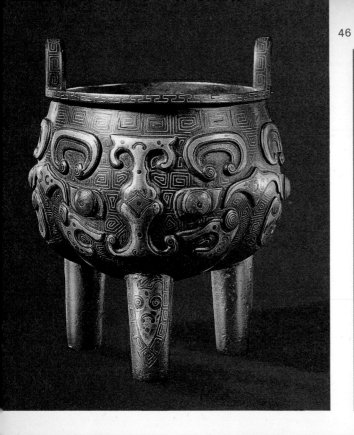

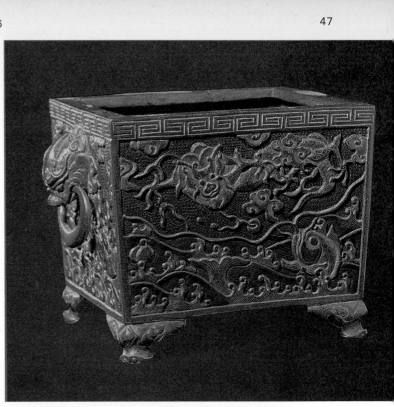

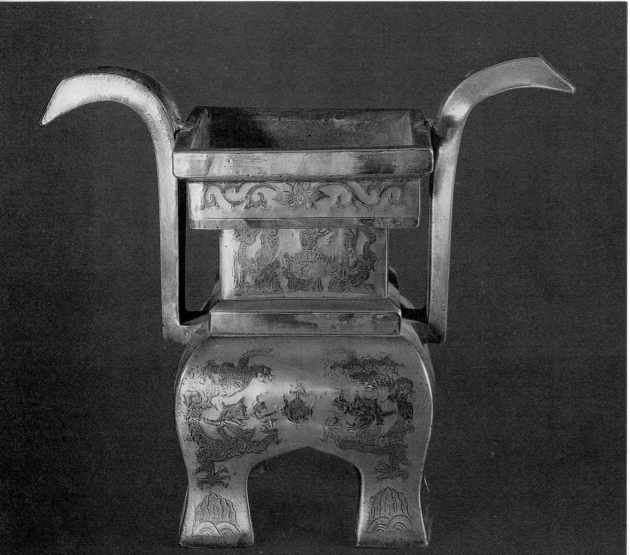

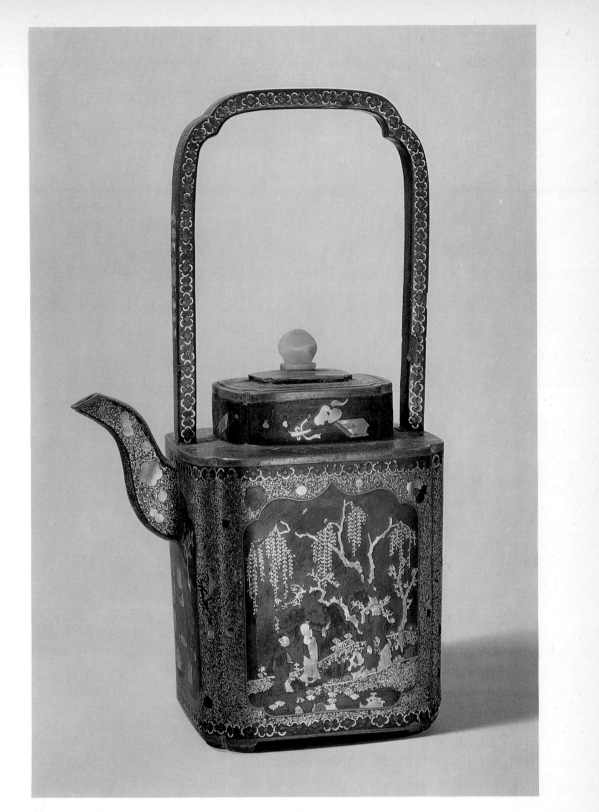

49

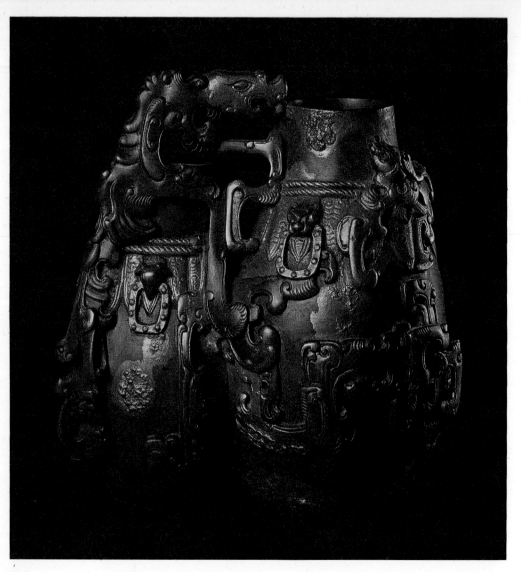

50

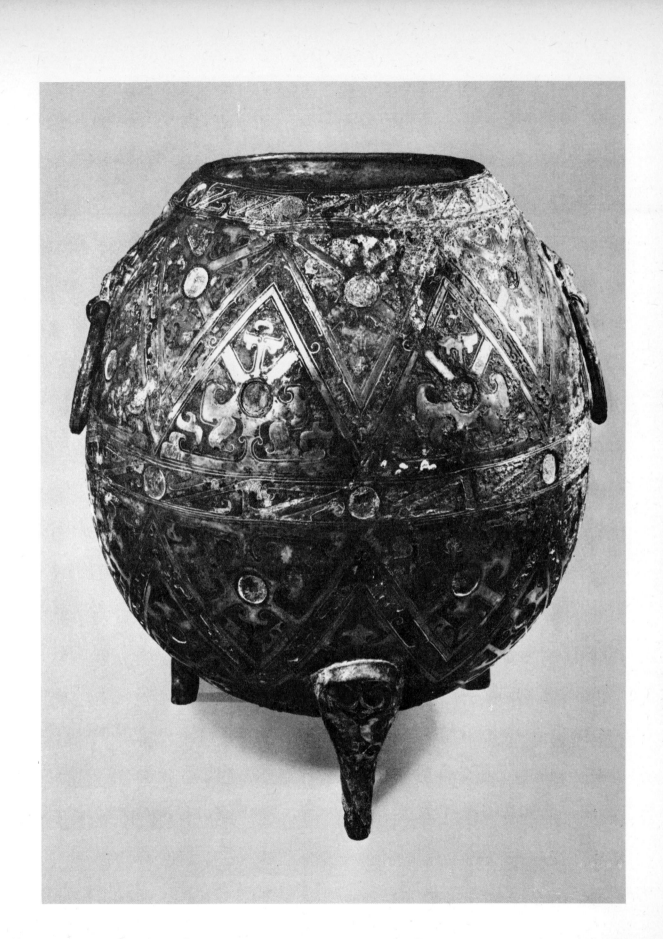

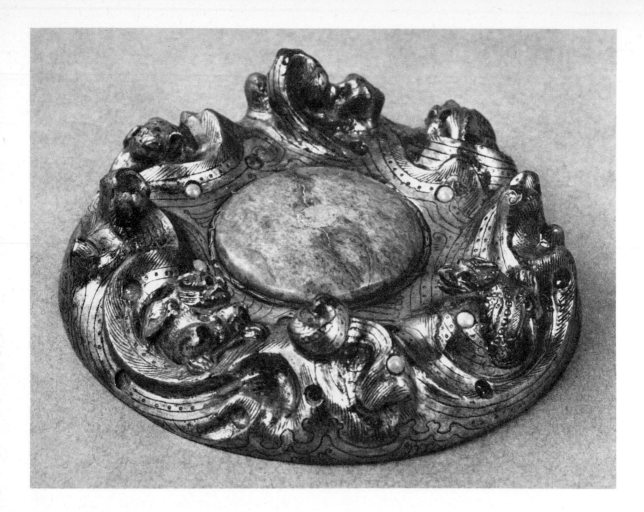

◁ 51. BRONZE RITUAL VESSEL, INLAID WITH GOLD AND SILVER

4th century B.C. *Height 31.8 cm. British Museum, London*

The vessel known by the ancient name of *tui*, was first made towards the end of the 6th century B.C. An early text describes it as "a container like the *fu* and *kuei*, but differing from them in being completely round, top and bottom, inside and outside". The earlier examples are divided at the middle and have similar projections at either end forming feet, so that both halves can stand upright and serve as containers. The *tui* illustrated here now lacks its lid. The silver-inlaid symmetrical motifs in triangular panels are typical of the geometricizing trend in the art of the late Chou period. The centre of each panel held glass inlay, now missing.

52. BRONZE PLAQUE, GILDED AND INLAID WITH JADE, TURQUOISE, CORNELIAN AND SILVER

2nd–1st century B.C. *Diameter 9.5 cm. Freer Gallery of Art, Washington, D.C.*

In the early Han period the combination of gilding with engraved pattern replaced the broad inlay of gold and silver practised in the fourth and third centuries B.C. A scattered inlay of small pellets of semi-precious stone, without logical relation to the design, is occasionally found on animal bronzes (such as the bear-shaped feet of vessels) and marks an influence from the barbarian art of the Asiatic steppes. The central roundel is of jade. The theme of dragons playing in waves is found in an ancient Chinese fable.

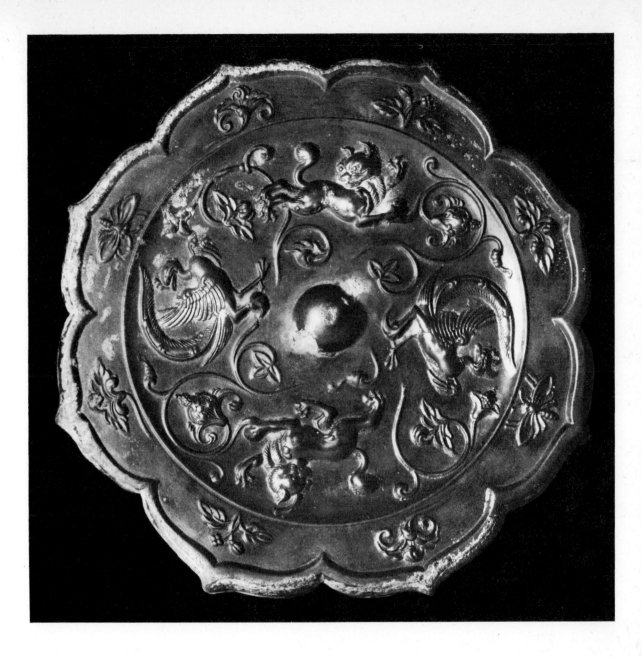

53. BRONZE EIGHT-LOBED MIRROR

*T'ang dynasty. 8th century. Diameter 19.4 cm. Brooklyn
Museum, New York*

Lions and phoenixes alternate in the procession around the
central knob of the mirror-back, taking the place of the Four
Celestial Animals or the dragons which provide the most fre-
quent ornament of mirrors in the period between the Han
and T'ang dynasties. Butterflies and conventionalized floral
sprays are placed on the rim.

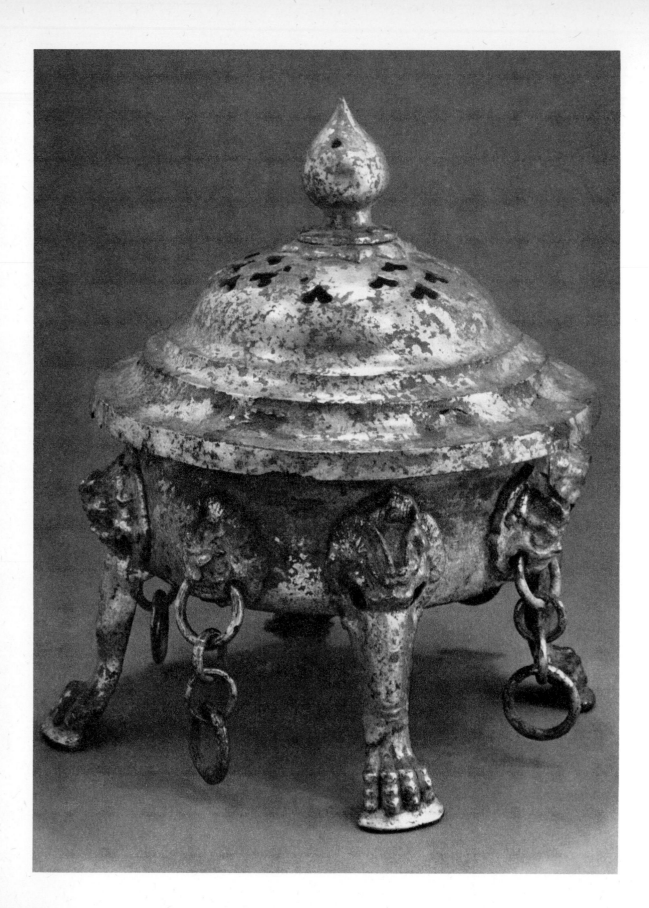

54. GILDED BRONZE CENSER

T'ang dynasty. Height 21.5 cm. Metropolitan Museum of Art, New York

The finest bronze casting attributable to the T'ang period is to be found among the Buddhist images and some rarer appurtenances of the temples, of which this censer is a notable example. The lion has a rôle in Buddhist iconography as a symbol of the powers that guard the doctrine. In sculpture lions are frequently depicted in relief on either side of a censer, and here are adapted as ornaments of the vessel itself. The combination of a lion mask with a leg and paw is an idea without precedent in pre-T'ang China.

55. BRONZE STILL, PARCEL-GILT AND INLAID WITH GOLD AND SILVER

Sung dynasty. 11th–12th century. Height 43 cm. British Museum, London

A still of approximately this shape, with a tube connecting the boiling-chamber to an outlet in the shape of an inverted hemisphere, was in use in China at least as early as the 1st century B.C., and was probably employed for a variety of chemical and alchemical processes. The Han specimens, called "rainbow vessels", have a pair of symmetrically placed tubes. The piece illustrated is unusual in having fine ornament which combines elements taken from the inlaid bronzes of the 4th–3rd centuries B.C. with such typical Han features as the bear-shaped feet. The precious metal is inlaid as foil, even where it appears as a wire-like line. The quality of the craftsmanship falls little behind that of the ancient work it copies. The treatment of the tiger-head at the base of the tube resembles that seen in the winged lion illustrated on plate 41.

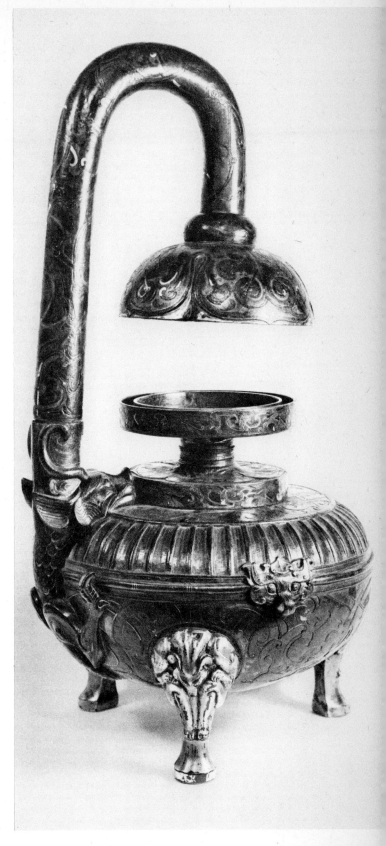

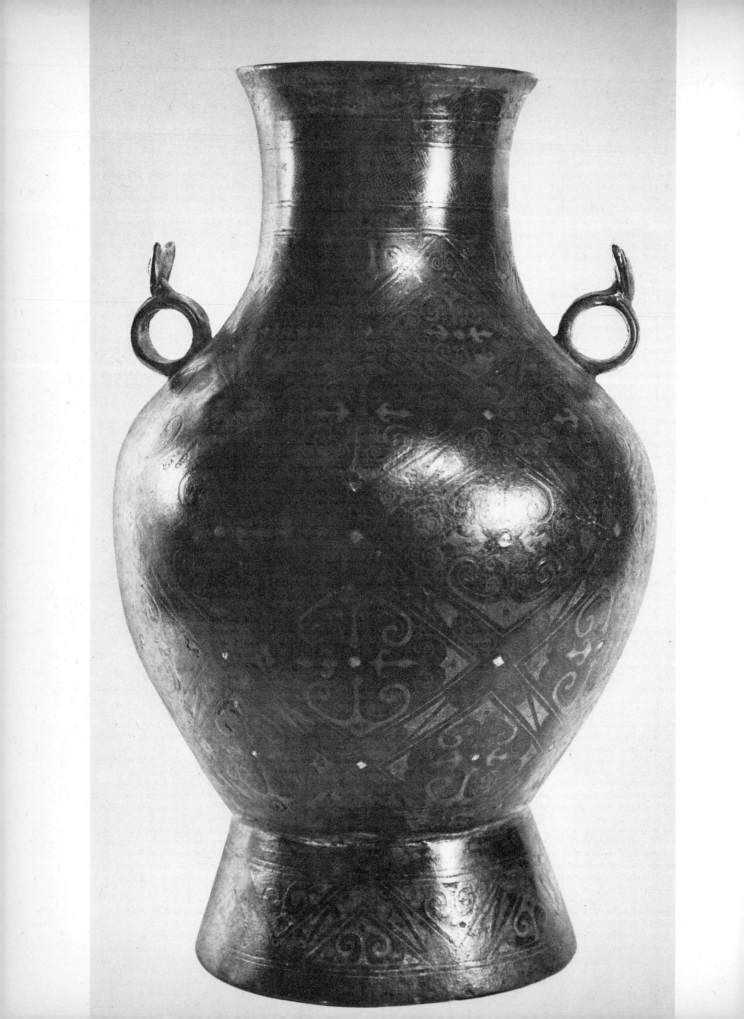

56. BRONZE VASE INLAID WITH GOLD, SILVER AND MALACHITE-PASTE

Sung dynasty. 11th–12th century. Height 34 cm. British Museum, London

The archaistic *hu* vases of the Sung dynasty follow mostly the form current in the late Chou period of the 4th and 3rd centuries B.C. The version illustrated here departs considerably from the ancient shape in the tall, expanding foot-ring (this is vertical in pieces of Chou date) and in the ring-and-crescent shape of the handles, which are unknown in antiquity. The inlaid ornament, set in broad lozenges, shares with the ancient style only its details of spirals and triangles and its general heraldic effect. The use of a malachite paste, also unknown to the ancients, was intended to simulate the rich green of well-patinated bronze.

57. BRONZE FIGURES OF LADIES READING

Sung dynasty. 12th–13th century. Height 11 cm. Formerly collection Dr. A. Breuer, Berlin

The naturalistic trend observed in life-size sculpture of the Sung period is reflected here in the easy pose and soft modelling of these figures. Such absence of mannerism, and of any elaboration of the dress for its own sake, and the neglect of decorative detail would not be looked for at a later period.

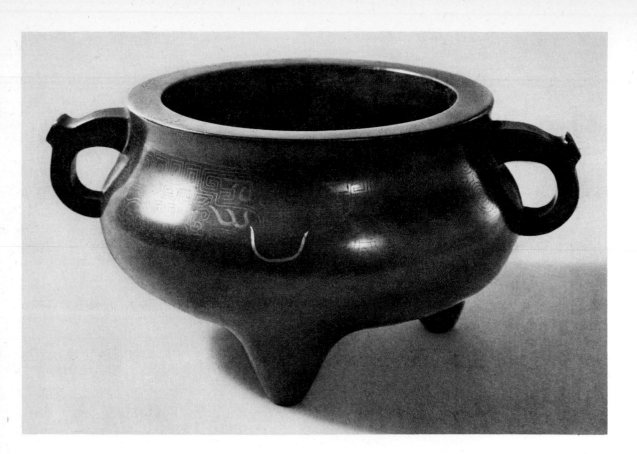

58. BRONZE CENSER OF *TING* FORM, INLAID WITH SILVER WIRE

Ming dynasty. Hsüan Tê period (1426–35). Height 9.1 cm.
British Museum, London

The florescence of bronzecraft which occurred in the Hsüan Tê period produced a number of modified versions of ancient ritual vessels, of which this form of *ting* was the most popular. The inlay of silver wire is held in deeply cut grooves, in the manner first found in use in the first half of the 14th century. The ornament consists of a modification of the ancient key-fret and the *t'ao-t'ieh* monster mask, the latter almost completely lost in a maze of lines, a treatment for which there is also ancient precedent. The surface of the bronze has been coloured after casting to a dark, reddish brown. The mark on the base consists of the two characters *Hsüan Tê* only, instead of the fuller formula commonly found on the bronzes of this period and their numerous later imitations, i.e. *Ta Ming Hsüan Tê nien chih,* "made in the Hsüan Tê period of the great Ming dynasty".

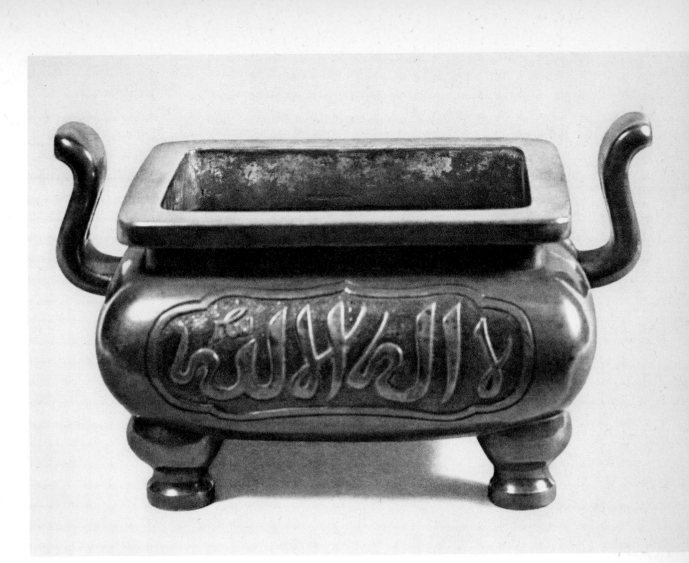

59. BRONZE CENSER OF *TING* FORM WITH AN ARABIC INSCRIPTION

Ming dynasty. Cheng Tê period (1506–21). Height 10 cm.
British Museum, London

In bronze, as in porcelain, vessels were made in the 16th century with large decorative inscriptions in Arabic script, perhaps through the influence of Muslim eunuchs employed in the palaces. The inscriptions give the formula of prayer: "There is no God but Allah and Mohammed is his prophet". The surface of this vessel has been given a reddish colour after casting, in the manner frequently employed in the Hsüan Tê period.

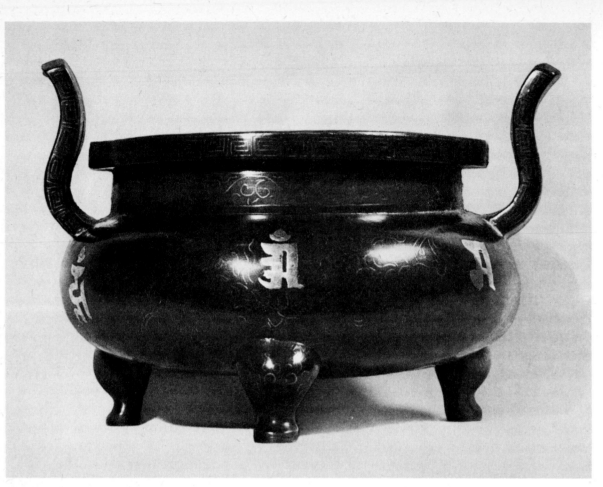

60. BRONZE CENSER OF *TING* FORM, INLAID WITH GOLD AND SILVER

Ming dynasty. Ch'eng Hua period (1461–87). Made by the Wan family. Length 14 cm. Musée Cernuschi, Paris

This shape is a modified version of the ancient *ting*, approximating to that found in imperial porcelain of the Southern Sung period. The ornament is inlaid with silver wire and combines a key-fret echoing an ancient decorative motif found on ritual bronzes with a floral design in contemporary taste. The Sanskrit letters inlaid with gold are an allusion to the Buddhist religion, in which the deities are on occasion denoted by this means. The silver-inlaid inscription on the base reads "made in the Ch'eng Hua period by the Wan family". It is rare to find reign marks other than Hsüan Tê on Ming bronzes.

61. GILDED BRONZE *CH'I LIN* ▷

Six Dynasties. 5th–6th century. Length 10 cm. Formerly collection Mrs. Walter Sedgwick, London

The fabulous *ch'i lin* was a creature of good omen, whose occasional appearance augured success for an emperor's reign and must be reported to him. The usual representation of the *ch'i lin* as a hart with a single horn seems to have been adopted in the 4th or 5th century A.D. In the transmogrification shown here the *ch'i lin* has taken on some of the features of the Buddhist guardian lion. In general the *ch'i lin* symbolized official success, the emblem of the fortunate civil servant.

62. GILDED BRONZE LION ▷

Ming dynasty. 16th century. Length 19.5 cm. British Museum, London

Among animal sculpture of the Ming dynasty, this piece is outstanding for its realism in the carriage of the head and the tension of neck and limbs.

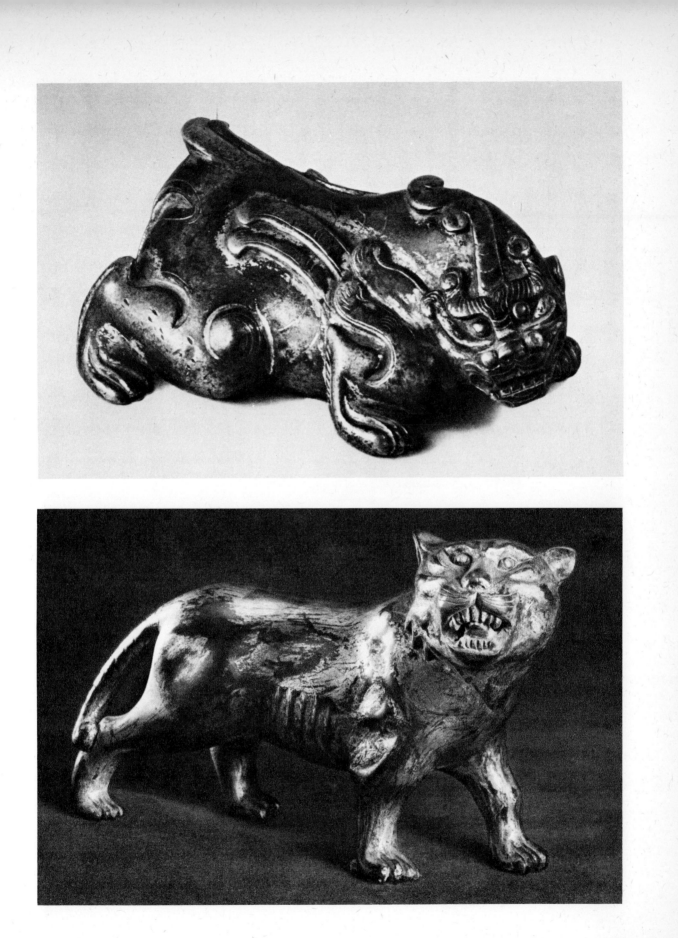

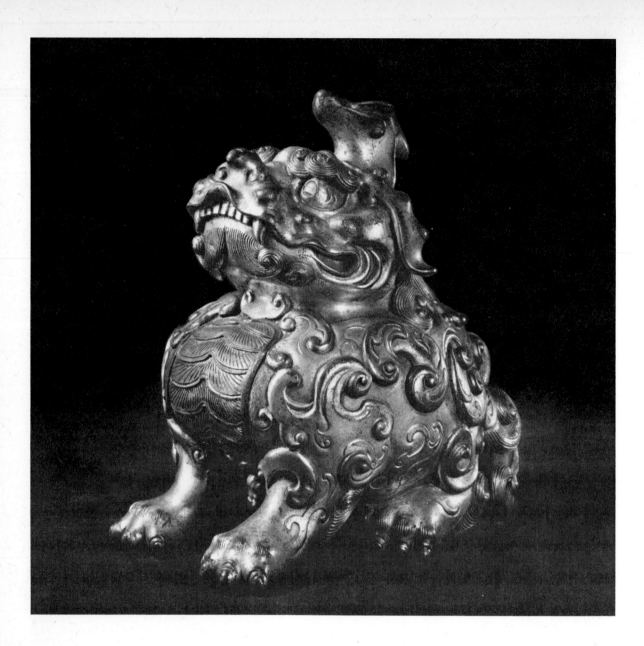

63. GILDED BRONZE WATER-DROPPER IN THE SHAPE OF A LION

Ming dynasty. 16th century. Height 13.8 cm. British Museum, London

An ornament of the scholar's writing table, intended for holding the water used in preparing ink, this lion follows the convention of the guardian lions of Buddhist sculpture. The eyes are inlaid with translucent stone.

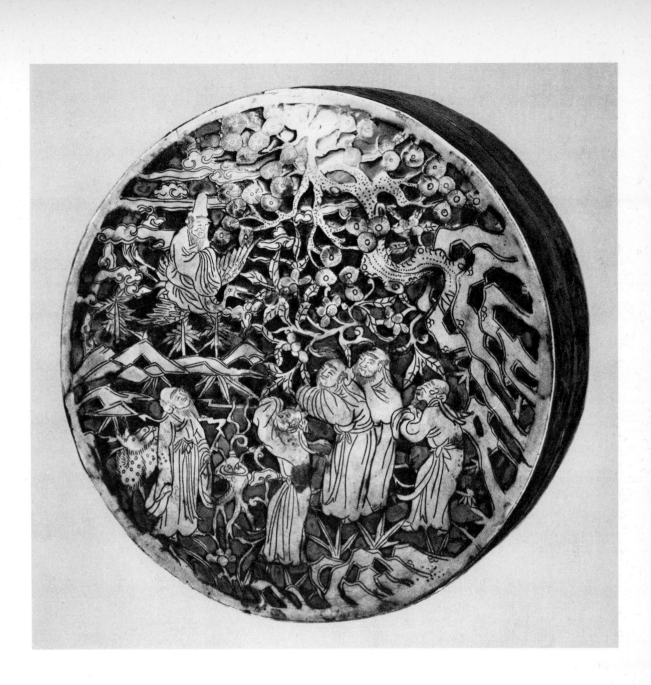

64. BRONZE BOX WITH TRACED AND LACQUERED DECORATION

Late Ming or early Ch'ing dynasty. 16th–17th century. Diameter 15.1 cm. British Museum, London

The box is made of light-coloured bronze. The scene is traced and engraved, the lower parts of the design filled with reddish-brown lacquer. It combines all the conventional symbols of longevity. The vegetable symbols are pine, plum, bamboo (the "three friends") and the fungus of immortality, *ling chih*. The persons are *hsien*, immortals, in the mountainous Taoist paradise in the west, watching the arrival on a crane of Lao Hsing, the god of immortality.

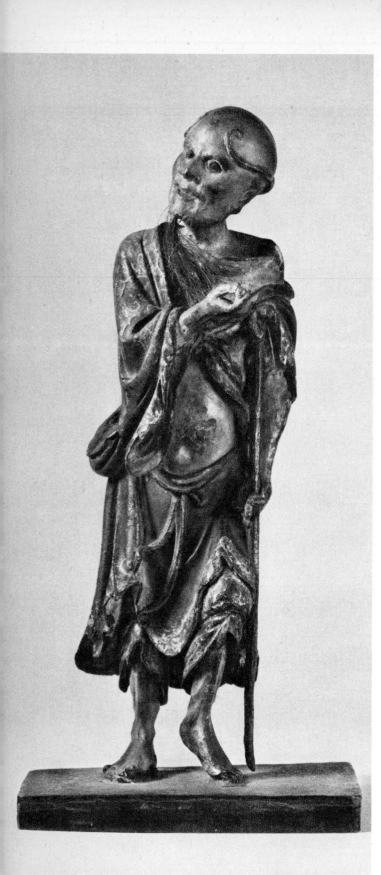

65. BRONZE FIGURE OF THE IMMORTAL
LI T'IEH-KUAI, LACQUERED IN COLOURS

Ming dynasty. Late 16th or early 17th century. Height 21 cm.
British Museum, London

Li T'ieh-kuai is one of the legendary patriarchs of the Tao-
ists. He is included among the Eight Immortals, and is dis-
tinguishable in representations of these by the iron staff
(t'ieh kuai) he carries. The flesh is painted pink and the gar-
ment black with ornament in gold, red and green.

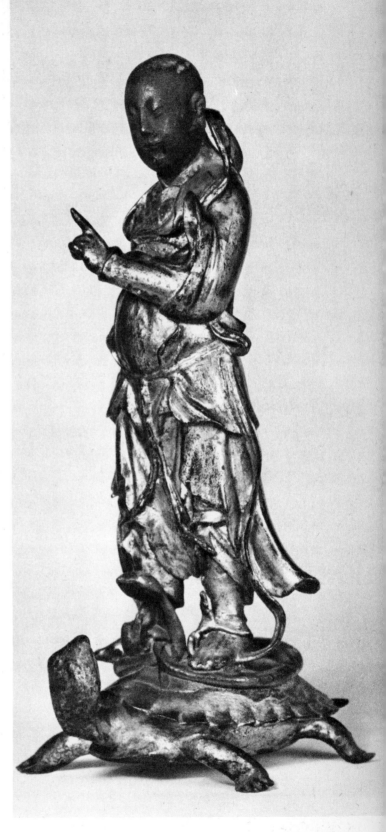

66. BRONZE FIGURE OF T'IEN TI, THE CELESTIAL EMPEROR

Ming dynasty. Late 16th or early 17th century. Height 22.5 cm.
British Museum, London

The Celestial Emperor, chief god of the Taoist pantheon, was identified with the brightest star of the seven north polar stars. His commanding figure is here shown mounted on the tortoise-cum-serpent symbol of the northern quarter of heaven. The head of T'ien Ti is unpainted bronze, the rest of his figure and the tortoise are lacquer-gilded, and the snake is painted red.

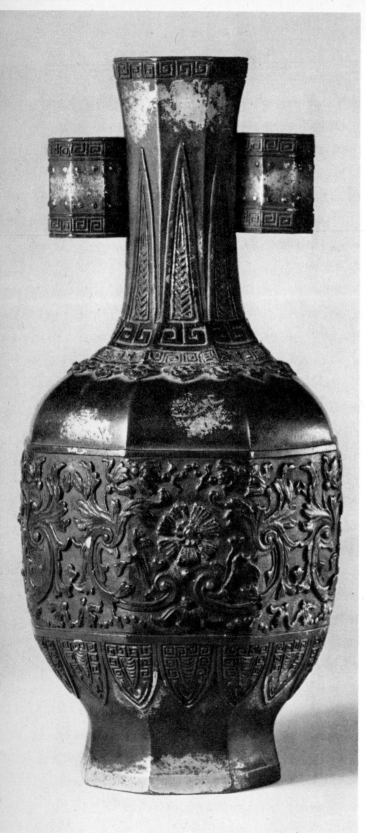

67. BRONZE VASE

Ch'ing dynasty. Ch'ien Lung period (1736–95). Height 17 cm.
Jenyns Collection, Bottisham Cambridgeshire

The dark bronze surface is variegated with splashes of gold
in the manner found in ornamental bronzes from the early
15th century onwards. The vertical tubular lugs at the neck
and the blade-shaped units of ornament on the neck and
near the foot, echo features of ritual vessels of the Shang
and Chou dynasties in ancient time. The decoration on the
belly of the vase is less traditional in flavour, and betrays an
influence of European art.

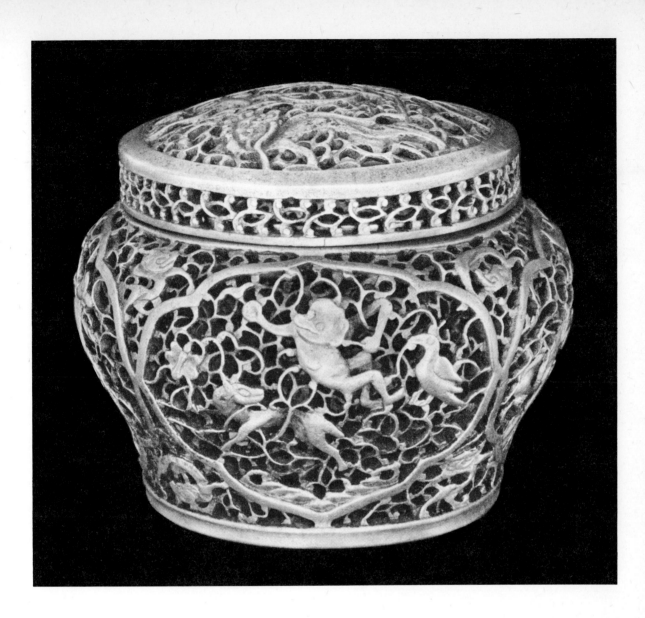

68. JAR OF PIERCED IRON

Late Ming or early Ch'ing dynasty. 16th–17th century. Height 13 cm. British Museum, London

The shape of this jar suggests a date for it towards the end of the Ming period. The sides and lid are entirely covered with openwork ornament rendered by drilling, chiselling and filing, the vessel having been cast with solid sides about 5 mm. thick. The monkey, bird, deer and butterfly in the facing panel appear against a ground of vegetable tracery in which the effect of intertwining is obtained by chiselling the surface to varying levels. Such *kuei jung* ("devil's work") in iron is comparatively rare. For artistic purposes iron was mostly forged, and used to represent floral sprays or landscape in the style of ink painting.

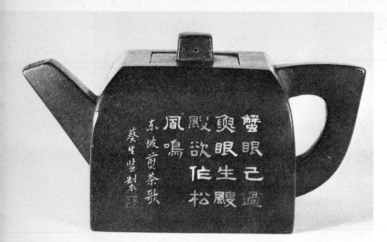

69. PEWTER TEAPOT IN THE I HSING STYLE

Late Ming or early Ch'ing dynasty. 17th century. Height 9 cm. Formerly collection Mrs. Walter Sedgwick, London

The teapot reproduces one of the shapes popularized by the potters of I Hsing on the Great Lake in Kiangsu Province. The maker, according to the signature, was K'uei Sheng-(?chao). The two verses of the inscription are taken from the "Song of Tea-making" by the 11th century poet, Su Tung-p'o: "The crab's-eye bubbles are past, and the fish-eye bubbles come up. Presently it will sound like the wind in pines". The allusion is, of course, to the boiling of water for tea-making, the very bubbles having their conventional names.

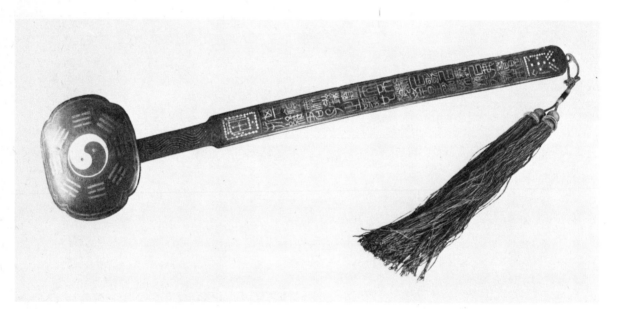

70. IRON *JU-I* WITH GOLD AND SILVER INLAY

Ming dynasty. Made by Chang Ao-ch'un. Dated to 1622. Length 48 cm. Formerly collection Mrs. Walter Sedgwick, London

The *ju-i* sceptre, with its ancient and auspicious associations (see plate 19), was often curiously worked as a gift for persons of age and rank. This specimen is decorated with "false" inlay of gold and silver, the precious metal adhering merely to the finely roughened surface of the iron instead of being inserted in depressions. The *t'ai chi* symbol of primeval chaos separating into the dual principles of *yin* and *yang*,

which occupies the centre of the head, and the constellations represented by dots at either end of the inscription, are inlaid with gold; the rest with silver. Around the *t'ai chi* are the trigrams of ancient divination. The inscription reads: "Its hook has no barb; it is upright without giving injury. With it sing and dance, if it disapproves it will break", the first part alluding to an ancient Confucian description of the superior man. The inscription is said to be supplied by Chao Nan-hsing, a notably honest and outspoken Grand Censor at the beginning of the 17th century, and the sceptre is to be "held and used" by one Sun Shen-hsing. It was made in 1622 by Chang Ao-ch'un.

71. GILDED BRONZE ALTAR OF ŚAMVARA

Ch'ing dynasty. 18th century. Height 28 cm. British Museum, London

Śamvara, a divinity worshipped in Lamaistic Buddhism as a protector against lapse into lower forms of life in the course of rebirth, is shown united with his Śaktī, his female energy.

Musicians and bearers of offerings stand around them. On the pillar of the altar is a ring carrying the Eight Precious Symbols. When the ring is moved upwards the petals of the lotus open to reveal the images. This piece is an outstanding example of the work executed at Peking for the Tibetan lamasery established in the K'ang Hsi period.

72. CHRYSANTHEMUMS IN IRON OPENWORK

Ch'ing dynasty. 18th century. Height 45 cm. British Museum, London

This "iron painting" is one of a set of four representing the seasons by the appropriate flowers and plants. The art of im-itating ink painting in forged iron is one of comparatively recent origin. It flourished in the late 17th century, when T'ang T'ien-ch'ih, in iron worker, set the example by vying with the painter Hsiao Yün-ts'ung in depicting landscape. In this composition the flowers and grasses are shown growing among strangely shaped rocks.

CHAPTER IV:
CLOISONNÉ AND CHAMPLEVÉ ENAMELS ON COPPER

CHINESE enamels can be divided according to their technique of manufacture into three classes: a) Champlevé enamels, b) Cloisonné enamels, and c) Painted enamels. It is with the first two categories that this chapter is concerned. The Chinese make no distinction between champlevé and cloisonné enamels, although they practised both techniques. In champlevé enamelling the cells or *cloisons* destined to hold the enamels are either cast in the metal, gouged out by chisels, or produced by a combination of both these methods. The enamels are embedded in the metal body and not encrusted on the surface. Cloisonné enamels, on the other hand, were made by soldering onto a metal foundation narrow, pliable bands of copper, silver, gold or softer metals, so as to parcel out the design into cells. Into this metal trellis-work the enamel pastes were inserted, and then subjected to a fire strong enough to fuse and melt the enamel paste, without destroying the metal-work which held the cells together. The finished effect of the cloisonné technique may in some pieces be almost indistinguishable from the cast or chiselled work of champlevé. The fundamental distinction between the two techniques was the use of solder in cloisonné to attach the wires to the base. Most solders used on bronze in the ancient world were soft solders having a lead base which melts at temperatures well below the temperature required to fuse the glass mixture constituting the enamels. In such circumstances the adoption of the cloisonné technique is clearly impossible. Looked at from this angle it is not surprising that the practice of encrusting jewellery with semi-precious stones, amber and other inlays, known in Egypt since the Old Kingdom and in Mesopotamia almost as early, did not lead directly to cloisonné enamelling.

The place of origin and date of the earliest enamels are still unknown, but it is probable that in the West the cloisonné technique anticipated that of the champlevé by many centuries. The technique of cloisonné enamels according to Garner[1] was invented somewhere around the 13th century B.C., probably in Mycenaean Greece, and a number of these pieces have been excavated in the present century from tombs in Crete and Cyprus. The possibility that this technique was introduced into Mycenaean Greece from Asia cannot be ruled out.

There followed a long interval, until Greek gold jewellery decorated with minute quantities of blue and white enamel was made in the 6th century B.C., followed by the enamel style adopted in South Russia in the 2nd century B.C., from which sprang the mediaeval enamels of Germany and France. "The next most important development in enamels has been attributed to the Byzantines and certainly culminated in fine and delicate miniature Byzantine cloisonné enamel on gold of the 10th and 11th centuries, which is preserved in Cathedrals such as St. Mark's, Venice."[2] By the 5th century A.D. Byzantium was undoubtedly the nursery of cloisonné enamelling, which reached its apogee at Constantinople in the 10th and 11th centuries – but comparatively few of these pieces have survived.

Apart from the much-discussed ewer preserved in the monastery of St. Maurice d'Agaune, the first evidence of Asiatic enamels lies in the existence of the copper cloisonné dish with Persian and Arabic inscriptions, which contains a dedication to an Ortokid prince who reigned at Hisn-Kaifa (1114–1144)[3]. This world-famous piece is in the Ferdinandeum at Innsbruck. The technique and design of this dish bear an obvious relationship to early Ming examples. It was probably made on the Upper Tigris for the Ortokid sovereign Da'ud ibn Sukman by non-Moslem craftsmen, possibly Armenian. It seems an unnecessary complication to speak of a provenance outside this area. Unfortunately this piece is unique, for very little metal-work from this region has survived, although it is rich in copper. The immense importance of this dish to a student of Chinese enamels is that the technique is very close indeed to those of the earliest Chinese cloisonné enamels known to us, of which it is the direct ancestor, although the Chinese do not claim to have made enamels until some two hundred years later, towards the close of the 14th century. Enamels continued to be made at Constantinople until the city was conquered by the Turks under Mohammed II in 1453, releasing a flood of Greek refugees carrying their knowledge with them. The earliest marked piece of Chinese cloisonné enamel is reputed to carry the mark of Chih Yüan (1335–1341), a hundred years before this catastrophe.

It is most mysterious why the Chinese took so long to master the enamel technique. Already by the 5th century B.C. they had the materials and the technical knowledge which could have been used for the manufacture of champlevé and cloisonné, but they did not, according to the *Ko ku yao lun*, take the next step and fire glass *in situ* to form enamels until towards the close of the Yüan dynasty (1279–1368). Yet before the Han period the Chinese knew how to make and handle glass and used it together with turquoise and gold and silver to inlay bronzes in the champlevé manner. The earliest champlevé enamelling in the West would appear to be a class of belt-buckles found in the Kuban culture of the Caucasus, which on the most conservative estimate is pre-Scythian (i.e. before the 7th century B.C.) and may be several centuries earlier. Enamel was not the only inlay applied to metal in the champlevé manner in the Caucasus; amber and other stones were also used. Probably it was the difficulty of fusing glass into soft-soldered cells that led to the wide adoption of the champlevé technique in this area.

This Caucasian tradition of enamelling seems to have been bequeathed to the goldsmiths of the Greek colonies in the Crimea, where again, through an ill-defined period embracing the 4th–2nd centuries B.C., gold jewellery of superb delicacy was enhanced by enamels laid in hollows formed in the thin gold plate, or outlined by filigree. But the enamel industry which spread its products, and the knowledge of its technique, throughout the ancient world of the West was of later date, and quite possibly represents an independent invention of the craft. This is the enamel-work of ancient Gaul, exemplified by the work done at Mont Beuvray (Bibracte), Saone et Loire. This may have been an offshoot of a tradition of working in glass transplanted from Syria. For the manufacture of enamels presupposes a knowledge of the fusing of coloured glass which composed the enamel, hence the art is associated with, and dependent on, the invention of glass, wherever it appears. In the Mont Beuvray excavations fragments of glass *millefiori* were found, and enamelled pieces incorporating this type of inlay are known.

From North Gaul, with the invasions of the Belgae from about 75 B.C. onwards, the art of enamelling passed into pre-Roman Britain, where champlevé enamelling in a variety of combined colours reached the heights of barbaric splendour. The most refined designs in this early champlevé are found in four generically similar bronze bowls decorated with vegetable and geometric patterns of metal reserved against various coloured enamels, of which one specimen at least has been dated by associated coins to the 3rd century A.D. These bowls, judging by their distribution, are likely to have been produced in the Western Roman Empire and probably in North Gaul. It should be noted in connexion with the problem presented by the migration of the enamelling technique, that small enamelled brooches, produced principally in Gaul, were an important commodity of Roman commerce in the 2nd and 3rd centuries A.D. There is no evidence, however, that these specimens ever reached the Far East, which was supplied by the products of the Syrian glass industry. Philostratus, writing in Rome about 200 A.D. of barbarian enamel horse-trappings, says: "They say that the barbarians who dwell in Ocean pour colours on heated bronze and that they adhere and become as hard as stone and preserve the designs made on them." From this period onwards cloisonné and champlevé enamels exist side by side, and often in combination. In the 12th century champlevé enamels were still in general use in the West for the decoration of ecclesiastical metalwork.

In China the two techniques were used singly or together, or combined with repoussé, as in the 18th century. In the last technique the cells are hammered out of the metal sheet and stand out in relief. In the Ming period repoussé work may be observed in some details of vessels otherwise executed by cloisonné technique, but by Ch'ien Lung times it was often used as a principal device in enamelling.

The Chinese never claimed the independent invention of the art of cloisonné enamelling, and ascribe its introduction to China from the West to Mohammedan intermediaries at the end of the Yüan period in the 14th century. It was not until the end of the reign of the last emperor of the Yüan dynasty, who reigned under two *nien hao*, Chih Yüan and Chih Chêng, that the existence of Chinese cloisonné was recorded in Chinese texts. The foot of a broken piece of cloisonné engraved with the four character mark of Chih Yüan (1330–1341) is said by Bushell to have been once exhibited at a meeting of the Peking Oriental Society[4]. The existence of another piece with a Chih Chêng mark (1340–1367) was discussed on the same occasion, while de Morant says he saw a piece with this mark in the collection of a Chinese viceroy[5]. But up to date no piece of Chinese cloisonné with a Yüan mark is in any collection known to the writer.

This Chinese tradition of a Yüan origin has, however, been questioned by some Japanese authorities, who have put forward at least two pieces of Chinese enamels in Japan as of T'ang date. The most important of these is the famous mirror (plate 85) in the Shōsō-in, and the other a champlevé stand for a Buddha figure, both of which have been published by Umehara as T'ang[6].

The usual Chinese terms for cloisonné are *fa lan* or *fa lang*, probably a corruption of the Chinese name for Byzantium, but it was also called *ta shih yao*, or Arabian ware, or *ching t'ai lan*, because the reign of Ching T'ai (1450–1457) was supposed to be the classical period of its production. The account of the *Ko ku yao lun*, written early in the Ming dynasty, says that cloisonné was introduced into China from

107

Ta Shih (Arabia) and *Folang* (Byzantium) and there is no doubt that the technique was a foreign introduction; for the Chinese called it the ware of the devils' country (*kuei kuo yao*). The fact that this craft appears in Chinese texts under two distinct names a) *fa lang* (Byzantine or Frankish enamel), and b) *ta shih yao* (Arabian ware) led me to suggest that it might have been independently introduced into the North of China under the first name by land, and then to the South under the second name by sea,[7] and perhaps at an even earlier date. The possibilities that the technique might have been introduced by a European prisoner or refugee at the Mongol court in Karakorum, like Guillaume Buchier, has been discussed by many writers. Ferguson even went so far as to suggest that *fa lan*, an alternative form of *fa lang*, was a corruption of Guillaume, the Christian name of this goldsmith[8]. Buchier came from Paris, and is described by William Rubruck as a slave in the service of the Great Khan. It is possible that Buchier had some knowledge of European enamels as practised by goldsmiths, but Garner points out that there is no mention of enamel-work among the pieces made by Buchier which are described by Rubruck[9]. He believes that enamelling on copper was the craft of the coppersmith rather than the goldsmith because "all the evidence we have, including that of the *Ko ku yao lun*, supports the view that the first enamels to be made in China were on copper wire and not on gold and silver. We can be fairly certain that Buchier had no part in the introduction of enamels to China".[10] But the truth is that we have no literary evidence other than this brief passage in the *Ko ku yao lun*.

The *Ko ku yao lun* (Discussion of the principal criteria of antiquities) was written by Tsao Ch'ao and first published in 1387, less than twenty years after the fall of the Yüan dynasty. The first edition had only three chapters as compared with thirteen in the second, which indicated in the margin where new material had been added, but as far as the section on enamels is concerned, the two versions are identical except for an added sentence in the second edition. This section is headed *Ta-shih yao* (Arabian ware) and the full account, which is very short, reads in the first edition, as cited by Garner:

"The body of the piece is made of copper, decorated with designs in colours made of various materials fused together. It resembles the inlay work of *Fo-lang*. We have seen urns for burning incense, vases for flowers, round boxes with covers, wine-cups and the like, but they are only fit for use in the ladies' apartments, being too gaudy for the libraries of scholars of simple tastes. It is also called the ware of the devils' country (*kuei kuo yao*). In the present day a number of natives of the province of Yunnan have established factories in the capital (Peking) where the wine-cups were made which are commonly known as 'inlay work of the devils' country'. This translation agrees very closely with that of Bushell, but his last sentence, from the second edition, reads 'The similar enamels made now at Yunnan-fu are fine, lustrous and beautifully finished'[11]."

The implication in Bushell's version that enamels were being made in Yunnan in the 15th century, when the second edition of the *Ko ku yao lun* was published, is not therefore substantiated.

We do not know where the early Chinese cloisonné enamel was made. Towards the close of the 17th century its manufacture is mentioned as a task of one of the twenty-seven factories established in the palace by the Emperor K'ang Hsi in 1680. Most enamel of this kind now in western collections has come from Peking, or its neighbourhood. It has not been suggested – as is the case with painted enamels – that there may have been distinct schools in north and south. Cloisonné may have been made by

itinerant craftsmen who visited many parts of China. Enamellers, unlike potters, do not require a static kiln, and could easily travel about.

All of this leads back to the discussion of the controversial enamelled mirror in the Shōsō-in, which Japanese authorities unanimously hold to be Chinese of the T'ang period (plate 85). It was published as T'ang by the great German scholar, Kümmel, in *Das Kunstgewerbe in Japan*, as early as 1908, and as late as 1960 by Miss Blair[12]. This mirror is of silver in the form of a twelve-pointed lotus flower, with gold wires enclosing translucent green and yellow enamels with gilded interstices between the points. It has been rumoured that there is no record of the presence of this mirror in the Shōsō-in in early times and that it is not listed in the ancient inventory, and its air of technical sophistication – as regards the metal part – is not of a kind we associate with T'ang metalwork. On the other hand, the concave surfaces of the enamel in each compartment, which leave the gold *cloisons* standing a little proud, appear to argue an incomplete mastery of enamelling technique. These contradictory characteristics have prompted doubts in the West about the T'ang date accepted by the Japanese authorities. Garner goes farthest in scepticism, averring it to be not older than the 17th century and probably made in Japan by the Hirata family, supporting his opinion by two technical arguments: 1) the fact that the thirty-one separate parts of the cell structure are not soldered to the silver base, leaving us to suppose that they were held in place during manufacture by a lacquer glue – a method not observed in Chinese cloisonné before the second half of the 17th century, and 2) that the evenness of the wires suggests that they were made by drawing through a die, a technique not attested for the T'ang period.

The second criticism, though powerful, is not conclusive. There is no doubt that silver mirrors were made in T'ang times, and that some of them were gilded or covered with gold foil. The petalled shape of the Shōsō-in mirror can be approximately paralleled elsewhere in T'ang art, and even if it cannot be exactly matched, this is no reason to reject a T'ang date. Basil Gray, who has handled the mirror, believes it to belong to the Momoyama period (1568–1615), when enamel was executed on silver, though as far as we know only for such things as clasps, beads, recessed handles of sliding doors and sword furniture. There are of course a number of other mirrors in the Shōsō-in decorated with designs of mother of pearl embedded in lacquer and of T'ang date. Several of these were at one time stolen, and were recovered in a badly broken condition. Could the enamelled mirror have crept in at that date as a replacement for a theft?

An even earlier date is claimed by Umehara for the coffin handle from the Kengyushi tomb in Nara prefecture. He infers, on archaeological grounds, that it belongs to the Asuka period (551–710). The handle is in the shape of a six-petalled flower outlined by bronze walls that were originally gold-plated. It has suffered from burial, and it is difficult to say whether the central flower, which is in yellow enamel on a whitish enamel ground, is champlevé or cloisonné. Miss Blair holds that the enamel was "formed by molten glass dropped from a glass rod heated in the flame"! If you allow this piece to be cloisonné and accept an Asuka date for the tomb from which it was excavated, it follows that the Japanese, if they made the piece, had mastered the art of enamelling before the T'ang period.

Brinkley suggests that the introduction of enamels into Japan may have come from Korea, and that

the technique of cloisonné enamel was well understood by the Koreans in the 16th century, if not earlier, adding what I believe to be true, that until the 19th century enamels were employed by the Japanese as decoration for accessory purposes only. Could the Shōsō-in mirror be Korean of the T'ang period? It is still accepted as of T'ang date by Professor Umehara and the Shōsō-in authorities in Japan and by Miss Blair in America, while in England W. W. Winkworth, who has spent a lifetime in handling Chinese objects, still believes in its T'ang date. Writing in 1950 the author suggested that this mirror might be either 1) of T'ang date, made by an Islamic craftsman, or a Chinese pupil in Canton, or 2) of Yüan date, made by one of the foreign artisans or his Chinese assistants working under the Khans in Karakorum, but this would necessitate its having been introduced into the Shōsō-in a long time after the original deposition was made in 756[13]. To this should be added that a Korean origin is another possibility.

The studies of Sir Percival David have shown that a number of objects were deposited in the southern section of the Shōsō-in at dates ranging between 818–1413, but with the single exception of a mirror, not described, which was found under the floor of the Sugimoto shrine and deposited in the Shōsō-in in 1902 (presumably not our mirror, at least no one has claimed that it is), there is no evidence that anything was deposited in the shrine after 1413. Today this enamel mirror has been handled and studied, and it is to be hoped that the irreverent criticisms of its date in the West will prompt Japanese scholars to investigate the matter more thoroughly.

Cloisonné enamels were usually done in a muffle-kiln, but pieces were, according to Bushell, often fired in an open courtyard over a charcoal fire on a primitive iron grill. Second firings were necessary to fill up the cells and remove irregularities. Early pieces tend to show flaws due to imperfect firings; traces of solder, want of polish on the surface and a tendency to pitting in the enamels. These defects were remedied in the 18th century by repeated firings and polishings with pumice-stone until a smooth and lustrous surface was obtained. Heavy gilding of the lip and foot, and of the narrow bands which separate the *cloisons*, was particularly favoured in this century.

It is significant that, with the exception of the Yüan pieces referred to by Bushell and de Morant, it is not until the reign of Hsüan Tê of the Ming dynasty (1426–1435) that the first marked Ming pieces of cloisonné make their appearance. The Ming interest in cloisonné enamelling thus almost coincides with the introduction of decoration executed in coloured vitrifiable enamels on stoneware and porcelain. These enamels are essentially similar to those used on metal. In the Chinese mind they were so closely associated that it is only in books dealing with ceramics that we find any description of enamels. Both are classed under the heading *yao*, which means fired in a kiln.

The so-called three-colour stoneware and porcelain wine-jars of the 15th century decorated with ornamental outlines in raised strips of clay which contain violet, turquoise, white, yellow and aubergine glazes on a dark blue ground, represent one of the earliest forms of coloured vitreous enamels on porcelain known. They are made entirely in the cloisonné technique, and the polychrome colours are placed under the same restraint as the cloisonné metal pieces. In fact the very forms are duplicated. Cloisonné *potiches* with raised outlines to the design, like those on plate 78, are without question linked

with the *san ts'ai* porcelains and pottery, of which they were the ancestors. The only porcelain members of this group have the Cheng Tê *nien hao*, but this comes at the fag-end of a long tradition[14]. Hobson wrote:

"There is little doubt that the barrel-shaped garden seats described in the *Ko ku yao lun* as a novelty of the Hsüan Tê period belong to this class of ware."

He even accepts the famous blue vase from the Raphael collection, with the Hung Wu mark (1368–1398), in the Fitzwilliam Museum, Cambridge, as belonging to this group, to which he also attributes a vase with a design of flowers in raised cloisonné style on a purple ground, dating it to about 1500. If this *san ts'ai* group of porcelains is ever assessed afresh as of earlier date (and this is still quite possible), then this group of cloisonné pieces with deep violet backgrounds might emerge as the earliest members of the Chinese cloisonné family.

It is understandable that cloisonné enamels should have appealed to the Mongols – those barbarians of the steppe, who revelled in gay and garish colours, and filled their temples, when they became converted to Buddhism, with gilded and jewelled images; and it is understandable that they should have continued to be popular in the Ming dynasty, for the Ming love of colour is reflected in the brilliance of its enamelled porcelain. The taste for cloisonné was natural again to the Manchus, another barbarian people from the steppe who replaced the Mings. From the number of cloisonné incense bowls and pricket candlesticks which have survived, it is evident that cloisonné work was favoured by Buddhist temples, and in particular by Lamaism. Chinese pieces appear to be much prized in Tibet, where they were copied, and it is probable that whoever is to investigate the treasures of the Potala will make some interesting discoveries. There must also have been many pieces presented by the Chinese Court to the Lama temples of Inner and Outer Mongolia.

Among the two or three pieces of Chinese enamels catalogued in this country as belonging to the Yüan period were two champlevé specimens exhibited at the Burlington Club in 1915. One of these was an incense burner in the form of a mandarin duck, enamelled in various colours on copper-gilt. The other is the figure of a deer, in purplish-grey enamel with gilt horns, which was once in the Eumorfopoulos collections and is now in the British Museum (plate 98). No particular reason seems to exist for these attributions, but both pieces must be of Ming date.

No piece of cloisonné or champlevé enamel has yet been identified as belonging to the first four reigns of the Ming dynasty. Quite a number of pieces have survived, however, with the *nien hao* of the fifth Ming Emperor, Hsüan Tê (1426–1435), of which three marked pieces have been accepted by Garner as belonging to the period (plate 86).

The enamels of the next reign but one, that of Ching T'ai (1450–1457), were so celebrated that this *nien hao* became a name in China for all Chinese cloisonné. Quite a number of pieces with the Ching T'ai mark have survived, but the great majority of these pieces belong to the Ch'ien Lung period, when the mark was freely used. Others may perhaps be attributed to the Ming dynasty.

The whole subject of marks on Chinese cloisonné is a fascinating one, as few of them can be accepted at their face value. The marks can either be cast, incised or incorporated in the enamel itself, but it is a

comparatively easy matter to add additional bases with marks to pieces of cloisonné. One of Garner's discoveries is that a large number of cloisonné pieces of Ming date have had new bases imposed upon them (plate 73) which in many instances bear the Ching T'ai mark. But do we know that in making cloisonné pieces the Chinese did not, in some cases, put in the bottom separately?

Marks incorporated in the enamel itself, unless they are those of Ching T'ai pieces, must be acceptable. This is true of a disc and a box with the reign mark of Hsüan Tê and of the magnificent *potiche* with the same mark in the British Museum. These marks must be accepted as of their periods. No objection has ever been raised to Wan Li marks of this kind.

It is surprising that cloisonné pieces carrying the reign marks of the Middle Ming emperors are so rare, and in some cases quite lacking. At the time of writing the known *nien hao* on Ming cloisonné are limited to the reigns of Ching T'ai, Hsüan Tê, Chia Ching and Wan Li, and no pieces with the marks of Ch'êng Hua, Hung Chih, Chêng Tê, Lung Ching and Yung Lo are known to us. But the same kind of position, with certain differences, appears in the field of Chinese lacquer.

It is to the colour of the enamels that we look for assistance in distinguishing the early pieces. Two shades of striking blue (one a turquoise and the other a lapis lazuli blue), a dark coral red inclining to brown, a yellow, a yellowish and a deep green, a black and a white, are the more usual colours of the early palette. As in porcelain, the *famille rose* colours do not appear till the end of the reign of K'ang Hsi. The early pieces are robust in shape, naturalistic in design and sombre in colour. They tend to be porcelain shapes rather than metal ones. For, although the bronze Buddhist forms with geometrical patterns appear in the reigns of Hsüan Tê and Ching T'ai, they do not achieve the elaboration and preponderance which they do in the 18th century. The bottoms and lips of many of the early pieces have been reinforced, regilded and sometimes dated or redated at a later period. Handles too were sometimes added in the Ch'ing period to damaged Ming pieces. Garner sums up his technical findings as follows:

"In the earlier work solder was always used. Indeed the earliest pieces suffer from an excess of solder, which often creeps up round the wires and fills in the sharp angles of the designs. It would seem also that the temperature of the enamelling in the earliest pieces was often as high as the melting point of solder, so that excess solder bubbles through the enamel, causing discolouration and sometimes even leaving globules of solder on the surface...

The alternative method of using an adhesive of vegetable origin that burns up in the heat of the enamelling process, leaving the wires to be held in place by the enamel, seems to have been introduced into China sometime during the late seventeenth or early eighteenth century."[15]

The roughness of the early Ming pieces is, in part, owing to the *cloisons* being imperfectly filled. The *cloisons* themselves are not always gilt and never, as in the Ch'ien Lung period, obtrude their glittering outlines. In the 18th century there is a decline in aesthetic quality of the enamels, and dull, formal designs are often repeated, like the infinitely extendible diaper patterns which were so popular in the Ch'ien Lung period. The parallel lines of the gilt tendrils of the Ch'ien Lung period are not difficult to detect.

The large vase with cover in the British Museum (plate 77) has two inscriptions, each in two lines; one of four, the other of six characters. In the first instance the characters are engraved in double lines

inside the rim of the lid on each side of the neck. The second pair of inscriptions, which are identical with the first, is set in champlevé on each side of the neck. The inscriptions read:

a) *Yu Yung Ch'ien tao* 'made for the Yu Yung Ch'ien' – one of the palace departments which was established in 1367 and run by eunuchs, whose responsibilities were of a supervisory nature. They had to see that a high standard of quality was maintained among the vessels made for the palace.

b) *Tai Ming Hsüan Tê nien chih* 'Made in the reign of Hsüan Tê of the Great Ming dynasty'. This piece is the most splendid surviving example of early Ming cloisonné.

Garner was the first person to observe that, with the exception of a small group of 18th century pieces, most of which were made on a gold base with gold wires, the whole remaining output of Chinese 18th century cloisonné makes use of copper wires, while the Ming pieces use brass wire. The change-over took place sometime in the 17th century. He also points out that among the cloisonné vases of the 15th and 16th centuries there can be found many examples of "split wires", which are absent on the 17th and 18th century pieces. This can be explained by the fact that the technique of drawing wire through dies arose in the 17th century. Garner's argument is that the Ching T'ai mark "was not used on cloisonné until a date long after the 15th century", possibly not until the mid-17th century. Why the undistinguished Ching T'ai period should be credited with such excellence in cloisonné work is not known. However, if one accepts the statement of the first edition of the *Ko ku yao lun*, published in 1387, as proof of the existence of Chinese cloisonné at that date, there is no inherent reason why cloisonné could not have been made in the Ching T'ai period (1450–1457). Before we dismiss so completely the mark of this reign on cloisonné I feel we should be in a position to explain how it obtained its extraordinary celebrity. At the same time it must be admitted that it is curious that there is no reference to the fame of the Ching T'ai enamels in the second edition of this work, which was actually published in the Ching T'ai reign. There is no doubt that the Ching T'ai mark was indiscriminately used on later pieces of Ming and also on Ch'ing pieces, but this does not prove that Ching T'ai pieces do not exist. Judgment must be suspended until the myth, if such it is, be explained.

If any piece may be allowed a Ching T'ai date the bottle belonging to Mrs. Sedgwick (plate 73) has considerable claims. Its shape recalls the onion-headed bronze vases, often attributed to the Yüan dynasty, and its colour pattern seems to be more subtle and quite different from any other piece in English collections. The only comparable pieces are the pair of lobed vases[16] in the Chinese Imperial collection, Taiwan (Garner, plate 46). These have a moulded mark let into the base. Garner places them in the early 17th century, or at the earliest, the second half of the 16th. The handles are detachable and the vases have collars of raised and gilded lappets. The decoration is of dragon arabesques in blue and yellow. The box decorated with parrots and peaches in the British Museum is, in my opinion, another 15th century piece. The ornament recalls the design on the famous Aso dish which has been published as of the Hsüan Tê period, and seems to have a very convincing mark[17]. This box is made of copper and the base and inside have never been gilded. It has a strange black and white and red enamel border to the base. The existence of the brown enamel is difficult to explain on an early piece, and for this reason Garner dates it to the 16th century.

When we reach the Ch'ing period there are not the same problems. Enamels of the K'ang Hsi reign still retain something of the Ming inspiration. In 1680 twenty-seven workshops were established inside the palace by the *Tso pan ch'u*, a department of the Imperial Household, which was charged with the duty of making and furnishing vessels for the use of the Emperor, and was under the control of the *Hsu-nei Fu*, the palace office of works. One of these was devoted to cloisonné enamels. From this period onwards the quest for technical perfection impairs aesthetic quality. The smooth finish, overpowering gilt *cloisons* and overcrowded designs ruin their looks, while their lustre is diminished by frequent firings, until the brilliant turquoise blue of the Ming period quite vanishes. Very few pieces of cloisonné enamel bear K'ang Hsi or Yung Chêng marks, although there must have been a considerable output in both these reigns. By the Ch'ien Lung period nearly all the finer pieces bear a Ch'ien Lung or Ching T'ai mark.

The output of cloisonné enamels by the Ch'ien Lung palace workshops can only be rivalled by their output of carved red lacquer; and the pieces which were brought back by the European armies from the sack of the Yüan Ming Yüan in 1860, and the expedition against the Boxer Rising in 1900, establish-ed a European taste for both these materials (plates 83, 99 and 100). As a result a big export trade in cloisonné sprang up with Europe in the early years of the 20th century. With the collapse of imperial patronage Chinese enamels have shed their expensive look without regaining the robust attractions of the earlier and more primitive pieces. It is the 15th century Ming cloisonné pieces which are likely to remain the chief monuments to the skill of the Chinese metalworker in this field.

R. SOAME JENYNS

[1] Sir Harry Garner, *Chinese and Japanese Cloisonné Enamels*, London 1962, p. 18.

[2] Garner, *op. cit.*, p. 21.

[3] Garner, *op. cit.*, pls. 6, 7.

[4] S. W. Bushell, *Chinese Art*, Vol. II, London 1906, p. 76.

[5] "Il m'a donné de voir une pièce portant la date Tche tscheng (1341–1367). Les couleurs étaient noir, rouge, brun, bleu foncé. Elle était en la possession du viceroi Chena Tsing-Ting. Les émaux de ce temps sont trop bons pour que l'on formule un juge-ment sur leur style." C. Soulié de Morant, *L'Histoire de l'Art Chinois*, p. 197.

[6] Garner, *op. cit.*, pls. 5a, 5b, 5c.

[7] Soame Jenyns, *The Problem of Chinese cloisonné enamels*. Oriental Ceramic Society Transactions, Vol. 25, 1949/50.

[8] J. C. Ferguson, *Survey of Chinese Art*, 1939, p. 127.

[9] W. Rockhill, *The Journey of Friar William of Rubruck to the Eastern parts of the world*, 1900.

[10] Garner, *op. cit.*, pp. 33–34.

[11] Garner, *op. cit.*, p. 32.

[12] Dorothy Blair, "The cloisonné backed mirror in the Shōsō-in", *Journal of Glass Studies*, Vol. II, 1960.

[13] Soame Jenyns, *op. cit.*, opposite pls. 7, 3.

[14] Hobson, Rackham and King, *Chinese Ceramics in private collections*, London 1931, fig. 125; R.L. Hobson, *Wares of the Ming Dynasty*, London 1923, col. pl. 4.

[15] Garner, *op. cit.*, p. 45.

[16] Garner, *op. cit.*, pl. 46.

[17] Kushi Takashi, *Mindai no Sometsuke to akae*, 1943, pl. 2.

73. CLOISONNÉ VASE

Ming dynasty. Early 15th century. Height 28 cm. Formerly collection Mrs. Walter Sedgwick, London

This vase has a pear-shaped body and narrow neck and is decorated with lotus scrolls on the body and fern fronds on the neck. It has a Ching T'ai mark incised on the base. This reign (1450–1457) was by tradition so famous for its cloisonné enamels that Bushell, writing in 1906, says "In the present day *Ching T'ai lan* is commonly used in Peking as a general synonym for cloisonné enamels". Garner, however, writing in 1962, believes that the Ching T'ai reign mark was not used on cloisonné till long after the 15th century! The earliest possible date for its use he says is the mid-seventeenth century. This mark, he thinks, came into use as a means of adding lustre to pieces already in existence, rather than as an addition to newly-made pieces. But he cannot explain why this otherwise rather undistinguished reign came to be chosen as a mark of commendation. In his opinion, the view that Ching T'ai's reign was the golden age of cloisonné is a complete myth; although once the reign became established as a mark to conjure with, it was used without discrimination on Ming cloisonné of every period. This may be true; but if one accepts the statement of the first edition of the *Ko ku yao lun*, published in 1387, as proof of the existence of Chinese cloisonné at that date, there is no inherent reason why cloisonné could not have been made in the Ching T'ai period (1450–57). Before we dismiss so completely the mark of this reign on cloisonné I feel we should be in a position to explain how it obtained its extraordinary celebrity. The base of this vase, on which the mark rests, is almost certainly a replacement inserted at a later date.

74. CLOISONNÉ BEAKER *(KU)*

First half of the 15th century. Height 21 cm. Garner Collection

This shape is an imitation of the archaic ritual bronze beaker *(ku)*. The beaker has gilt-bronze serrated fittings, and is decorated all over with lotus scrolls, except round the interior of the neck. It has a scroll border at the foot.

75. CLOISONNÉ INCENSE BURNER

First half of the 15th century. Width 14 cm. Garner Collection

Cloisonné incense burner *(ting)* with fitted cover, standing on three feet and with two side handles, inlaid in champlevé. The body is decorated with lotus below a fret border. There are lotus scrolls on the feet and the cover, which is surmounted by three gilt-bronze animals in relief, standing amid flower scrolls above a band of clouds.

76. CLOISONNÉ INCENSE BURNER

First half of the 15th century. Width 18 cm. Garner Collection

Cloisonné incense burner *(ting)* with fitted cover, standing on three feet and with two side handles inlaid with champlevé. The body is decorated with a lotus scroll between a narrow band of cloud scrolls separated by gilt-bronze bosses. There are lotus scrolls on the feet and cover, which is surmounted by a boss with a *yin-yang* symbol and formal borders.

Chinese bronzes have been described by the Chinese themselves as divided into those which were made before and after the introduction of Buddhism in A.D. 67. The incense burner form was introduced by Buddhism, for although earlier bronze vessels may have been called into existence for this purpose, they are in fact rice bowls, wine jars or sacrificial vessels. It is obvious from their shapes that many pieces of Chinese cloisonné were made for Buddhist or Lamaist temples.

77. CLOISONNÉ VASE AND COVER

Mark and period of Hsüan Tê (1426–1435). Height 63.5 cm. British Museum, London

This Imperial vase and cover is decorated with five-clawed dragons with open mouths pursuing pearls in a clouded sky. The collar is decorated with cloud scrolls, and the neck has a lappet band, while at the foot there is a band of horizontal leaves, with the ribs of each leaf outlined in gilt wire. The lid is decorated with a similar dragon in clouds, with a finial in the shape of a lotus pod enclosed in petals surrounded by a lappet band at the base.

The vase has two inscriptions, each in two lines; one of four, the other of six characters. In the first instance the characters are engraved in double lines inside the rim of the lid on each side of the neck. The second pair of inscriptions, which are identical with the first, are set in champlevé on each side of the neck. The inscriptions read:

(a) *Yu Yung Ch'ien tao* (made for the Yu Yung Ch'ien) – one of the Palace departments run by eunuchs, which was established in 1367. Their responsibilities were of a supervisory nature. The eunuchs had to see that a high standard of quality was maintained among vessels made for the Palace.

(b) *Tai Ming Hsüan Tê nien chih* (Made in the reign of Hsüan Tê of the Great Ming dynasty.)

This vase is probably the most important piece of cloisonné of the 15th century to have survived.

78. CLOISONNE JAR AND COVER, ONE OF A PAIR

Ming dynasty. 15th century. Height 41.5 cm. Jenyns Collection, Bottisham, Cambridgeshire

Cloisonné jar and cover decorated with peacocks, rocks and peonies with a cloud collar border above and petal borders round the base and shoulder. Cloud scrolls round the neck.

This vase, which has raised outlines to contain the design, is undoubtedly the ancestor of the *san ts'ai* porcelain group, which is decorated in the same manner, and often in the same colour schemes. If they are marked the porcelain members of this group bear a Chêng Tê *nien hao* (1506–1521), but these marked pieces come at the fag end of a long tradition. Garner accepts Hobson's dating for the family as about 1500. But if the *san ts'ai* group of porcelains is ever assessed afresh as being of earlier date (and this is still quite possible), then the small group of cloisonné pieces with deep violet

backgrounds might emerge as the earliest members of the Chinese cloisonné family. The porcelain and pottery copies of this shape have invariably lost their lids.

79. CLOISONNÉ BOX AND COVER

Probably late 15th century. Diameter 25.5 cm. British Museum, London.

Cloisonné box and cover, the lid of which is decorated with two parrots perched on a spray of fruiting peaches, surrounded by a lotus scroll border, which is repeated round the body of the box. The body of the box is copper, which has not been gilded.

Garner believes that this box has a close affinity to a group of cloisonné dishes decorated with fruit (plate 89). He says that the translucent brown enamel, used most effectively on the stems of the peach sprays, was never used in the 15th century and that the box probably dates to the early years of the 16th century. The design of peaches and parrots, however, is also reminiscent of the decoration of the famous Aso blue and white Hsüan Tê dish in Japan, which has a very convincing mark and appears to be of this period. Although the presence of the brown enamel on the box may be difficult to explain if it belongs to the early 15th century, the black, white and red enamel border to the base sets it apart from the other early 16th century pieces.

80. CLOISONNÉ *JARDINIÈRE* OR INCENSE BURNER

Probably 16th century. Length 52.5 cm. Musée des Arts Décoratifs, Paris

Cloisonné *jardinière* or incense burner with two gilt-bronze handles in the form of a lion standing on a lion's head and four feet of scroll design with three claws, decorated with figures in a landscape. *Ching T'ai* mark cast in the base.
We have already drawn attention to the unreliability of the *Ching T'ai* mark in the description of the bottle in plate 73. The decoration of this incense burner showing a landscape with figures is exceptional. Garner believes this incense burner, despite its marks, cannot be earlier than the second half of the 16th century, and may be later. A somewhat similar incense burner with the same kind of handle and claw feet, but with no scroll decoration and complete with a lid, was illustrated in *The Arts of the Ming dynasty,* plate 85, fig. 318. This piece had a Hsüan Tê mark, but was also probably late 16th century in date.

81. CLOISONNÉ EWER WITH LID

Ming dynasty. Middle 16th century. Height 32.5 cm. Garner Collection

Cloisonné pear-shaped ewer with a domed lid and with heart-shaped panels on each side, decorated with a *ch'i-lin* in a landscape, and each panel surrounded by flower scroll border. Flowers and cloud collar border on the lower neck, and fern fronds above.
This is very common in porcelain of the reign of Chia Ching (1522–1566), to which period this ewer probably belongs.

82. CLOISONNÉ MOON VASE

17th century. Height 21 cm. Garner Collection

Cloisonné moon vase, or pilgrim bottle, decorated on the one side with dianthus (pinks), and on the other with peonies sprouting from a rock. Onion-shaped neck decorated with lotus flowers among clouds above a leaf-shaped border. This is a particularly attractive piece, and the decoration of flowers and plants is freely drawn. Garner notes that the family generally has a turquoise blue background in an unusual greenish tinge.

83. IMPERIAL CLOISONNÉ ICE-BOX

Ch'ien Lung period. 1736–1796. Length 117 cm. Height 40 cm. Victoria and Albert Museum, London

This ice-box is in the form of a rectangular vessel supported by two kneeling figures in relief wearing shell-shaped hats; evidently representations of foreigners from the South. It is decorated with lotus scrolls. The box has a perforated cover surmounted by a lion in relief. It is one of a pair taken from the Summer Palace in Peking.
It was illustrated by Bushell in Volume II of his *Chinese Art,* published in 1906. In the 18th century there is a decline in the artistic quality of the enamels and dull, formal designs are often repeated, such as the infinitely extendible diaper pattern, which was so popular in the Ch'ien Lung period. The parallel lines of the gilt tendrils of the Ch'ien Lung period, of which this is a splendid example, are not hard to detect. The output of cloisonné enamels of the Ch'ien Lung palace workshop must have been prodigious. The pieces brought back from the sack of the Yüan Ming Yüan in 1860 established a European taste for this commodity.

84. CHAMPLEVÉ BULL

Ch'ien Lung period (1736–1796). Height 19.2 cm. Victoria and Albert Museum, London

Figure of flower-holder in the form of a standing bull decorated in champlevé enamels, with a mark set in champlevé reading *Ch'ien Lung fang Ku* (Ch'ien Lung, in imitation of the antique).
The two techniques, champlevé and cloisonné, were used either by themselves or in combination in the 18th century by the Chinese. Garner writes that there is no evidence that champlevé preceded cloisonné in China, or that it was ever used on an extensive scale before the 18th century. But there are champlevé birds and animals, like magpies and the deer (plates 97 and 98) which seem to date from the Ming period. The bull, which has some details in cloisonné, is a very fine example of Chinese 18th century champlevé, in which the enamelling cells, or *cloisons,* intended to hold the enamels are either cast on the metal or gouged out by chisels, or produced by a combination of both these methods. The enamels are embedded in the body, not, as in cloisonné, encrusted on the surface. The Chinese made no difference between the two techniques, but Chinese champlevé pieces are, at all periods, noticeably less common than cloisonné.

73

74

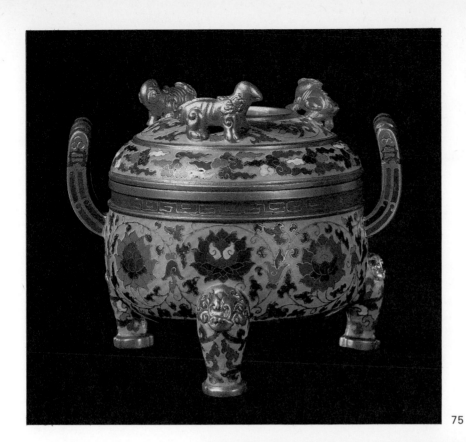

75

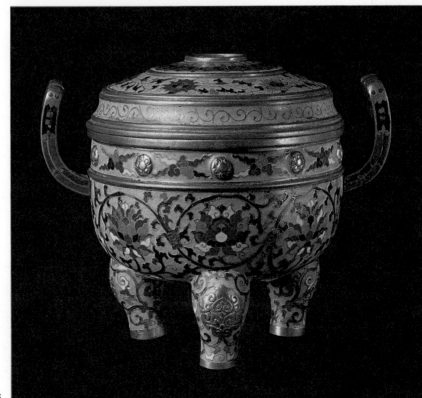

76

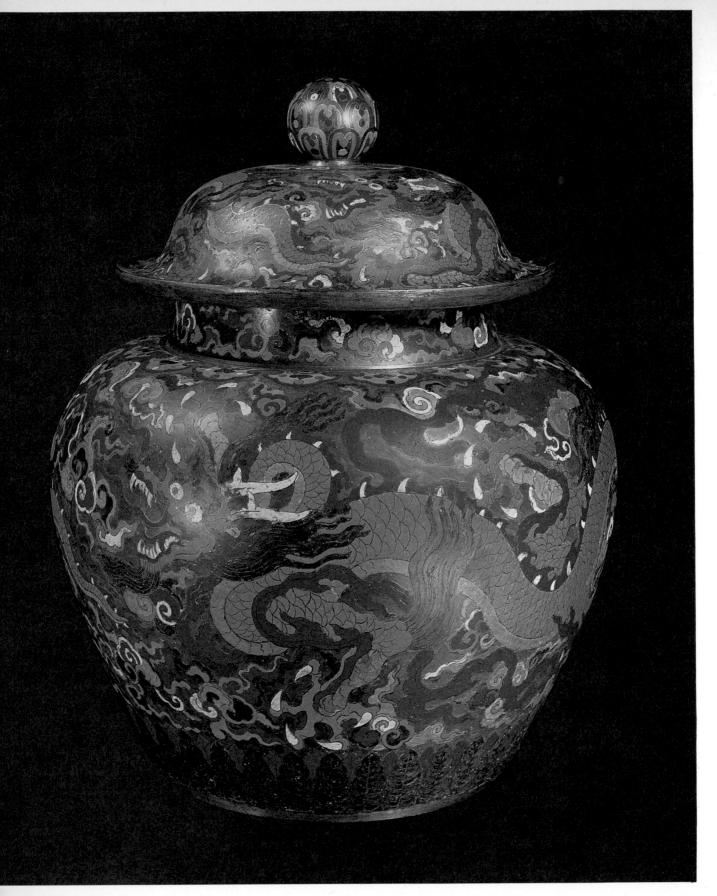

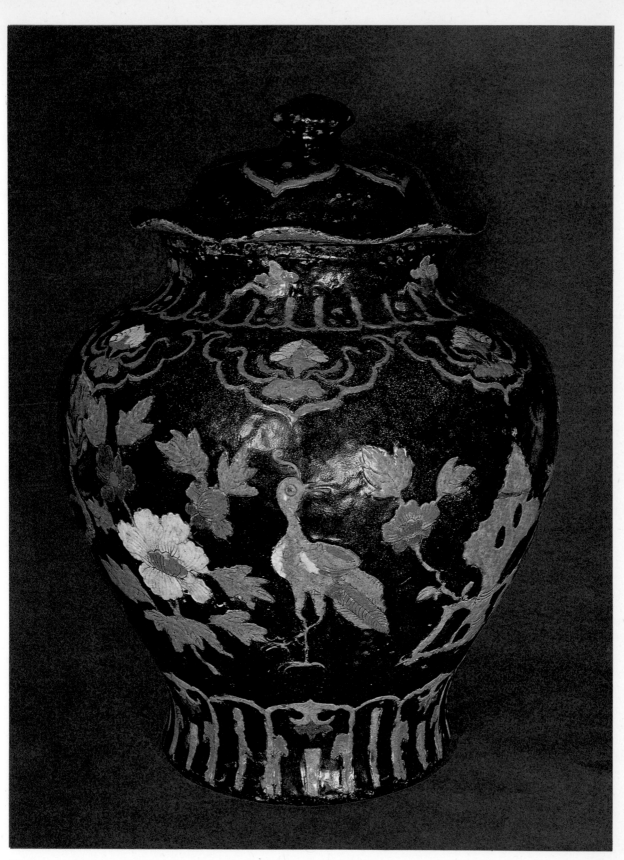

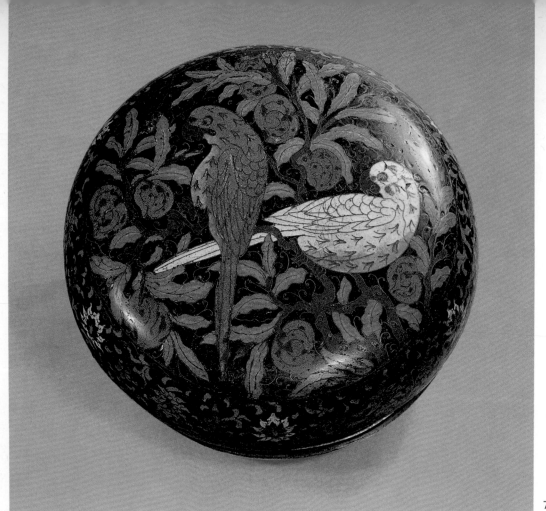

79

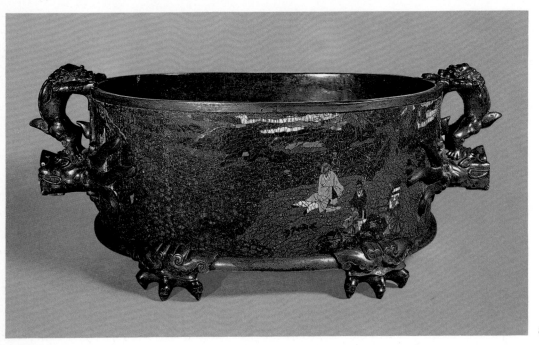

80

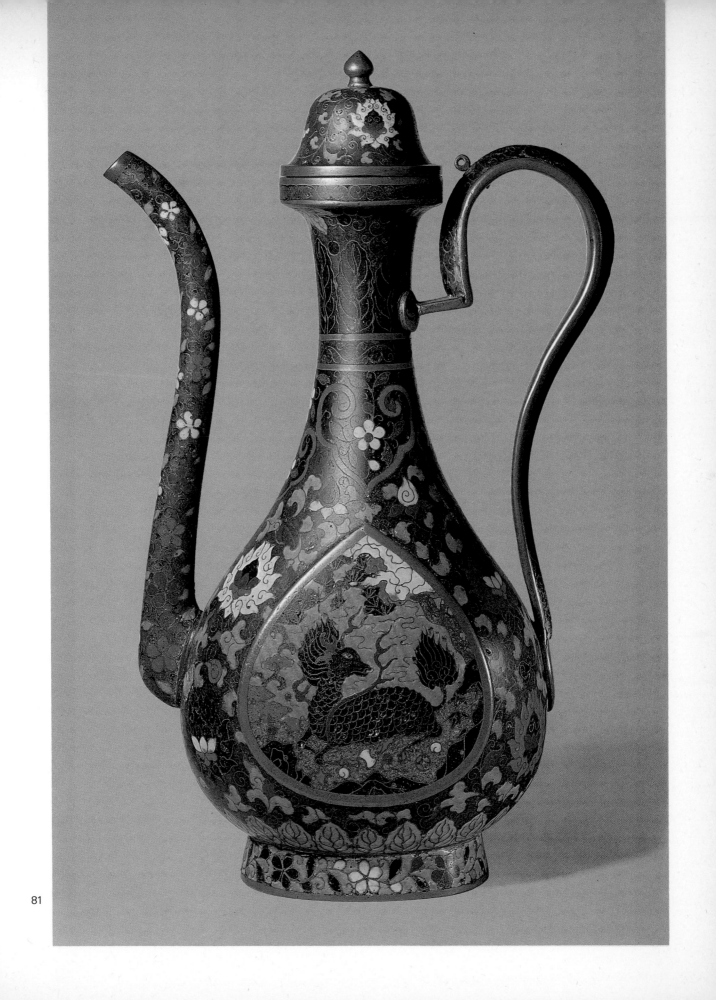

81

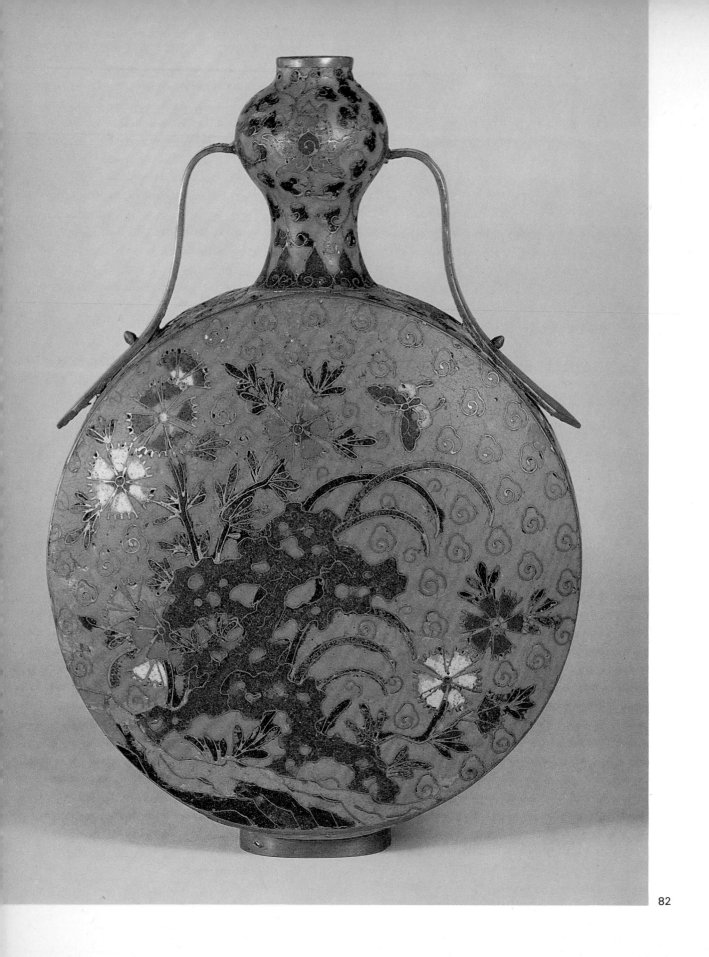

82

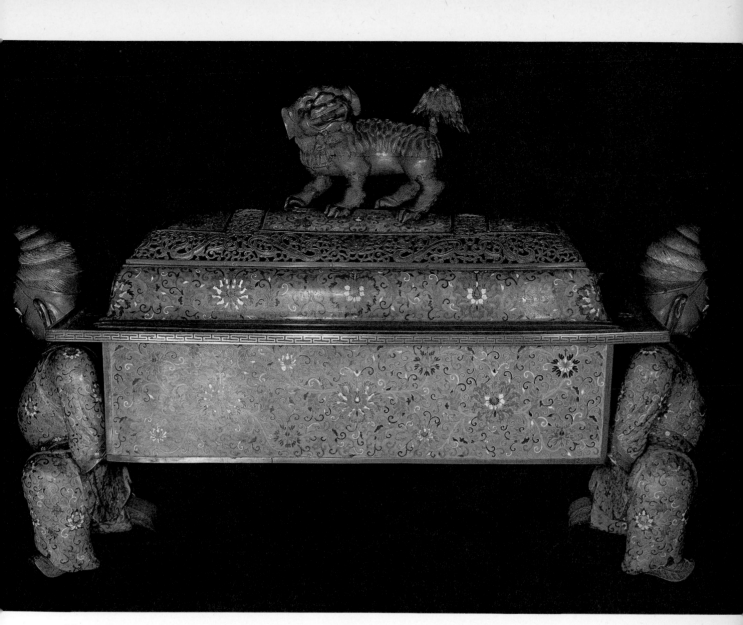

83

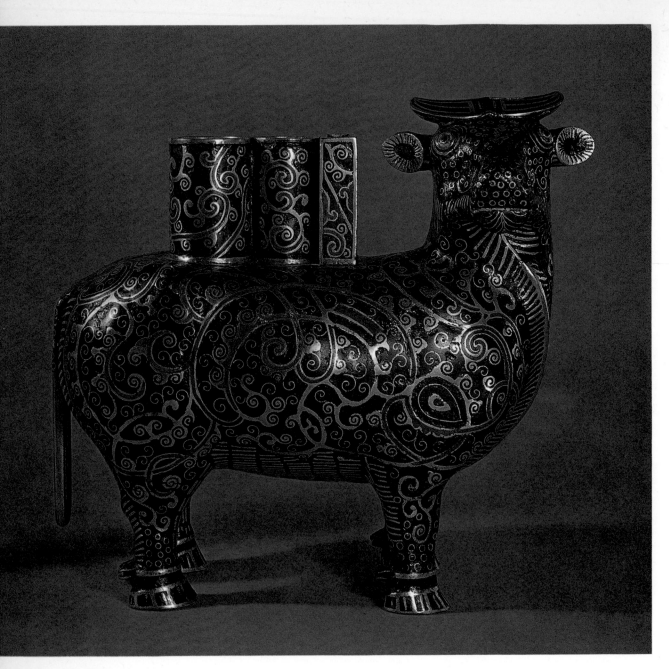

84

85. CLOISONNÉ MIRROR OF SILVER IN THE FORM OF A TWELVE-PETALLED FLOWER, WITH GOLD WIRES ENCLOSING TRANSLUCENT GREEN AND YELLOW ENAMELS, AND GOLD INTERSTICES BETWEEN THE POINTS

Probably T'ang dynasty: 8th century A.D. *Diameter 18.2 cm. Shōsō-in, Japan*

The doubts entertained by western scholars on the date of this piece are reviewed on page 000. They turn mostly on the apparent precocity of technical aspects of the manufacture. Japanese scholars adhere to their opinion that the mirror belongs to the original contents of the Shōsō-in repository, and so dates to the 8th century A.D. It is difficult to imagine the circumstances and motive which would have led to a latter-day reproduction of a T'ang design in which the enamelling is so markedly inferior to any subsequent standard.

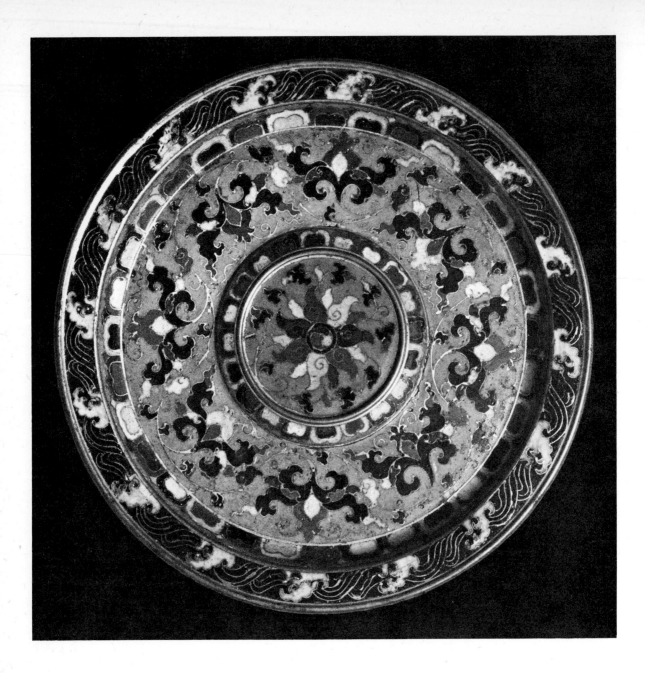

86. CLOISONNÉ CUP-STAND

*Mark and period of Hsüan Tê (1426–1435). Diameter 18.5 cm.
Garner Collection*

A cup-stand of cloisonné enamel in which the body is of cast
bronze, undecorated beneath, with the central raised plat-
form made separately and riveted on after the enamels had
been applied. Such dishes with raised centres are called cup-
stands and are a fairly common form of the 14th and 15th
centuries. No contemporary cup, either of cloisonné or

porcelain, is known, and, as Garner says, it is rather surpris-
ing because the rather earlier celadon cup-stands are often
seen with contemporary cups. "It has been suggested", says
Garner, "that the cups used with Chinese porcelain or cloi-
sonné cup-stands were made of gold or silver and have not
survived. But it must be pointed out that there are two refer-
ences in the *Ko ku yao lun* of 1387, to wine cups made of
cloisonné." This piece bears the mark of Hsüan Tê incised
on the base, and filled in with blue enamel. It is one of the
few marked pieces of the period.

128

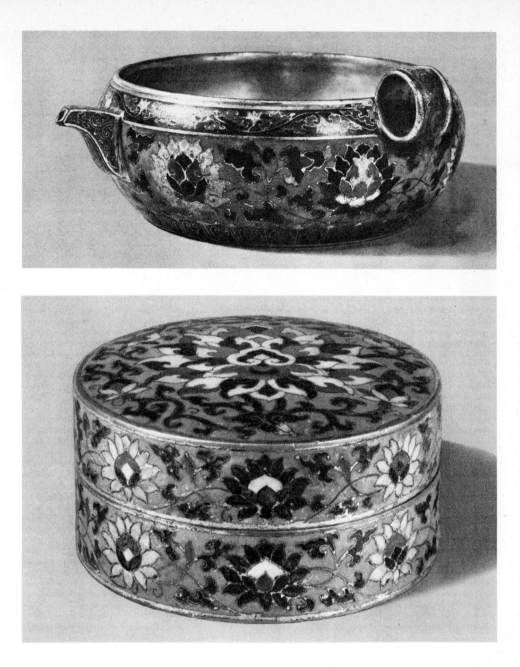

87. CLOISONNÉ SPOUTED RITUAL VESSEL WITH
RING HANDLE, DECORATED WITH LOTUS SCROLL
ROUND THE BODY; A CLASSIC SCROLL BORDER
ROUND THE RIM AND A BORDER OF FALSE
GADROONS ROUND THE BASE

*First half of the 15th century. Length 15.1 cm. Victoria and
Albert Museum, London*

This is one of the earliest metal shapes in porcelain, appear-
ing in the 14th century. It can also be found in Yüan silver-
ware. This vessel has a finely engraved *vajra* on the base,
showing its Buddhist origin. The *vajra* is a thunderbolt de-
sign for keeping away evil spirits.

88. CLOISONNÉ CYLINDRICAL BOX AND COVER

15th century. Diameter 8 cm. Garner Collection

A cylindrical box and cover of cloisonné enamel which is
decorated on the top with a lotus sprig, and round the sides
with a lotus scroll border. The mark incised on the base is an
owner's mark, *Chêng-yen*.

The colours are dark green, cobalt blue, red, yellow and
white, on a turquoise blue ground.

89. CLOISONNÉ CYLINDRICAL BOX AND COVER
DECORATED ON THE TOP WITH FRUITING
SPRAYS AND ROUND THE SIDES WITH LOTUS
SCROLL BORDERS

*Hsüan Tê mark on the base and inside the lid, but this piece
probably belongs to the second half of the 15th century. Diameter
11 cm. Musée des Arts Décoratifs, Paris*

A similar box, decorated with pomegranate fruit and of the
same date, is in Lord Cunliffe's collection. See Garner, *Chinese and Japanese Cloisonné Enamels*, plate 23.

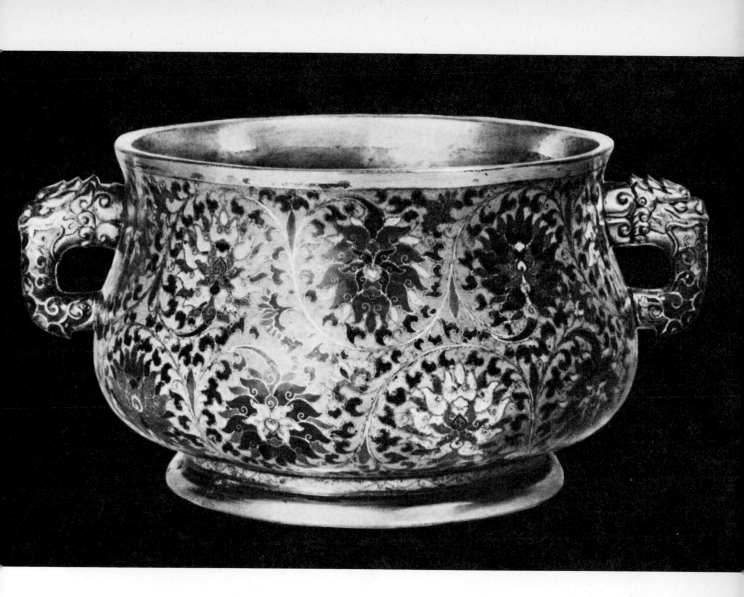

90. CLOISONNÉ INCENSE BURNER WITH ANIMAL
HEAD HANDLES IN CHAMPLEVÉ, DECORATED
WITH TWO ZONES OF LOTUS SCROLLS AND A
FLORAL BORDER

*Early 16th century. Width 28.4 cm. Formerly collection Mr. J.
Paul Getty, Malibu, California (ex Kitson Collection)*

The shape of this piece is copied from the ritual bronze *kuei*.
Garner calls it an important border-line piece, but thinks
that the crowded arrangement of the design and the use of
the purple enamel and an additional shade of green suggest a
date later than the 15th century. The foot of this piece does
not seem to be original.

131

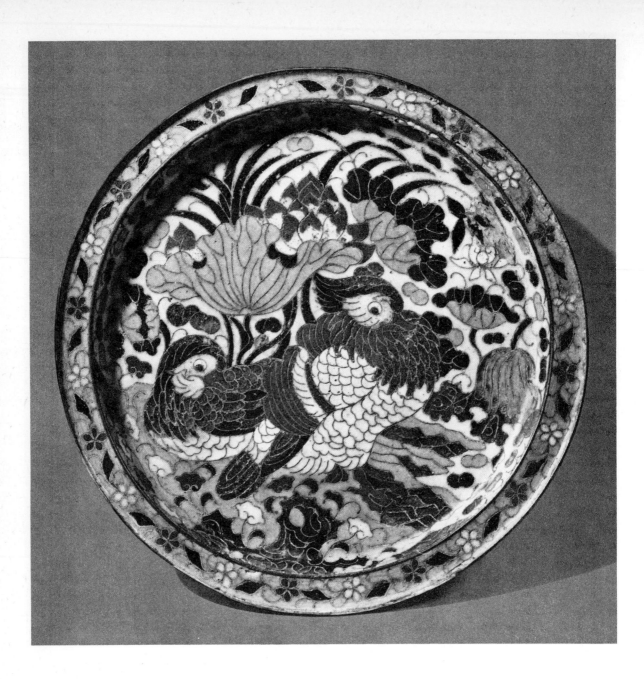

91. CLOISONNÉ DISH

First half of the 16th century. Diameter 17 cm. Musée des Arts Décoratifs, Paris

This cloisonné dish has a flanged rim, and is decorated with two mandarin ducks on a pond with water plants, surrounded by a flower scroll border.

The dish is made of cast bronze and the whole of the underside is of plain metal. It has a hole in the centre, which has been carefully filled in. "It is likely" writes Garner "that all these dishes were originally the bases of simple pricket candlesticks, and have been converted to dishes or salvers. No complete pricket candlestick of this type is known."

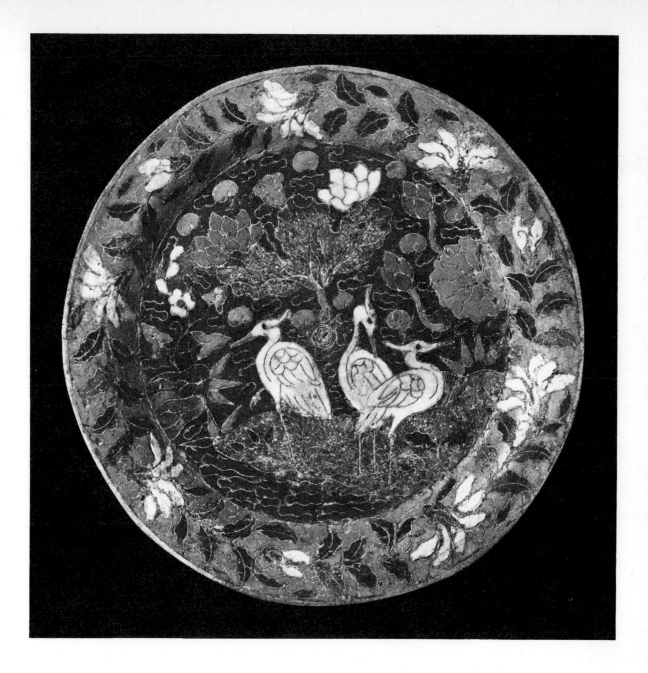

92. CLOISONNÉ DISH

First half of the 16th century. Diameter 25.5 cm. Garner Collection

The dish of cloisonné enamel is decorated with three white egrets standing on the side of a lake surrounded by water plants, on a dark green background. The borders are decorated with yellow gardenias on a turquoise blue ground.
This dish, like the one illustrated on the previous plate, has a hole in the middle which has been carefully filled in. It is also probably a converted pricket candlestick.

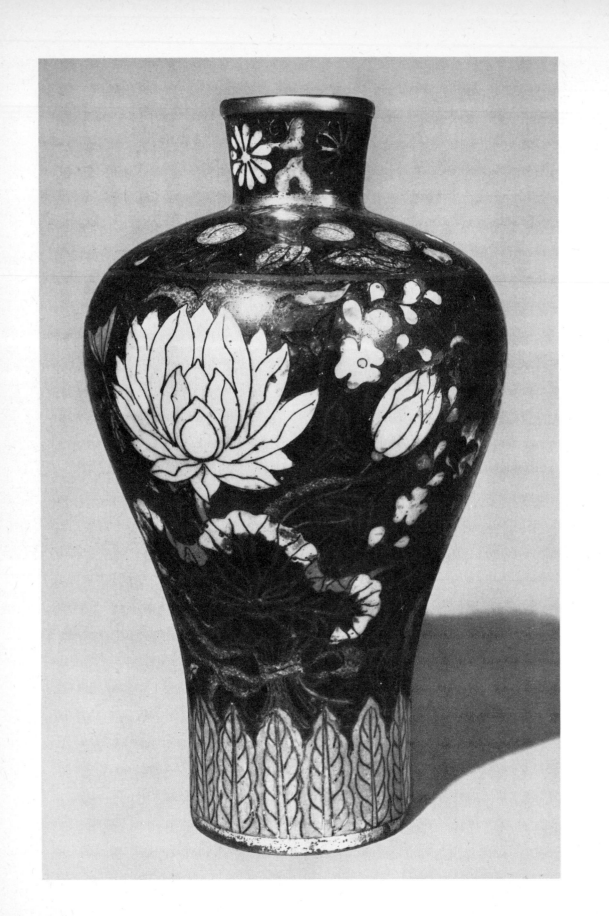

134

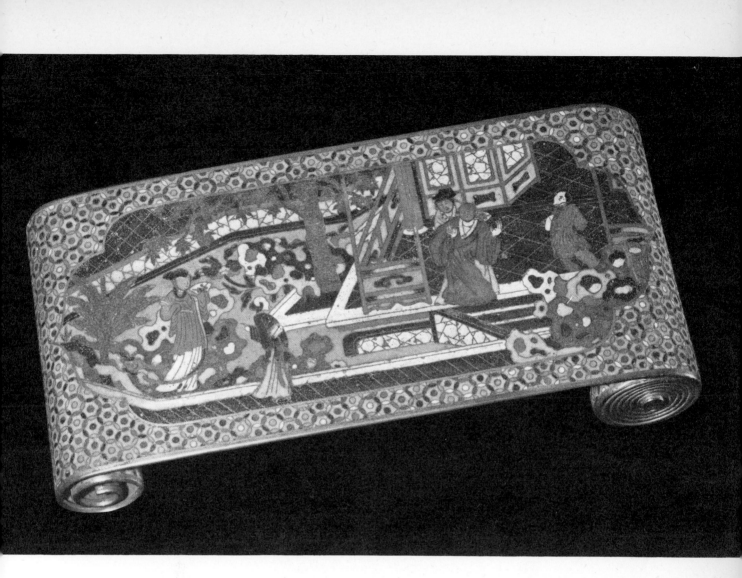

◁ 93. CLOISONNÉ VASE

Middle of the 16th century. Height 20.5 cm. Musée des Arts Décoratifs, Paris

This cloisonné vase is of *mei ping* shape, and is decorated on the body with peony, mallow and lotus plants with a border of fruiting sprigs on the shoulder and a border of leaves round the base, on a black ground. This is an unusual piece, both in shape and colour.

94. CLOISONNÉ ARM-REST

First half of the 17th century. Length 37 cm. Formerly collection Mrs. Walter Sedgwick, London

A cloisonné arm-rest in the form of a half-open picture scroll decorated with figures in a garden. The faces of the three principal figures are made of mother of pearl inlay with incised features, and these may have been added later. This piece belongs to a group in which (although the pieces themselves are of fine workmanship) the faces are left without details. It may be that the whole group was decorated with gilding, painting and inlay.

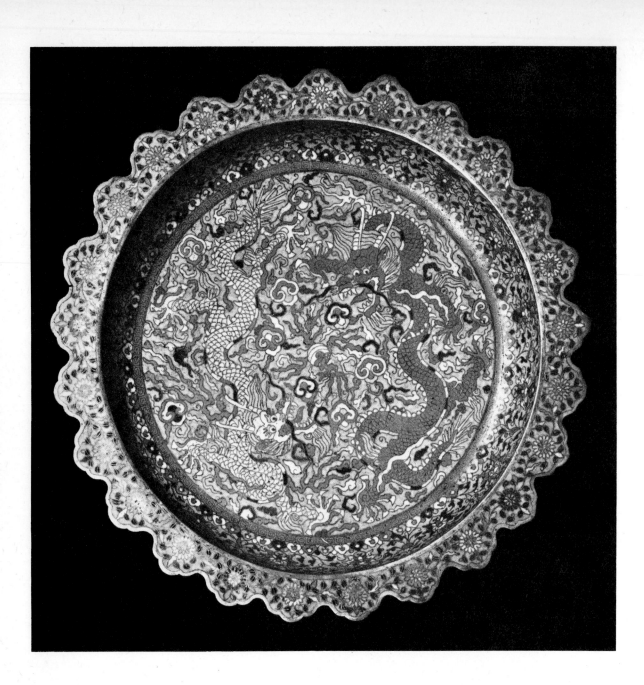

95. CLOISONNÉ DISH WITH PETALLED EDGE,
DECORATED IN THE CENTRE WITH A YELLOW
AND A RED DRAGON DISPUTING FOR A PEARL ON
A TURQUOISE BLUE GROUND WITH A RED RIM,
BENEATH A SCROLL BORDER. FLOWER SCROLL
ON THE RIM.

*Mark and period of Wan Li (1573-1619) in enamel on the base.
Diameter 50 cm. British Museum, London*

Another piece – a round box and cover with a Wan Li mark
in enamel on the base – is in the Percival David Collection.
Garner says that such marks can be accepted without reser-
vation. He remarks that the use of the Chinese character *tsao*
("made") on this dish, in the place of the *chih* is not common
on Imperial wares, which he believes this piece to be. The
Wan Li *nien hao* is common on lacquer, sometimes with a
cyclical year-mark in addition, but this combination has yet
to be found on Wan Li cloisonné.

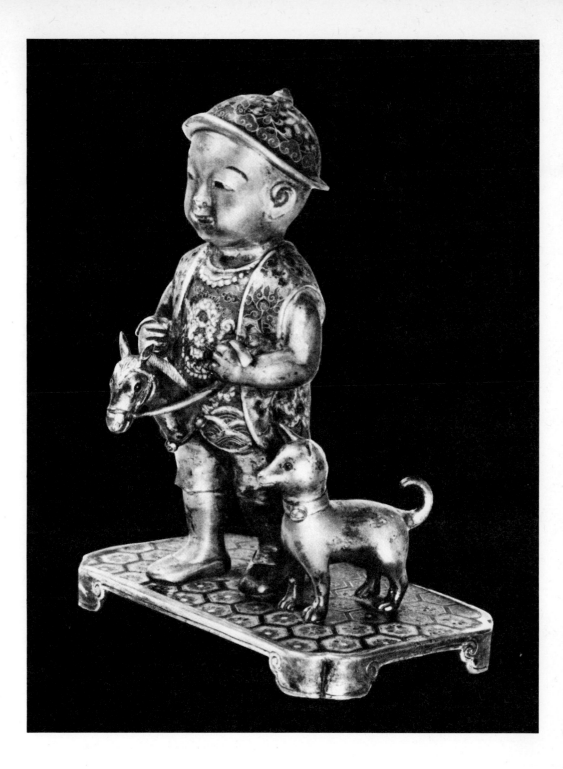

96. CLOISONNÉ FIGURE OF A BOY ON A HOBBY
HORSE WITH A DOG BY HIS SIDE, ON A
RECTANGULAR BASE

*Second half of the 17th century. Height 14.5 cm. Collection
Mrs. R. H. Palmer, Reading*

This is a charming piece. It was attributed to the late Ming
period in the London Oriental Ceramic Society's Exhibition
of 1957, but as Garner says, an early Ch'ing attribution now
seems more likely.

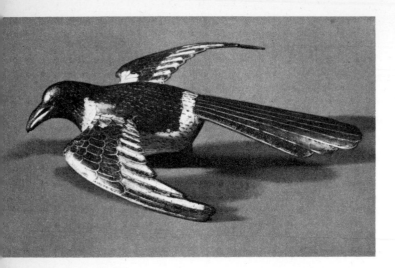

97. CHAMPLEVÉ MAGPIE

17th century. Length 25 cm. Musée des Arts Décoratifs, Paris

This magpie is decorated in black and white champlevé enamels, and has eyes inset with red stones.

The Chinese term for the magpie is literally "bird of joy" as it is considered a bird of good omen. It was always held in especial esteem by the Manchus, as one of their clan, Fan Cha-chin, when pursued by his enemies, was saved by a magpie, which perched on him so that he was mistaken for a tree trunk.

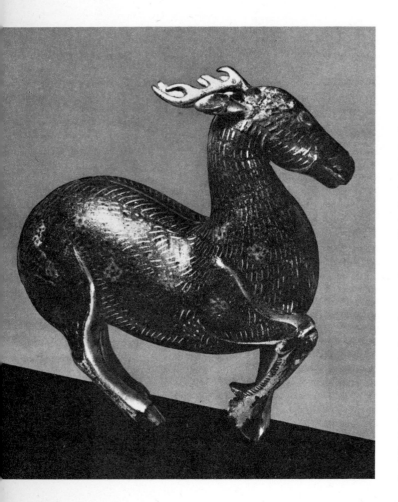

98. CHAMPLEVÉ FIGURE OF A DEER, DECORATED WITH BROWN ENAMELS WITH BLUISH-GREEN SPLASHES, AND GILT HORNS AND MARKINGS

This piece which came from the Eumorfopoulos Collection, has been published as Yüan in date, but it is unlikely to be earlier than Ming. Height 12 cm. British Museum, London

The deer is believed by the Chinese to live to a great age, and has thus become a symbol of longevity. In its old age it turns white. It is usually portrayed by the Chinese carrying the sacred fungus of immortality in its mouth. Its horns, when "in velvet", are eaten by the Chinese as an aphrodisiac, and with the hope of prolonging life.

A picture of a deer also represents "official emoluments", a play on the word *lu*.

99. IMPERIAL CLOISONNÉ BRAZIER AND COVER ▷

Ch'ien Lung period (1736–1796). Height 50 cm. Formerly in possession of Spink and Co. Ltd., London (ex Kitson Collection)

This brazier and cover is supported on three jewelled gilt-bronze elephant heads; the lower part has a stylised floral pattern and a wide, flanged rim with flowering branches and interlaced blue strap-work on a turquoise key-fret ground, from which rises the main body which is in two tiers. The domed cover has three barbed cloisonné panels filled with flowers and reserved on a gilt-bronze cloud band and fret ground. The finial is pierced with a coiled dragon.

This is a fine example of an ornate piece of cloisonné made for the Chinese Court.

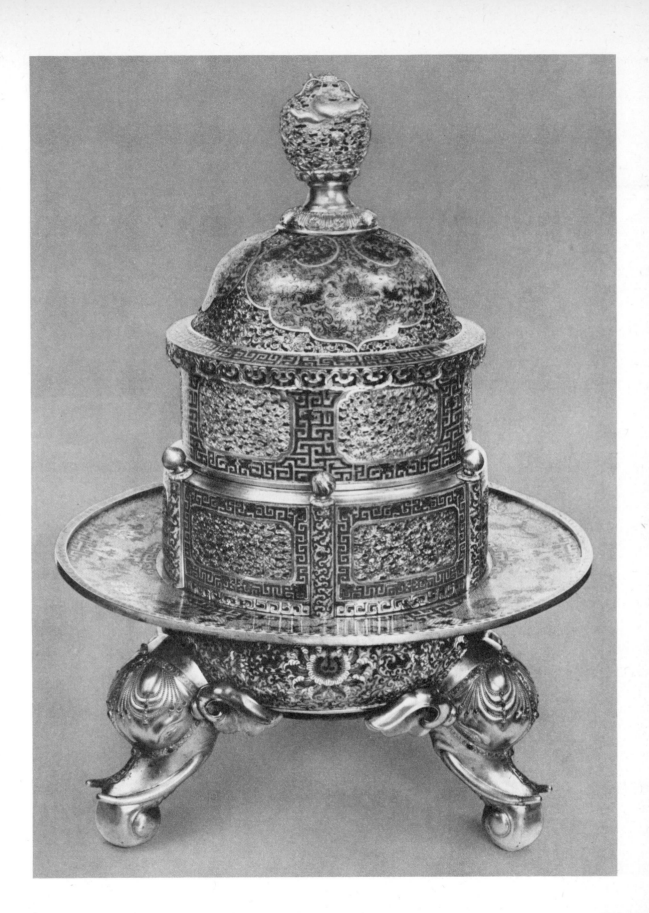

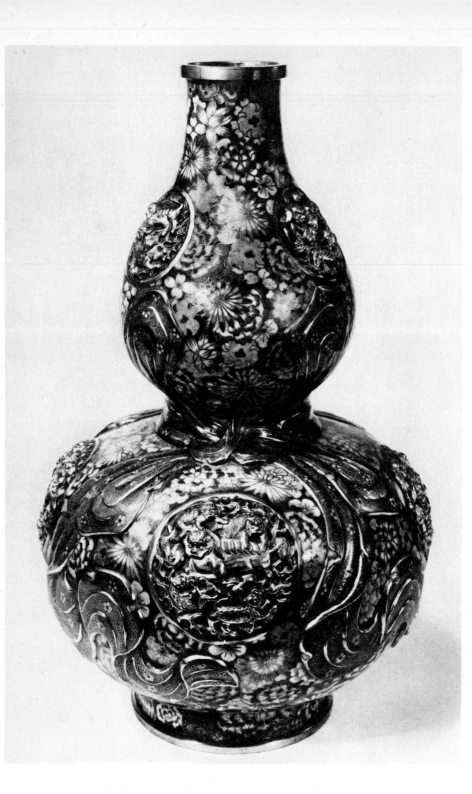

100. CLOISONNÉ DOUBLE GOURD VASE; ONE OF A PAIR

Mark and period of Ch'ien Lung (1736–1796). Height 37 cm.
Collection I. & E. D. Vandekar, London

This vase is tied round the middle with a blue scarf in relief enamelled with small flowers. Both neck and body are decorated with embossed gilt-bronze roundels containing *ch'i-lin* on a cloisonné *millefleurs* ground. It is obviously a palace piece.

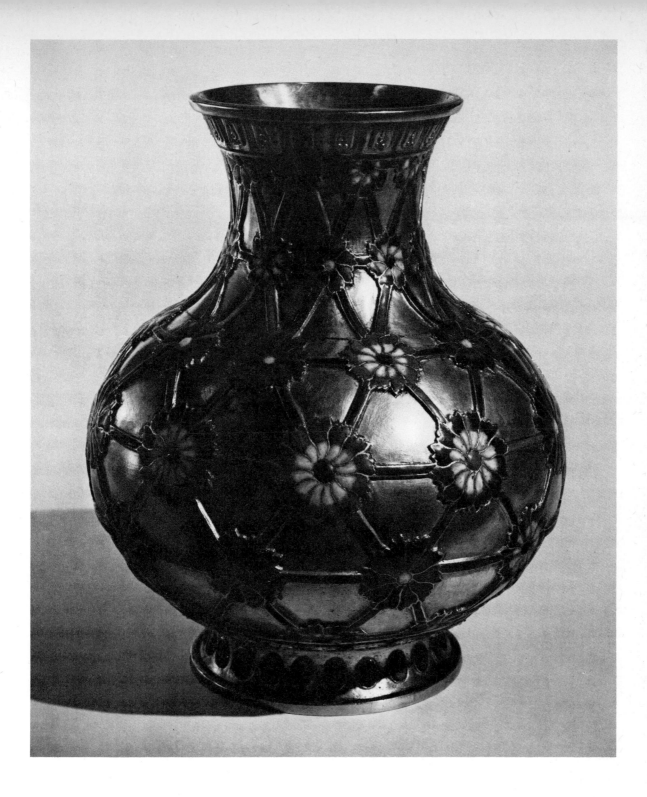

101. IMPERIAL VASE IN EMBOSSED ENAMELS WITH
DETAILS IN CLOISONNÉ, DECORATED WITH
RAISED TRELLIS WORK ON THE BODY
CONTAINING FLOWER ROSETTES IN TWO
COLOURS IN CLOISONNÉ

*Ch'ien Lung period (1736–1796). Height 24 cm. Victoria and
Albert Museum, London*

The details are hammered from the surface and the *cloisons*
are prominently rimmed, so as to project boldly from the
gilded background. This method, hardly known before the
18th century, is occasionally found in combination with cloi-
sonné enamel in the Ch'ien Lung period. The rare earlier ex-
amples of the technique are perforated covers of Ming date.
The illustrated piece figures on a plate in Volume II of Bush-
ell's *Chinese Art* of 1906.

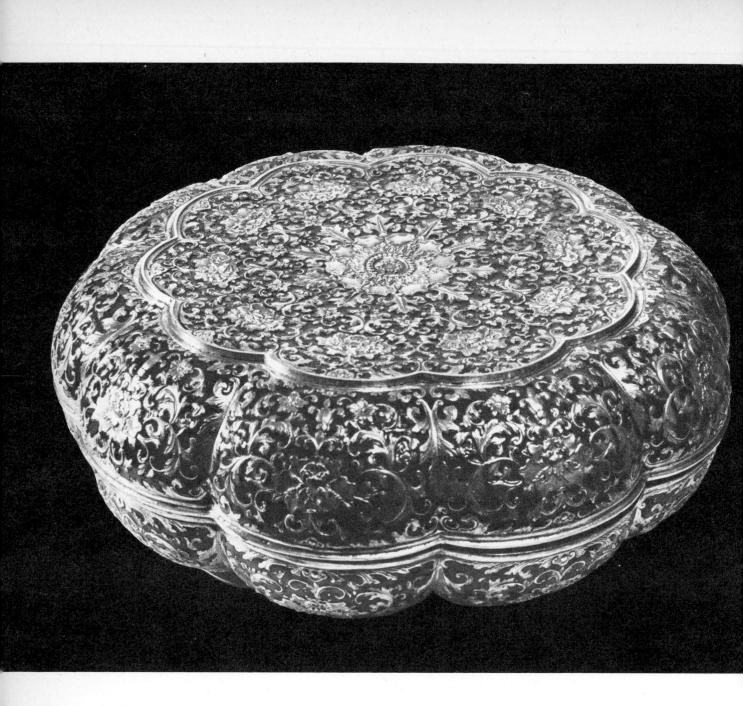

102. IMPERIAL *REPOUSSÉ* ENAMEL BOX AND COVER; ONE OF A PAIR

Ch'ien Lung period (1736–1796). Diameter 39 cm. Victoria and Albert Museum, London

The form of the box is circular with ten lobes decorated in delicate *repoussé* with floral ornament. The floral scrolls are gilt on a monochrome dark blue enamel ground. The inside is enamelled turquoise. This piece is entirely *repoussé* with a base of gilded copper. It was possibly used as a sweetmeat or cake box and came from the Summer Palace, Peking. It was illustrated by Bushell in *Chinese Art*, Volume II in 1906.

CHAPTER V:
PAINTED (CANTON) ENAMELS ON COPPER AND GOLD

THE PROCESS of painting in enamels on metal is a simple one. The surface to be decorated is covered with an even coating of opaque enamel, and the design painted in enamel colours on this, as on porcelain. In China the origin of this technique is indicated by the Chinese name *yang tz'û* (foreign porcelain) for these wares.

The date of the introduction of painted enamels into China has not hitherto been recorded, although it has been suggested by M. Soulié de Morant that foreign missionaries had brought the technique to Canton as early as 1683 and to Peking in 1685[1]. From an unpublished letter, dated 1720, from de Mailla, a French missionary in China, it is clear that the Emperor K'ang Hsi had become acquainted with European painted enamels before 1713, either through the medium of the French missionaries in Peking, or by way of traders at Canton, and that in 1713 or 1714 he set up an *atelier* at Peking for the manufacture of enamels. This letter ran:

"Dans mes lettres de l'an passé (que je n'ai pas encore retrouvées), je vous marquay l'heureuse arrivée en Chine de nos chers frères Rousset et Gravereau; l'accueil favorable que l'empereur (K'ang Hi) leur fit en Tartarie, où il les vit pour la première fois; l'espérance de Sa Majesté d'en profiter avantageusement et la joye que nous avions tous du service insigne que vous nous aviés rendu en nous les envoyants (sic), non seulement à notre mission françoise, mais encore à toute notre mission de Chine. Permettés-moi, mon Révérend Père, de vous dire le succès que l'un et l'autre ont eu dans leur employ depuis le temps qu'ils sont en Chine... Si le frère Gravereau ne s'était appliqué en Europe qu'à l'émail, comme le frère Rousset à la chirurgie, sans doute qu'il auroit mieux réussi qu'il n'a fait. Mais deux choses luy ont un peu fait tort. La première qu'il a trouvée en arrivant ici, qu'on n'y estoit pas tout à fait ignorant sur l'émail. Et effective-ment on peut dire que les Chinois qui n'y travaillent que depuis cinq ou six ans par les ordres de Sa Majesté, y ont fait un progrès considérable. Le frère Gravereau est cependant encore leur maître et si ce cher frère au lieu de s'occuper à plusieurs autres occupations qui n'ont servies (sic) qu'à le distraire de la principale, qui estoit l'émail, certaines pièces que les mandarins chinois trouvent moyen de se procurer sur les vaisseaux venus d'Europe et qu'ils offrent à l'empereur, ne lui nuiroient pas, et c'est la seconde chose, que j'ai dis (sic) qui a fait tort. Sa Majesté estime sa peinture, mais il le souhaiteroit plus habile en émail[2]."

Matteo Ripa, writing from the Ch'ang Ch'un Yüan as early as March 1716, had reported that:

"His Majesty having become fascinated by our Europe enamel paint, tried by every possible means to introduce the latter into the imperial workshops which he had set up for the purpose within the Palace, with the result that with the colours used there to paint porcelain, and with several large pieces of enamel which he had brought from Europe it became possible to do something. In order also to have European painters, he ordered me and Castiglione to paint in enamels. Each of us, considering the intolerable slavery that we would have to suffer by having to stay from morning to evening in a workshop filled with such a crowd of corrupt persons within the Palace, we excused ourselves by saying that we had never learned the art, and making up our minds that we would never want to know it, we painted

so badly that the emperor on seeing what we had done said: 'Enough of that!' Thus we found ourselves freed from a galley-slave existence."

When Brother Gravereau, a French missionary, who was skilled in painted enamels, arrived at Peking in 1719 in response to an appeal from the mission at Peking, it was found that the Chinese artists had made some progress during the interval. And John Bell, who accompanied Ismailoff to Peking in 1721, reports that 'the Emperor, on February 10, 1721, sent three officers with presents to his Czarist Majesty; the chief of which were... a set of small enamelled gold cups...' While in a letter from Peking dated November 29, 1721, Angelo de Borgo San Sero O.F.M., who was presented by Mezzabarba, writes: 'The Emperor showed us some enamelled vases made at the Court!'

Among the presents sent by the Emperor K'ang Hsi to Pope Clement II by Mezzabarba were ten enamel vases, one hundred and twenty-eight porcelain vases, thirty-six Peking glass vases, as well as sixteen Chinese picture scrolls.

Another missionary presented by Mezzabarba was Nicolo Tomocelli of the Regular Clerks Mission. P. Perroni, the Procurator of the Propaganda in Canton, wrote in 1722 that Tomocelli was quite well; that he was pleasing the Emperor who had set him painting in enamel, and although he knew nothing of that profession, yet, with the help of Castiglione, who was said to have prepared the designs for him, he was held in esteem. Tomocelli left Peking for Europe in 1724. Castiglione, apart from painting pictures of horses and hounds for the Emperor, is also said to have painted European figures on *ku-yüeh hsüan* porcelain. Lastly, on November 17, 1725, Maria de S. Giuseppe Rinaldo reported that the thirteenth Prince was in charge of the *yang hsin tien*, the Tribunal of the '*operarij manuali di divertimenti*', i.e. manual workers and craftsmen in ornamental and decorative arts. The Prince expressed a desire for craftsmen of various kinds from Europe. Father Rinaldo recommended that the Propaganda should at least send an expert 'Smaltista' (i.e. enameller)[3].

It is probable that further research in the Jesuit records in Paris would provide other details on the foreign priests like Gravereau and Tomocelli who instructed the Chinese Palace workshops, and even perhaps the exact date of the introduction of the painted enamel technique.

It is quite clear that the date of the appearance of the first painted enamels in China is bound up with the question of the date of the first use of the *famille rose* enamels; for with few exceptions Cantonese enamel pieces are decorated with this colour scheme. These pink enamels were an invention of importance dating from near the end of the K'ang Hsi period, whose introduction is attributed by the Chinese to Ts'ang Ying-hsüan, who was appointed Director of the Imperial Porcelain Factory at Ching-tê Chên in 1683. In the next reign these enamels replaced the Chinese admiration for *famille verte*. Unquestionably they were a European invention, but the exact date of their introduction into China is still unknown. Kuo Pao-ch'ang believed that they were introduced as early as the twentieth year of K'ang Hsi (1682). If so, they were remarkably little used over a long period. Honey writing in 1945 says:

"The opaque rose pink colour, which was later to give its name to the *famille rose*, was introduced into China at some undetermined date towards the close of the reign of K'ang Hsi. It was of foreign origin and had in fact been in use in Europe for scarcely half a century before its adoption in Chinese porcelain. Its discovery dates from about 1650, when

Andreas Cassius of Leyden produced from gold chloride and tin the rose-purple colour named after him. The first use of this colour in pottery was probably made by Nüremberg enamellers such as Wolf Rössler (the Monogrammist WR) about 1680. The rose-pink and the other opaque colours associated with it were known as *yang ts'ai* (foreign colours) or *yüan ts'ai* (soft colours) to the Chinese, who have obscurely referred to Western enamelling (*fa lang*), either cloisonné or painted in the Canton manner, as the source from which they were derived. It has recently been argued from the Chinese side that the term *fa lang* definitely referred to cloisonné enamel and that the wares with the 'foreign colours' were made from the twentieth year of the reign of K'ang Hsi (1682). While the date seems impossibly early, it seems certain that the rose-pink and crimson were at the disposal of the Chinese potter for some time before the end of K'ang Hsi's reign[4]."

But in his *Dictionary of European Ceramic Art*, page 521 published in 1952 he says that the first *recorded* use of the purple of Cassius was in 1685. Although it had obviously been discovered before this, the exact date is unknown. Kunckel used it in ruby glass in 1679, but it can hardly have been discovered more than a few years before – not as early as 1650.

These 'foreign colours' can be seen creeping into both the *famille verte*, and the *famille rose* in a subsidiary capacity. If you accept a bowl in the British Museum with ruby sides and a painting of flowers and fruit within[5], as bearing a cyclical mark corresponding to the year 1721 on the base in underglaze blue, there is evidence that the ruby-back technique, so closely associated with the next reign, that of Yung Chêng, was fully developed before the closing years of K'ang Hsi. Hobson accepted this bowl[6], but there is a tendency today in some ceramic circles to doubt the cyclical date which Hobson selected, and to put it sixty years later (i.e. 1781), which I think should be resisted.

The refusal to admit the genuineness of *famille rose* porcelain with K'ang Hsi marks is reflected in the American Catalogue of the *Chinese Art Treasures* from the Palace Museum, Taiwan, exhibited in Washington in 1961/62, where two bowls decorated in *famille rose* enamels with Imperial K'ang Hsi marks (Catalogue numbers 186 and 187) are written down to the latter part of the Ch'ien Lung period[7]. This catalogue even ventures to say that "the technique of making pink enamel which came from Europe does not seem to have reached China before 1717, when it first appeared in a crude form on copper grounds; such a highly refined pink as on the saucer dish (No. 186) was not perfected until later. For this reason a late Ch'ien Lung date seems most likely for extremely sophisticated enamelling of this kind".[8] It would be interesting to know in the context how the year 1717 was arrived at. This catalogue does not accept the K'ang Hsi *nien hao* on the pieces of Cantonese enamel reproduced with imperial K'ang Hsi marks, which include the pair of vases No. 208/209 (our plate No. 116), the teapot, No. 210, (our plate 118), and the squat vase, No. 211, (our plate 117). The vases "are more likely to date from the later decades of the 18th century". The teapot is "probably late Ch'ien Lung", and the mark on the squat vase is "probably an interpolation on a piece made some fifty years later". It seems clear that the author of the catalogue would be reluctant to accept any Cantonese enamel pieces with K'ang Hsi reign marks. The question of the date or dates at which the *famille rose* enamels and the technique of painted enamels, were introduced is still undecided. There is no doubt, however, that the technique of painting enamels on copper was not developed before the introduction of the *famille rose* enamels, and from the extracts I have quoted there seems to be evidence that K'ang Hsi had begun to

experiment with painted enamels on copper already in the year 1713. This would be nine years before the end of his reign. Personally I have no hesitation, until further evidence appears to the contrary, in accepting all those pieces of Cantonese enamel I have seen with K'ang Hsi imperial marks as of the period and as having been made between 1713 and 1722. This would also entail the belief that the K'ang Hsi potters had complete control over the *famille rose* medium before the end of the reign; and I am unable to identify the 'crude form' of this technique mentioned in the passage quoted above. As to the date of the first introduction of *famille rose* enamels, 1682 may be, as Honey says, too early, but I feel equally certain that 1717 is too late. But even if we accepted the date of 1717 as the date of introduction there would still have been time, under the guidance of foreign tutors, to perfect the technique in the four years that remained before the close of the reign.

It is quite possible that the painted enamel technique was introduced at an earlier date to the South of China than to the North, as Soulié de Morant suggests but does not substantiate. Ferguson, who distinguishes between enamels painted at Peking and those painted at Canton, writes that the Peking enamels "were made after the model of the Limoges pieces brought to China by Catholic missionaries. A few of the missionaries themselves were skilled in enamel painting, and they trained Chinese artists. Some of these pieces are copies or adaptations of those brought from France, and have persons in foreign dress and backgrounds; others have familiar Chinese designs... The enamels painted at Canton are inferior in quality to those formerly made in the *Tsao Pan Ch'u* of the Peking Palace. Canton enamels have been made in large quantities chiefly for foreign export and are still being produced, but they cannot be classed among the artistic wares."[9] Perhaps he had in mind the opinion of the author of the *Wên fang ssu k'ao* (published in 1782) whose deprecation of painted enamels has been applied to cloisonné. "One often sees" he says "incense-burners and flower-vases, wine-cups and saucers, bowls and dishes, ewers for wine, and round boxes for cake and fruit, painted in very brilliant colours; but, although vulgarly called porcelain, these things have nothing of the pure translucency of true porcelain. They are only fit for use as ornaments of ladies' apartments – not at all for the chaste furniture or the library of a simple scholar."[10] This does not seem to have been the view held by either of the emperors K'ang Hsi and Ch'ien Lung, both of whom were fond of this ware.

Canton enamel, however, continued to be classed as a species of foreign porcelain in works devoted to Chinese ceramics, but Chinese writers usually distinguish between cloisonné and champlevé enamels.

Thus the *Ching-tê Chên t'ao lu*[11] divides porcelain with copper bodies into *Ta shi yao* (porcelain of the Arabs), *Fa lang yao* (porcelain of France) and *Yang tz'û yao* (foreign porcelain ware). The first two groups appear to refer to cloisonné and champlevé enamels and the last to painted enamels. The passage under the heading of *Yang tz'û yao* (foreign porcelain wares) runs:

"It is made in the land of Kuli[12] in the Western Ocean. The origin of the ware has not yet been investigated. In like manner [to the cloisonné enamel] it has a copper body. This is very thinly coated with *tz'û fên* [powder made of porcelain stone] which is fired. When complete it has brilliant painting in enamels [*wu ts'ai* – five colours] admirably executed. When struck it emits a note like copper. In glossiness, elegance, freshness, beauty it is not really equal to porcelain wares. At the present in Kwangtung imitations are made in great numbers."[13]

This account does not mention that many of the finest pieces of 'Canton' made for the Palace were enamelled on gold. The catalogue of the exhibition of pieces from the Palace collections sent over to London by the Chinese government in 1936, Volume II which deals with porcelain, includes seven pieces of Canton enamel (Nos. 300–306) illustrated between porcelain described in the catalogue as painted in "cloisonné enamels" and pieces described as cloisonné enamels on glass. Five painted enamel pieces (three of which are enamelled on a gold body) are reproduced in volume IV in the miscellaneous section, which is devoted to cloisonné. It is difficult to understand why this division was made.

The similarity of decoration and enamel colouring between the painted enamels on copper and those of contemporary pieces of *famille rose* "eggshell" porcelain, particularly in some of the ruby-backed plates, has often been noticed. Dishes occur in the two materials with the identical decoration and ruby-backs and the same brocade patterns and diaper borders, interrupted by foliate panels filled with the same devices. The figure subjects and Chinese interiors, the groups of furniture and vases of formal flowers, the intricate diapers of the borders, and the ruby-backs of the dishes typical of the "eggshell" porcelain appear also on the Canton enamels. Hobson writes: "it is practically certain that most of the well-known class of 'eggshell' porcelains, such wares as the 'seven-bordered plates' and the 'ruby-backed' dishes, if not all of it, though made at Ching-tê Chên, was enamelled at Canton."[14] It is probable that many of these pieces were made in the same *atelier* by the same decorators. (See plate 107)

The enamels on the porcelain glaze stand out in relief like incrustations[15], while the colours of Canton enamels are painted on a ground of opaque enamel, usually white. It is like painting on the tin-enamelled surface of delft, or to a lesser degree, on the easily fusible glaze of soft-paste porcelain. The colours sink in and are incorporated with the soft excipient, and assume a softer appearance. As some of the colours do not do themselves justice on the enamel excipient the Chinese verdict that "in glossiness, elegance, freshness and beauty they [viz. the Canton enamels] cannot equal the porcelain wares" is justified. It is unfortunate that they easily crack and chip.

Canton enamels often carry dynastic marks on the base, the *nien hao* of Ch'ien Lung being the most common (plates 109, 110, 113). A group of pieces with K'ang Hsi marks has been brought together in this book (plates 103, 104, 114–118). They are comparatively rare. The Yung Chêng mark is, as far as I know, unknown, although Canton enamels must have been made in his reign (plate 107). More rarely "hall-marks" or marks of commendation appear, often in seal characters[16]. One looks in vain for pieces signed by their enamellers.

Studio-marks occur on certain pieces. The name Pai Shih[17], usually in seal form and attached to a stanza of poetry, or a short descriptive sentence, occurs fairly frequently on Canton enamels, but always (as in the "eggshell" plate [18] in the British Museum collection) in the decoration and never under the base. The latter is the proper and usual place for the dynastic mark or painter's signature on porcelain or enamel; the former is a quite usual place in a picture for the signature of the artist. Hobson was convinced that Pai Shih was merely the name of a Canton artist, whose pictures were freely used by the enamellers; he may even have designed specially for them. There is no uniformity of style in these Pai Shih pieces[19]. The signature has been found on "eggshell" porcelain plates painted with elaborate

finesse with masses of flowers and borders of the "seven border" style. The same signature will be found on Canton enamel usually attached to a landscape, sometimes well painted, but sometimes rendered in a rough and sketchy style. "It would have been much more satisfactory had the signature of Pai Shih been that of a porcelain and enamel painter, and so served definitely to bring the two materials under one roof; but the theory must be dismissed and with it the significance of the date 1724 attached to a Pai Shih painting on porcelain. It is no longer considered the date of the porcelain but of the design only."[20]

In some Cantonese enamel pieces it is their decorative *motifs* (plates 112 and 113), entirely alien to China, which betray that they have been made for the foreign market; in others the shape shows their export origin (plate 105). This is evident in the form of a kettle on a stand, which must have been made for the English market about 1760, as the shape has been taken from contemporary English silver[21]. Canton enamel pieces seem often to have been included among the porcelain ordered for the European market in the 18th century but I have not found any mentioned in bills of lading.

It is difficult to find documented pieces of Canton enamel, but perhaps this is because no one so far has searched for them! The candelabrum (plate 123) ordered at Canton in 1740 is one of these few pieces, but others must exist. It would be exciting if one could identify the work of such artists as Gravereau and Tomocelli. The bowl and cover, decorated with peonies in a curiously un-Chinese hand (plate 106), might be one of these pieces. And there is in the British Museum collection a cup and cover decorated with European figures[22] which in some quarters has been called Canton enamel-ware and in others European! This again might well be the work of one of the European missionaries from the Palace work shop. A vase, which belongs to Mr. Reitlinger, if not by a European hand, may easily have been made under Jesuit influence[23]. It is decorated with a landscape containing several churches; the trees are not painted in the usual Chinese style, while the sky is a bright cerulean blue. It is intentionally left white on most Chinese pieces!

By the end of the reign of Ch'ien Lung (1796) Canton enamels had lost all their quality of colour and design. By the 19th century they were decadent, but still manufactured in large quantities at Hoihow in Hainan, often on a silver body. Pale blue is now the dominant colour and the decoration is simple. There were also pieces made in black enamel which probably came from the same port. A vast quantity of painted enamel is still made in China, both at Canton and Peking for export to the West. It is not difficult to distinguish it from the 18th century pieces, for it lacks their charm and grace.

R. SOAME JENYNS

148

[1] Soulié de Morant, *Histoire de l'Art Chinois*, p. 23. – He states that painted enamels were made in Peking between 1685 and 1719 for the *Compagnie de la Chine*. "Le décor" (he adds) "est frais, très fin et délicat". He suggests the year 1683 as the first date of manufacture at Canton, but he gives no documentation of these opinions.

[2] MS letter from Father de Mailla (from Jehol) dated October 26th, 1720, to Orry, Chinese Mission of Paris. This information was given me by Father Henry Bernard of Paris.

"In my last year's letters (which I still have not been able to find) I told you of the safe arrival of Brothers Rousset and Gravereau; of the favourable welcome given them by the Emperor K'ang Hsi in Tartary, where he met them for the first time; of his Majesty's hope that he would be able to make use of them, and the joy we felt that you had sent them to us... Allow me, Father, to relate to you the successes that they have enjoyed since they arrived... although it would have been better if Brother Gravereau had learned something of enamelling in Europe in the same way as Rousset learned surgery, because he was at a loss in two things: the first was that on arrival he discovered that the Chinese workers were not completely ignorant of the enamelling process. It is true to say that, although the Chinese have only been working on enamel for His Majesty for about five or six years, they have made considerable progress. Brother Gravereau is fortunately still ahead of them and had this dear Brother not busied himself with several other things which are of no use except to distract his attention from the main thing – enamelling – he would not have been so alarmed by the complicated pieces which the mandarins had procured for the Emperor from Europe. In this he was wrong. His Majesty finds him a good painter, but would like to see him more skilled in the use of enamel."

[3] These references have been supplied to me by Dr. C. R. Loehr, who at the moment is devoting himself to research on the subject of the life of Castiglione, in the course of which he will, no doubt, unearth many details on the work of the foreign priests in the Palace workshops, which will be of the greatest interest.

[4] W. B. Honey, *The Ceramic Art of China and other countries of the Far East*, London 1945, pp. 151–152.

[5] Soame Jenyns, *Later Chinese Porcelain* London, 1951 pl. LIX, 2.

[6] R. L. Hobson, *Handbook of the pottery and porcelain of the Far East in the British Museum*, 1st ed. London 1924; 2nd ed. 1937; 3rd ed. 1949, p. 98.

[7] See Catalogue of *Chinese Art Treasures loaned from the Chinese National Palace Museum and the Chinese National Central Museum, Taichung, Taiwan*, Washington 1961/62, p. 263, pls. 186, 187.

[8] Catalogue *Chinese Art Treasures*, p. 263.

[9] John C. Ferguson, *Survey of Chinese Art*, Shanghai 1939, pp. 128, 129.

[10] Quoted by S. W. Bushell, *Chinese Art*, London 1906, Vol. II, p. 85.

[11] Published in 1815.

[12] Calcutta, from which town no doubt Limoges enamels were imported.

[13] Stanislas Julien, *Histoire et Fabrication de la porcelaine Chinoise*, Paris 1856, p. 37.

[14] R. L. Hobson, "A Note on Canton enamels", *Burlington Magazine*, Vol. XXII, December 1912, pp. 165–167.

[15] The enamel colours used in Canton are well-known from analyses by Ebelmann and Salvetat of a collection actually taken from the palette of an enameller, while he was working at his table, by a French attaché in the year 1844, and published in the *Recueil des Travaux Scientifiques* (M. Ebelmann), Vol. I, p. 377.

[16] S. W. Bushell, *Chinese Art*, London 1906, Vol. II, p. 84. – e. g. *Ch'ing Wan* (Pure trinket); *Ch'ing Wan t'ang* (Ch'ing Wan Hall); *Wên Kung t'ang* (Hall of general inquiry); *ju-i* (as you wish).

[17] "White Stone".

[18] See R. L. Hobson, *Handbook of the pottery and porcelain of the Far East in the British Museum*, p. 99, pl. 155. – The porcelain plate in question is of the "ruby-backed eggshell" family, painted with quails with an inscription *Lingnan hua chi* (painted at Canton), accompanied by the studio name *Pai Shih*.

[19] R. L. Hobson, *Burlington Magazine*, Vol. XXII, December 1912, pp. 165–167.

[20] R. L. Hobson, *op. cit.*

[21] Margaret Jourdain and Soame Jenyns, *Chinese Export Art of the 18th century*, London and New York 1950, p. 130, pl. 114.

[22] Jourdain and Jenyns, *op. cit.* p. 132, pl. 123.

[23] Jourdain and Jenyns, *op. cit.*, p. 129, pl. 113.

103. VASE. COPPER PAINTED WITH ENAMELS

K'ang Hsi mark, and probably of the period (1662–1722).
Height 8 cm. Garner Collection

The mark on this vase is *K'ang Hsi yu chih* (K'ang Hsi Imperially made) and the question is whether one can accept the piece as the period of its mark. In any event there is every reason to believe that it is a Palace piece. (Compare vases, plate 116.) The owner believes that it is not earlier than late Ch'ien Lung, but the writer would prefer to accept, if tentatively, the genuineness of the K'ang Hsi mark. The question of whether we do or do not accept the genuineness of a number of K'ang Hsi Imperial marks, usually in enamel, on a small group of porcelain and Cantonese painted enamel, which include *famille rose*, is still under discussion. The Catalogue of the Exhibition of Chinese Art Treasures from Taiwan 1961/62 took the view that this group was unacceptable (see a porcelain dish, cat. Nos. 186 and 187, and in the Cantonese enamel 208, 209, 210, 211, and our plates 116, 117 and 118.) On the foot of the porcelain dish (cat. No. 186) is a four-character Imperial mark *K'ang Hsi Yu chih* in red enamel in a double square, showing that the piece was made under Imperial patronage in that reign. "But", says the Catalogue, "the technique of working pink enamel, which came from Europe, does not seem to have reached China before 1717, when it first appeared in a crude form on copper panels. Such a highly refined pink as we see on this dish was not perfected till later." Some Chinese authorities have suggested that the pink enamel was imported from Europe as early as 1682. This possibility is unlikely, but has yet to be investigated. Even if this cannot be substantiated we should be able to accept the genuineness of the K'ang Hsi marks on this group if they were made as late as 1712, ten years before the end of this reign, as Jesuit sources suggest.

104. BOWL. COPPER PAINTED WITH ENAMELS

K'ang Hsi mark (1662–1722), and probably of the period.
Diameter 15.2 cm. British Museum, London

The bowl is decorated with plum blossom boughs in bloom on a *famille rose* ground. The pistils of the flower are delicately picked out in green and yellow, the small branches are green, and the bigger boughs black. The mark *K'ang Hsi yu chih* (K'ang Hsi Imperially made) is in blue enamel in a double square on the base. See above.

105. TEA-CADDY AND TRAY. COPPER PAINTED WITH ENAMELS

Unmarked, but probably Yung Chêng period (1722–1735).
Tea-caddy: Height 11 cm. Tray: Diameter 12.7 cm. Collection of the late Hon. Mrs. Basil Ionides. Buxted

The tea-caddy and tray were obviously made for the foreign market. The shape is quite un-Chinese, and many of the flowers are European in conception.
The piece is in excellent taste and probably belongs to the Yung Chêng period. It is unmarked.

106. BOWL AND COVER PAINTED WITH ENAMELS ON COPPER OR GOLD

Yung Chêng (1722–1735) or Ch'ien Lung (1735–1796) period.
Height 10.8 cm. Formerly collection Mrs. Alfred Clark, Fulmer, Bucks.

This bowl is decorated on the outside with peony blossoms in the most beautiful and delicate tints of pink, blue and mauve on a white ground. The painting is European in feeling, and it is possible that this was one of the pieces painted by one of the Jesuit fathers in Peking, such as Castiglione, who is believed to have taught the Chinese the technique. The top of the lid is decorated with grapes; the inside is lavender blue. This piece is so heavy that it is possible that, like the pieces illustrated on plates 124, 125 and 126, it is enamelled on gold. It is unmarked.107. DISH. COPPER

107. DISH. COPPER PAINTED WITH ENAMELS

Probably Yung Chêng period (1722–1735). Diameter 23 cm.
Formerly in possession of Blairman & Sons, London

This dish is decorated with a design of a lady seated on a couch surrounded by books and antiques, with two small boys in attendance, one of whom is offering her lotus flowers in a vase. It has a border of diaper with three *cartouches* containing flowers and fruit. It has a ruby back.
The interest of such plates, which are not uncommon, is that they are often exact reproductions of ruby-backed "eggshell" porcelain dishes of the same size. These ruby-backed porcelain dishes are unmarked, but are usually attributed to the Yung Chêng period. It is probable that identical enamellers in Canton decorated both the porcelain and the enamel. Many such pieces were made for export.

108. DISH. ONE OF SIX, EACH DIFFERENTLY DECORATED WITH FLOWERS AND FRUIT. COPPER PAINTED WITH ENAMELS

Probably Yung Chêng period (1722–1735). Diameter 15.3 cm.
Formerly collection Mrs. Alfred Clark, Fulmer, Bucks.

This particular dish is decorated with begonias, pear-blossom, iris and peony, with two fruit which may be loquats. It has a ruby back. Very similar decoration can be met on ruby-backed porcelain (see Catalogue of the International Exhibition of Chinese Art at Burlington House, 1935/1936, plate 221).
As ruby-backed porcelain dishes are usually associated with the reign of Yung Chêng, it probably belongs to the period.

109. VASE. COPPER PAINTED WITH ENAMELS

Mark and period of Ch'ien Lung (1736–1796). Height 12.2 cm.
British Museum, London

The body of this vase is decorated with quail, millet, and mallow flowers in a rocky landscape on a yellow ground. The neck is decorated with arabesques in colour on a pale

blue ground. The base is plain copper without enamel or mark. The Ch'ien Lung mark is in four characters on the side of the body.

This is a charming little vase in the very best of taste. The design of quail and millet is a common one in Chinese painting and dates back at least to the Sung period. The quail, because of its pugnacious character, is an emblem of courage in China, where quail fighting was once a popular pastime.

110. VASE AND LID. COPPER PAINTED WITH ENAMELS

Mark and period of Ch'ien Lung (1736–1796). Height 46 cm. Collection of the late Hon. Mrs. Basil Ionides, Buxted

The body of this vase is covered all over with a conventional peony scroll pattern in colour on a pale green ground. It has handles in the shape of bats and the lid is decorated with a band of scrolling peonies underneath a band of *ju-i* heads. The designs on the body, which are also found on enamelled porcelain of the Ch'ien Lung period, were probably taken from textiles. The mark on the base is in blue enamel in archaic characters.

111. VASE. COPPER PAINTED WITH ENAMELS

Ch'ien Lung period (1736– 1796). Height 60 cm. The Fairhaven Collection, Anglesey Abbey, Cambridgeshire

This vase, which is in the shape of a double gourd, is decorated with a trellis of fruiting gourds on a yellow ground, with panels of flowers and birds and butterflies on a white ground. The panels illustrated show two Chinese bulbuls (Chinese nightingales) perched on a spray of apple blossom. It is unmarked.

The Chinese bottle-gourd is a universal favourite. It is often tied to the backs of children of the boat-people of Kwangtung to keep them afloat if they should fall overboard. It is used as a receptacle for medicine, moulded into water-droppers (see plate 210) or cricket cages, and is a symbol of necromancy in the hands of such immortals as Li T'ieh Kuai, who kept a horse in her gourd.

112. PLAQUE DECORATED WITH PAINTED AND *REPOUSSÉ* ENAMELS ON COPPER

Ch'ien Lung period (1736–1796). Height 1.3 m. Width 80 cm. Collection Mrs. J. Clifford Roscoe, Tadcaster, Yorkshire

This plaque is one of several depicting European men and women; in this particular piece beneath the colonnades of a European house, with a European vessel on a lake and a European building in the background. Some of the figures are in *repoussé*.

The series must have been made for the European market, or for the European rooms in the Yüan Ming Yüan, the great palace built by the Emperors K'ang Hsi and Yung Chêng which was destroyed by fire in 1860.

113. VASE. PAINTED WITH ENAMELS ON COPPER

Mark and period of Ch'ien Lung (1736–1796). Height 22.5 cm. British Museum, London

Both the neck and body of the vase, with its scroll handles, are decorated with a design of scrolling rosettes on a pale blue ground, with panels showing a European man and his dog in a landscape and a lake in the background. The shaded treatment of the sky is a very European feature. The probability is that this piece was made by Chinese artisans for the European market.

The mark on the base is in blue archaic characters.

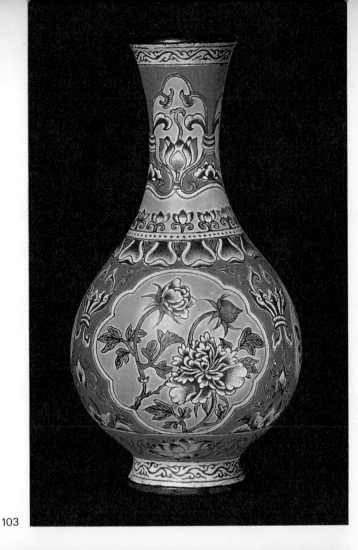

103

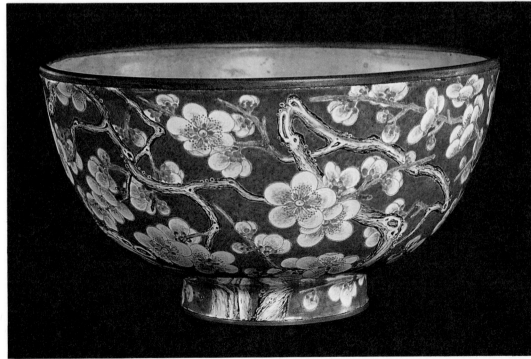

104

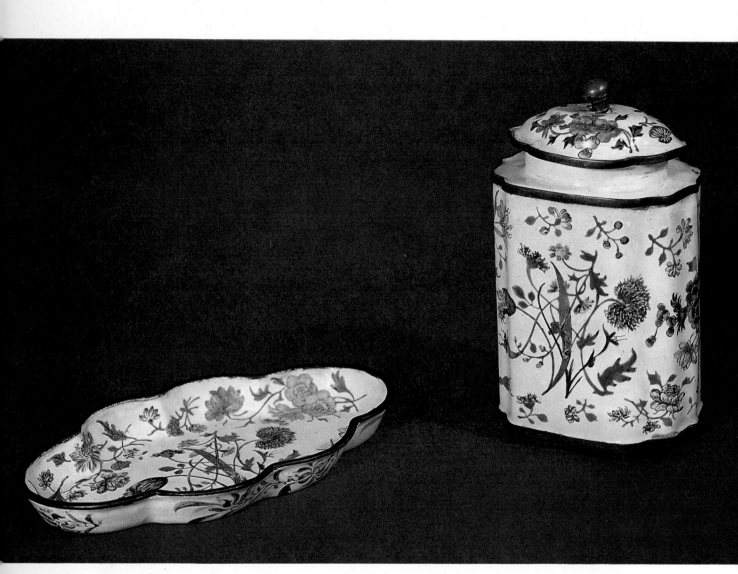

105

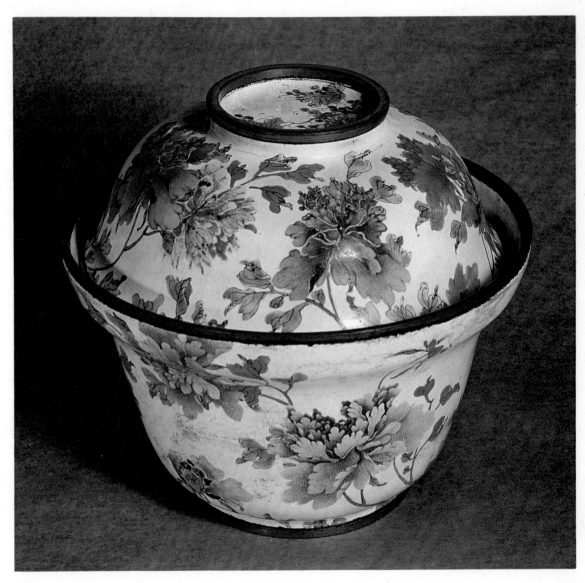

106

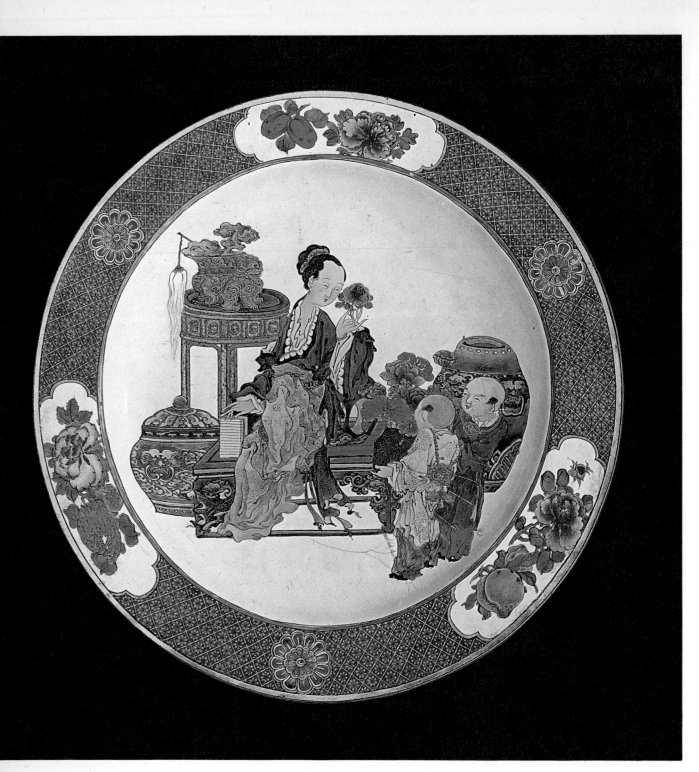

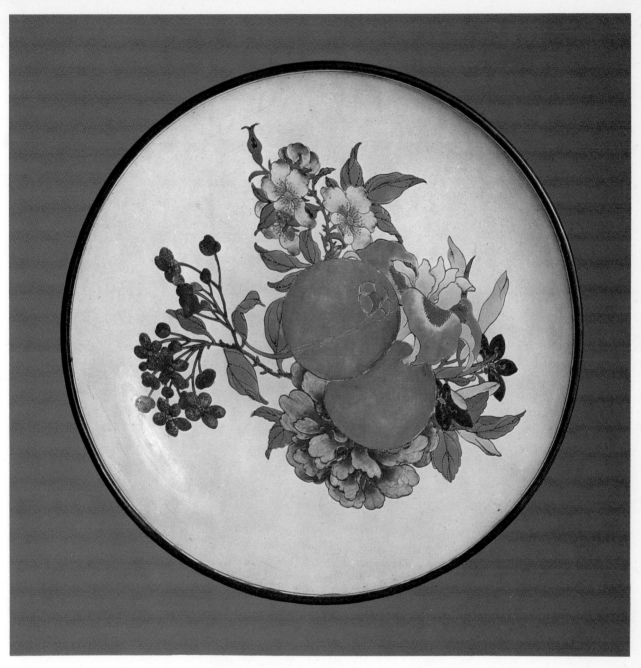

108

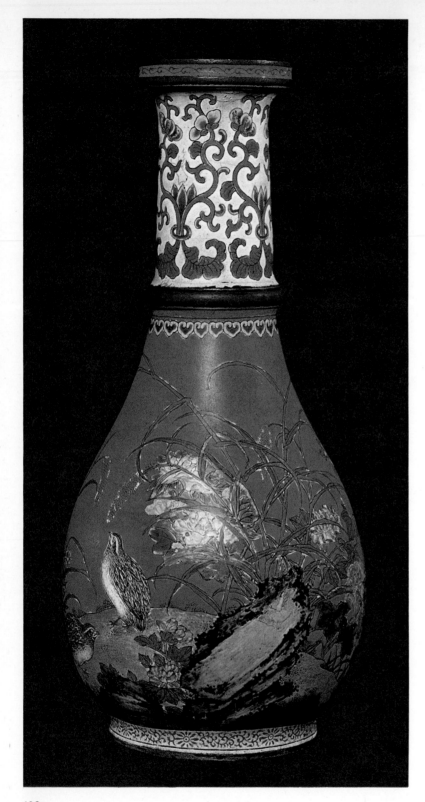

109

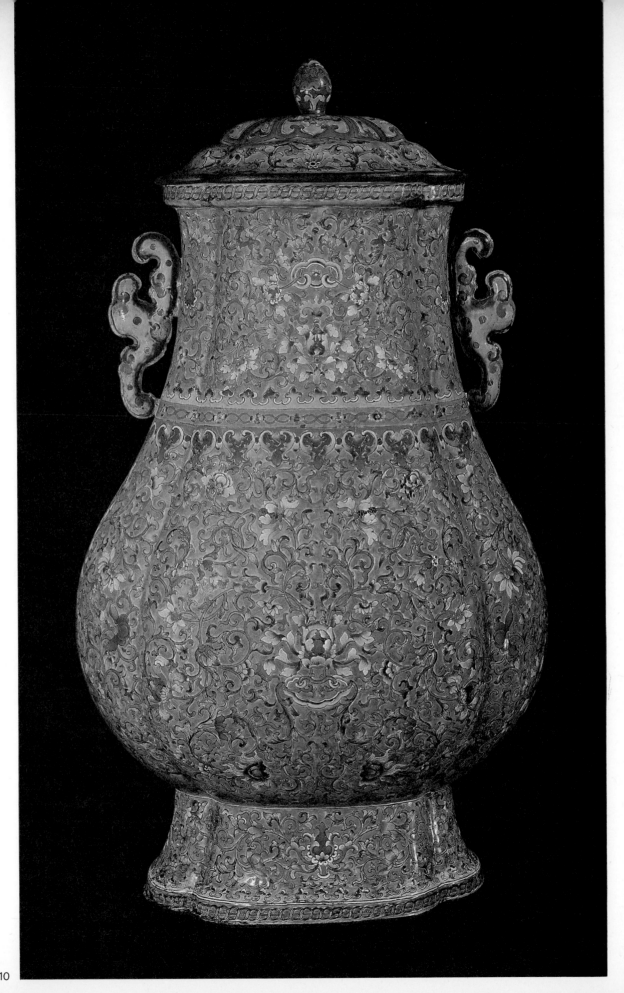

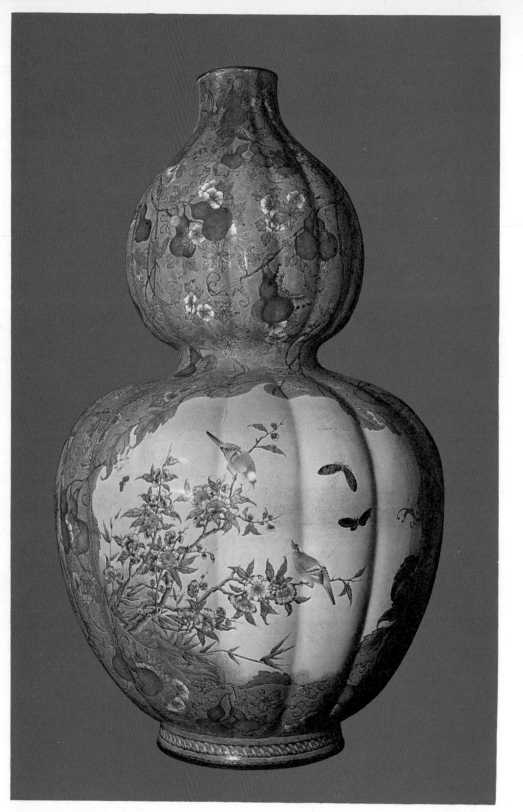

112

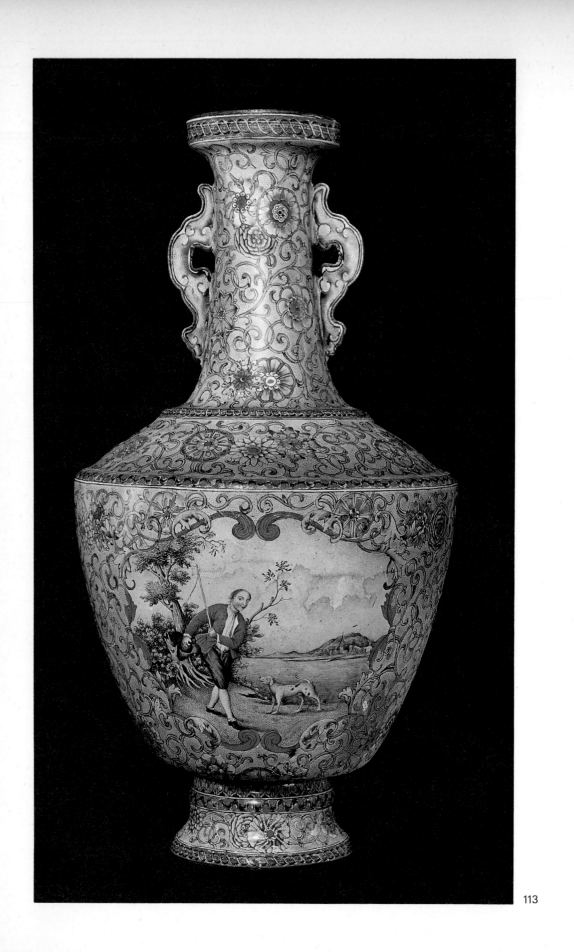

114. ROUND BOX AND COVER. PAINTED ENAMELS ON COPPER

Mark and probably period of K'ang Hsi (1662–1722). Diameter 5.5 cm. Formerly collection Mr. R. H. Palmer, Reading

This box is decorated in pale *famille rose* colours, which have an early look. On top are floral scrolls round a central floral medallion, and on the lower part floral scrolls are repeated. The mark *K'ang Hsi yu chih* is in black in a double square.

115. BOWL. PAINTED ENAMELS ON COPPER

Mark and probably period of K'ang Hsi (1662–1722). Diameter 15.5 cm. Formerly collection Mr. R. H. Palmer, Reading

This bowl is decorated on the outside with branches of flowering plum blossom in pale pink against a pale yellow ground. The inside is turquoise blue.
The white base bears the mark *K'ang Hsi yu chih* (K'ang Hsi Imperially made) in a blue enamel double square.
Compare with plate 104.

163

116. PAIR OF VASES. COPPER PAINTED WITH ENAMELS

Mark of K'ang Hsi and probably of the period (1662–1722). Height 13.5 cm. Palace Museum, Taiwan

These vases are decorated with floral pattern and ornamental scrolls. The right hand one carries the four different auspicious fruit ("Buddha's hand" citron, pomegranate, lichee and peaches) together with flowers of the four seasons; the left hand one is decorated with grapes, melon, lotus and apple blossom, in each case on a yellow background for the body, and light blue ground for the neck. The eight seal characters in medallions with jewelled pendants are read together and may be rendered:

"May your longevity be like that of the mountains and the peaks. May your happiness be as vast as the seas and heavens".

The Imperial K'ang Hsi mark is written in four characters in a double frame on the bottom of each. When these pieces were exhibited in America there was doubt about the genuineness of the mark and the American catalogue says, "They are more likely to date from the later decades of the 18th century". But it seems to the author that they may well be the period of the mark. In design the vases compare with the vase illustrated in colour on plate 103, which has an Imperial K'ang Hsi mark in blue enamel and must also be a Palace piece.

117. SQUAT VASE, POSSIBLY A SPITTOON. COPPER PAINTED WITH ENAMELS

Imperial K'ang Hsi mark (1662–1722) and probably of the period. Height 7.5 cm. Palace Museum, Taiwan

This vase has a *ju-i* lappet panel round the neck containing rosettes. The body is decorated with large peony blossoms with foliage on a yellow ground.

The genuineness of the Imperial K'ang Hsi mark on the base is questioned in the American catalogue of the objects from the Palace Museum, Taiwan, where it says "it is probably an interpolation made some fifty years later". The present author is inclined to believe in the possibility that the piece is the period of its mark.

118. TEAPOT. COPPER PAINTED WITH ENAMELS

Imperial mark of K'ang Hsi (1662–1722) and probably of the period. Diameter 16.5 cm. Palace Museum, Taiwan

The decoration of this teapot consists entirely of chrysanthemums, either disposed in enamel colour on the body of the teapot on a yellow ground, or as a single chrysanthemum in a large raised medallion on four sides of the vessel. The lid is the underneath of a single chrysanthemum, while the neck, spout and handle are decorated with chrysanthemum rosettes. The Imperial four-character mark of K'ang Hsi is in blue enamel on the base. The American catalogue of the Palace Treasures from Taiwan believes that it is "probably late Ch'ien Lung", but the present author thinks it possible that the piece is the period of its mark.

119. DISH. PAINTED ENAMELS ON COPPER

18th century. Diameter 20 cm. Formerly collection Mrs. Alfred Clark, Fulmer, Bucks.

This attractive hexagonal petalled dish is decorated in the centre with a group of flowers, butterflies and "Buddha's hand" citron in *famille rose* enamels, with a lavender blue diaper border picked out in black.

166

120. TRAY. PAINTED ENAMELS ON COPPER

18th century. Length 20.5 cm. Collection Mrs. R. H. Palmer, Reading

This leaf-shaped tray, with a butterfly-shaped handle, is decorated in *famille rose* enamels with a bulbul (a Chinese nightingale) perched on a peony spray growing from rocks on a lavender ground.

The underside is enamelled pale pink. There is no mark.

121. WINE-EWER. PAINTED ENAMELS ON COPPER

*Ch'ien Lung period (1736–1796). Height 17.5 cm. Formerly
collection Mrs. Alfred Clark, Fulmer, Bucks.*

This type of ewer is not uncommon in the West, and, like
Cantonese enamel kettles on stands, seems often to have
been included with sets of armorial porcelain made for the
British market. The hoop handle denotes that it is a wine-
ewer rather than a teapot.

It is decorated in *famille rose* enamels with panels of birds
and flowers. The side illustrated shows a Chinese blue jay
perched on a wild rose with diaper surround. The lid is
picked out in black.

This is a typical piece of Cantonese enamel made for the ex-
port market.

122. VASE. PAINTED ENAMELS ON COPPER

*Ch'ien Lung period (1736–1796). Height 14.6 cm. Formerly
collection Mrs. Alfred Clark, Fulmer, Bucks.*

This bottle-shaped vase is charmingly decorated in the Chi-
nese taste with a spray from a fruiting and flowering peach
tree and bats against a background with clouds. It was prob-
ably made for the Chinese market.

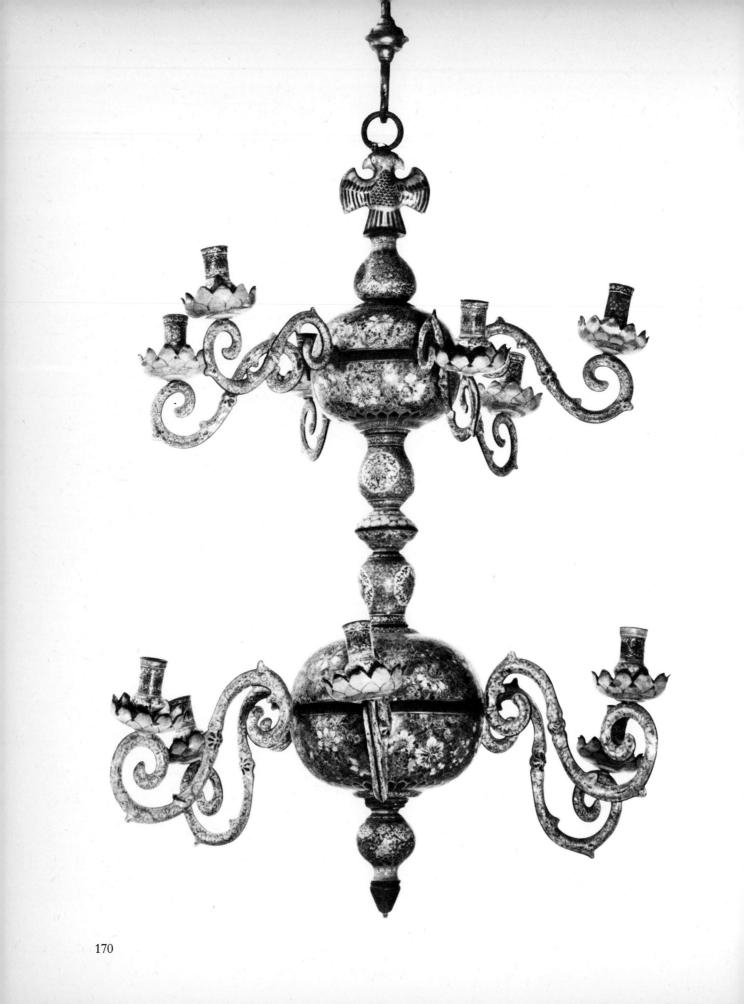

170

123. CANDELABRUM, ONE OF A PAIR, PAINTED ENAMELS ON COPPER

Date 1740. Height 82 cm. Rosenborg Castle, Copenhagen

The interest of these candelabra is that, at the moment of writing, they are the only exactly documented pieces of Cantonese enamel known to the author, although no doubt others exist.

The supercargo Lintrup of the Danish Asiatic Company ordered this pair in 1740 in Canton together with a number of other objects, including a bureau and 16 sconces, and a mirror frame in Cantonese enamel. They were dispatched from China on December 8, 1740. (See André Leth. *Det danske Kunstindustrimuseums Virksomhed*, 1956, p. 55 figs. 27 and 29.)

124. VASE WITH HANDLES. GOLD PAINTED WITH ENAMELS

Mark and period of Ch'ien Lung (1736–1796). Height 8.5 cm. Palace Museum, Taiwan

On the body of the vase, which is covered with floral scrolls, is a brocade pattern and two framed panels with European figures and buildings in a landscape. On the neck, which has dragon handles, are two other panels. The one on the side illustrated depicts two swallows in a branch of flowering apricots; on the other side the panel shows more birds, prunus and bamboo. This vase is of superb quality.

Only a limited number of painted enamel pieces seem to have been made on gold, and these only for the Palace. The painting of the women might be by the hand of Lang Shih Ning (Castiglione) who was reputed to have done similar painting of European women on pieces of *ku yüeh shan* porcelain, but it is more probably by one of his Chinese pupils.

125. TEA-BOWL AND COVER. CLOISONNÉ AND PAINTED ENAMELS ON GOLD

Mark and period of Ch'ien Lung (1736–1796). Height 8.5 cm. Palace Museum, Taiwan

This tea-bowl is a combination of cloisonné and painted enamel. On this piece a cloisonné ground, decorated with peony scrolls, surrounds four panels of landscape scenes with European figures in painted enamels. A coral bead serves as a finial to the lid.

126. EWER, CUP AND CUP-STAND. CHAMPLEVÉ AND PAINTED ENAMELS ON GOLD

Mark and period of Ch'ien Lung (1736–1796). Ewer: Height 19 cm. Palace Museum, Taiwan

In these three pieces the compartments for the enamel are sunk in the body instead of being kept from running together by built-up metal wires. In this case painted enamel panels containing European subjects are reserved on each piece and a coral bead and a gold chain are attached to the finial of the ewer.

This is the kind of ewer from which one assumes the Imperial concubines took their wine.

172

CHAPTER VI: LACQUER

Lacquer is the sap[1] of the lacquer tree (Rhus vernicifera), the *ch'i shu* of the Chinese, and is a ready-made product of nature. Trees are said to supply the best quality of lacquer when they are between fourteen and fifteen years old. Some of the lower grades may be adulterated with the sap of other trees and such substances as pig's blood, while the Burmese lacquers are made from the juices of an insect. The lacquer tree is indigenous to the southern and central provinces of China, and was probably introduced to Japan by way of Korea in the 6th century A.D. It is grown today more especially in Chekiang, Fukien, Anhui, Kuangsi, Hupeh and Szechwan, and in the wild state is almost entirely confined to foothills from twelve hundred up to fifteen hundred feet; it is probable that it once enjoyed a much wider habitat and grew in the plains, from which it has since disappeared. Lacquer trees will grow anywhere – on mountains, in woods, on plains – and cultivation is not difficult; they need no manure, but weeds ought to be cleared away from them during the first four or five years of growth. Chinese sources suggest that they once spread over the whole of Honan and southwestern Shantung, where, as far as I know, they are quite unknown today. Attempts appear to have been made as early as the later Han period to re-introduce this tree into parts of Honan where it had formerly flourished.

In the preparation of lacquer horizontal incisions are made in the bark of the tree, or small branches are cut off, barked, and soaked in water. When the bark has been pierced or removed a white resinous substance exudes slowly from the stem, which turns from transparent white to grey and then to black when exposed to the air. It is drained from the tree into small wooden dishes and sent to the market in a semi-fluid state or dried, in cakes. This tapping takes place in the summer time from June to September. Impurities are removed by constant boiling, stirring, skimming, and straining through a hemp cloth. Lacquer is applied with a spatula or brush. The *Liu tzǔ hsiu lun* says:

"When a good workman brushes on lacquer juice, if he does it very slowly then it is too hard when it dries, if he does it too quickly it is not hard enough or smooth. He does it not too slowly and not too quickly."

It can be used to coat the surface of almost any material. In China it has been applied to fabrics, bronze, porcelain, basketwork, pewter and, most commonly of all, wood. It provides a smooth surface of a lustrous hue which can be artificially coloured; it is a splendid preservative and gives a smooth surface for carved and painted decoration.

Either soft pinewood or a rough hempen cloth supply the skeleton of most Chinese lacquer objects. Lacquer must be dried in a damp atmosphere, and it is at all times adversely affected by a very dry climate. The Japanese today often dry off their lacquers on lakes in boats.

There are numerous ways of decorating the surface of lacquer. It can be carved, painted, or inlaid with shell, ivory, jade or semi-precious stones. The Chinese have made it in a large range of colours

including yellow, light brown, chestnut, olive-green, black, aubergine, gold and silver, and various shades of crimson and vermilion. The colour of red lacquer comes from cinnabar, black lacquer from iron-filings, yellow lacquer from orpiment (the yellow sulphide of arsenic).

One of the problems in tracing the records of lacquer in the early Chinese texts[2] is the variety of the terms used and the difficulties of identifying them. One of the earliest references to lacquer is a passage on the decoration of musical instruments in the *Book of Songs* which is believed to go back to the 9th century B.C., but we cannot be certain of the interpretation. *The Book of History*, a collection of historical documents of equal age, appears to refer to tributes of lacquer. The legendary Emperor Shun is said to have used lacquered wooden dishes for eating, and for sacrificial vessels, which were black outside and red inside – the characteristic colours of later times. He was the first person to make lacquer, and his ministers, finding this very extravagant, petitioned against the making of it and stopped production. There are many references to lacquer in the *Chou-li*, a ritual text compiled in the Chou period, when the substance was used in the decoration of carriages, harness, and bows and arrows.

The art of lacquer manufacture, like that of porcelain and silk, is a Chinese invention. It did not even begin to make its impact on the West until the end of the 17th century. At this time it had a great vogue in Holland, France and England, where it was imitated by a varnish, based on shellac, which was far less durable. But because the Chinese export lacquer for the West was of poorer quality than the black lacquer exported from Japan, it was Japan, not China, which was credited in the West with the manufacture of the best lacquer. The name 'Japanned ware' survives in use today.

The statements made in the *Chou-li* concerning the use of lacquer on important paraphernalia of official and military life are borne out by discoveries made in excavating Shang and Chou tombs. With one exception, which we shall notice below, the evidence is of lacquer used as paint on wood, its preservative virtue in this connexion having apparently been appreciated from very early times. Red lacquer was probably used to colour the pillars and sides of some sepulchral chambers of the Shang period. Examples of red pigment, believed to be made with a lacquer base, have been recovered from the royal tombs at Hsi Pei Kang and from a similarly impressive tomb at Wu Kuan Ts'un, both near the Shang capital at Anyang in Honan. In both instances the paint covered elaborate relief carving on wood, which had perished long before the tombs were opened. It is possible also that the paste used to fill the interstices of relief ornament cast on ritual bronze vessels, setting off the designs against a black or red ground, was prepared in a lacquer medium. In these specimens the condition of the pigments does not, however, allow a categorical identification of the basic substance. We are on surer ground regarding a vessel of the *tou* form excavated at Shang Ts'un Ling in Honan and attributable to the period 750–650 B.C. The wrinkled skin covering the core, presumably of wood, is clearly lacquer, and it is inlaid with large roundels of a white material[3].

A later stage of the story is documented by the find of massed chariots buried in one of the great tombs at Hui Hsien, Honan. Again the wooden parts of the vehicles had vanished, leaving scales of their red paint adhering to earth 'ghosts' of their shapes. From a time about a century later than the Hui Hsien tombs, we owe abundant evidence of lacquer craft to the fortuitous circumstances of the sandy

and damp subsoil near Ch'ang Sha in Hunan province, an ancient capital of the Ch'u state, where local kings were still recognized by the Han emperors. From the tombs of an extensive burial ground, sited near the town, and spanning the last three centuries B.C., have been recovered in recent years (latterly in controlled excavations) a great variety of relatively intact pieces of lacquered ware, some with painted ornament of the most sophisticated kind. The majority of these are cylindrical boxes, often with the interior subdivided, usually containing other small boxes, combs and appurtenances of the toilet. Other lacquered objects included trays, musical instruments, the facing of shields, and a number of grotesque cult figures – tongue-protruding monsters, and the pair of cranes set on snakes illustrated on plate 127. The less ornate pieces are decorated with vermilion, others have yellow and even green and white besides, all in lacquer paint on a black lacquer ground. The lacquer of the boxes is on a thin wood base, which after removal from the ground has shrunk and robbed the objects of the pristine splendour which met the eyes of the excavators. The dating of these finds, depending on the accompanying material (particularly bronze mirrors), is less sure than could be desired, but it is clear that a considerable proportion of them belong to the pre-Han period. They probably do not go back much, if at all, beyond 300 B.C. It is thus established that the tradition of the lacquer craft which flourished – on the evidence of inscriptions on the pieces – in the 1st century B.C. had a comparatively long history. The toilet-box of plate 131 and the cups of plates 129 and 130 closely resemble specimens of pre-Han date found at Ch'ang Sha[4].

On 3rd century lacquer both figures and abstract ornament are to be found. Women in rows, standing or seated in a pavilion, decorate a toilet-box with bronze feet and ring handles and lid-mounts, and mark the beginning of the first decoration with the human figure. A scene of horsemen and a chariot in a summary landscape shows an increasing sophistication that suggests an early Han date. The greater part of the ornament is, however, copied from the geometric style of the late Chou period, whose lively and elaborate dragon scrolls are very exactly reproduced on such a piece as an almost intact shield-facing, which, painted in red and yellow on black, is almost certainly pre-Han. Subsequently, in Han times, this kind of ornament was continued, suffering either a simplification (often dispirited enough) or conforming to the cloud scrolling which the Han artists developed from the traditional patterns. These Han lacquer factories were strongholds of conservative taste. Originality appears most strongly in the free, painterly handling of the scrollwork as it appears on the toilet-box from Haichow in Kiangsu (plate 131).

There is no trace among the Ch'ang Sha material of any attempt to carve thick lacquer in the manner which revolutionised lacquercraft a millenium later, in the Yüan dynasty.

Wine-cups with flange handles, called *pei*, like those illustrated on plates 129 and 130 which appeared in great numbers at Ch'ang Sha, have also been found at other widely separated places – at Noin Ula in Northern Mongolia, Tun Huang in Kansu, and especially at Lolang, the Chinese colony in North Korea. This last place is the provenance of the splendid specimen of plate 129. Its inscription gives an insight into the elaborate organization of the lacquer industry in Han government workshops[6].

"4th year of Yuan Shih (A.D.4). Shu Commandery. West factory. Imperial cup of wood, lacquered, engraved and painted, with gilded handles. Capacity one *sheng*, 16 *yüeh*. Initial work, *I*. Application of lacquer, *Li*. Top work, *Tang*. Gilding of bronze handles, *Ku*. Painting, *Ting*. Engraving, *Feng*. Finishing, *Ping*. Production, *Tsung Tsao*. Official in charge of the soldiers of the factory guard, *Chang*. Manager, *Liang*. Deputy, *Feng*. Assistant, *Lung*. Head clerk, *Pao Chu*."

The West factory is one of three which are recorded in Han times in the Shu Commandery, which is included in the modern Szechwan province. At least another ten lacquer factories are known to have been established by the Han government. Their products appear to have been used as official gifts, particularly, one might think, to officers exiled at outposts of the empire. The grave of Secretary Wang Kuang at Lolang contained eighty-four thousand lacquered vessels, including cups, ladles, goblets, a clothes chest, cosmetic boxes and trays. The record of the workmen's names given in the inscriptions on a number of cups commemorates the meticulous bureaucracy on which the strength of Han government was built. The finer ware, such as the British Museum pieces just instanced, was constructed on a base of coarse cloth, *chu*, which has been held to be hempen cloth, though recent investigation has shown it to be ramie. The style of the lacquer painting varied between the comparatively heavy manner seen on the cup of plate 129 and the delicate movement of the design on the toilet-box of plate 131. There is some evidence that, within these limits, the factories practised individual styles. The design of birds and spirals seen on the cup seems to have been used at the Kuang Han factory of Shu as early as 43 B.C. It is last recorded at the West factory in A.D. 13. There is a gap in the series of dated cups between A.D. 13 and A.D. 45. Between A.D. 45 and A.D. 71 the cups made at both factories were lacquered in plain black. It thus appears that the traditional geometric ornament was discontinued towards the middle of the 1st century A.D. A circular tray of the West Factory, made in A.D. 69, is plain but for small deer and a pair of celestial beings riding on a cloud. This revolution in the decorative style points the way to the famous painted basket found in a 2nd century tomb at Lolang. The basket is decorated with seated rows of male figures painted in red, white, yellow and green, all engaged in animated conversation and portrayed with obvious humour. Here the lacquer medium is used by the painter with complete freedom. Unfortunately, among the survivals of late Han lacquer there is nothing to show that this emancipated manner flourished to the same extent as the more timid official art of the factories.

Between the end of the Han period and the T'ang dynasty the gap in our knowledge is quite complete as regards surviving material. We hear of a lacquerer, Shên T'u-p'an[7], who is said to have worked for fully ten years on some important pieces of lacquer in the 2nd century A.D., and a prince of the Northern Wei, Hsiao P'o-chuan (484–502), who decorated his palace with red and green lacquer, but it is unlikely that any of these pieces has survived.

T'ang lacquer (618–906)

From the historians of the T'ang period we know that both architecture and sculpture were decorated with carved lacquer in different colours, and small pieces of furniture were powdered with fine gold and silver. But very little is known at present of the lacquer of the T'ang period outside Japan, and it is to

the Shōsō-in collection[8] (deposited at Nara in the grounds of the Tōdaiji Monastery by the widow of the Emperor Shomu after his death in 756) that we owe our chief information. This collection contains many lacquered bronze mirrors and musical instruments inlaid in ivory and mother of pearl. Whether these were made by Chinese workmen, or by contemporary Japanese, or Koreans in imitation of the Chinese, is still disputed, but it is not likely that they were manufactured in Japan. The technique and designs of these pieces are quite alien to earlier Japanese tradition. It is not, however, possible to determine whether these imports came from China or from the centres of Korea under Chinese influence. In the T'ang history we read: "The people of Hsiang Chou made lacquer and others copied their methods. It was said that the shape and form of the best lacquer was that of Hsiang."

But we cannot yet identify these objects. Curious 'dry' lacquer figures of gods and animals appear on the market from time to time with a T'ang attribution. Many of these, for all we know, may be of Sung date, and some are fakes. Lacquer work with inlay of mother of pearl is particularly associated with the T'ang period. Whether such work was executed at an earlier date is difficult to say, though on present evidence this seems impossible. It has also been suggested that the first carved lacquers date to the T'ang; and when we reflect that carved wood covered with lacquer was known by the later Chou period, it would not be surprising if the further step of carving the lacquer itself had been taken as early as T'ang times.

The clearest evidence for the modelling of figures in lacquered cloth in China during the T'ang dynasty is the appearance of this technique in Japan at a time when the Chinese arts were being actively imitated. In Japan the method was termed *kanshitsu* ('dry lacquer'). Several figures made in this way have survived at the Kōfukuji temple in Japan, but the number of such pieces which can plausibly be attributed to China of the T'ang and Sung dynasties is very small (plate 143). In the lack of other evidence, it is difficult to speculate on the course of development of lacquer craft in China from T'ang times until the beginning of the Yüan period, when new methods were invented. For use as a fine tableware we may imagine that lacquer was early displaced in China by the relatively cheaper porcelain. In Japan, on the other hand, it was not until the 19th century, when porcelain first became cheap enough for ordinary people, that lacquered table vessels ceased to be generally used.

Sung lacquer (960–1279)

The Sung lacquerers, as we know them, seem to have specialized in simple uncarved shapes, soup bowls, small dishes in the shape of lotus flowers, petal-shaped cups with stands, and round boxes without painted or carved decoration. Most of these are small pieces (plates 144, 145 and 147). Yet the *Ch'ing pi tsang* (Collection of artistic rarities) by Chang Ying-Wên, published in 1595 by his son Chang Ch'ien-tê, says:

"The people of the Sung dynasty carved red lacquer objects for palace use. For many they used gold and silver to make the body and these were very skilfully carved, round and masterful with hidden edges, which are not disclosed; and they used red vermilion which was very bright, and the lacquer was solid and thick with no cracks. (In it) they carved landscapes and storied buildings, and figures and birds and animals like painted pictures. In this kind of work they were unsurpassed."

177

The *Tsun shêng pa chien* by Kao Lien (published in 1591) adds:

"Master Kao says: 'The people of the Sung dynasty carved red lacquer like the small boxes used in the palace. Most of these had gold and silver bodies covered with thick crimson lacquer juice in several tens of layers and carved with figures, palaces, the tea shrub, grasses and so forth. The skill of the workmen in carving and engraving made them just like painted pictures. Some had lead bodies, others a grey lacquer ground, others red flowers on a yellow ground, the two colours very brilliant. They also used lacquer juice of five colours. The method of carving the body is deep and hollow according to fashion, exhibiting colours like red flowers, green leaves, yellow chrysanthemums, black stones and so forth. If you look upon them your eyes are dazzled. Nowadays there are very few pieces left. On another kind they used red to make a background upon which to carve brocade designs, and used black to make the outside face, and carved flowers on this ground. Those with flowers in red and black are very lovable. There are many boxes and plates and cases, and so forth, made. The boxes show steamed-cake form, the Western river form, the sugar-cane form, the three-meeting form, the two-meeting form, the plum-flower form, the young-gosling form; the big ones about a foot in length, the small ones little more than an inch, the two faces carved with flowers. The plates are both round and square, kidney-form, four turned in corner-form, four corner peony-form. The cases are oblong, exactly square, two-meeting form, three-meeting form, all four kinds."

After this it is a little confusing to read in the *Ko ku yao lun* that "during the Sung dynasty the articles made for the palace were of gold and silver lacquer without decoration". I must confess I am at a loss to identify this carved red lacquer of the Sung period; but if we are to trust these two accounts there is every reason to believe that it existed. As for the lacquer on gold and silver "bodies" (there is no doubt that this is what the term used means), I have still to see it. Both gold and silver lacquer grounds may well date back to the Sung. Some of the lacquered objects in the Shōsō-in have drawings in gold and silver upon them, and the *Ko ku yao lun* says such pieces were made at the beginning of the Yüan in Chekiang. The *T'ui ch'ao lu* also says that "green lacquer was first made by Wang Chi Kung in the time of Hsiang fu (1008–1017) and T'ien Hsi (1017–1022). This kind of lacquer comes from Chiangnan (Chekiang). It was very simple and plain; after the time of Ch'ing Li (1041–1049) Chê Chung began to make this kind of lacquer". There were certainly Sung pieces inlaid with mother of pearl. We hear also of lacquer figures made in Sung times. The *I chien chih* mentions that "in the time of Shun Hsi (1174–1190) there was a lacquer figure of Kuan Yin in the White Cloud Temple of Min Ch'ing (Fukien)".

Lacquer is a dangerous substance to handle. The Sung artist Su Tung Po, in his collected essays, says that when he ordered lacquer, if his workmen suffered from lacquer poisoning he gave them crab to eat, which was a certain cure against the poisoning; he adds "if lacquer juice be added to Indian ink it makes it still more brilliant, but you have to add crab yellow (intestines of the crab) to dilute it, otherwise it is hard and obstinate". The *Pên ts'ao kang mu* (published in 1596), though remarking on the danger of lacquer poisoning, tells us "if a woman gives birth to a child and she faints, the smell of burnt lacquer will revive her; it also keeps off insects".

It is to Japan rather than to China that we must turn for the identification of, and for further information on Sung lacquer. More than one Chinese text of the period on the subject has survived in a Japanese translation. Chinese lacquer of this period was used in the Tea Ceremony. Small Chinese boxes of undecorated lacquer might very well lend themselves to this use. Japanese sources relate that P'êng Chün-

pao, who was working in lacquer in gold relief about 1279 (the end of the Southern Sung, and the beginning of the Yüan), made pieces of lacquer which in shape were copies of *Ting yao* porcelain (plate 144), and that some pieces of carved black lacquer he inlaid on a mixture of lacquer and resin with silver and gold mosaics. Any of the pieces that were made by this lacquerer, if they can be identified, will probably be found in Japan. The technique of inlaying silver on lacquer is exemplified much earlier by material from the tomb of Wang Chien (A.D. 918) which included a lacquered box decorated with roundels of *ajouré* silver sheet.

Yüan lacquer (1279–1368)

The Chinese texts that I have been able to consult give no information about the painted, incised or undecorated lacquer of the early Yüan dynasty, beyond the reference to P'êng Chün-pao. It is not until we reach the closing years of the dynasty that we hear of two artists working in carved red lacquer, Chang Ch'êng and Yang Mao. The *Tsun shêng pa chien* says:

"In the Yüan dynasty there were Chang Ch'êng and Yang Mao; but these two did not use lacquer thick enough, and much of it was cracked."

The *Ko ku yao lun* tells us they worked at Hsi T'ang Hui in the province of Chekiang and that:

"they carved red lacquer very well and became famous, but their vermilion coating is thin and much of it does not wear well. Both Japan and Luchu are extremely fond of their work. Today the people of Ta Li Fu in Yunnan make it, but there are many spurious imitations. Many of the noble families of Nanking have genuine specimens. There is one kind which is entirely red and another which is black mixed with red. Good specimens are valuable but there are many imitations, and great care is needed to distinguish them."

Several pieces purporting to have been made and signed by Chang Ch'êng are known to me and some of these are in Europe[9]. One dish signed by Yang Mao is in Sir Percival David's collection. There is unfortunately no doubt that the work of both these artists has been widely faked, particularly in Japan.

The most satisfactory evidence of these two lacquerers is provided by a box recently excavated from a tomb datable between 1351 and 1359[10]. The box is of red lacquer carved on the top with a scene of figures in landscape, and on the sides with borders of key fret. It is similar to some boxes in the Peking National Museum which are marked with the name of Chang Ch'êng. Garner holds that carved lacquer (apart from some rudimentary carving on T'ang lacquered armour) was first made in the Yüan dynasty[11].

The most important work on the minor arts, the *Ko ku yao lun* (to which we have referred several times above) was written by Ts'ao Chao in 1387, in the reign of Hung Wu, and reprinted in 1459, the texts of the two editions differing slightly. It divides lacquer into five categories, which hold good for the Sung dynasty and later. The author says:

"Old carved lacquer objects and utensils have a smooth ground. The purple lacquer is the dearest. Their bottom is like concave earthenware, bright and fine, strong and thin. Their colour is like the fruit of the jujube tree, and so they are commonly called jujube lacquer and there are those deeply cut and in strong relief. These are the commoner. Those that were of old times in Foochow are of a yellow colour with a glossy surface and with round flowers in relief and are called Foochow lacquer. They are strong and thin and hard to get and they also have red markings.

During the Yüan dynasty a new factory was established in Chia Hsing Fu at Hsi T'ang, Yang Hui, where lacquer was made in considerable quantities and carved in deep relief, but they have an oily surface and only a few pieces are very hard, for the rest the yellow ground easily chips.

1. *Carved red (t'i hung)*. No matter whether articles of this lacquer are old or new they should be distinguished according to the thickness of their vermilion and the freshness of their red; the strength and sleekness of their lacquer; and their heaviness. Those [with these qualities] are the best. The carved sword-rings, the perfume grass boxes are still better; such as the yellow ground ones carved with landscapes and figures and flowers, trees and birds and animals, but although the workmanship was very skilful and they are cleverly finished, they are easily chipped and damaged, for the vermilion crust is thin: and the price of the red ones is very low.

During the Sung dynasty the articles made for palace use were of gold and silver lacquer without decoration. [Here follows the passage about Chang Ch'êng and Yang Mao, already quoted above.]

2. *Painted lacquer (tui hung)*. Imitators of carved red lacquer use lumps of raised lime and cover it with lacquer juice. Such objects are called *tui hung*, but the sword-rings and perfume boxes they made in this way are not worth much money; it is also called *chao hung* (plastered red) and is made today in quantitites at Ta Li Fu in Yunnan.

3. *Lacquer with gold relief (ch'iang chin)*. Those objects in gold relief lacquer which are very hard and well painted are very good. At the beginning of the Yüan period at Hsi T'ang in Chekiang was an artist, P'êng Chün-pao, who was very famous for this work. He painted landscapes and figures, pavilions and temples, flowers, trees, birds and animals and so on, all very marvellous and beautiful. At Ning Kuo Fu today there are *miao chin* [pencilled in gold] objects made in the two capitals [Nanking and Peking]: there are many others who do the same work.

4. *Pierced lacquer (tsuan Hsi)*. Pierced lacquer objects in which the body is strong generally date from the Sung dynasty, and are old pieces. The gold decoration of figures and landscapes etc., has been made by using a drill to hollow out the empty places and so it is called *tsuan hsi*.

5. *Mother of pearl inlaid in lacquer (lo t'ien)*. Lacquer objects with mother of pearl inlay come from Kiangsi, Chian-fu, Lu Ling-hsien. In the Sung period they were made for imperial use, and the old pieces are very strongly lacquered. Some of the best have an inlay of copper wire and these are very good.

In the Yüan period those which were ordered by rich families were made at leisure; they are very strong and the figures are delicate and lovable. Today much of the modern work of Lu Ling is mixed with lime and pig's blood and vegetable oil and is not strong, and is easily damaged. They even use the rhizomes of lotus root, but that is still worse and does not last.

They must be made in private houses in order to be strong and good. Today in Chian-fu department, old families have preserved beds and chairs, screens inlaid with mother of pearl and decorated with figures, which are marvellously beautiful and excite universal admiration. Many of the big families have newly-made fruit boxes, inscribed plaques, low chairs, which are as good as the old ones, because they are privately made. In the time of Hung Wu they confiscated the property of a Soochow man called Shên Wan-san. This family had big benches, chairs and tables inlaid with mother of pearl and carved red lacquer which was very good. In the various yamens of the six departments, pieces are still preserved."

Ming lacquer (1368–1644)

The tradition set by the two renowned Yüan artists was carried on by their children. The *Records of Chia Hsing* (a town near Hangchow) tells us:

"Chang Tê-kang, a native of Hsi T'ang, whose father's name was Chêng (Chang Ch'êng) came from the same district as Yang Mao, both of them were masters of the art of painted and carved red lacquer. In the time of Yung Lo Japan and Liuchow bought these kinds of lacquer and presented them to the Chinese court. The Emperor Ch'êng Tsu, noticing this, called upon the two lacquerers to (go to court), but both had already died. Tê-kang was able to continue his

father's work and went to Peking, was examined by the Emperor and gave satisfaction and was appointed assistant in the Ying Shan factory to repair the fortunes of his family; in that time another person, Pao Liang, was as skilful as Tê-kang. During the time of Hsüan Tê, he was called to be an assistant at the same factory."

From the end of the Yüan onwards, the majority of red lacquers were carved. The lacquer was put on thickly, often in different colours and cut back from the surface when it was cold to expose one or more of the colours. This technique is said to go back to the Sung period. The most famous pieces seem to have been produced at the Kuo Yüan (fruit garden) factory.

The *Tsung shêng pa chien* tells us:

"In the Yung Lo period they used pewter bodies or wooden bodies, and carved on the bodies very fine brocade pictures. For the bottoms they used black lacquer juice and used a pin to scratch the characters *Ta ming yung lo nien tsao*. The style of the inscription was somewhat superior to that of Sung and Yüan. In the period of Hsüan Tê the red colour was brighter and fresher than in that of Yung Lo; the lacquer bottoms were also bright black lacquer and cut with a knife with *Hsüan Tê nien tsao* (made in the Hsüan Tê period), and they used gold dust to fill them. The plates and boxes were both large and small just like those of the Sung and Yüan dynasties, and there were parted hairpin vases, and dinner cups like those described in the *Tea Classic*, and tea-bowls, perforated-through-the-heart boxes, and walking sticks, fan sticks, inkstone cases and so on.

Those that are made for the people are mostly black, their worksmanship very pretty and skilful; there are chairs, plates, boxes, nests of boxes, spring-meeting forms, all these objects lacquered; from the four and five-inch perfume boxes, to those of little more than an inch; there are very few of these pieces. In Yunnan province there are artisans who make a profession of making them, but they do not use a knife so skilfully as to hide the sharp points, and they do not grind the corners smooth. Although their use of cutting is very detailed, they do not use enough lacquer. Still the old pieces are acceptable, but modern ones not worth looking at. And there are copies made of red alum, heaped and piled and carved and covered over with two coatings of red lacquer, made for stupid buyers; it is necessary to distinguish them.

In the time of Mu Tsung (1567–1573) at Hsi An, Huang P'ing-sha made lacquer that can compare with the best of the Royal factory – flowers, fruit, figures, all marvellously done. His method of carving was smooth, clear and clean. Alas! The bad workshops for profit have made many imitations. All of them are beneath contempt and should not be looked at, when compared with those of ancient days, of which one box was worth three thousand cash. Today they are no more. How is it possible to make good ones?

At Nanking they also made this sort of thing. At the beginning of the dynasty we had the fine painted lacquer of Yang Hsüan, and the Wang family coloured lacquer, the worksmanship of which was very good. My family possessed one or two pieces very superior to other articles. For the painted lacquer they used white powder, after several years it became black, but Yang painted a plum blossom picture-screen using broken lines and plum flower dots, which is still like snow. The method of using colour was very skilful we know. In the time of Hsüan Tê they used five-colour concentrated lacquer, raised to make flowers, they rubbed the colour flat as in painting. It seems it was rather hard to make; for even when worn it looks like new. Today there are also very few of these. Then there are the floating-sunset gold dust, inlaid shell-work and raised lacquer and so on. Also at Hsian An, Fang Hsin-ch'uan made good ones, like the inlaid gold-dusted Japanese boxes."

It is interesting to find a complimentary reference to Japanese lacquer as early as the end of the 15th century, and to hear that the work of Chang Ch'êng and Yang Mao was apparently brought to

181

the attention of Yung L'os court through Japanese gifts. Hirth tells us too that lacquer presents, brought by a Japanese Embassy to the court of Hsüan Tê, excited the greatest admiration[12]'. Several Chinese workmen in metal and almost certainly some Chinese lacquerers went to study their trade in Japan at this period. We know one lacquerer, Yang Hsüan, imitated Japanese models in the reign of Hsüan Tê, for the *Tung Hai Chi* says:

"Yang Hsüan, whose pseudonym was Ching Ho, had a father who used to send men to Japan to learn the splash-gold and paint-lacquer methods. When they came back Hsüan learned it from them and himself added his own ideas. He used five colours combined with gold filigree. His work was very natural and brilliant. The Japanese lacquer-smiths, on seeing it, bit their fingers and ranked him very highly, saying that they could not equal his work."

The *Ch'ing pi ts'ang* repeats the information that, whereas the inscriptions on coral-red lacquer of the Yung Lo period were scratched, on that of the Hsüan Tê period they were cut with a knife and filled with gold dust:

"The method of carving was far inferior to that of the Sung, and the bodies of their lacquer were powdered with gold and inlaid with shell and pieces of gold and silver. This kind of lacquer only the Japanese make really well. Imitations are heavy and easy to distinguish."

The *Chin ao t'ui shih pi chi* tells us that:

"The Kuo Yüan workshops were situated to the West of the Lin Hsing gate. In the time of Yung Lo of the Ming dynasty they made lacquer objects with gold and silver, and lead and wooden bodies. They had carved red lacquer, and that filled in with lacquer juice – two kinds. The carved red boxes were of sugar-cane form, steamed-cake form, western-river form, three-meeting and two-meeting forms and so on. The sugar-cane form [painted] with figures were the best. And the steamed-cake form [painted] with flowers and grasses were next to them. The basins were round, square, octagonal, in circular belt style, quadrangular or peony petal form. The boxes were long and square, of two-meeting form and three-meeting form.

The method of making them was to use thirty-six coats of lacquer, carved with fine brocade decoration. The bottoms had black lacquer on which was scratched *Ta ming yung lo nien tsao* ('made in the Yung Lo period of the Ming dynasty'). Their sword-hilts and perfume-flower boxes were even better than those of Chang Ch'êng and Yang Mao of the Yüan dynasty. They were carved with flowers and birds, filled in with painted and piled lacquer juice, polished smooth like a painting. You can keep them a long time and they are still like new. Of the boxes made, the smaller are the more precious, the deep ones had five-colour *ling chih* [fungus] on the edge. The shallow one had *lei wên* [thunder pattern] edges. The price of this kind of lacquer is several times as expensive as red lacquer. These two kinds were made at the Kuo Yüan workshop."

The marks of the 15th century reigns of Yung Lo and Hsüan Tê are to be found on many pieces, the former scratched on the edge of the bottom of lacquer pieces close to the rim of the foot (plates 133, 151, 152, 153, 154, 155 and 156), and the latter cut (plates 134 and 148) sometimes at the centre, sometimes at the side. We cannot rely upon the genuineness of these inscriptions which could have been added at any time. Nevertheless we can agree with Garner in accepting a group of carved lacquers datable to the first half of the 15th century. A technical trick to be observed in them is a black line

revealed in the carving produced by a distinctive layer inserted as a guide to the carver, warning him that he was nearing the base of the lacquer. The background is sometimes formed of a yellow lacquer. Garner infers that the use of this black guide-layer was discontinued some time in the 16th century[13].

Low-Beer has proposed a chronology for the dating of Ming carved red lacquer[14]. According to him, all the best pieces of this kind were made either towards the close of the Yüan dynasty or in the thirty-two years corresponding to the reigns of Yung Lo and Hsüan Tê (i.e. 1403–1435). It is, however, difficult to give one's full assent to Low-Beer's determination of pieces made for imperial use, since he bases this only on the representation of the five-clawed dragon and the uniformity of style in the floral borders. Garner remarks that there was no imperial edict against the use of the five-clawed dragon except as regards court robes. Examples of porcelain certainly exist, decorated with imperial dragons, where the poor quality of the ware hardly accords with palace standards.

Fine lacquer must have been made at all times, and particularly during the Ming period, over extensive areas in China, including Chekiang, Yunnan, Szechwan and Fukien, but the finest carved red lacquer was always associated with Peking, and is believed to have been made in an imperial factory over a span of time not exceeding thirty years. It may eventually be possible to infer the provenance of a piece of lacquer as well as its date. "We know," writes Garner, "that the designs of imperial lacquer were based on cartoons supplied to the workers; the workmen generally seem to have been given a good deal of freedom in the choice of a subject and its treatment – we seldom see two pieces alike – the variations suggest a number of factories in widely separated places, each with its own traditional marks and ideas."[15]

The early 15th century carved red lacquer is often decorated with floral (plates 149, 151, 153 and 154) and landscape designs (plates 155 and 156). Dragons, the phoenix, and other animals and birds are common (plates 148, 152). The carving is deep, skilful and spontaneous. The floral designs usually have a plain yellow ground which has faded to buff through exposure to light, and the landscapes have red diaper grounds showing considerable differences of style and craftsmanship. Sometimes old pieces have been relacquered, particularly on the base, and others have evidently had inscriptions added later. Attributions can be based only on considerations of style and technique.

The carved red lacquer attributed to the Yung Lo period is of the finest quality and taste. The British Museum possesses a fine red lacquer covered box of this period, decorated with landscape scenes within a peony border, and inscribed *ta ming yung lo nien chih*[16], ('made in the Yung Lo period of the Ming dynasty') (plate 156) but it is not easy to distinguish these pieces from the Hsüan Tê pieces that came afterwards. This may be partly explained by the fact (as the *Chin ao t'ui shih pi chi* informs us) that during the Hsüan Tê period the Kuo Yüan workshops bought up Yung Lo pieces, erased the marks, and supplied their own! Two of these pieces were included in the Oriental Ceramic Society's Exhibition of the *Arts of the Ming Dynasty* in November and December, 1957. Mr. Low-Beer has suggested to me that it is his experience that when a *motif* of birds and flowers has been used and no background is visible, the piece is more likely to be Yung Lo, while in the Hsüan Tê pieces the background is more often visible between the stalks.

Before the end of the 15th century an entirely new style of carved lacquer develops, though there is no reason to believe that the earlier style was wholly superseded. The new manner is exemplified in the delicately carved and far less robust red lacquer dish of Sir Percival David dated to 1489, the second year of Hung Chih (plate 160). This is an important document, as up to the present no other exactly dated piece of the 15th century has come to light, and indeed there are no other marked and dated pieces until we come to the reign of Chia Ching (1522–1567). The same traditions persist through the whole of the Ming period, but a progressive decline is perceptible in the quality of the carving. The veins of the leaves and etching of the birds' plumage become more perfunctory. By the time of Chia Ching there were two distinct styles of carving, one with rounded smooth edges and the other with sharply incised edges. Few pieces have survived from the reign of Lung Ch'ing, but we know of a lacquerer, Huang Ch'êng, working about 1570 in Hsian in Anhui, whose life was published in 1625 with a commentary by Yang Ming. Pieces from the reigns of Chia Ching and Wan Li are very common (plates 138, 165 and 166), many from the latter reign bearing the cyclical dates which fix the date of manufacture to a particular year. The output of Wan Li lacquer was enormous, but the designs are cramped, the engraving monotonous and the inscriptions poor.

There is a particular group of carved lacquers associated with the Ming rather than the Ch'ing period, which in Japan has been termed *guri*, the name by which they are now known in the West. The lacquer is carved through alternating layers of different colours in scrolled and rectilinear designs (see the border of the tray on plate 138). Sometimes the layers were as many as five or six, but more usually only three – one red between two black. Ming *guri* is limited to these two colours, the general effect being a dark brown. In Japanese imitations of this work as many as fifteen layers appear, in red, black and yellow. The Chinese evidently believe that the *guri* technique goes back to the Yüan dynasty. One piece, in a museum in Anhui, carries the mark of Chang Ch'êng and is accepted as being of his time[17]. The dating of *guri* pieces within the Ming dynasty, and indeed the dating of all carved lacquer produced from the middle of the 15th century to the beginning of Chia Ching's reign (1522), remains problematical and calls for investigation.

Incised, painted and inlaid lacquer (plates 169 and 170) was made in great variety and quantity in the Ming and subsequent Ch'ing periods. These pieces are more fragile than the carved red lacquer and for this reason not in such good condition. There is also a quantity of what one can only call "folk lacquer", usually articles made for peasant use. The designs are first engraved, sometimes roughly, on the ground lacquer, and then inlaid with lacquers of different colours, the surface being polished smooth. Imprecision of the engraving may be masked by the gilding and painting which is usually combined with the inlay. Often inlay and paint are barely distinguishable. The cylindrical brush pot (plate 137) in Edinburgh, dated to 1602, which has painted decoration supporting the coloured lacquer, is a splendid example of this technique; and even more magnificent is Mrs. Dreyfus' tray (plate 138). Most of the pieces of painted lacquer that have survived appear to belong to the 17th century, and some of these can be assigned to the K'ang Hsi period. A feature of many of these pieces is a finely plaited bamboo border (plate 142). A rectangular plate in the Garner collection, decorated with figures in colour

on a black ground belongs to this group (plate 140). It is dated to the fourth year of T'ien Ch'i (1624). A good deal of Ming lacquer furniture was incised and painted. Black lacquer was decorated with inlay of mother of pearl depicting figures in a landscape, or birds and flowers (*laque burgautée*). This technique was practised not only on wood, but also on porcelain and even pewter (plate 49) in the late Ming and K'ang Hsi periods. The pieces of *laque burgautée*, like the painted lacquers, may have plaited bamboo borders (plate 142). Three pieces of lacquer decorated with mother of pearl are illustrated on plates 172–4. The dish (plate 173) has been attributed to the 15th century, but it is very light in weight, and I should place it, with the cup-stand, in the reign of Chia Ching, and the round box of plate 174 in the Wan Li period.

Ch'ing lacquer (1644–1912)

The carved red lacquer of the Ch'ing period has neither the rich colour nor the breadth and simplicity of the Ming designs, although in technical accomplishment it is unsurpassed. The first great exportations of carved lacquer to the West took place during the reign of K'ang Hsi. They included the twelvefold giant lacquer Coromandel (*fêng-p'ing*) screens, with lacquer painting in low relief, which are a common feature of our old country houses (plate 180). Another popular export of the reign of K'ang Hsi[18] was *laque burgautée* porcelain executed in the most delicate designs (plate 142). On the earlier screens designs are painted and raised in relief, and on the later ones cut in *intaglio*. The screens were often cut up on arrival in Europe and used to panel commodes. They acquired their name in the West from the fact of their being imported by the East India Company from the Coromandel coast. Subsequently English imitations of the Coromandel lacquers were applied to the furniture of the reign of William and Mary.

The prodigious output of carved lacquer in the later Ch'ing period is formal and stereotyped. For all the superb workmanship their monotonous designs and interminable opulence soon pall. As Mr. Winkworth has remarked, "like Sèvres porcelain, these lacquers fulfill very well the task of looking expensive, but they must not be mistaken for art".

The Emperor Ch'ien Lung himself seems to have been partial to lacquer. His famous red throne can be seen at the Victoria and Albert Museum (plate 178) and the red lacquer coffin in which he was buried was on sale in Peking not many years ago. Very little carved red lacquer of any quality was made after the death of Ch'ien Lung, but Bushell tells us that the imperial workshops were not destroyed till 1869, when they perished in the T'ai P'ing troubles. Today, although cheap lacquer flourishes, the art of fine lacquer is practically at an end. Men remain who are competent to do good work if the opportunity occurs, but the process is slow and laborious, and under modern conditions the workmen rarely obtain adequate wages for their labour. Only the old system could provide the lavish patronage which gave these men the opportunity to display their skill.

R. SOAME JENYNS

[1] "The lacquer tree is incised and bled of its precious sap, like the man who is thought to possess knowledge and is continuously worried by inquiries much to his discomfort; it were better to be thought a fool, and to be able to enjoy peace and quiet." From the *Nan Hua Chên Ch'ing* by Chuang Tzǔ.

[2] See, for a study of Chinese sources, "Materialien zur Geschichte des chinesischen Lacks", by Otto Mänchen-Helfen in *Ostasiatische Zeitschrift*, Vol. XXIII, 1937.

[3] *The Cemetery of the State of Kuo at Shang Ts'un Ling.* Institute of Archaeology of the Academy of Sciences, Peking 1959, Pl.XLI, no. 2.

[4] Lacquered vessels from Ch'ang Sha are illustrated in *Ch'ang sha ch'u t'u ku tai ch'i ch'a t'u an hsüan chi*, Peking Historical Museum, 1954.

[5] Basil Gray, "The Eumorfopoulos Lacquer Toilet-box", *British Museum Quarterly*, Vol. XIV, no. 1, 1940, p. 49 ff.

[6] William Watson, "Chinese Lacquered Wine-cups", *British Museum Quarterly*, Vol. XXI, 1957, p. 21 ff.

[7] Breuer, *Burlington Magazine*, June 1914.

[8] Out of the 644 items recorded in the Catalogue of the Treasures of the Imperial Repository of the Shōsō-in, no less than 150 are treated either wholly or in part with lacquer. Dr. R.H. van Gulik in an article "On three antique lutes", *Transactions of the Asiatic Society of Japan*, Vol. XVII, Dec. 1938, dates the most famous of the Shōsō-in lacquered and inlaid lutes to the Northern Wei and suggests that the cyclical year inscribed on it corresponds to either A.D. 435 or 495.

[9] For illustrations of two other pieces inscribed Chang Ch'êng see *Ostasiatisches Gerät*, by O. Kümmel, Eerlin 1925, pls. 85, 120.

[10] *Wen wu ts'an k'ao tzǔ liao*, 1957, no. 7, p. 24 ff.

[11] Sir Harry Garner, "The Arts of the Ming Dynasty", *Oriental Ceramic Society Transactions* 1957, p. 34.

[12] See F. Hirth, *Über fremde Einflüsse in der chinesischen Kunst*, 1896, p. 64.

[13] Sir Harry Garner, *Ming Lacquer*, London 1960.

[14] *Bulletin of the Museum of Far Eastern Antiquities*, Stockholm, No. 22, 1950: "Chinese lacquer of the early fifteenth century." *B.M.F.E.A.*, No. 24, 1952: "Chinese lacquer of the middle and late Ming period."

[15] Sir Harry Garner, *Ming Lacquer*, London 1960.

[16] See *British Museum Quarterly*. Vol. XIV, no. 2.

[17] *Wen wu ts'an k'ao tzǔ liao*, 1957, no. 7.

[18] Descriptions of the lacquer industry of the period appear in the works of Père d'Incarville in 1760: "Sur le vernis de la Chine", *Académie des Inscriptions et Belles Lettres*, Vol. XV, p. 117, and du Halde in 1735; also Pater Buonami in 1697 in a letter inserted in the *Museum Kircherianum Romae* of 1709, p. 233.

127. SERPENT PEDESTAL OF LACQUERED WOOD

From Ch'ang Sha, Hunan Province, 4th century B.C. Width 57.5 cm. Cleveland Museum of Art. Purchase of the J. H. Wade Fund

The snakes are a base on which stand two cranes. The association of these birds with snakes is not confined to China. The snakes denote chthonic powers and the cranes are their vanquishers. These figures were excavated from tombs at Ch'ang Sha in Hunan, where other related sculptures were recovered; all testify to a cult of the underworld alien to the main Chinese tradition. The scales and other ornament of the snakes are painted with thin lacquer in red and black.

128. LACQUERED BOWL

1st Century A.D. Diameter 25 cm. British Museum, London

The bowl is decorated with alternate bands of red, and dark brown which was originally black. The lozenges and spirals covering the dark bands and the cloud scrolls of the central roundel are drawn in vermilion. The scrolls still carry a hint of the stylized dragons of an earlier period, pointing to the origin of the Han cloud scrolls in the art of the 4th–3rd centuries B.C. The base of the lacquer is wood, in this case showing comparatively little of the distortion which commonly overtakes lacquer after excavation.

129 and 130. LACQUERED WINE-CUPS

a) 1st century A.D. b) 4th century A.D. a) Height 16.7 cm. b) Height 17 cm. British Museum, London

Cups of this type, called *yü pei*, "winged cup", have been found on many Han sites, even at remote stations on the frontier. Their flange handles served to support them on racks consisting of parallel bars. The upper cup comes from a tomb at Phyong-yang, in North Korea, the site of the Chinese colony of Lolang. The inscription has a date corresponding to 4 A.D. and names persons responsible for every stage of its manufacture. The 'Shu Commandery', where it was made, was situated in the centre of the modern province of Szechwan. The birds were painted in vermilion (some of which retains its full colour) and yellow on a black ground. The lower cup, excavated at Ch'ang Sha in Hunan Province, is of somewhat coarser make and painted in the same colours. Both cups are decorated in a style related to the designs of inlaid bronze of the 4th–3rd centuries B.C. The base of the cup on plate 129 is probably cloth; that of the other cup is wood.

131. LACQUERED TOILET-BOX, WITH SILVER INLAY

1st century B.C. *C. Diameter 9.5 cm. British Museum, London*

The box is said to have been found in a tomb at Haichow, in Kiangsu province. It contained a mirror of white bronze with parcel-gilt decoration in the style of the mid-Han period. The original black ground has faded to a greenish brown. The painting, in pristine vermilion and faded yellow, consists of cloud scrolls, in which appear twelve creatures, rapidly drawn, which carry suggestions of the tiger, dragon and tortoise, symbols of the West, East and North quarters of heaven. One of the figures is a Feathered Man of the Taoist mythology. Apart from the quatrefoil on the lid, the figures, originally inlaid with silver (now intact on only one of them), consist of pacing tigers, a charging bull, and an archer shooting from a horse depicted in the "flying gallop". The lacquer is built on a base of coarse cloth.

132. LACQUER PLAQUE

Early 15th century. Diameter 31 cm. Garner Collection

This circular plaque of carved red lacquer was probably the top of a box lid. It is decorated with a five-clawed dragon among clouds, standing on waves. The background is of "earth" diaper. Although a fragment, and slightly cracked in places, this is a superb example of carved red Chinese lacquer of the classic period. The dragon standing on the waves probably denotes the Lung Mên legend. In this legend the carp, when they leap over the Lung Mên, or Dragon Gate, in the Yangtze, turn into dragons. The struggling carp is often compared to the struggling scholar, who, if he is successful in his examination, turns into a dragon, that is an Imperial official.

133. LACQUER BOX AND COVER

Mark of Yung Lo (1403–1424) and early 15th century in date. Diameter 13.5 cm. Formerly collection Mrs. Walter Sedgwick, London

This round box and cover of carved red lacquer is decorated with narcissus on the top and round the edge of the base. It has a Yung Lo mark scratched on the base. The piece belongs to the earliest group of carved red lacquer, which can be attributed to the late 14th or early 15th century. No reliability can be attached to the Yung Lo mark, which may have been added later, but this is no reason why the piece should not be the period of its mark.
The decoration of narcissus is unusual and beautifully handled. The Chinese narcissus is *Narcissus tazetta*. There is only one variety – white with a yellow centre – commonly sold, which is called the Water Fairy flower. It is grown from bulbs in bowls filled with pebbles in water, and forced into bloom at the Chinese New Year, when it is supposed to confer good fortune for the next twelve months. The flower is a native of the Mediterranean region and the Near East, and was not originally native to China. It has been stated that it

was introduced by the Portuguese to China in the 16th century; but from the date of this box it is clear that the introduction came earlier, and probably by way of Persia.

134. LACQUER JAR AND COVER

Mark of Hsüan Tê (1426–1435), but probably late 15th century in date. Height 40.5 cm. Royal Scottish Museum, Edinburgh (ex Percival David Collection)

This jar is carved in black lacquer on a crimson ground, on a metal foundation. The decoration, in eight shaped panels, is of the Eight Immortals, between phoenixes amid horses and waves. The cover is decorated with phoenixes.
The Hsüan Tê mark (which is usually carved and not scratched like the Yung Lo mark) is unreliable and can easily have been applied later.
The names of the Eight Immortals are: Chung-li Ch'üan, Ho Hsien Ku, Chang Kuo, Lü Tung-pin, Han Hsiang Tzŭ, Ts'ao Kuo-ch'iǔ, Li T'ieh Kuai, and Lan Ts'aiho. Just when they came to be grouped together and why is a mystery, but by the Yüan period this traditional unit is definitely established. This jar has also a Ch'ien Lung inscription dated 1776 on the base.

135. LACQUER BOX AND COVER

Early 15th century. Height 4 cm. Diameter 9.2 cm. Linden-Museum, Stuttgart (formerly Low-Beer Collection)

This box is decorated with incised and gilded *lichee* fruit and leaves within a circular medallion bordered by peonies and lotus, on a diaper ground. The flowers are followed by a narrow border of thunder pattern. The lower part of the box is decorated in the same fashion. "The *lichee* fruit and the blossoms are in red and the leaves in green and the stems dark brown," writes Low-Beer. "The markings of the fruit, the veins and contours of the flowers, leaves, and stems are engraved and filled in with gold. The gold was thinly applied and does not obscure the design of the lines and markings. The diaper is done in light brown on a black background; the thunder pattern in light and dark brown. The inside of the box is lacquered red." He believes the design was carved out and the resulting spaces filled in, engraved, gilded, ground and polished. (Fritz Low-Beer, *Chinese lacquer of the early 15th century*, Museum of Far Eastern Antiquities, Stockholm. Bulletin No. 22, page 153.)

136. LACQUER CABINET

Early 15th century. Length 56.8 cm. Width 42 cm. Height 49 cm. Low-Beer Collection, New York

This cabinet is incised and gilded with five-clawed dragons, phoenixes, clouds and lotus. "The exact determination of the basic colours is difficult," writes Low-Beer, "due to the technique of superimposing a layer of one colour on others of a different shade. Grinding brought out some of the low-

er layers, either partly or completely, and wear has acted in much the same way, so that it is difficult to determine in some places whether a shade was made intentionally or whether it resulted from wear. I think that the basic colours are: slightly bluish cinnabar red, orange red, dark wine red, dark green, green, ochre, brown, black and gold. Except in minor details the design is the same on all four sides and the top. The remarkable front panel is worn and its gold decoration almost gone, therefore the rear panel is chosen for the illustration." As far as I know, it has no parallel.

137. LACQUER BRUSH POT

Wan Li cyclical year mark corresponding to 1602. Height 23 cm. Royal Scottish Museum, Edinburgh

This red lacquer brush pot is decorated with an inlaid and painted design in various colours with incised gold outlines within four quatrefoil panels, each of which encloses two facing dragons in clouds, above rocks and waves. Between the dragons is a column twisted to form a *Shou* character (the emblem for long life) and above their heads two swastikas. The background between the panels is diapered with swastika symbols.

138. LACQUER TRAY

Probably Wan Li period (1573–1619). Length 51 cm. Width 30.5 cm. Collection Mrs. Dreyfus, London

This tray of lacquered wood with a dark brown *guri* border is decorated with a garden scene showing four female figures incised in red and brown lacquer and gilded. The scene is inscribed 'Painting of the four concubines of Sun Liang'. Sun Liang became Emperor in 252 and died in 260 A.D.; a note on him can be found in H. A. Giles' *Chinese Biographical Dictionary* No. 1813. It does not mention the fame of his concubines.

The term *guri* lacquer, which is Japanese, has been used to describe a group of carved lacquer in which alternate layers of different colours are used to provide decoration. The design, as in the border of this tray, is usually of scrolls. Garner in his paper *Guri Lacquer of the Ming Dynasty*, (Oriental Ceramic Society's Transaction, Vol. 31, 1957/59) traces the beginnings of this technique to the Yüan dynasty and follows its course to the end of the Ming period.

139. LACQUER BOWL

17th century. Probably made in Fukien. Diameter 17.3 cm. Collection Mrs. Dreyfus, London

This black lacquer bowl has a silver lining, while the outside is painted in red, green and yellow with a golden oriole on a flowering tree. Most of the painted lacquer came from Fukien, while the carved lacquer came chiefly from Peking.

140. LACQUER TRAY

T'ien-Ch'i cyclical mark corresponding to 1624. Length 57.5 cm. Garner Collection

This painted lacquer tray with shaped corners is decorated with figures in a river landscape on a red ground. The border has panels with archaic dragons in gilt on a black ground, while the sides underneath are formed of plaited bamboo. The plaited bamboo feature is quite common to a group of painted lacquer belonging to the Transitional period, i. e. late Ming and early K'ang Hsi. We do not know where this group was made, but probably in the South of China.

141. LACQUER BOX AND COVER

14th or 15th century. Diameter 8 cm. Formerly collection Mrs. Walter Sedgwick, London

This cylindrical box and cover is of dark brown lacquer inlaid in mother of pearl with a single spray of plum blossom and a crescent moon. Some authorities have suggested that this piece may be Korean, but the box itself is too delicate and the sides too thin for this to be probable. At the same time it must be admitted that this type of lacquer with mother of pearl inlay is so poorly represented in the West that it is difficult to decide on its provenance or date. This box Mr. Wirgin dates to the Yüan period (see *Some Ceramic wares from Chi Chou*, The Museum of Far Eastern Antiquities Bulletin, No. 34, Stockholm, 1962 plate 22a), although in 1958 it was shown in the Exhibition: *Arts of the Ming dynasty*, Catalogue No. 273.

142. LACQUER BOX AND COVER

First half of the 17th century. Length 39 cm. Garner Collection

This box is of black lacquer with shaped edges. It is decorated in mother of pearl *(laque burgautée)* with figures at various pursuits in a river landscape. The borders are of red lacquer with painted bamboo panels.

The great majority of pieces of lacquer decorated in this technique date from the K'ang Hsi period (1662–1722), when this process was also used to decorate porcelain. The plaited bamboo panels, as has already been remarked (see plate 140) are typical of the Chinese lacquer of the Transitional period (i. e. late Ming, early Ch'ing).

127

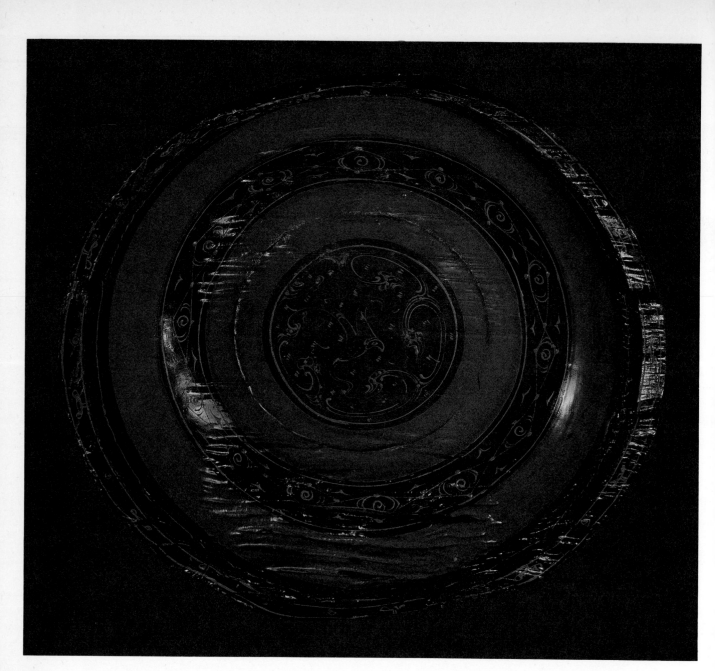

128

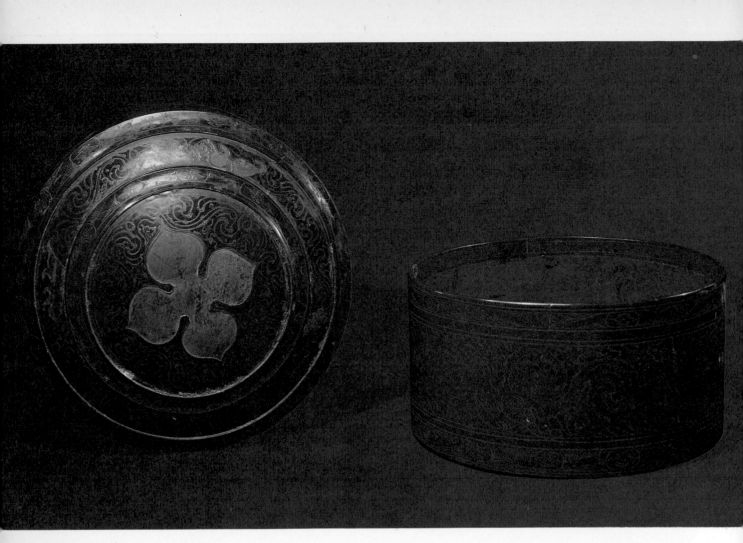

131

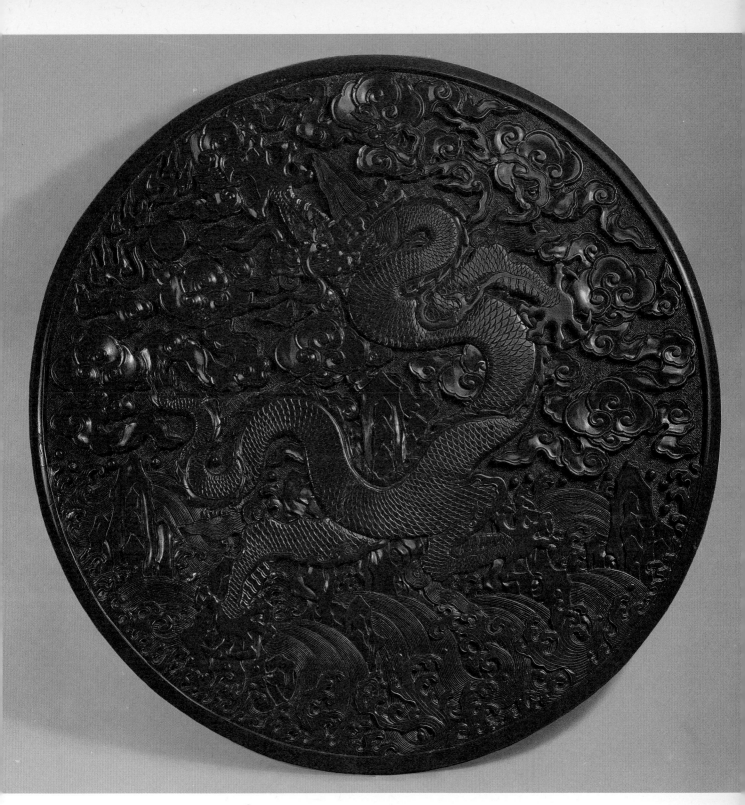

132

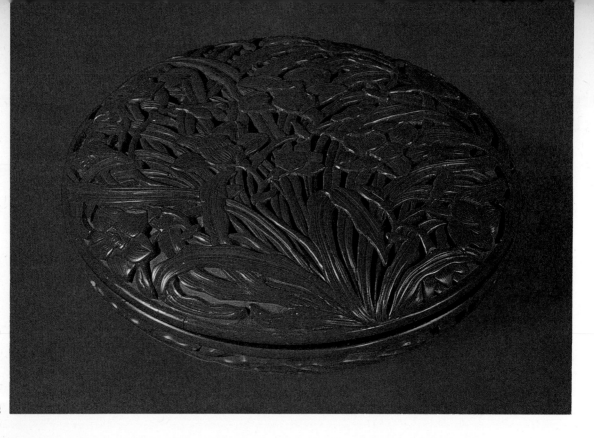

133

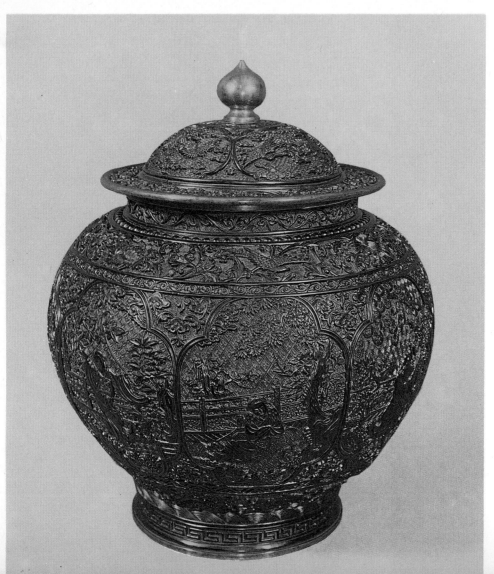

134

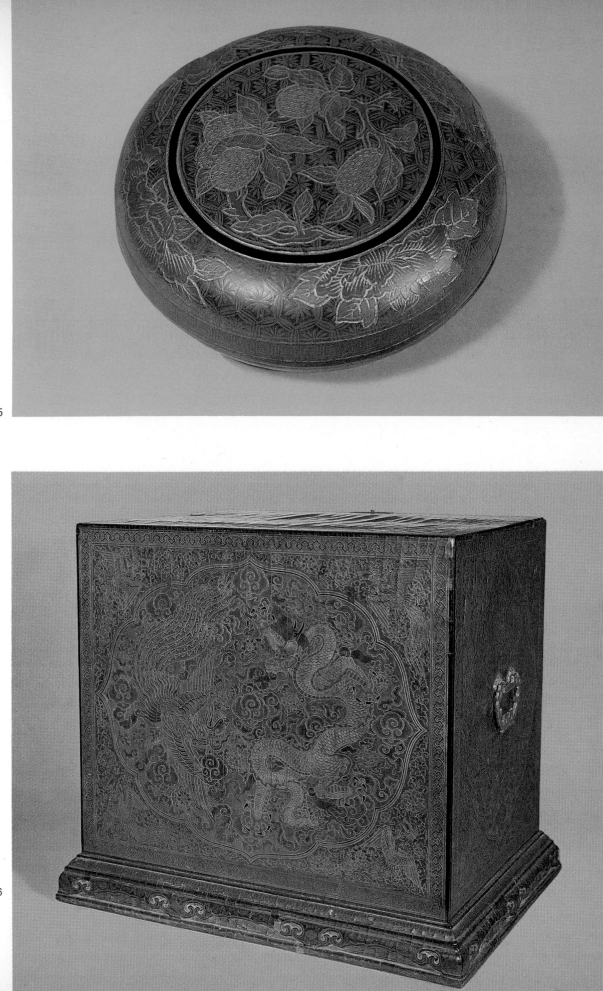

135

136

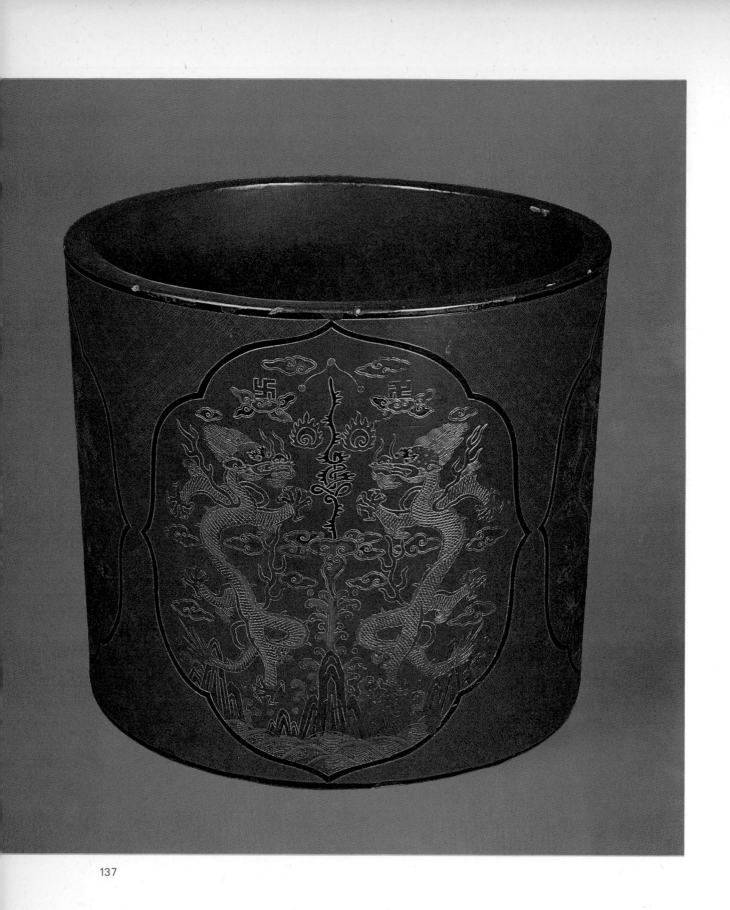

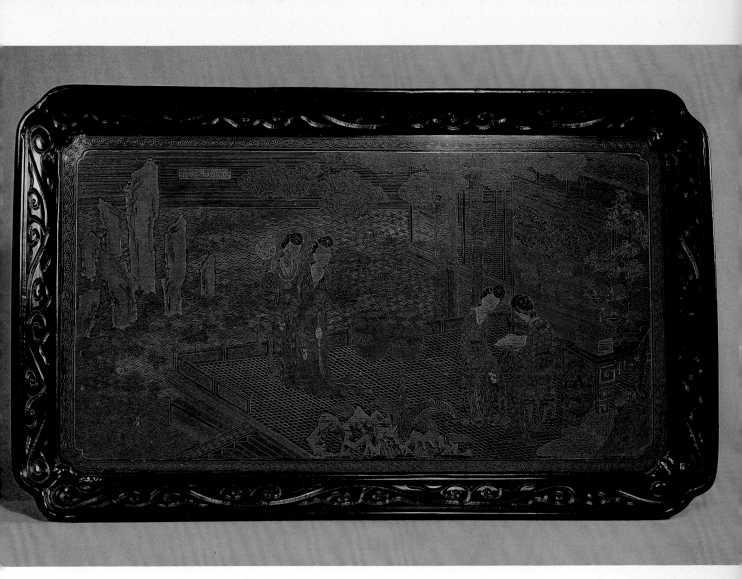

138

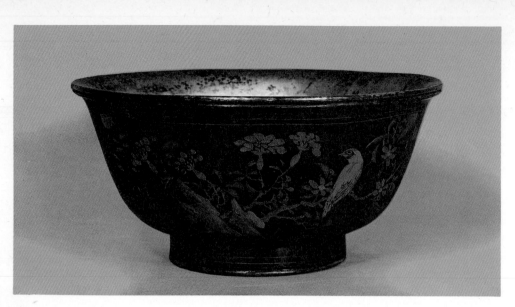

139

140

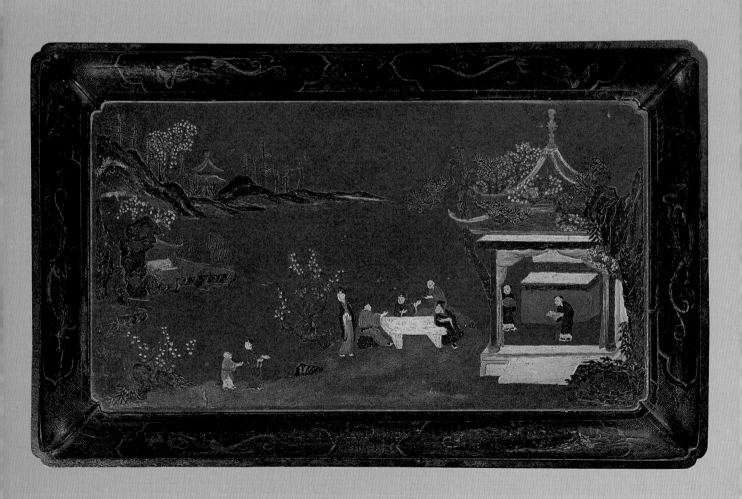

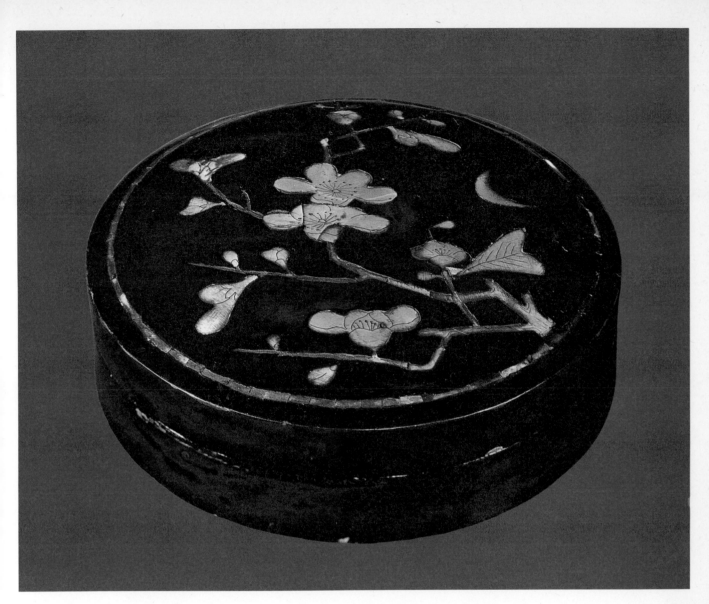

141

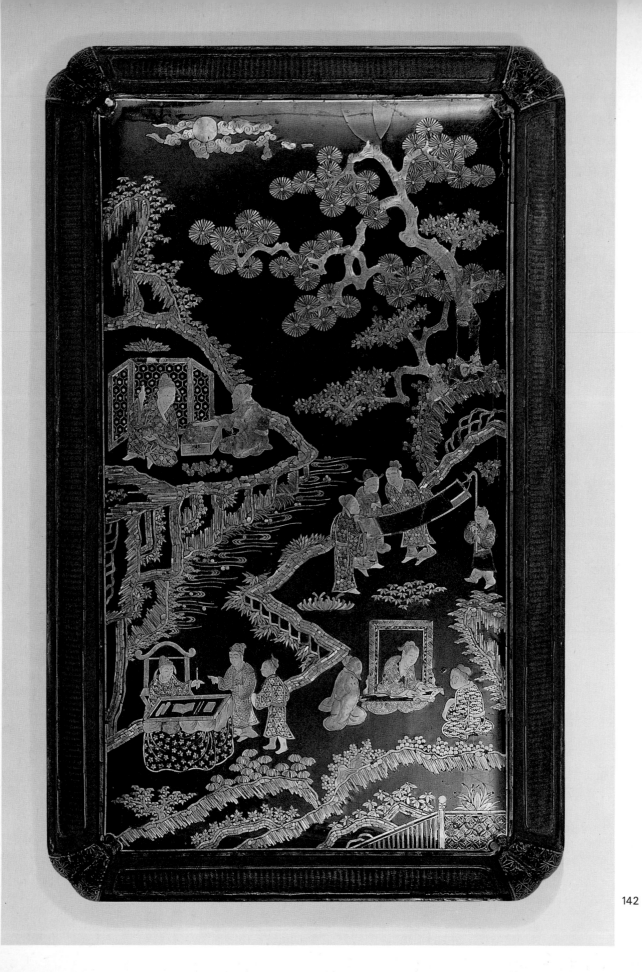

142

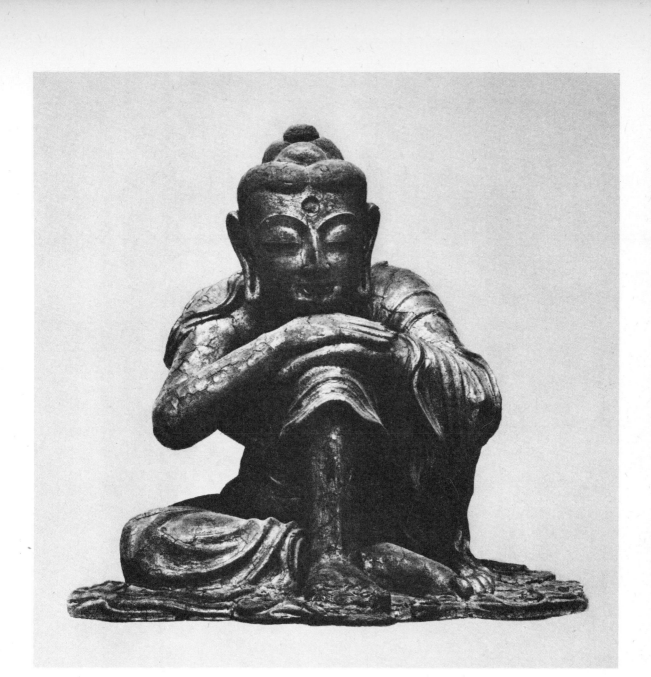

143. DRY LACQUER FIGURE OF BUDDHA

9th–11th century. Height 81.3 cm. University Museum of Pennsylvania, Philadelphia, Pa.

This Buddha is of dry lacquer which has been gilt. He crouches with his chin on his hands, which rest on his knees. Either soft pinewood or rough hempen cloth supply the skeleton of most Chinese lacquer objects; the latter method of construction was called *Kanshitsu* (dry lacquer) by the Japanese. Its use seems to have been almost entirely confined to the production of large size Buddhist figures during the T'ang and early Sung Periods after which it falls out of favour and is only occasionally revived (see plate 169). Most of these T'ang dry lacquer figures have survived in Japan. Their construction made them light to carry and easy to move, as they were hollow. Curious dry lacquer representations of gods and animals appear from time to time on the market with T'ang attributions. It is not easy to date all these pieces with security. Many of them, like the figure illustrated, may just as well be Sung in date, and others, one suspects, are fakes, as dry lacquer is not a difficult medium to use.

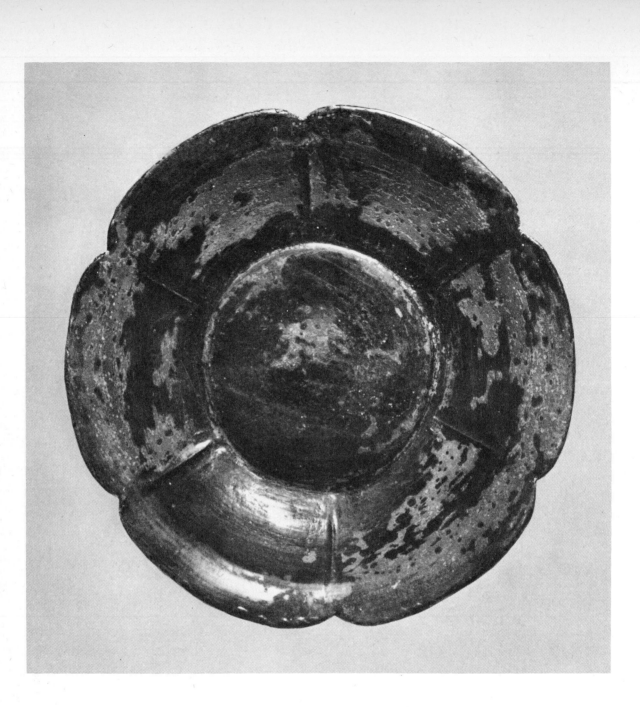

144. LACQUER DISH FROM CHÜ-LU-HSIEN

Sung period (before 1108). Diameter 10.5 cm. British Museum, London

This dish has sixfold lobes covered with worn red lacquer over a black priming. The site of the city of Chü-lu-hsien, near the borders of Chihli and Shansi, was submerged in 1108 by a change-of-course of the Yellow River. As a result of long burial in waterlogged ground, the glaze of the porcelain recovered from this site has crazed in a way which is easily recognizable, but it does not seem to have harmed the lacquer. Most of the Sung pieces of lacquer which have survived seem to come from this site.

The resemblance between this dish and similar dishes of Sung *Ting* ware should be noted.

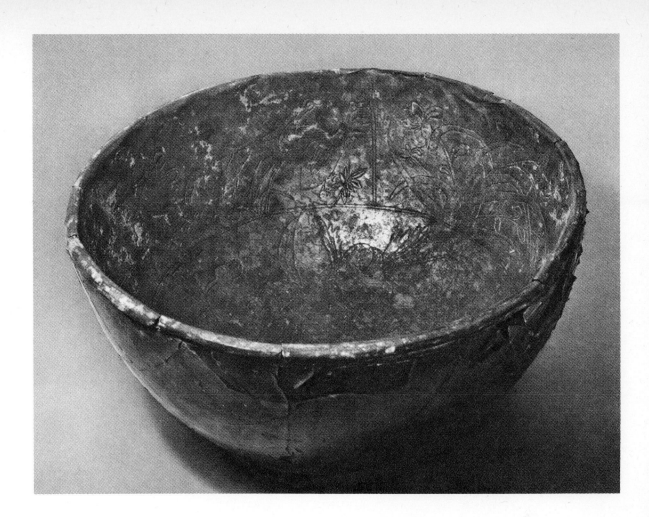

145. LACQUER BOWL

Sung dynasty (960–1279). Diameter 23 cm. British Museum (Eumorfopoulos Collection), London

This bowl is of dark brown lacquered wood with a silver lining. The surface is streaked with red in some places and the silver lining is engraved with birds and flowers. The piece is unfortunately, as the photograph shows, in a very fragile condition.

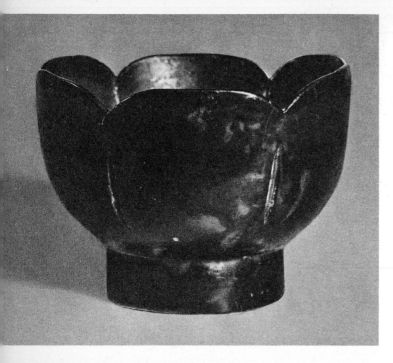

146. LACQUER BOWL

Sung period (960–1279). Diameter 10.8 cm. Low-Beer Collection, New York

This bowl is of lotus shape with four parallel lobes on a high foot. It is covered with brownish lacquer outside and red inside. The shape, and that of the lobed box on the next plate would appear to have been taken from metal forms.

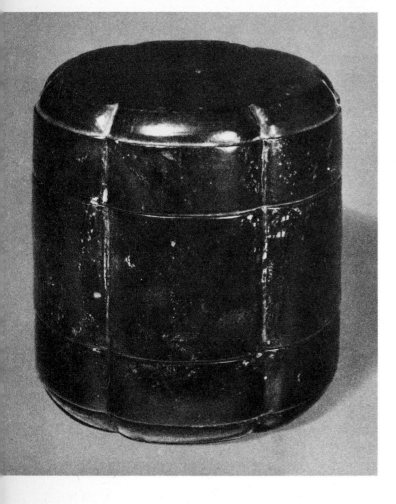

147. LACQUER BOX

Sung period (960–1279). Height 16.5 cm. Low-Beer Collection, New York

This box of black lacquer and lobed shape is divided into three tiers, with a shallow box and tray inside.
As in porcelain, the Sung preferred lacquer of simple shapes, usually undecorated.

148. LACQUER TABLE TOP ▷

Mark and period of Hsüan Tê (1426–1435). Diameter 83 cm. Victoria and Albert Museum, London (formerly Low-Beer Collection)

This is the top of an Imperial table in carved red lacquer illustrated in colour on plate 175.
Five-clawed dragons and phoenixes combined with lotus flowers are the principal themes of the decoration. The carving is done in red on an originally yellow ground, which has now assumed a dirty buff colour. The underside of the table top is lacquered. For a description of the table itself see the text accompanying plate 175, but this plate does not give the detail of the splendid design.

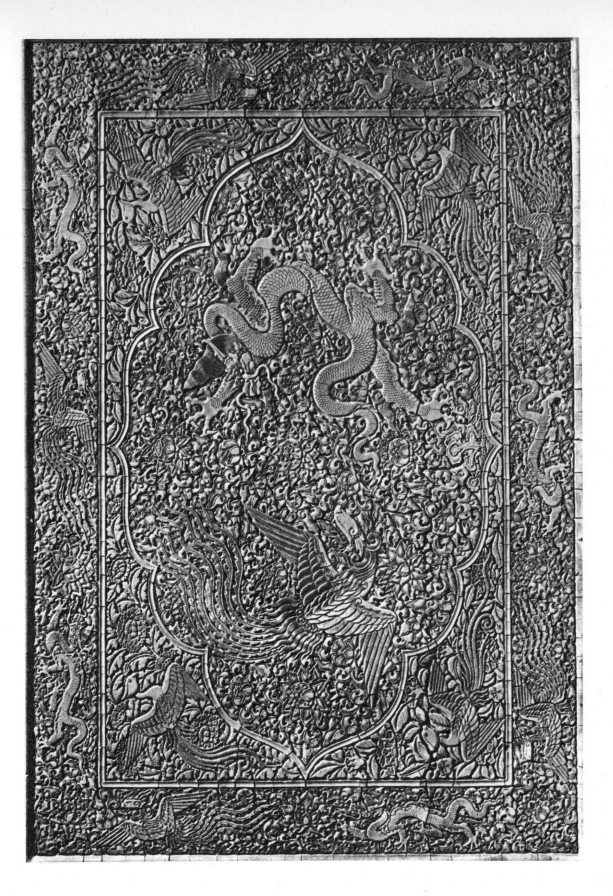

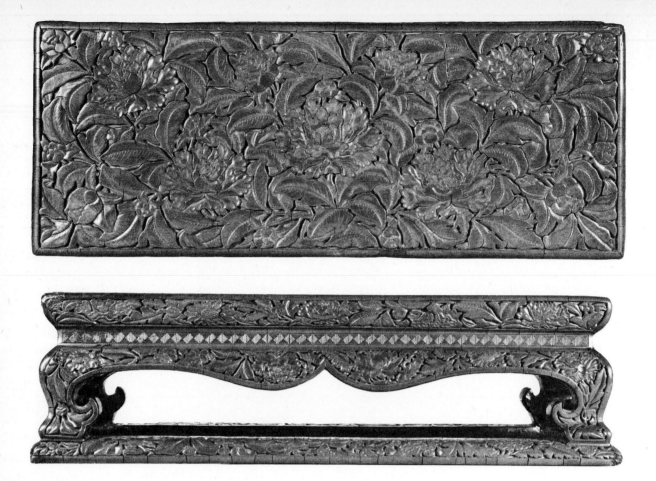

149 and 150. LACQUER FOOTSTOOL

Early 15th century. (a) Length 51 cm. Width 19.6 cm. (b) Length 53 cm. Width 21 cm. Height 14.8 cm. Museum für Ostasiatische Kunst, Staatliche Museen, Berlin (formerly Low-Beer Collection)

The top (plate 149) and side views (plate 150) of a carved red lacquer footstool decorated with peony flowers and leaves. The peony design on the top of this footstool is very close-knit. The sides and legs show a border of peonies with the addition of chrysanthemums, lotus and prunus. The carving is just over three cm. deep and done in a bright cinnabar red over a yellow ground. The footstool is not marked.

151. LACQUER VASE ▷

Yung Lo mark (1403–1424) and early 15th century in date. Height 17 cm. Palace Museum, Taiwan

This vase of carved red lacquer has the body decorated with peony, lotus, mallow and chrysanthemum flowers, and the lip with a border of "thunder" pattern. The shape of this vase, which recalls the so-called 'paper beater's' form of the Sung celadon vases so highly valued in Japan, is, as far as I know, unique in lacquer.

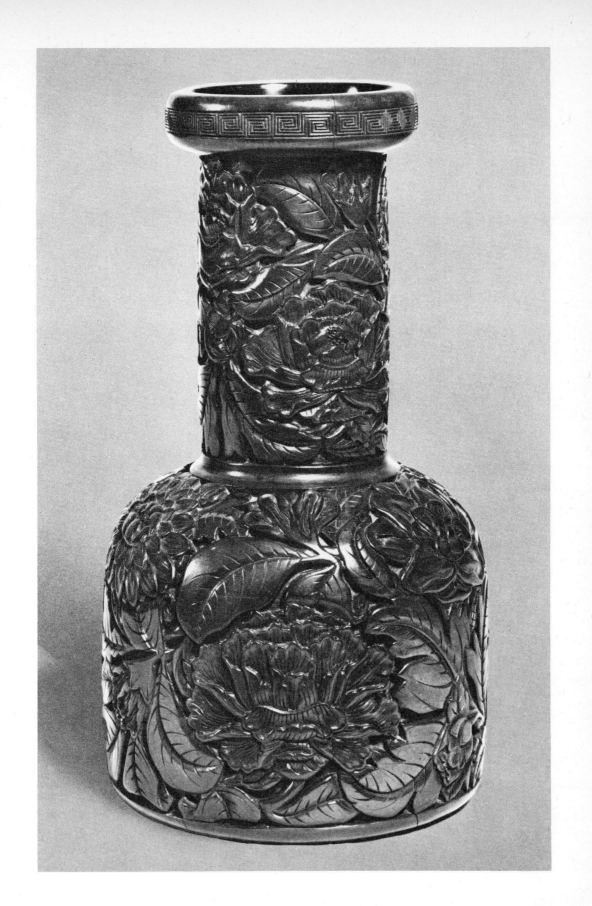

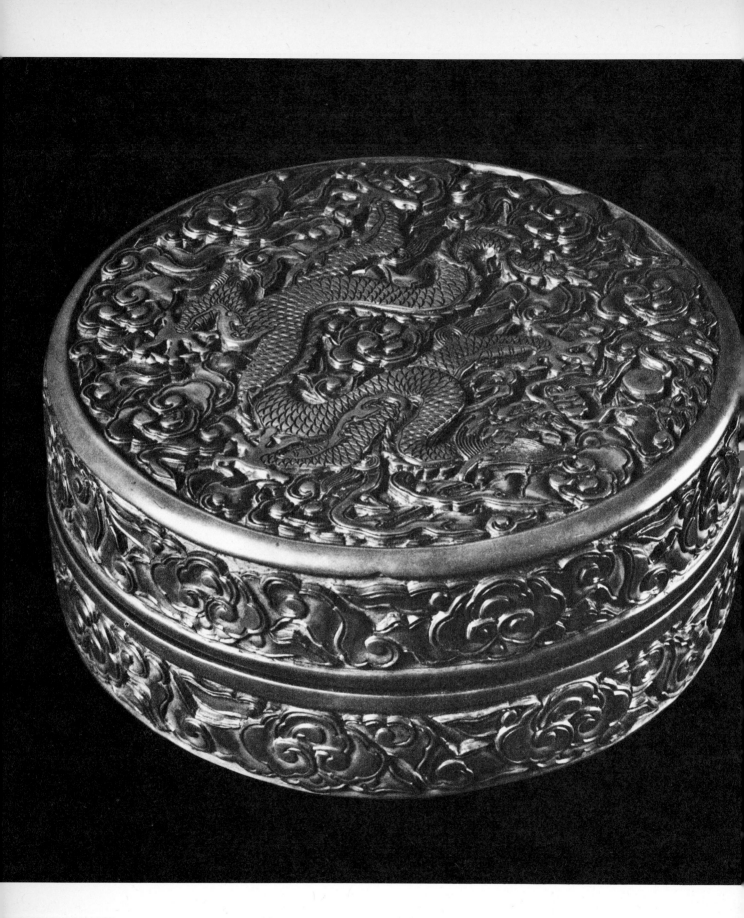

208

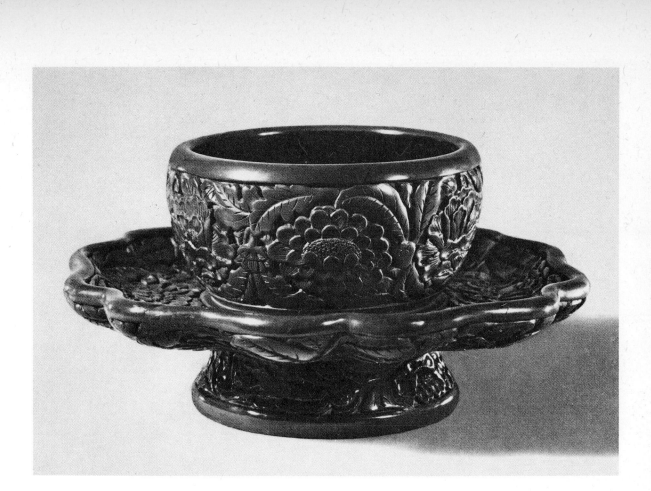

153. LACQUER BOWL-STAND

Early 15th century. Diameter 17 cm. Garner Collection

This carved red lacquer bowl-stand has a foliate flange, and is decorated with flower scrolls round the body and the upper and lower surfaces of the flange, and the foot.
A very similar bowl-stand, with a Yung Lo mark (1403–1424) and a Ch'ien Lung inscription dated 1781, belonged to Sir Percival David. (See *The Arts of the Ming dynasty,* plate 23b.) These cup-stands, complete with cup attached, remind one of similar shapes in the Korean celadon wares of the Koryo dynasty which were popular in Japan for the Tea Ceremony. Another type of Chinese lacquer bowl-stand is shown on plate 172.

◁ ## 152. LACQUER BOX

Mark of Yung Lo (1403–1424). Diameter 13.5 cm. Formerly collection Mrs. Walter Sedgwick, London

This carved red lacquer box and cover is decorated on the top with a five-clawed dragon amid clouds. It has cloud borders round the sides of the cover and the box. The piece has a Yung Lo mark and, although this is, in itself, unreliable, this piece is probably of the period.

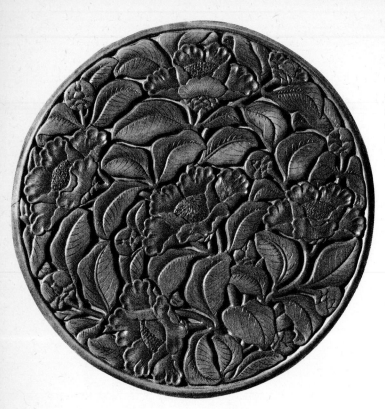

154. LACQUER BOX AND COVER

Mark of Yung Lo (1403–1424) and early 15th century in date.
Diameter 22 cm. Garner Collection

This carved red lacquer box and cover is decorated on the
top with camelia sprigs, and has floral borders round the
sides of the cover and the base. It has a Yung Lo mark on
the base, and although this is in no way to be relied upon,
there is no reason to think that the piece is not of the period.

155. LACQUER BOX AND COVER

Mark of Yung Lo (1403– 1424) and early 15th century in date.
Diameter 22 cm. Formerly collection H.R.N. Norton, London

This carved red lacquer box and cover is decorated with a
landscape of figures on the top. There are flower scrolls
round the side of the cover and the base. The Yung Lo mark
is not reliable, but the piece is probably of the period.

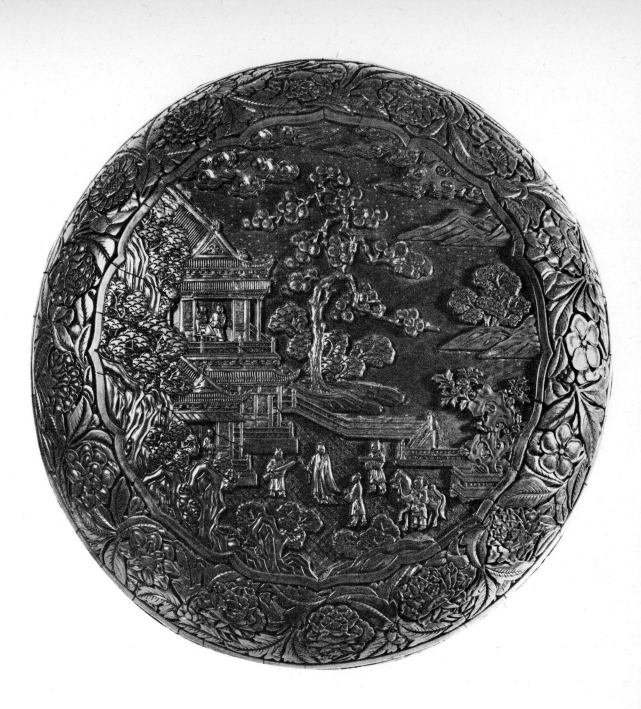

156. CAKE-BOX AND COVER

Mark of Yung Lo (1403–1424) and early 15th century in date.
Diameter 37 cm. British Museum, London

The cover of the box of carved red lacquer is decorated with a scene depicting an official in his garden outside his house, with three attendants carrying musical instruments and a fourth leading a horse, surrounded by a floral border which is repeated round the side of the base.

The mark is not reliable, but the box is probably of the period.

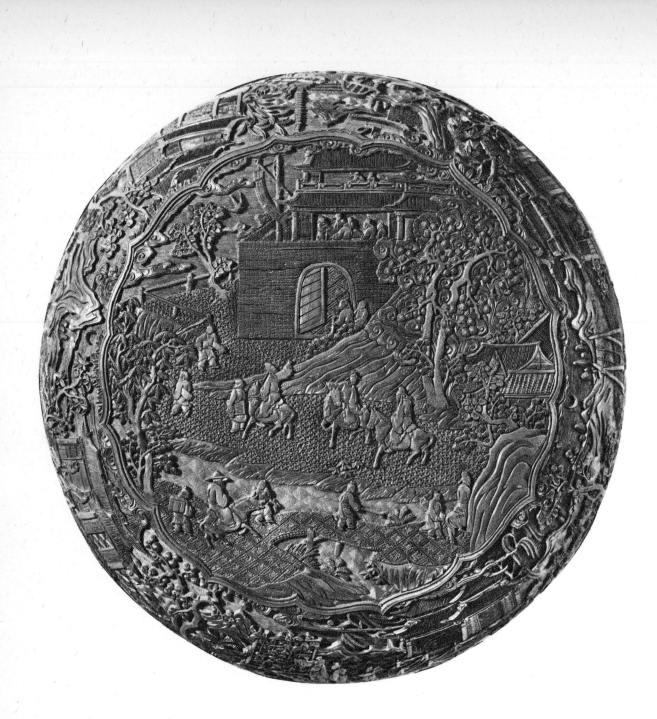

157. LACQUER CAKE-BOX AND COVER

Late 15th or early 16th century. Diameter 26.5 cm. Garner Collection.

This box and cover is of brownish-red lacquer, carved on a yellow ground. The cover is decorated with a scene of horsemen approaching an inn along a rocky path, surrounded by a border of landscape scenes. There is a similar border round the base. These scenes are described by eight poems of the T'ang and Sung dynasties. This box is more intricately carved than the cake-box represented on plate 156, and the colours are also more elaborate, as it is later in date.

158. LACQUER BOX AND COVER

Late 15th century. Diameter 8 cm. Garner Collection.

The box is decorated on the lid with a bird on a branch of
flowering plum, and on the bottom with flowering plum
alone, in back lacquer carved on a crimson brocade ground.
Such boxes were adapted as *Kogo* (incense boxes) for the
Tea Ceremony in Japan, where they are highly treasured.

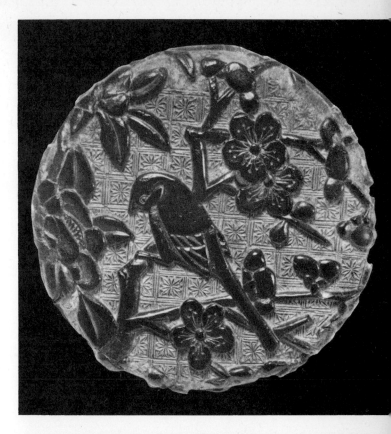

159. LACQUER BOX AND COVER

*Late 15th century. Diameter 7.5 cm. Formerly collection Mrs.
Walter Sedgwick, London*

This carved red lacquer box is decorated all over with sprays
of gardenia on a diaper ground. The gardenia grows wild on
the hillsides of Kwangtung and Hong Kong, but in the wild
state it produces a single, not a double, flower. There are
several varieties of this shrub native to China.

Although no particular symbolism is associated with this
plant, its flowers are valued by the Chinese for their fra-
grance. They are used for flavouring tea, and in the prepara-
tion of cosmetics. During the season they are in bloom, gar-
denias are much worn by Chinese women of the old school
as hair ornaments. Its fruit is used in China to produce a
beautiful yellow dye.

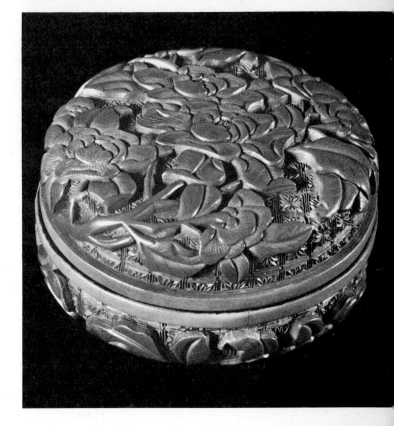

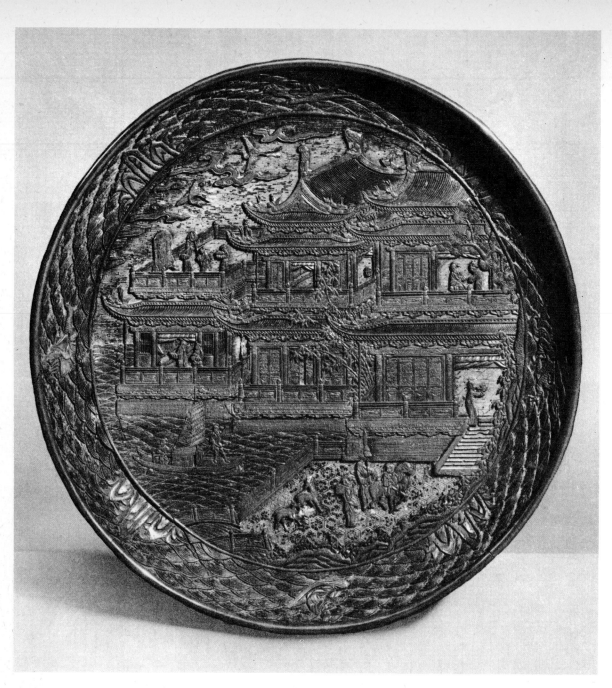

160. LACQUER DISH

Dated 1489 (the second year of Hung Chih). Diameter 18.5 cm. Formerly David Collection, London

This dish is of red lacquer carved on a dark green and yellow diaper background. The subject of the front is a pavilion by a lake, with figures in the foreground and a boat in the middle distance. On the doorway of the palace is the mark of the second year of Hung Chih (1489). The building is surrounded by a border of shrubs and rocks with four Taoist Immortals. On the base is a poem, in raised black lacquer characters on a yellow ground, on the "Pavilion of Prince T'ang", with a border of panels containing figures, dragons and phoenixes.

This dish is of great documentary importance as it is the only dated piece at present known which bridges the gap between the relatively numerous pieces of carved red lacquer belonging to the 15th century, with Yung Lo and Hsüan Tê marks, and the even more numerous group of the Chia Ching period (1522–1566). By this last reign the use of a plain yellow ground in carved red lacquer pieces had been generally discarded in favour of brocade grounds. The carving of this dish, which is delicate and shallow, is of very high quality. It is a landmark, illustrating the change of style between the robust pieces of carved red lacquer of the early 15th century and the more detailed pieces of the late 16th century.

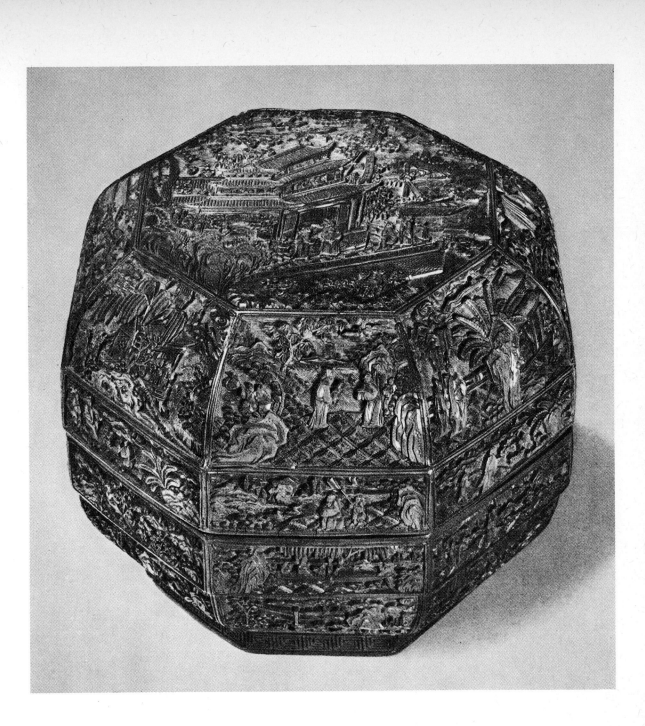

161. LACQUER BOX AND COVER

Probably 16th century. Diameter 28.7 cm. Height 21.4 cm.
Linden-Museum, Stuttgart (formerly Low-Beer Collection)

This carved red lacquer octagonal box is decorated in high relief with landscape panels containing figures. It has a high foot, which is decorated with a bold "thunder" pattern. De-tails such as the brick walls of the terrace or the markings on the treetrunks, are carved in considerable depth, and the diaper ground is on a high level. The inside and base are in black lacquer but do not appear to be in their original condition.

The piece probably belongs to the Chia Ching period (1522–1566).

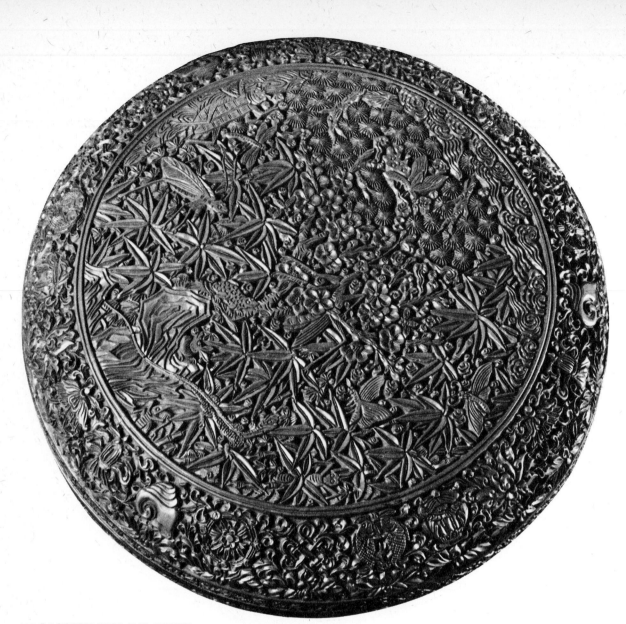

162. LACQUER BOX AND COVER

16th century. Diameter 28 cm. Formerly collection Mrs. Walter Sedgwick, London

This carved red lacquer box is decorated with a central panel of pines, plum trees and bamboos (the "Three Friends"), and rocks, with a lizard, toad and various insects. The surrounding border is decorated with the 'Eight Precious Things' amid foliage scrolls, which are repeated on the base.

The 'Three Friends in the cold of the year', the pine, plum and bamboo, are the three plants which survive through the Winter months. The Chinese plum blossoms in December. The "Eight Precious Objects" are the jewel, the coin, the lozenge, a painting, the hanging musical instrument of jade, the pair of books, the pair of rhinoceros horns, and the artemisia leaf. They are sometimes contrasted in decoration with the "Eight Buddhist Emblems".

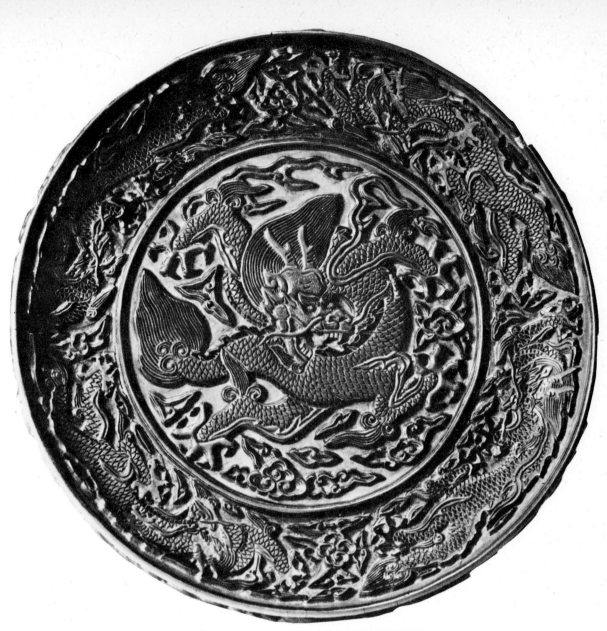

163. LACQUER DISH

Mark and period of Chia Ching (1522–1566). Diameter 19.5 cm. Palace Museum, Taiwan

This dish is of carved red lacquer on a yellow ground. The centre is decorated with a five-clawed dragon amid clouds, while four smaller dragons in clouds are reproduced in the border, and on the underlip.

The claws of the dragons and the tip of the cloud scrolls are accented in black. There is no need here to dwell on the importance of the dragon as a *motif* in Chinese art, for it is well known that "from the Han period to the Ch'ing, the representation of a dragon, or two dragons disputing a pearl, was the emblem of the Chinese Imperial house."

A very similar dish, with the same mark, is in the Royal Scottish Museum, Edinburgh.

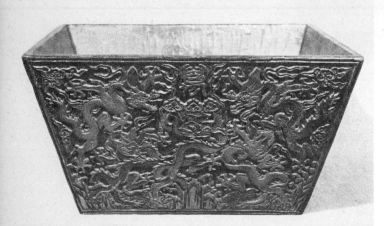

164. LACQUER BOWL (PERHAPS A RICE MEASURE)

Mark and period of Chia Ching (1522–1566). Length 32.4 cm. Width 32.4 cm. The Royal Scottish Museum, Edinburgh

This bowl or vessel differs from most other specimens in the variety of the colour used in the carving, which is red, dark brown and wine-red. It is decorated in the middle of each panel with a dragon supporting the character *Shou* (long life). The dragon is standing on the rocks amid waves, and surrounded by clouds, supported on each side by two other dragons. The diaper background in the form of a three-lobed spiral is a novel feature.

165. LACQUER BOX AND COVER

Wan Li cyclical date corresponding to 1595. Length 32 cm. Royal Scottish Museum, Edinburgh

The box has shaped edges and is carved in red and multi-coloured lacquer. The central panel of the lid is decorated with a dragon in clouds above waves, supporting the *Shou* character (long life) over its head, and surrounded at each corner by cloud scrolls. The sides of the lid have floral panels, with a plum blossom panel at each corner.

Wan Li pieces of lacquer dated to an exact year are not uncommon. The date on the next dish is the same year of the same reign.

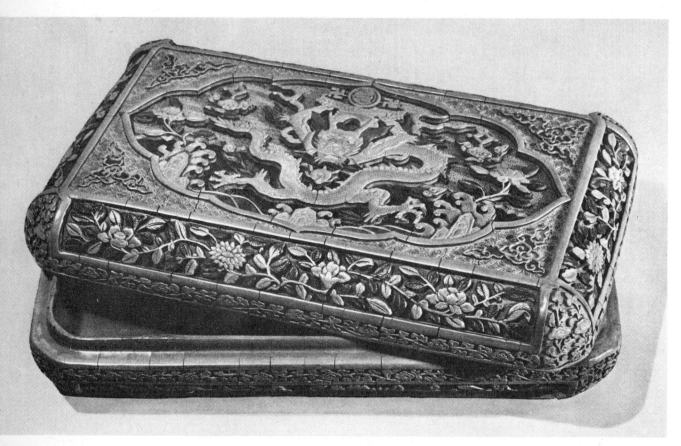

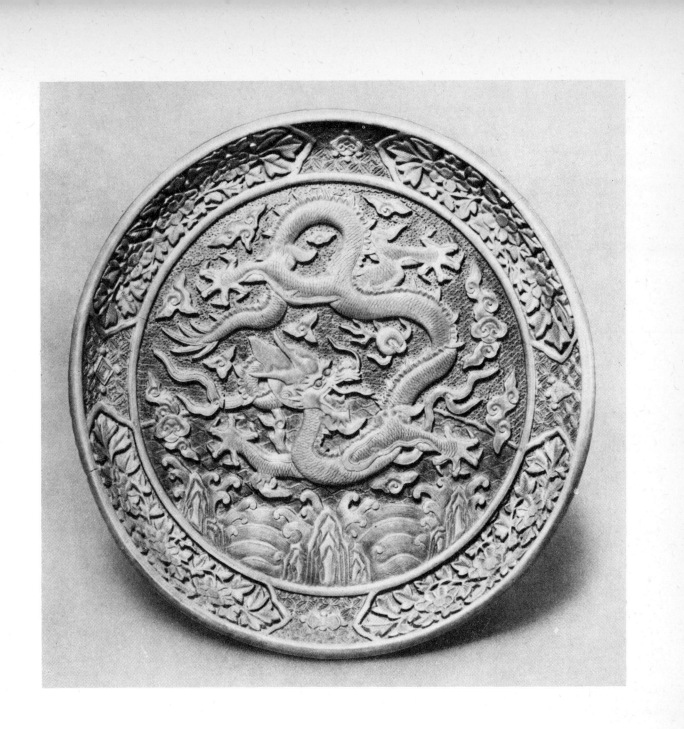

166. LACQUER DISH

Wan Li date mark corresponding to 1595. Diameter 21.5 cm.
Garner Collection

This dish is of carved red lacquer on a crimson ground. It is
decorated with a dragon in clouds, over rocks and waves in
the centre, surrounded by a border of four flower panels.
There is a continuous scroll border beneath the lip.
For a box with a corresponding date, see the previous plate.

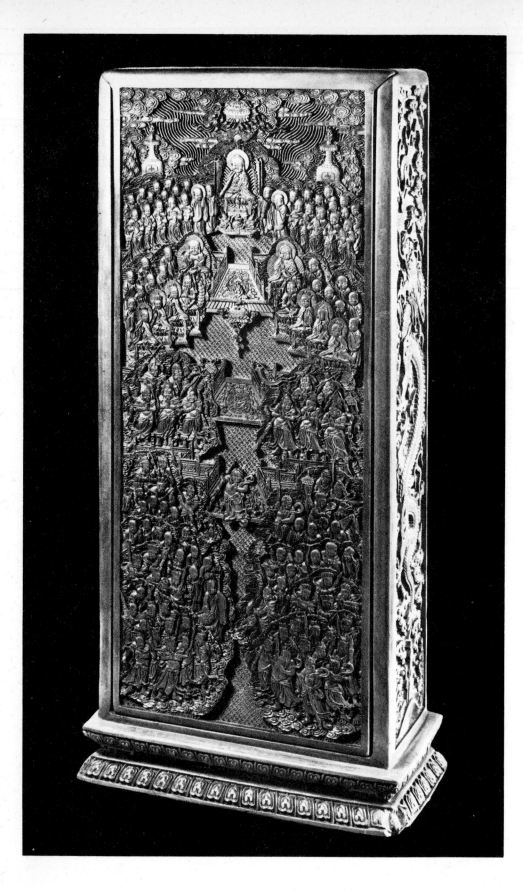

◁ 167. LACQUER BOX, INTENDED TO CONTAIN THE
"SPIRIT TABLET" OF THE EMPEROR CH'IEN LUNG

Mark and period of Ch'ien Lung (1736–1796). Height 34.5 cm.
Collection Mrs. R.H. Palmer, Reading

This carved red lacquer box is provided with a sliding front
decorated with an assembly of Buddhist saints and defenders
(lokapala), presided over by Maitreya, the coming Buddha.
The back of the box is carved with two dragons amid waves,
surrounding a *cartouche* inscribed in green and red lacquer
characters: "Reverently offered to the Emperor Ch'ien
Lung". The sides and the top are also decorated with drag-
ons amid clouds and waves. In the old China, after a man's
death, his name was recorded on a spirit tablet, which was
kept in the ancestral temple and taken out to receive prayers
and offerings at the suitable festivals. This box presumably
once held the spirit tablet of the Emperor Ch'ien Lung.

168. LACQUER BOWL AND COVER

Ch'ien Lung mark and period and dated 1776. Diameter 11 cm.
Garner Collection

This bowl and cover is of the shape which was used for both
tea and rice in China, but it is doubtful whether this piece
was used for either of these purposes. It is made of thin ver-
milion lacquer and in a fluted form.
It carries the seal mark of the Ch'ien Lung period in gold on
both the bowl and the inside of the cover, and an inscription
written in the Imperial hand with the date 1776.
It must be part of a set that came from the Palace.

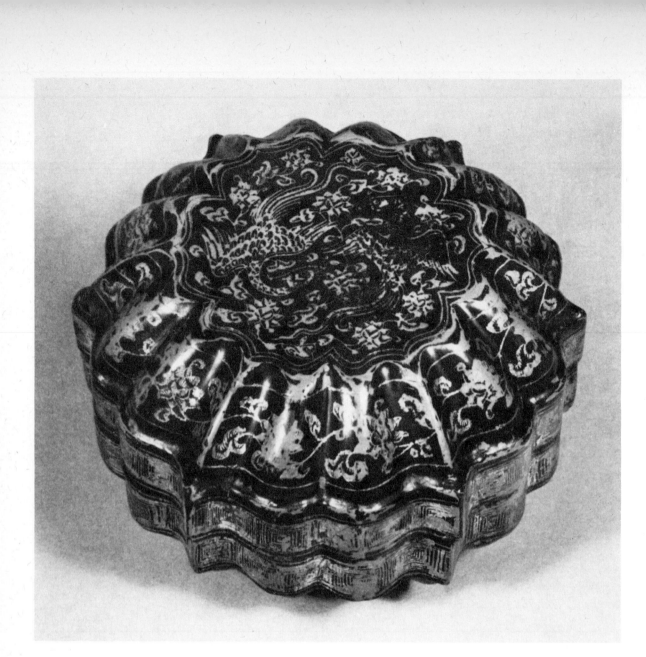

169. LACQUER BOX AND COVER

Early 15th century. Diameter 12.5 cm. Height 7.5 cm. Low-Beer Collection, New York

This box, which is of an unusual foliate shape, is relatively light in weight. Mr. Low-Beer believes it may have been made by the *Kanshitsu* or dry lacquer technique, in which hemp cloth alone is used as the basic material. (See plate 143 for a description of this process.) It is lacquered black over red, inside and out, and where the surface is worn, the red shows through. The decoration, of two phoenixes and lotus flowers on the central panel of the lid, is engraved and filled in with gold. The design, drawn with great elegance, approaches in feeling similar designs found on the blue and white porcelain of the Hsüan Tê period (1426–1435). The sides of the lid are also engraved with scrolling peonies, gilded in the same manner.

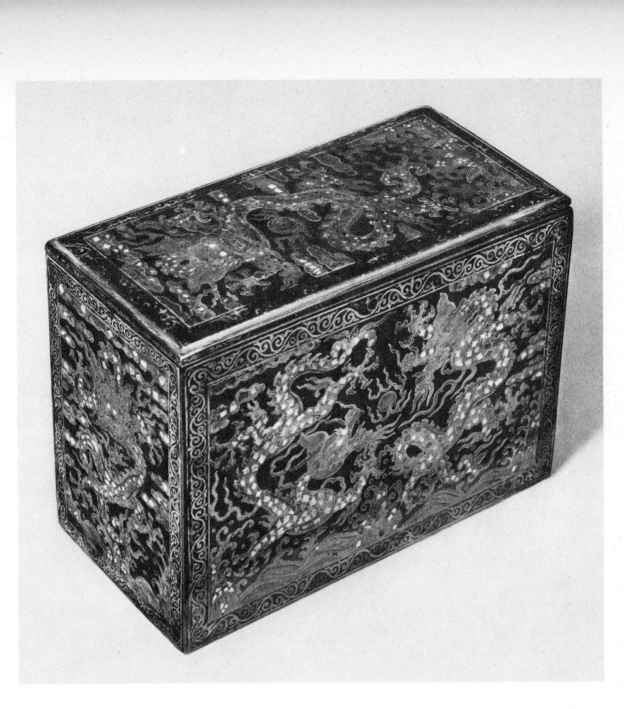

170. LACQUER BOX WITH SLIDING LID

Early 15th century. Length 17.8 cm. Width 8.7 cm. Height 12.5 cm. Linden-Museum, Stuttgart (formerly Low-Beer Collection)

"This box," writes Low-Beer, "is unusual in construction and decoration. It is rectangular and relatively narrow. The cover is made to slide forward and the front panel can also be removed by sliding it upwards. About 10 mm. behind the front panel is another panel, fitted above the bottom of the box. Underneath this panel is a little drawer extending the entire length of the box. The floor of the box is above this drawer, and has a shallow depression for an ink slab in the centre. The entire interior of the box has been re-lacquered in Japan and it may be that the structural arrangement was altered at the same time." The outside of the box is lacquered black, and the decoration of five-clawed dragons amid clouds above waves is painted in white, red, gold and brown, with black outlines, combined with mother of pearl inlay. This may be the process referred to in the *Tsun-shêng Pa-chien* as "clouds in sunset". The cover is considerably worn.

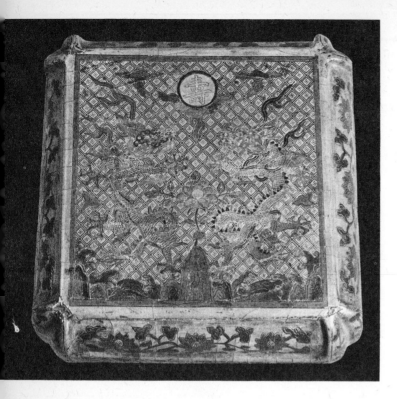

171. LACQUER BOX AND COVER

Wan Li cyclical mark corresponding to the year 1605. Length 20 cm. Royal Scottish Museum, Edinburgh

This square box has shaped edges and is decorated in red and dark green lacquer on a brown ground with gilt outlines. The design on the lid is of two flaming dragons disputing a pearl, which contains the *Shou* character (long life), amid clouds on a diaper ground above a rocky sea.
There are panels of scrolling lotus along the sides.

172. LACQUER BOWL-STAND

16th century. Diameter 18 cm. Formerly in possession of Bluett & Sons, London (ex Percival David Collection)

This bowl is covered with black lacquer. It has a foliate edge to the rim, and a high, conical foot. It is inlaid in mother of pearl with birds flying among the "Three Friends" (plum, pine and bamboo), and with dragons, phoenixes, butterflies, hares and rocks.
This kind of bowl-stand was highly prized by the Japanese for the Tea Ceremony and the few which have survived are nearly all in Japan. It was probably made in the Chia Ching period (1522–1566).

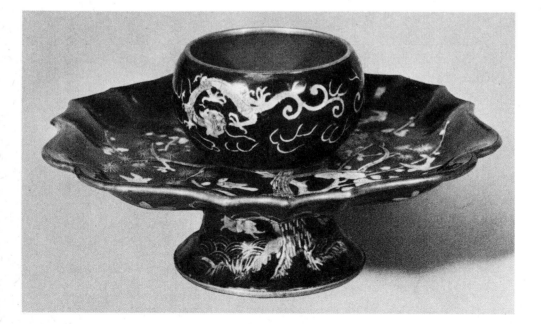

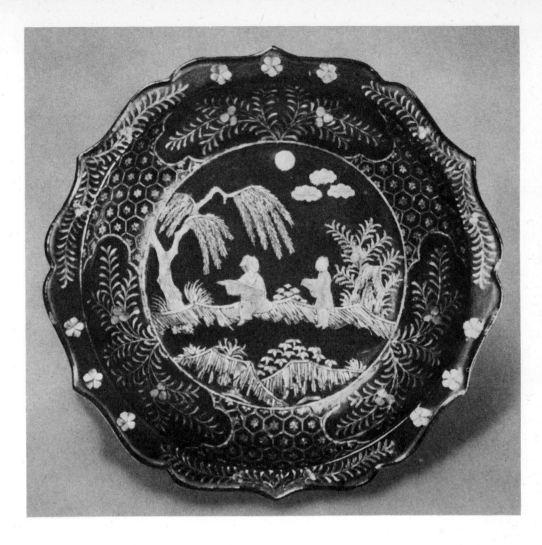

173. LACQUER DISH

Probably 16th century. Diameter 19 cm. Formerly collection of Mrs. H. R. N. Norton, London

This black lacquer dish has a foliate rim. It is inlaid in mother of pearl with two figures in a garden scene, surrounded by a border of diaper, enclosing panels of fruiting sprays. It is very difficult to date such a piece. It probably belongs to the 16th century, either to the Chia Ching (1522–1566) or Wan Li (1573–1619) period; but it is just possible that it dates back to the early 16th or late 15th century because of its shape. It is however very light in weight and the inlay is coarse, like that on Korean pieces.

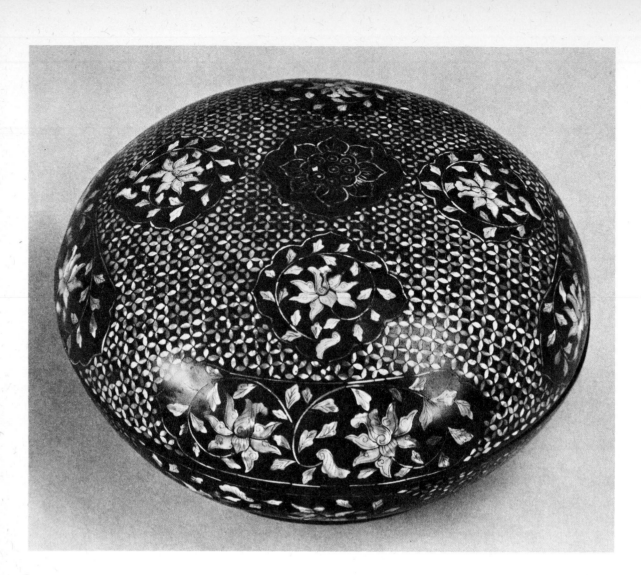

174. LACQUER SPHERICAL BOX AND COVER

Mark and period of Wan Li (1573–1619). Diameter 21.3 cm.
Height 11.3 cm. Linden-Museum, Stuttgart (formerly Low-Beer
Collection)

This box, carved with black lacquer and decorated with pan-
els of lotus blossoms on a diaper ground, is inlaid in mother
of pearl. The mark is inlaid in mother of pearl on the box
and in excellent calligraphy. The inlay effect produces curi-
ous pink and green tints.
This piece, if it were not marked, might easily pass as Ko-
rean.

CHAPTER VII: FURNITURE

THE CHINESE have not thought it worthwhile to record the history of their furniture, and not one name of a cabinet-maker occurs in Chinese literature. Without the literary evidence of tradesmen's bills and careful drawings we have to rely for our information largely on book-illustration, paintings of domestic scenes, and, for the earlier period, stone engravings and clay and bronze models from tombs. The earliest pieces of furniture which survive, of the 8th century A.D., are the low tables, stools and clothes racks preserved in the Shōsō-in at Nara, in Japan. Furniture of a kind is depicted in the Shantung bas-reliefs from the 1st and 2nd centuries A.D. in the form of low platforms with dignitaries leaning on a narrow stool, like a miniature bench, and with food and drink spread on long, low tables. As late as the T'ang period the Chinese still lived as their ancestors did, at floor level on low platforms, like the Japanese do today, where in the traditional Japanese house the manners of the T'ang still prevail. Life at this level demands low tables, couches and arm-supports for a reclining person. This kind of low furniture was perpetuated in the North of China where life in the Winter was lived on the *K'ang*, a brick platform perhaps two feet from the floor, running the width of the room, and usually part of the construction of the house. This platform was faced with bricks and mildly heated by interior flues.

In Han rubbings can be found the forerunner of a bed, which appears in the developed form of the tester bedstead in the British Museum's copy of the *Admonition of the Instructress*, attributed to Ku Kai Chih of the 4th century A.D. Other representations could be found among the paintings from the Buddhist cave temples of Tunhuang, and Ecke reproduces the representation of a four-poster bed with a canopy and curtains from a stone carving in the style of the Six Dynasties (6th century A.D.)[1]. Writers on Chinese furniture agree that the chair, as we know it, was first introduced into China from India or Central Asia and generally estimate the date of its arrival as the 2nd century A.D. Maspero has stated that both the armchair and the folding stool came from the Occident to China about the 3rd century, and he does not think they were much in use until the T'ang[2]. Ferguson, the most explicit of all, says: "The first chairs were introduced in the reign of Ling Ti (168–187) of the late Han dynasty, and were known as *hu ch'uang*, or 'barbarian couches'."[3]

Chinese furniture can be divided into a) lacquered furniture; b) hardwood furniture. Lacquered furniture tended to be used in temples, palaces and public places of entertainment. It was the fine black-wood furniture of the private houses of the aristocratic and wealthy class which provided the outstanding feature of Chinese cabinet-making. These pieces were made in traditional simple patterns, with an emphasis on structure in perfect proportion, in finely grained aromatic dark, heavy, woods which took a flawless polish (plate 181). Chinese cabinet-making depended on its splendid joinery, where a minimum of glue was used and no nails or screws, so that a chair or desk could be, even if antique, knocked

down and reassembled by an experienced cabinet-maker with little difficulty. Ecke mentions a German inventory of the 18th century describing a *hua li* Chinese bed by saying: "The curiosity of the bedstead consists in the fact that no nail has been employed in its construction... its wood is supposed to secrete a delicate scent, which however has almost vanished in the course of time."[4]

Fine furniture was a prerogative of the upper classes, and the best of it was probably made during the Ming and early Ch'ing periods for the lakeside aristocratic patrons of Suchow and Hangchow. The furniture of restaurants and other public places was either of lacquered wood or of heavy, overcarved blackwood, in surviving 19th century examples often inlaid with marble panels. Unfortunately in painting and book-illustration the artist's fancy has often taken liberty with the designs of the furniture, and for purposes of dating the details can hardly be trusted. According to Kates the old furniture dealers of Peking used to call all good cabinet-work *kuang tso*, or Kwangtung manufacture and, surprisingly, termed inferior pieces *ching tso* or 'manufacture of Peking', since in the good old days the best furniture was made in the South. This is a surprising statement, but it must not be forgotten that the woods themselves either came from the borders of the empire in the extreme South, or from such places as Siam, Indo-China, Burma and India, and that these sea-borne logs or the furniture itself, must have been dispatched from the South by Grand Canal to Peking. The Chinese trade-name for many of these woods survives, but it is difficult to discover the exact botanical names, or to distinguish between indigenous and imported. The most important was the *pterocarpus* species, in the West termed collectively rosewood, of which some thirty varieties were used in China at one time or another. This wood was *tzŭ-t'an*, the most expensive of all, of hard grain, brownish violet in colour with reddish black veins, fragrant and polishing to a bright surface. Many of the Shōsō-in pieces are made of it. Ecke believes it can be identified with either *Pterocarpus santalinus* (red sandalwood) or *Dalbergia bethamii*, both of which seem to have been sold under the name of *tzŭ-t'an*. Certainly it was an imported wood coming from South India, Annam and the Philippines. The second most important wood in the Chinese estimation was *hua li* or China rosewood. In Ecke's opinion this was either *Ormosia henryi* or *Pterocarpus indicus*. It is a heavy, close-grained, aromatic wood which takes a good polish. Some of the supplies came from Yunnan, Chekiang, and Hupeh, while others were imported from Borneo, India, and the Malay Archipelago. Several species shelter under this name. The third of these high-ranking woods was *hung mu*, or blackwood. Ecke describes it as a sub-species of *Pterocarpus* or *Dalbergia latifolia*, or perhaps *Adenotheria pavonina*. A much-favoured wood although light in colour, was *chi ch'ih mu* or 'chicken wing wood', a kind of satinwood, probably *Cassia siamea* or *Ormosia hosier*. Other favoured woods included *nan mu* (*Machilus nanmu*) from West China, which was at one time reserved for imperial use. It was close-grained, fragrant, easily worked and durable, in much demand for temple pillars, coffins and cabinets. Wan Li's coffin was made of this wood. The white fir (*Cupressus funebris*), a heavy wood, served for cheaper furniture and lacquered pieces. The wood of the gingko tree was respected for never cracking or warping, but it is easily broken. The wood of the camphor tree was used for clothes chests, and walnut for carving, while the Chinese mahogany (*Cedrula Sinensis*), which was brown, soft and easily worked, was good enough for the cheapest furniture.

So far no European has proposed convincing criteria for dating the furniture, and Europeans remain sceptical of the Chinese dealer's 'Late Ming', 'Late K'ang Hsi' and even his 'Ch'ien Lung'. The archaistic trend of styles has led Europeans to date their pieces too early. Cescinsky[5] is prepared to generalize regarding the quality, though his principles in recognizing it are far from clear. He holds that the craft of the Chinese cabinet-maker reached its zenith in form and artistry between 1580 and 1720, but reached its highest level of mechanical perfection in the following eighty years. Ecke refrains from dating a single piece of the one hundred and twenty-two pieces he illustrates, which include couches and beds, tables, seats and chairs, cabinets, stands, screens. "The best period of Chinese furniture," he says, "may coincide with the flourishing time of the blue and white porcelain, while soon after 1500 the gradual decline seems to have begun[6]. During the 17th century the surviving traditions of the classical Ming style were lost, feature after feature. A regulated but often charming delicacy now replaces the boldness of the earlier designs... sumptuous carvings encroach upon the natural beauty of the wood, and start interfering with the linear composition." Then comes the introduction of *hung-mu*, due also, we assume, to the exhaustion of the supply of the nobler rosewoods, but the author does not attempt to fix the period even of this important change.

While Ecke confines himself to the study of plain wooden furniture, the earlier book by Cescinsky is devoted entirely to the lacquered pieces[7]. Chinese lacquered furniture falls into three groups. In the first the ornament was raised; in the second, painted on the surface; in the third, cut or incised. Although there was never any demand for Chinese hardwood furniture in the West, imports of 'lackwood furniture' from China by merchantmen of the Dutch and English East India Companies began in the middle of the 17th century. In the inventory of Lady Arundel's possessions at Tart Hall, taken in 1641,[8] 'Indian' cabinets, chests and tables are listed, but such goods make an infrequent appearance in English inventories until the late years of the century. John Evelyn[9] noted the rare quality of the 'Indian' cabinets brought from Portugal by Catherine of Braganza, and also speaks of the house of a neighbour in Kent, in which was 'a cabinet of elegances, especially Indian'. In 1700, Samuel Pepys' home at Clapham was 'wonderfully well furnished, especially with Indian and Chinese curiosities'[10].

The East India Company was the channel through which much of the merchandise of China found its way into this country. The first reference to lacquered wares in the Company's extant records is in the Court Minutes of 1683, where lacquered trunks are mentioned as sold. The Company's instructions to the supercargoes give evidence of their interest in the quality of the imported wares. In 1690, a letter to their chief of council at Tongking complains that the lacquered ware sent over was 'so slight and nought, and of such low esteem' that it did not defray the cost of its freight. Lacquered boards were required to be 'lacquered on both sides fit for screens or pannels, to be done by the best artists and of the finest Lacker works procurable, or else none at all'[11].

The extent of the trade about 1700 is shown by the records of sales of the cargoes of three ships at East India House. According to *A Discourse of Trade and Coyn* (1697)[12] nothing was thought so fit... 'for the ornaments of chambers like Indian screens (plate 180), cabinets, beds and hangings'. By the 18th century Fukien was exporting lacquer to Java, India, Russia, Japan and Mecca; and Peking and Soochow,

Canton and Foochow, had become the respective centres of the carved and painted lacquer industry. Chinese lacquer varied in quality. It was recognized by Europeans that Canton-made lacquer was not so fine, nor so much in demand, as that from the towns of Tonking and Nanking. This inferiority was the result of haste on the part of the craftsmen, and too great a conformity with European taste. As Du Halde explains 'a work well japanned ought to be done at leisure, and a whole Summer is hardly sufficient to bring it to perfection; it is very uncommon for the Chinese to have any (lacquer) beforehand or that has lain for some time, for they almost always await the arrival of ships before they begin, that they may conform to the taste of the Europeans.'[13] In another passage he says: 'There is no reason why lacquer objects made at Canton should not have been as beautiful and of as good workmanship as those made in Japan or Nanking. It is not that the workmen do not use the same lacquer and the same gilding, but that those who undertake the work do it too hurriedly, and if they please the eyes of the Europeans they are content with it'.

Patterns of cabinet work began to be sent out to China in the reign of Charles II. Pollexfen states that, about 1670, 'some artisans were sent out to introduce patterns suitable for sale at home'. In a document dating from about 1700 it is recorded that several artificers were sent out by the East India Company with 'great quantities of English patterns to teach the Indians how to manufacture goods to make them vendible in England and the rest of the European markets', after which began the great trade in manufactured goods from the Indies. In 1700 English joiners as a body complained that 'several merchants and others have procured to be made in London of late years and sent over to the East Indies patterns and models of all forms of cabinet goods and have yearly returned from thence... quantities of cabinet wares, manufactured after the English fashion'. So great was the volume of this export that the Joiners' Company petitioned against it, maintaining that their trade was 'in great danger of being utterly ruined'. The demand for Oriental lacquer pieces exceeded the supply, and both Chinese and Japanese pieces were imitated in Holland, France and England. By the reign of William and Mary English imitation of the cut lacquer was practised. The design of English incised lacquer cabinets is of convincingly Oriental character, for the design was traced from Oriental panels. Stalker and Parker write in the 'Treatise on Japanning' that the most successful practitioners 'copy out the Indian as exactly as may be in respect of draught, nature and likeness'. The practice of shipping models to China appears to have reached its height in the reigns of Queen Anne and George I.

Apart from lacquered goods there was little Chinese furniture suitable for the European market. Lord Macartney, during his embassy to China of 1792–94, observed 'a want of useful furniture – no bureaux, commodes, lustres or looking-glasses'. Chinese cabinet work was not (according to Captain William Dampier's report) acceptable in this country. 'The joyners in this country,' he writes, 'may not compare their work with that which Europeans make; and in laying on the lack upon good or fine joyned work, they frequently spoil the joynts, edges or corners of Drawers or Cabinets.'[14]

The Chinese piece most frequently met with is the rectangular cabinet with brass hinges, locking-plates, and corner-pieces, which was mounted on a carved stand of European workmanship. In the inventory of Ham House[15], taken in 1679, 'one Indian cabinet with a gilt frame carved' is listed in the

Picture Gallery. Large Chinese cupboards ('cupboard-fashioned Indian cabinets') are listed among the contents of Tart Hall in 1641. A large number of lacquered chests and trunks were imported, and many of these have been preserved in country houses for their utility as blanket-chests. In spite of the number of tea tables listed in ships' cargoes, few have survived.

Folding screens decorated with incised lacquer were much in demand (plate 180), and though not originally made for the European market, proved so 'vendible' that they were exported in large numbers during the late 17th and early 18th centuries. Incised lacquer was known as 'Bantam work'[16] in England in the late 17th century and the 18th century, and is defined in Ephraim Chambers' Cyclopaedia (1753) as 'a kind of Indian painting and carving on wood, resembling Japan work only more gay'. The designs were cut in *intaglio* and painted. So far as can be determined this type of lacquer originated in the latter part of the Ming dynasty and was imported into England and France before the end of the 17th century. The technique consists in overlaying a base of wood with a composition of fine white clay. An English cabinet-maker who specialized in the repair of incised lacquer wrote that the composition consisted of a preparation of clay, finely ground, and next a coating of fibrous grasses. This was followed by at least one (sometimes two or three) coats of finer clay, rubbed down to an even surface. On this surface, lacquer was painted in sufficient coats to ensure a body for rubbing down and polishing. The design is scratched on the lacquer ground and then incised with sharp tools, and the hollowed out portions filled in with colours and some gilding. The design is clear cut and follows the style of contemporary painting, so that its date can be fixed with some certainty. The colours of the design, ranging from white to aubergine, turquoise blue, green, yellow and red, are thrown up by the lustrous ground of black, dark brown or red lacquer. Two six-fold screens of red lacquer showing European influence were given by the Jesuit Fathers to the Archduke Leopold of Austria, who laid claim to the Spanish throne in 1700[17]. Screens are sometimes dated. At Erthig, in Denbighshire, is a six-fold screen, incised and coloured representing a cavalcade on a mountain pass. It was a present in 1682 from Elihu Yale, an East India merchant to Joshua Edisbury of Erthig[18]. One example known to the author is inscribed in gold to the effect that it was made in 1781 on a lucky day and presented for public keeping by the family of Pa Hsien Liu. Another, in the Metropolitan Museum, New York, is dated 1690[19], and another in the Hearst collection is reproduced in the *Ostasiatische Zeitschrift*[20].

Panels from screens were made up by cabinet-makers into effective mirror-frames, cabinets, table tops and brackets (plate 194)[21]. Miniature screens were found most suitable for forming mirror frames[22], lacquered surfaces were treated as veneer, and in piecing the sections together all continuity of design was disregarded[23]. Some rooms were lined with panels from screens. This form of decoration is mentioned by Evelyn in 1682 at the house of a neighbour, in whose hall were 'contrivances instead of wainscot'. In a small room east of the state bedroom at Drayton, Northampton, the lacquer wall-lining is preserved. In some cases a screen or panel was sawn down the middle to make two thicknesses. Among lacquered (exported) furniture following the design of European models were seat-furniture, and case-furniture, such as desks and bookcases and knee-hole dressing and writing-tables. In case-furniture an inscription in Chinese characters is often found on a small space at the back of a drawer.

Any classification of the Oriental lacquer pieces imported into England during the 17th, 18th and early 19th centuries is difficult[24]. In the English inventories pieces are referred to indiscriminately as Indian, Chinese and Japanese. The confusion can be accounted for by the fact that the lacquer was rarely shipped direct to Europe from the country of its origin, but found its way to some intermediate *entrepôt* – such as Dutch Batavia, the Coromandel coast of India, or the port of Canton – before it reached Europe. The term 'lack work' or 'japanning' is applied equally to all these lacquered objects, regardless of whether they come from China or Japan.

Lacquer imports were not named after their place of origin, but are known by the name of the trading stations whence they were dispatched to Europe. Thus 'Bantam work', to use the early name for cut or incised lacquer (not always Chinese or Korean in origin), commemorates the old Dutch trading station in Java, and the 'Coromandel' screens another trading station on the East coast of India. The designs of English incised lacquer cabinets are often of a convincingly Oriental character, for in the best pieces the designs were traced from Oriental panels. Some of these pieces can easily be confused with Chinese. But, as Cescinsky says, much European lacquer which professed to imitate the Chinese 'is simply glorified coach-painting at its best; and at its worst a mere daubing of paint, surfaced with shellac polish, either applied with a brush or rubber'.

Japanese lacquered export furniture can easily be distinguished from Chinese by its superior quality, its designs, and glossier surface, and it was preferred by Europeans to the Chinese. In the Directories of the East India Company for 1699 it was stated "that none of the wares are to be sent, but what is lacquered in Japan"[25]. The design of the Japanese lacquered panels is usually carried out in gold in relief (*takamakie*) which is nearly all confined to painted or raised surfaces of gold on black, or more rarely, on a red ground; and sometimes they are decorated with mother of pearl. Nearly all the incised and raised lacquer came from China or Korea. Ming red lacquer is usually darker in tone than Ch'ing lacquer, more highly polished because of its age, and in far better taste than the Ch'ing (plate 175). But for absolute perfection of workmanship and intricacy of ornament there is nothing comparable to the carved red lacquer throne (plate 178) of the Emperor Ch'ien Lung (1736–1796).

The interplay of influence on furniture between Europe and China merits further study. From the design books of the middle of the 18th century it is well known that Chippendale and Matthias Darly copied Chinese models. On the other hand the furniture of the early Manchu period was highly influenced by Western models. Three lacquered tables reproduced by Cescinsky are based on English models, and another is unquestionably Dutch in inspiration[26]. The table illustrated on plate 188 belongs to this class, and the checkered inlaid top looks decidedly Dutch. Some chairs have a typical Queen Anne splat-back pattern. A great deal of painstaking research by a diligent student of decorative form remains to be carried out before we can differentiate, not only between the furniture of the various reigns of the Ming and Ch'ing dynasties, but also between the furniture of these two dynasties. This is bound to be a teasing study, based as it is on such meagre Chinese sources, but it is one which will repay any student who is prepared to lavish his affection and enthusiasm on it. Until this enthusiast appears our knowledge of the subject will remain superficial.

As this book goes to the press I have received The Bulletin of the Philadelphia Museum of 1963, entitled *Chinese Furniture* by Miss Gordon Lee in which the museum collection of furniture is illustrated. This book illustrates a lacquered wooden arm-chair with chased gilt copper mounts of the 8th century from the Shōsō-in and gives a list on page 49 of the various species of wood used for Chinese furniture with their Chinese, English and Latin names. For the first time an attempt has been made to date the pieces illustrated.

R. SOAME JENYNS

[1] G. Ecke, *Chinese Domestic Furniture*, Peking 1944, fig. 10.

[2] H. Maspero, "La Vie privée en Chine à l'époque des Han", *Revue des Arts Asiatiques*, Tome VII, 1931–32; also G. Ecke, "Wandlungen des Faltstuhls, Bemerkungen zur Geschichte der Eurasischen Stuhlform", *Monumenta Sinica*, IX, 1944, pp. 34–52; G.N. Kates, *Chinese Household Furniture*, New York 1948.

[3] J.C. Ferguson, *T'ien Hsia Monthly*, 1937, p. 246–253.

[4] Ecke, *Chinese Domestic Furniture*, p. 28.

[5] H. Cescinsky, *Chinese Furniture*, London 1922, pp. 16, 17.

[6] From this vague statement one can only presume that Ecke believes that probably the best Chinese furniture was made in the Hsüan Tê period (1426–35), when the best blue and white porcelain was made. One wonders if there is any evidence from literary sources to support this statement.

[7] Cescinsky, *Chinese Furniture*. The pieces of lacquered furniture are as follows: a) Cabinets and coffers Plates I–XXII. – b) Tables Plates XXIII–XXVII. – c) Couches Plates XXXVIII–XXXIX. – d) Chairs Plates XL–XLV. – e) Stools Plates XLVI–XLVIII. – f) Coromandel screens Plates XLIX–LIV.

[8] "A Memorial of the Rooms at Tart Hall", (1641) published in *Burlington Magazine*, Nov. 1911 and Jan. and March 1912.

[9] John Evelyn, *Diary*, July 30th, 1682.

[10] John Evelyn, *Diary*, July 23rd, 1700.

[11] Company's instructions for surface cargoes of the ship 'Trumball' bound for Amoy, October 27th, 1637. (Records of the East India Company.)

[12] Pollexfen, *A Discourse of Trade Coyn and Paper Credit*, 1697, p. 99.

[13] Du Halde, *Description de la Chine*, in Brookes' translation, Vol. II, p. 303.

[14] *A Collection of Voyages*, ed. Masefield, 1906, Vol. I.

[15] MS Inventory of Ham House, 1679.

[16] Bantam was the name of a trading station of the Dutch East India Company in Java, where lacquer was collected for export. This station was abandoned in 1817.

[17] One of the pair of screens was presented to the Duke of Marlborough by the Archduke Charles (son of Leopold I) and passed to the Spencer family through Anne, second daughter of the Duke of Marlborough, who married Charles Spencer, the Earl of Sunderland. The other screen, formerly in the Mulliner collection, is illustrated and dated in *The Decorative Arts in England*, Chapter IV, p. 35.

[18] See Margaret Jourdain and Soame Jenyns, *Chinese Export Art, in the 18th century*, London and New York 1950, p. 80, pl. 13.

[19] Jourdain and Jenyns, *op. cit.*, p. 80, pl. 14.

[20] N.F. 11, Heft 6, pl. 24.

[21] In *A Treatise of Japanning and Varnishing* (1688) it is stated: "Some who have made new Cabinets out of old Skreens; and from one large old piece, by the help of a joyner make little ones such as stands or tables, but never consider the situation of their figures, so that in these things, so torn and hacked to joint a new fancie, you may observe the finest hodgpodg and medley…"

[22] For frames of convex section, lacquer panels were cut very thin, to allow them to be bent to a curve.

23 Instances of high-handed treatment of lacquer are a chest and cabinet at Castle Ashby (Figs. 19 and 21). In the chest, portions of the border of a screen are combined. In the cabinet, the exterior is a complete composition, but for the inner face of the doors and drawer fronts, sections have been applied at haphazard, 'without considering the situation of the figures'.

24 The carved red China lacquer known as 'Cinnabar' or 'Peking' lacquer in Europe was never made up into European furniture and most of the boxes, vases and other decorative objects in this technique in England date from the reign of Ch'ien Lung (1736–1796), were not made for export, and did not reach the country till the 19th century. Many of the large pieces, such as the red lacquer throne at the Victoria and Albert Museum were loot from the Peking Palace at the beginning of this century.

25 In the instructions (1699) specifications of the goods to be imported included screens, tables, and folding card tables. MS Records of the East India Company.

26 Cescinsky says in his book that the pieces on Plates XXIII, XXIV and XXV are based on English models, and that on Plate XXVI on Dutch inspiration; that the chairs on Plates XXVII and XL are influenced by the typical Queen Anne splat-back pattern, and that the chair on the left of Plate XLII is an adaptation of a Dutch model.

175. IMPERIAL TABLE

Hsüan Tê mark and period (1426–1435). Length 119.5 cm. Width 84 cm. Height 79.2 cm. Low-Beer Collection, New York

This must be the largest and most important piece of carved red lacquer of the Hsüan Tê period in existence. At one time it was believed to date from the reign of Wan Li, as the Hsüan Tê mark placed on the inside of the rear apron had not been discovered. This mark is cut with a knife in six characters, and was once gilded. The ground of the table was once yellow but has become a dirty buff with age. Underneath, the table is lacquered black. The three drawers are red outside and black within.

Four-clawed dragons together with phoenixes and lotus flowers are the principal theme of the decoration. A detail of the table top is shown on plate 148.

The floral decoration of the four corners, as well as the sides of the top, the legs, and the narrow panels of the apron, are decorated with peonies, chrysanthemums and prunus. The vertical and horizontal ribs of the apron are in lotus decor. "The dragons are drawn," writes Low-Beer, "in flowing curves emphasized by variation in the scales, which engenders an impression of vigorous strength so typical of the period. It is perhaps noteworthy that the fifth claw has been obliterated, but was restored on all four legs of the principal dragon. This practice (of obliteration) can be observed fairly frequently, and we may assume that such pieces had been removed from the Palace prior to the Revolution in 1911."

176. TABLE AND TWO ARMCHAIRS

Ming dynasty. Probably Wan Li period (1573–1619). Table: Length 165 cm. Width 70.5 cm. Height 86.25 cm. Chairs: Height 115 cm. Width 65 cm. The Fairhaven Collection, Anglesey Abbey, Cambridgeshire

This long rectangular table is of buff lacquer with the top decorated in shaded brown, greens and reds. It is decorated with a design of lotus plants, cranes and flying birds against a formal linear brocade ground. The sides, valance and legs have scroll foliage and flowers in the same colours against a plain ground, and between the legs is an openwork frieze of rectangular dragon *motif.*

The armchairs are also of buff lacquer. The backs have three panels on both sides incised in the same colours with a design of flowers, birds and rocks. The same decoration is used for the sunk panel on either side of each arm. The seats are decorated with lotus flowers and birds. The borders of the panels and also the lower parts of the chairs have formal flower *motifs.*

It is rare to find a suite of this kind and of such an early period in the West.

177. THRONE

17th century, probably late Ming in date. Height 94 cm. Width 120 cm. Diameter 88 cm. Kunstindustrimuseet, Copenhagen

This lacquer throne has been constructed like a low table with three vertical wooden sheets encased in frames to form the back and sides. Its body is supported by four inwardly carved legs standing on a square frame. The seat, a wooden slab, is notched into the framework. The woodwork is covered with a heavy *gesso* priming, covered with red lacquer, on which the designs are incised, gilded and painted in various colours. The back and sides are decorated on the inside with four-clawed dragons and cloud scrolls above a rocky sea, supporting an archaic character, probably *Shou* (long life). The seat is decorated to resemble wickerwork. Along the legs, and the rail which joins them, there are dragons amid cloud scrolls. The lip of the seat is decorated with a key-fret border, and the square base, on which the legs rest, with false gadroons.

Dr. André Leth has published this piece in *Kinesik Kunst i Kunstindustrimuseet,* where he states that he believes that it is 17th century in date and may belong to the Wan Li period (1573–1619). Very few pieces of furniture of this nature from the Ming period have survived.

178. THE THRONE OF THE EMPEROR CH'IEN LUNG (1736–1796) FROM THE IMPERIAL HUNTING PALACE, AT NANHAITZE OUTSIDE THE YUNG TING GATE, PEKING

Height 122 cm. Width 117 cm. Depth 90 cm. Victoria and Albert Museum, London

This throne, like the throne on plate 177, is constructed on the basis of a back and two wings, which are detachable and slotted into the base of the seat and each other. The left and right arms detached are illustrated by F. Strange in his *Catalogue of the Chinese Lacquer at The Victoria and Albert Museum,* Plates XI and XII.

Both sides of the back panel and the wings exhibit a wide *ju-i* scroll in high relief, decorated in carved lotus scrolls surmounting a band of dragons and clouds. Within this feature on the inner side of the back is a shaped medallion carved in high relief showing an elephant bearing a vase of pearls on his back with attendants, one of whom is mounted and carries a banner in a rocky landscape, a rebus which can be interpreted as "peace reigns in the North".

Each of the wings, on either side, is decorated with medallions, in which are represented attendants carrying treasures and precious emblems in a garden landscape. The back (illustrated by Strange, plate X) has no such medallion, but is decorated in the centre with a carving of a pair of fish representing conjugal felicity and fertility, beneath a musical instrument suspended from the mouth of a bat. The scrolling peony background contains four other bats; the four representing the Five Blessings – Longevity, Riches, Peace, Love of Virtue and a Happy End. On the border above are other bats in clouds. The seat of the throne is supported by four heavy incurved legs suggesting elephants' tusks, their surface carved with dragons and the sacred pearls. The whole body is supported on a double frame, carved with scrolling peonies and key-fret.

The red lacquer is deeply cut through to show inner layers of light and dark olive green, brown and yellow lacquer. The seat is of uncarved red lacquer decorated with an incised design of peony scrolls, peaches, bats and swastikas in olive green and gold, with a border of black key-fret. It is provided with a yellow brocade cushion, contemporary in date. No finer example of Ch'ien Lung carved red lacquer can possibly be cited. For perfection of workmanship, and intricacy of ornament, this piece is incomparable.

179. CUPBOARD

Late Ming or early K'ang Hsi (1662–1722). Height 2.54 m. Width 1.63 m. Depth 80 cm. Kunstindustrimuseet, Copenhagen

This cupboard is constructed of sheets of wood fastened to a frame. These sheets are covered with a coarse canvas, which has been well primed before it was lacquered in subdued tones of red, green, yellow and brown on a brown ground. The two large doors of the upper part of the front are decorated in parts in rather high relief with four geese standing by the side of a rocky stream, which divides the design. Above on each bank, amid mallow flowers and flowery rushes, are a pair of wagtails and a pair of kingfishers respectively; in each pair one is perched, the other in flight. The lower unbroken panel, which makes up the front, is also decorated with a flowing stream and flowers (begonia, lilies and pinks) growing amid rocks, and with butterflies and other insects.

On the narrow band which takes the hinges is a frieze of dragons, and there is a pierced border to the base. Hinges and other fittings are of brass. Inside are two drawers, their fronts decorated with flowers.

The whole décor is a splendid illustration of the academic style of bird and flower painting of the late Ming and early Ch'ing.

This cupboard makes a pair with another in the Musée Guimet, Paris.

180. COROMANDEL SCREEN

Dated 1718. Height about 3 m. Length about 6 m. Collection Mr. Philip Blairman, London

These so-called "Coromandel" screens, which acquired their name because they were imported via the Coromandel coast of India, were made up of panels of soft pinewood cut in vertical sections and bound together with dowels. The designs were cut *intaglio*, painted and incised, and brushed with a sanded preparation to which the lacquer pigments were added, part incised and part in high relief. Many of these pigments have peeled or fallen off by reason of their weight in the course of time.

These incised lacquer screens were much in demand in England during the late 17th and early 18th centuries. The work was known as "Bantam" work, the name of a Dutch East India Company trading-station in Java, from which Chinese lacquer was collected for export.

The colours of the designs range from white to aubergine, turquoise-blue, green, yellow and red on black or dark brown or more rarely a dark red lacquer ground. Panels for these screens, which are still often to be found in English country houses, were made up by English cabinet-makers into mirror-frames, cabinets, table tops and brackets (see plate 209).

This particular screen is a splendid example of its kind. The central panels are decorated with figures in scenes from a palace garden, with an elaborate border of flowers and antiques.

It was undoubtedly made for indigenous consumption, for there is a long inscription of dedication on the back dated 1718. There are twelve panels in all. Another example of this kind of screen, dated 1690, in the Metropolitan Museum, New York, is reproduced in Jourdain and Jenyns' *Chinese Export Art*, plate 14.

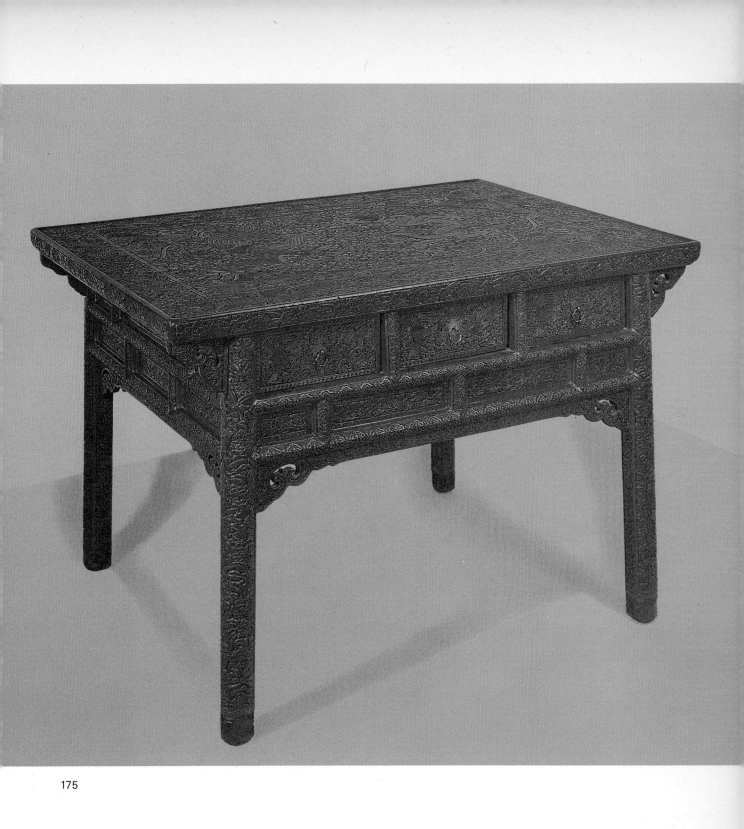

175

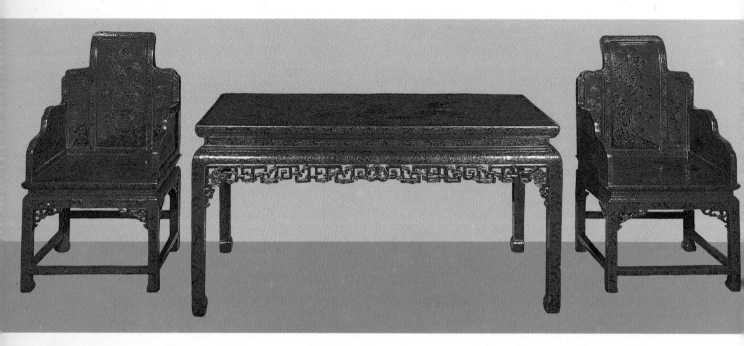

176

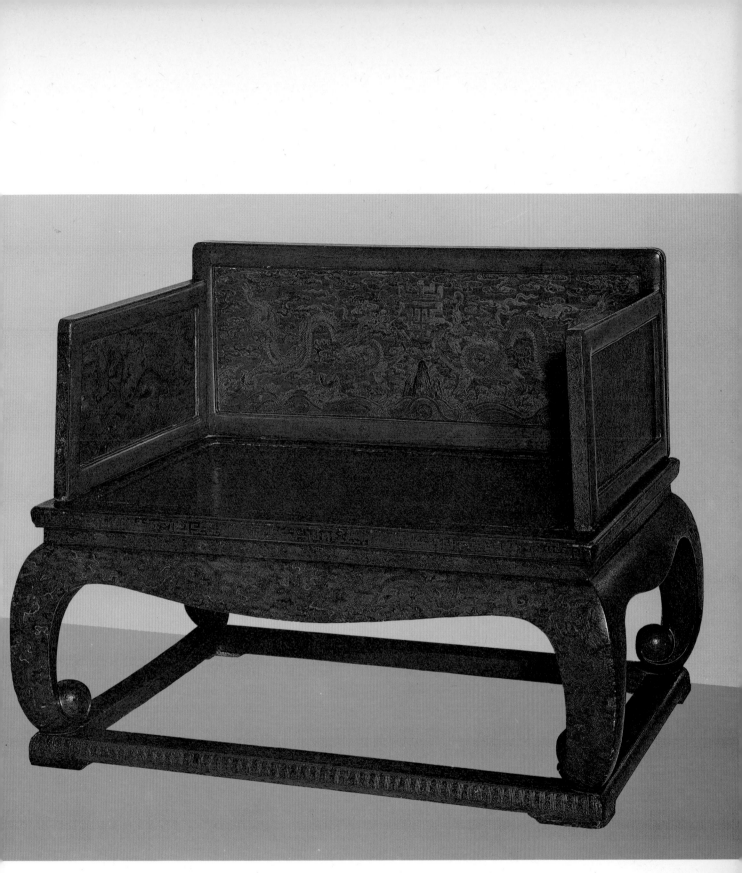

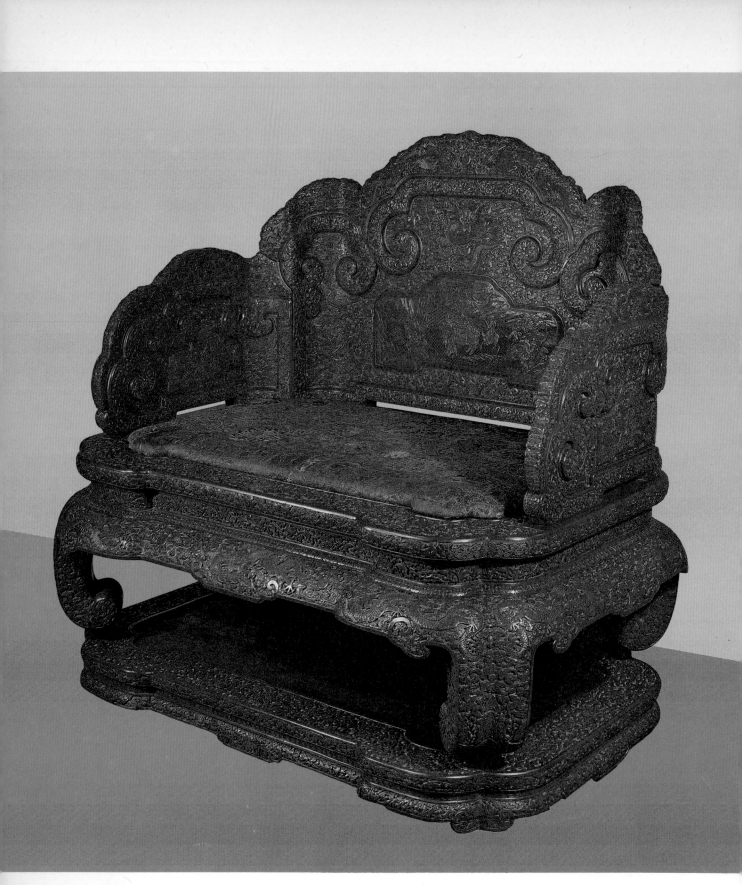

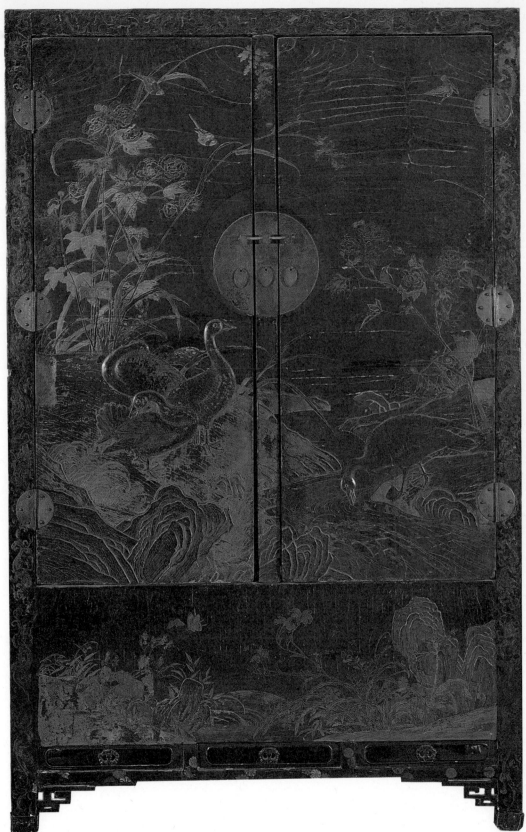

179

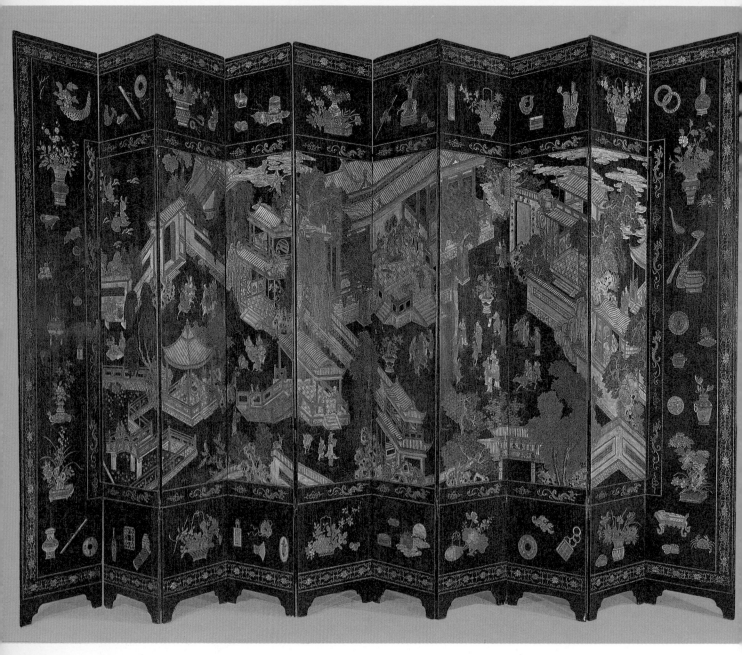

180

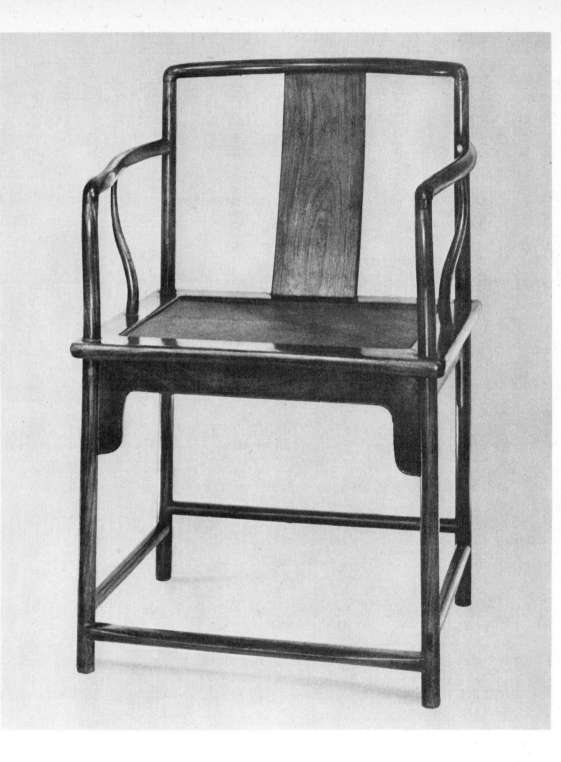

181. ARMCHAIR. ONE OF A PAIR

Ming dynasty (1368–1644). Height 88.2 cm. Width 59 cm.
Depth 58.4 cm. Kunstindustrimuseet, Copenhagen

The legs, arms, back and leg-supports of this chair are rounded. The seat is of wood, but covered with straw matting fitted onto a frame. It is supported underneath on all four sides. The back splat is flat. Dr. Ecke, well-known for his study of Chinese furniture, believes this chair, from its absence of ornamental detail and on account of its vigorous construction, to be a typical example of the best Ming furniture which has survived.

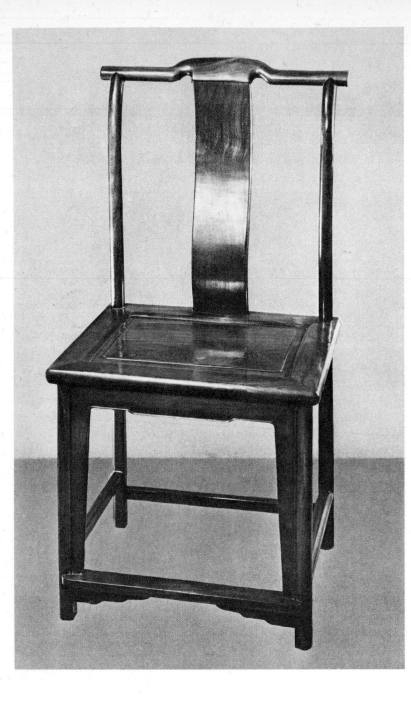

183. ARMCHAIR ▷

Late 17th or early 18th century. Height 92.5 cm. Width 65 cm. Collection Mr. H.T. Haon, London

This armchair, of so-called "Lohan" type, is carved in the round and has a dragon in relief on the back splat. It is made of *huang hua li* (East Indian Rosewood), and has a cane seat. Because of the age-long traditions which govern the design of Chinese furniture it is difficult to date such a piece with any accuracy.

182. CHAIR WITHOUT ARMS

Probably late Ming period (1368–1644). Height 95 cm. Width 48.75 cm. Collection Mr. H.T. Haon, London

This chair has no arms and is made of *chin tzŭ t'an* (golden threaded and purple sandalwood). It is very simple in design and effective in its proportions.

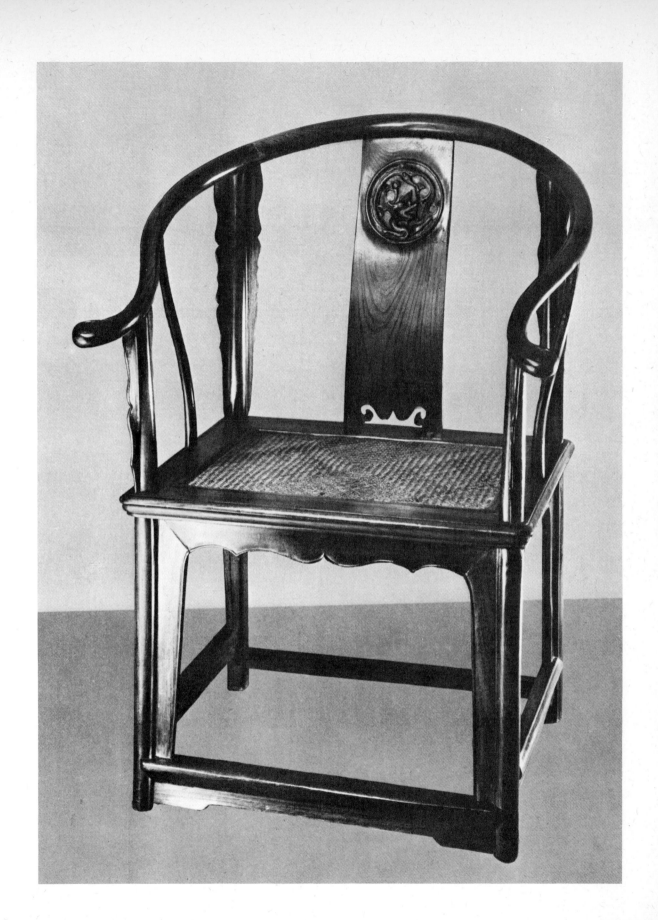

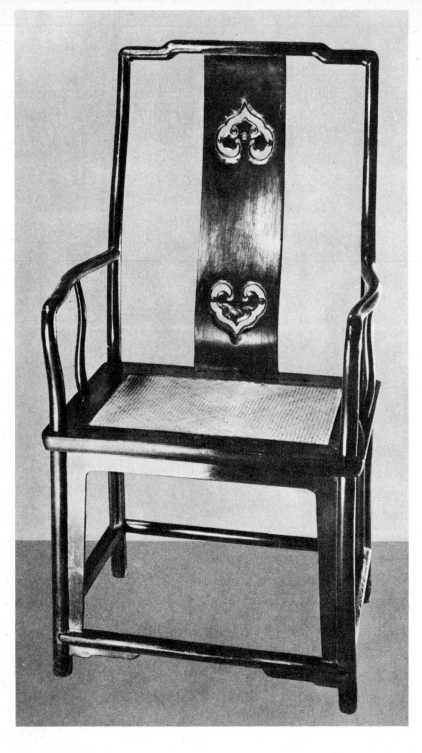

184. ARMCHAIR

Early 18th century. Height 1.10 m. Width 52.5 cm. Collection Mr. H.T. Haon, London

This armchair has a *ju-i* design cut in openwork on the back splat. It is made of *huang hua li* (East Indian Rosewood), with a cane seat. The *ju-i* symbol conveys the idea "as you wish", or "in accordance with your heart's desire". Its shape is derived from the head of the *ling chih* fungus, a species of agaric, at first regarded as an emblem of good luck and afterwards as a Taoist emblem of Immortality (see also plate 209).

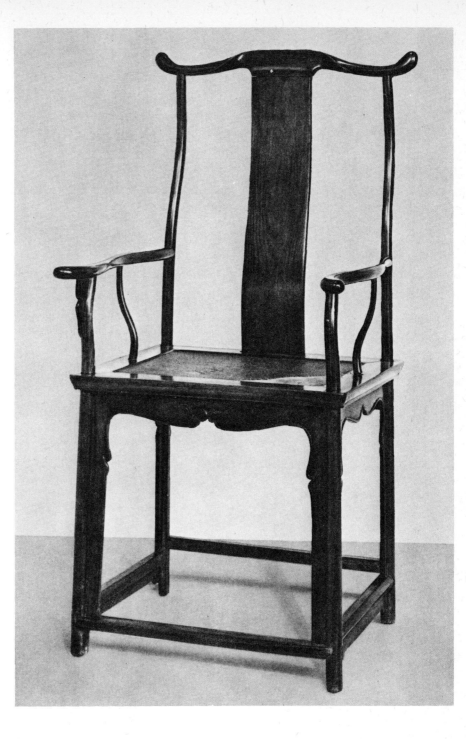

185. ARMCHAIR

*18th century. Height 114.6 cm. Width 59.5 cm. Depth 54.6 cm.
Kunstindustrimuseet, Copenhagen*

The lines of this chair, which is made of padouk wood, are straightened by profiled flanges. The wooden seat is covered with matting notched into the frame.

"Like so much else in the arts of China", writes Dr. André Leth, "Chinese furniture is strongly traditional; types of chairs like the present specimen date back as far as Sung times, and are often depicted in Sung paintings. Virtually unaltered, the type was repeated through the ages, which makes dating difficult. The various elements of this chair, rather slender in conception, would seem to harmonize with the 18th century taste."

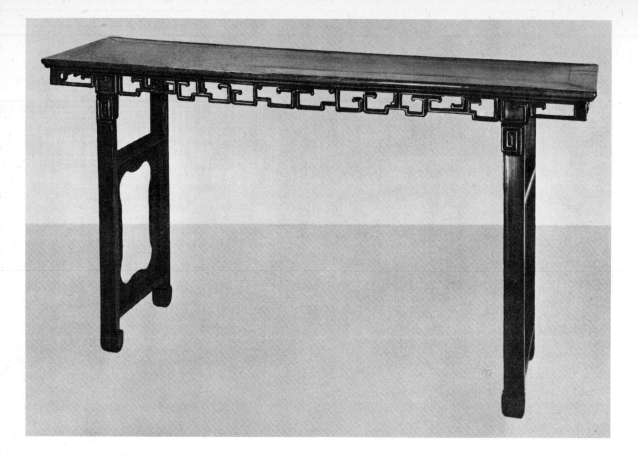

186. TABLE

Perhaps 17th century. Length 1.75 m. Width 45 cm. Height 95 cm. Collection Mr. H.T. Haon, London

This narrow table has an openwork band of key-fret under the lip and is made of *huang hua li* (East Indian Rosewood). From its shape it might have been used in an ancestral temple to hold offerings.

187. TABLE ▷

Late 18th century. Length 1.25 m. Width 77.5 cm. Height 80 cm. Collection Mr. H.T. Haon, London

The table is decorated under the lip with an openwork band of key-fret. It is made of *tzǔ t'an* (purple sandalwood). This kind of table was still in use in the Chinese houses of the upper classes up to the Revolution.

188. TABLE ▷

Ch'ien Lung period (1736–1796). Height 33.5 cm. Length 1 m. Width 42.5 cm. Jenyns Collection, Bottisham, Cambridgeshire

This narrow, so-called "lute-table" has a most elaborate inlaid *marquetry* top, probably copied from Dutch veneer, with a border of key-fret carved in relief beneath. The legs and cross-section are elaborately and intricately carved with interlocking key-fret patterns in relief, but although the decoration is so elaborate the whole effect is delightful.
This is the kind of Chinese table Chippendale may have copied.

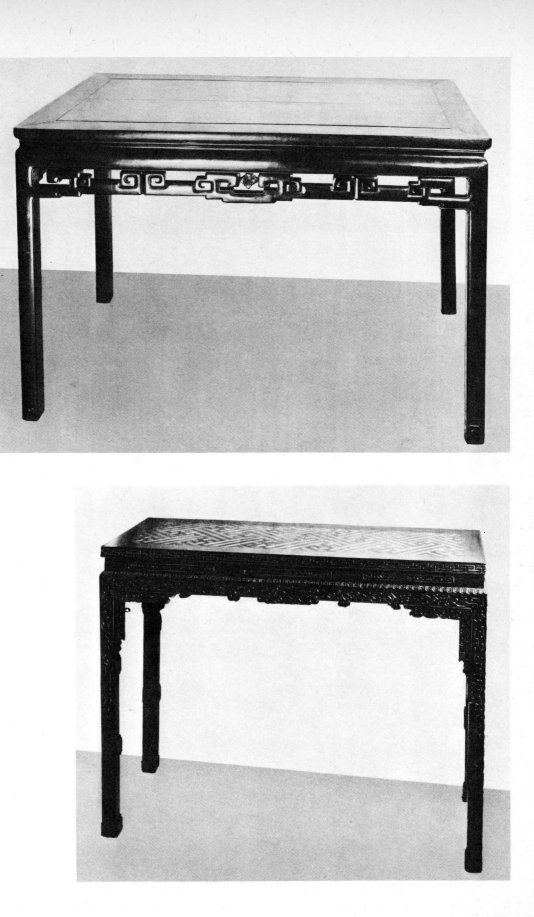

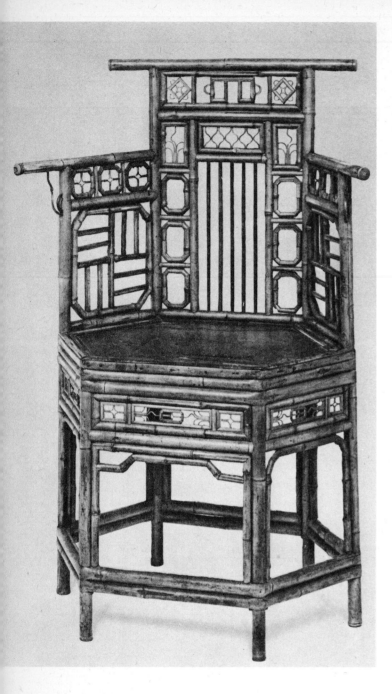

189. ARMCHAIR

Late 18th century. Height 95 cm. Width 1.49 m. Depth 61 cm.
Kunstindustrimuseet, Copenhagen

This armchair is constructed of bent and split bamboo canes. The seat is made of wickerwork on a wooden base. There are ivory knobs on the projecting arms and headrest. This chair, one of a pair, together with a settee (illustrated by A. Leth, *Kinesisk Kunst i Kunstindustrimuseet*, last plate in the book), came from a country house lying on the outskirts of Copenhagen, which was built in the 18th century and rebuilt between 1782 and 1795. The cane furniture was undoubtedly procured at this period.

190. LACQUER TABLE ▷

Probably 16th century. Height 80 cm. Width 50 cm. Musée Guimet, Paris

This table is of wood covered with a dark brownish-black lacquer inlaid with mother of pearl: on the top with the Eight Immortals and their symbols, two philosophers playing chess, cranes and other longevity symbols, and on the surface of the base with a fine prunus sprig. The sides and legs are decorated with peony scrolls.

This table was exhibited at the Chinese Exhibition at Burlington House in 1935/36 (No. 1546) as 14th–15th century, although it is more probable that it belongs to the Chia Ching period (1522–66). Two other tables of not very different form, but made of cloisonné enamel, were exhibited in the same exhibition (Nos. 2504 and 2507) and dated to the K'ang Hsi period (1666–1722).

This shape of lacquered wood table was frequently copied in Japan.

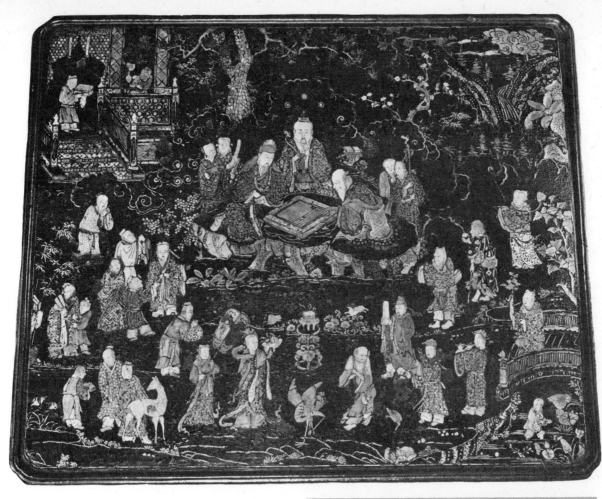

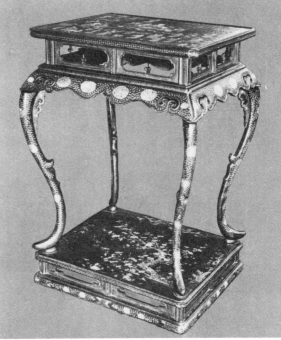

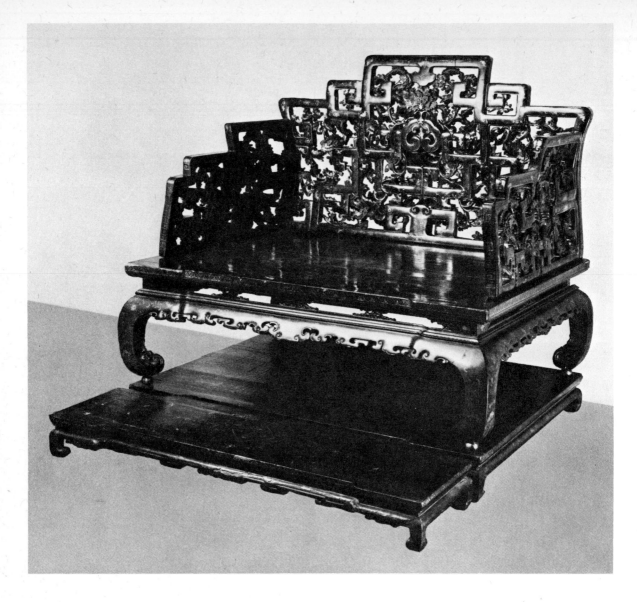

191. THRONE AND STOOL

Early 17th century. Height 1.375 m. Width 1.375 m. Depth 1.025 m. Victoria and Albert Museum, London

This throne is constructed like the two others (plates 177 and 178), with detachable back and wings, but it is older than both of them. The back and arms are in bold openwork of key pattern filled in with peonies, and are arranged so that they slope slightly inward. It is painted with flowers, bats and clouds in gold, red and brown lacquer on a black ground. The centre of the seat is decorated with a large peony flower in red surrounded by two phoenixes, and each corner is a chrysanthemum blossom, while the background is painted with flowers, bats and cloud scrolls in blue, red, green and brown lacquer on black, but much worn.

The four legs, heavily incurved, are linked by a band, the edge of which is carved in an outline of cloud forms; the front legs are supported by gilt balls on a low stand.

The stool is decorated with a design of bats, clouds and key pattern.

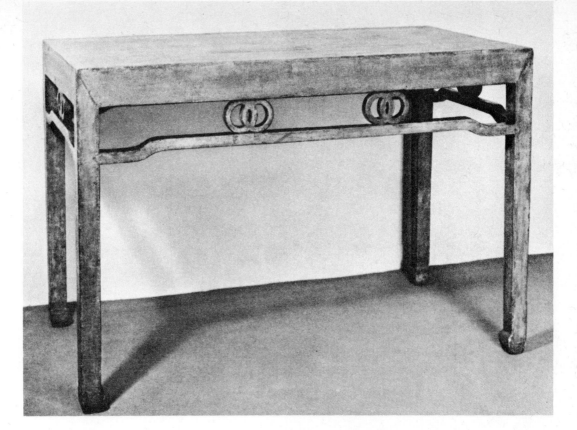

192. TABLE

*Ming period (1368–1644). Length 1.225 m. Height 80 cm.
Depth 62.5 cm. Collection Alan Roger, London*

This rectangular table is covered with a yellowish-white lac-
quer. The four legs are square in section, with the feet
turned in. It has high cross stretchers decorated above with
simple, circular, reticulated *motifs*, carved in the round. It is
one of the rare examples of Chinese lacquer furniture made
for the Chinese connoisseur along simple classical lines, and
without any decoration.

193. CHAIR

*17th century. Height 85 cm. Collection Mr. Dennis Buxton,
Caister Hall, Norfolk*

This chair is covered with a black landscape scene in gold. It
is probably a little later in date and certainly coarser in quali-
ty than the throne illustrated on plate 191. The back splat
and the arms are carved in a most elaborate fretwork pat-
tern, beautifully balanced. It is difficult to say in the present
state of our knowledge whether such chairs belong to the
K'ang Hsi period (1662–1722) or to the late Ming.

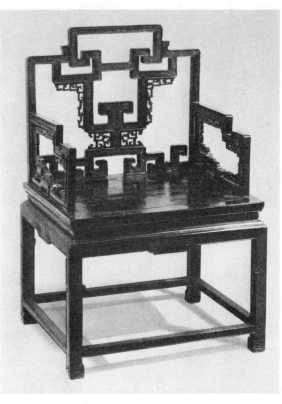

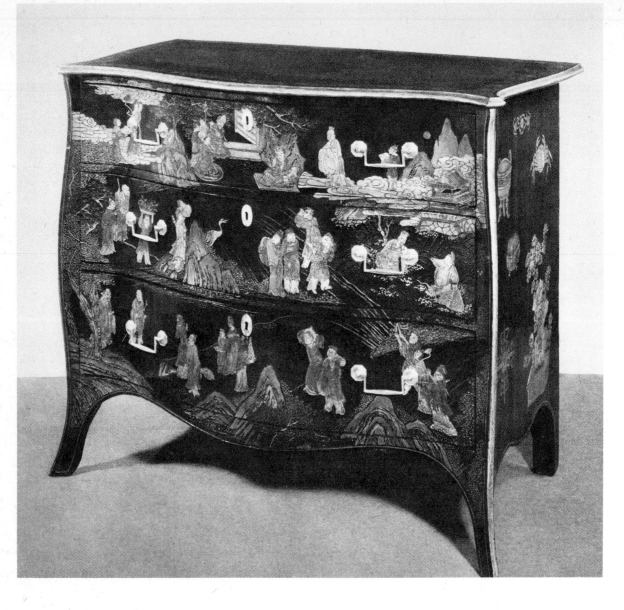

194. COMMODE

Late 18th century. Height 72.2 cm. Formerly in possession of Mallett & Son, London

This Hepplewhite serpentine commode was made up in Europe from Chinese lacquer panels, decorated in relief with figures in green, beige and red on a black lacquer ground. The panels were probably originally part of a "Coromandel" screen, made in the late 17th century.

195. LACQUER SCREEN

▷

Early 18th century. Height 1.80 m. Length 4.2 m. Formerly in possession of Mallett & Son, London

A fourfold black lacquer screen with scenes of scholars looking at paintings, listening to music, playing chequers and studying poetry in a garden, inset in semiprecious stones – turquoise, agate, jade. There is no reason to believe that this screen was made for the foreign market.

254

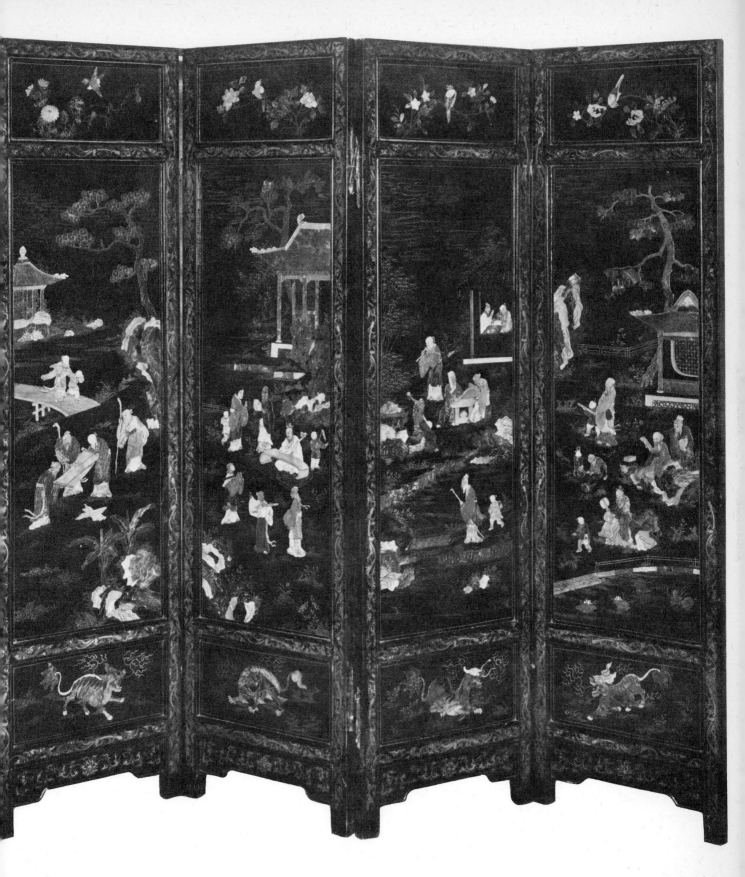

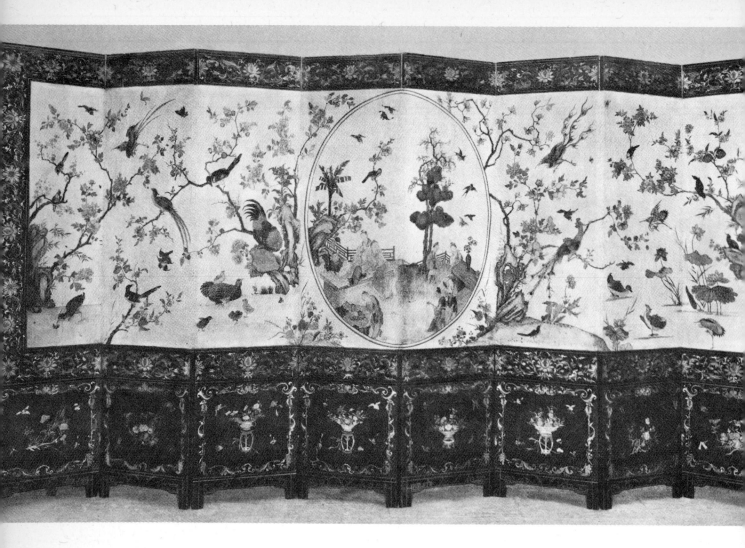

196. LACQUER SCREEN

About 1745. Height 2.35 m. Width of each panel 57.5 cm.
Formerly in possession of Mallett & Son, London

This eightfold lacquer screen has upper panels of cream lacquer painted with a design of birds and flowers. The central panel contains a representation of a music party in a garden. The top border is painted in vermilion chrysanthemums with gold leaves on a black lacquer ground. The lower panels contain flowers and insects, or flowers in baskets on a stool, on a black lacquer ground. This screen was brought to Holland by Andreas Everardus Van Braam Houchgeest after a journey to China in 1794–1795. It was probably made about 1745.

256

CHAPTER VIII:
WOOD-CARVING WITH SPECIAL REFERENCE TO BAMBOO

A THOROUGH study of Chinese wood-carving would include the decorative work of buildings, particularly their screens and trellis-work panels, and the image-carving of the Buddhist temples; but both these themes lie outside the scope of this book, which is concerned instead with the minor works of the Chinese carver in which no less ingenuity is displayed. Probably among the most interesting Chinese wood-carvings, and certainly the most charming, were the small objects in box-wood, willow, olive and bamboo made for the scholar's desk, many of which have been preserved in the Palace collection in the form of brush-rests, brush pots, vases or small bowls (plates 200, 201, 206 and 207). These *bibelots* are carved in a great variety of woods, including roots, nuts, gourds and fruit stones, but for all manner of ornamental carvings bamboo was the most favoured material.

Among pieces in the former Palace Museum, and illustrated in its journal, *Ku kung*, there is a large dish of palm-root with a Ch'ien Lung imperial inscription[1]; and a smaller wooden bowl of maple-wood, inscribed "wooden bowl from the western store-house for the imperial use of Ch'ien Lung".[2] The latter is similar in appearance to many wooden Tibetan rice-bowls. There is also an olive-wood vase (*p'ing*), and a carving in which there appears to be some petrified wood representing a rock, with figures entitled "The nine old men of Hsiang Shan"[4], and an inscription in Ch'ien Lung's hand. A brush pot of *lan* wood, described as a species of palm growing in Kwangtung, has been favoured in the same way[5]. There are a number of wrist-rests and brush pots of box-wood or willow-wood. When the author was in Taiwan he was shown several small wooden copies of archaic bronzes in the imperial collection. One of these was a willow-wood *ku*, carrying an inscription by Tung Ch'i-chang, the painter and calligrapher. A wooden brush-rest purports to have belonged to this celebrity, while a brush-rest in the shape of a wooden leaf inscribed by Ch'ien Lung is thought to have belonged to the famous collector, Hsiang Yüan-pien. Wood-carvings of a monkey and her young with pomegranate flowers, a lotus leaf with a crab, and a lotus flower half in pod, were pieces thought worthy of admission to the palace. The last two bear the signature 'San Sung', or 'three pines', the name of a famous bamboo carver who lived in the Ming period at Chia-ting in Kiangsu. In the exhibition recently held in America of Palace treasures from Taiwan was a box-wood brush pot decorated with the three friends – pine, plum and bamboo[6].

A curious speciality was the carving of shell of a species of coconut from Hainan. According to the *Liang piau-lu-i* "the people of the South made slop-bowls of coconut" in the T'ang period[7]. Small wine bowls carved in this material and often lined with silver were not uncommon in the Ch'ing period. Human figures carved from tree-roots, generally Fukien or Cantonese work of poor quality in which the natural irregularities of the root are utilized to produce fantastic forms, were exported to Europe from the 18th century onwards, and are still exported today. They were known in the trade as "carved

tea-root josses". Fruit-stones carved into the form of junks were another feature of the export market, as well as carved fans, frames, glove and work-boxes, many of which were lacquered black with gold decoration. And the name of a Miss Chiao Hsüeh-hai of the Ch'ing period has been recorded, who "was extremely good at carving peach stones into various forms of boats". Among the names of other carvers of peach stones recorded are Feng Wan-kwan, Feng Pen-kwan, Feng Yuan-kwan, and Feng Yuan-shêng. Another group of artists from Soochow specialized in carving fan frames, among them Yang Lung-shih, Wang Su-chun, Tan Sung-po, Chen Ju-jin and Mu Ku-hsien, of whom the last "specialized in flowers and female figures on fan frames". Other carvers like Yang Ch'ien and the Yangchow monk Shih Chu-tang, specialized in making seals from bamboo roots.

Although it is not generally realized, the Japanese *netsuké* was anticipated in China, where wooden and ivory toggles were carved in various forms for the belt[8]. There must also have been many artisans, like Miss Feng who was celebrated for her carvings of toads, who made small carvings of animals, birds and figures in wood, but their names and work are unrecorded.

Another woody material which was decorated by Chinese craftsmen was the dried gourd of *Lapenaria vulgaris*, which can be still seen growing over so many garden fences in North China. It was discovered that certain strains of vines produced more suitable and attractive gourds than others. These strains became famous and their owners jealously guarded the seeds, profiting by the sale of the gourds. In some cases the surface of the gourd shell has designs scratched or incised upon it. In others the growing gourd is enclosed in a patterned mould so that it presses into this pattern as it grows and eventually shows a fine embossed design (plate 210). The growing of these gourds in moulds became an artistic hobby in the neighbourhood of Peking[9]. The art was to force the unplucked growing gourd, while it was still soft, tightly into the carved mould. This was an intricate process, and only a few gourds in every hundred would shape themselves without some minor imperfection. The Chinese found these gourds were ideal receptacles in which to house crickets. Crickets were originally kept for the sake of their song, and it was not until the T'ang dynasty that the Chinese began to keep them for fighting. In the Sung period the cult of the cricket developed a special literature of its own. The first of these works was the *Tsu chi-ching* (the Book of Crickets) written by a minister of State, Chia Sê-tso. The author, a passionate cricket-fancier himself, gives minute descriptions and subtle classifications of all species of crickets known to him, their treatment and care. A similar book the *Tsu-chi-chi* (Record of Crickets) by Lu Tung, was written in the Ming dynasty, and another, the *Tsu chi p'u*, (Treatise on Crickets) was written by Fang Hu of the Ch'ing[10]. Ways and means of decorating these cricket gourd cages became a hobby of the rich, just as we find in the Ch'ing dynasty elaborate bird-cages with tortoiseshell perches and ivory seed-boxes. Some of the cricket cages had perforated lids of jade, tortoiseshell or ivory. Sowerby, writing in 1933 in *The China Journal*, says that it was still possible in his time to pick up old gourd cases, which dated to the Ming period and had been the pride of some old connoisseur[11].

The moulded gourds were used not only for crickets, but also for brush-holders for the scholars' writing-tables. There are five or six of these in the Palace Collection, Taiwan. Most of them have K'ang Hsi marks and all of them were probably made from gourds grown around Peking. One of these brush-

holders, three inches high, square in shape, was inscribed on the base with a poem of the four seasons, and the words "K'ang Hsi precious jewel". It is lacquered inside in black. The British Museum possesses a little water dropper made of this material which also has a K'ang Hsi mark, and there is no reason to believe it is not of the period (plate 210).

Many of the species of wood mentioned by Chinese writers as imported from the South Seas are difficult to identify, like the arm-rest of *huan yang* wood in the Palace Collections[12]. Apart from those used in the production of furniture, there were others valued for their appearance or their scent, like ebony. Chau Ju Kua describes it as hard as iron and as glossy as lacquer[13], and says it is a product of Hainan, where it is used to make chopsticks; and "there is a variety which is brought to China by foreign ships which is so dense that it sinks in water. There are a great many varieties, all of which are good for making canes and tables. None is real unless it sinks in water". This wood is described as a product of Annam and Malaya. There is also Sapan wood (*su mu*) from Cambodia which produced a purple dye.

Scented woods have always been in demand in China, both for carving and incense. The most important of these were gharu wood (*chou liang*) and sandalwood (*t'an hiang*). Gharu wood was the most precious of them all. Chau Ju Kua tells us that the best came from Cambodia and the second-best from Annam, and inferior varieties from Malaya, Java and Hainan. Sir Percival David had a pair of small cups of this wood attributed to the Sung dynasty, carved in relief with landscapes by the Chang brothers[14]. Sandalwood has always been in demand by the Chinese for incense. "Its smell catches the breath and its taste is bitter and pungent... in burning it surpasses all other incenses." By tradition the earliest figures of Buddha are said to have been made of this wood, and it is still the favourite material for the 108 large and 18 small beads which make up the Buddhist rosary, of which the last are often carved in miniature representation of the eighteen Lohan. It is also in popular use for fan sticks. Chau Ju Kua says it was brought to China by the Persians (Arabs?) in the 10th century. It was a product of Ceylon, Annam, Palembang, Malaya, Java, Zanzibar, Timor and India, and a heavy tax was placed on it and on *gharu* wood in the 10th century. Among the sandalwood pieces in the Palace is a big wood screen described as inlaid with yellow willow and decorated with dragons and clouds[15].

The elaborate little carvings made for the scholar's table (plates 208 and 209) and for the palaces, as in the case of rhinoceros horn cups and ivory wrist-rests, were often signed with the name of the maker, particularly in the case of the bamboo brush pots and wrist-rests. The carving of these also became a hobby among scholars, and many of the surviving pieces are the work of gentlemen amateurs. Some carvers' names are recorded, but the identification of their work is fraught with uncertainty, since the names of famous carvers might be added to unsigned pieces. Among such artists the *Ch'ing pi ts'ang* mentions "Chou Ch'eng of the Kao-tsung period (1127–62) of the Southern Sung dynasty, who could carve palaces, landscapes, figures, animals and birds and flowers on a small piece of bamboo with such delicate lines that his work is considered miraculous. Hsia Pai-yen, who worked during the Hsüan Tê period (1426–1435), could carve on an olive-stone sixteen frogs, each with a distinctive type of face, or nine dragons and egrets. The skill of the two artists has been equalled in recent years by Yu Shih

who could engrave more than a thousand characters on the surface of ivory not larger than an inch square"[16].

But perhaps the favourite wood in the hands of the Chinese woodcarver is the bamboo. The compartmented hollow stem, with its indescribable gloss and pleasurable touch, was readily turned into brush pots and arm-rests; while the fantastically contorted root suggested subjects for the carver based on its strength and natural form. The brush pots (*pi t'ung*) and arm-rests (*chen shou*) are the commonest bamboo objects in collections (plates 198–201 and 203). Carved decoration can be merely engraved, carved in high or low relief, or cut in openwork. Floral sprays, dragons or phoenixes are frequent subjects, often accompanied by verses or other quotations from literature. The convexity of the hand-rest supported the writer's wrist, while the straight edge helped to preserve the alignment of the written characters.

Bamboo flourishes particularly in Chekiang, Hupeh, Szechwan, Yunnan, Kwangtung, Kwangsi, Fukien and Hainan; although it will grow as far north as Peking, it does not flourish there, and the art of the bamboo carvers in China belongs to the South rather than the North. The wood is as hard as horn and acquires a wonderful lustre from age and polish, ranging in colour from lemon-yellow through many shades of sherry, madeira and mahogany to black. There are also spotted varieties, which are fancied as fan sticks. In some pieces the skin is left on and the drawing blacked in with pigment. Other designs were engraved by burning with metal tools. As the colour of the skin of the bamboo is lighter than the wood, designs can be left in reserve against the darker background (plate 203). This process was invented in the Ch'ien Lung period and known as *chu huang* (i.e. bamboo yellow or skin bamboo). There is a considerable Chinese literature on the subject of bamboo carvings which has not been translated into any European language, including articles in such books as the *Chu jên lu*, the *Ch'ing mi ts'ang* (Notes on different kinds of trinkets by Chang Ying-wên) and the *Ch'ien chin ming ying lu* of the Ming period, and the *I shou chia* of the Ch'ing period. A section is devoted to bamboo carvers in the *Chung kuo i-shu chêng lueh*, compiled by Li Fang in 1914; the names of some fifteen Ming carvers of bamboo and some forty-eight Ch'ing carvers have been recorded.

In a recent article on the subject of bamboo carving, J. H. W. Grice suggests that the earliest work was executed in the initial stages by burning with heated metal tools, leaving a minimum to be finished by knife and chisel[17]. His article is valuable for its translation of notes on carvers, providing material which the present writer has gratefully used. According to tradition, bamboo carving began in the Sung period (although there is no reason why it should not have originated earlier). Of the bamboo carvers of the Sung dynasty only two names have come down to us, those of Chan Ch'eng and Hsia Pai-yen, but their work has not been illustrated. Chan Ch'eng, we are told in the *Cho Keng-lu*, lived in the reign of the Emperor Kao Tsung (1127–1162):

"He could carve and engrave (bamboo) beautifully and exquisitely, and was ranked above his fellow-artisans. I have seen a birdcage which he made; it consists of decorative panels on all four sides. All the bamboo perches were engraved with high buildings, human figures, landscape, flowering plants and birds. The delicate and fine lines on all these are as fine as silken threads. Moreover it is in open-work and some parts are movable."

No bamboo carvers of the Yüan period seem to have been recorded, but many of the Ming period receive notices in such works as *Ssŭ mien chai chi*, *Tui shan shu wu mo yü lu*, *Chia ting chu jen lu*, *Chu ko ts'ung-ch'ao*, and *T'ai ping fu chih*, all of which have contributed to the description of the twelve leading Ming carvers listed below. The most famous were the three Chu's of Chia-ting, Chang Hsi-huang and P'u Chung-ch'ien.

1. Chu Hao (called Sung Liu) "was well-versed in the ancient seal-characters and skilled in engraving seals and also in carving. He could engrave on material less than an inch square landscape, human figures, high buildings, birds and animals, using his knife according to the nature and texture of material". The carving and engraving of bamboo is said to have virtually begun with Chu Hao, whose work was as simple and elegant as "scholars' hats".

2. Chu Ying (called Ch'ing Fu, Hsia Sung). The son of Chu Hao, who carved images of immortals and engraved landscape scenes in ancient style. He engraved a Lohan with a rosary "as fine as the eyelash of a mosquito", but was otherwise noted for his bibulousness.

3. Chu Chih-cheng (called San Sung). The second son of Chu Ying. It is said that his knife never deviated from the beginning to the end of a stroke. He carved pen jars, figures, arm-rests for writing, and incense-jars in the form of crabs and toads. He was a good painter of rocks and bamboo groves and donkeys. A brush-holder of his in the Palace Collections carved with figures in relief against a background of engraved birds and flowers is illustrated by Ferguson, and in the Ku Kung (plate 200).

4. Chiang Hsi-huang, who carved hand-rests, is recorded to have decorated one with a blossoming peach after T'ang Yin. A brush pot of his in the David collection is engraved with landscape (plate 198), and another with characters is in Lord Fairhaven's collection (plate 199).

5. Ko Liao-ting, who excelled in making bamboo flutes.

6. Li Liu-fang, who carved bamboo, stone and jade seals as a hobby in the style of Chiang Su-lin and Wen Kuo-po.

7. Li Wen-fu, who was a native of Nanking. "He excelled in carving the framework of fans. The flowers and herbs he engraved in openwork. He engraved seals for Wên San ch'iao (i.e. Wên P'êng 1498–1573) the eldest son of the painter Wên Cheng Ming)."

8. Pu Chung-ch'ien, famous for various carving and engraving. "As soon as rhinoceros horn, jade, lacquer and bamboo vessels passed through his hands they became archaic, elegant and admirable; they are longed for, admired and collected by high officials." He delighted in the twisted roots and gnarled joints of bamboo, carving them with a few touches of his knife.

9. Shen Tu-sheng, a physician, painter and poet.

10. Wang Hsing-lien, who specialized in flutes and seals.

11. Hou Yao-tseng.

12. Ch'ih I-chüeh.

But the vast majority of bamboo brush pots and hand-rests which have survived were the products of the Ch'ing period and chiefly of the reign of Ch'ien Lung (1736–1796) and Chia Ch'ing (1796–1821). A list, drawn from the five books on the subject already quoted, supplies no less than forty-eight names of which the four most famous are characterized as follows:

1. Wu Chih-fan (called Lu Chen) was a Taoist, who was famous for the characters he cut in relief. "Today we possess his figures, flowers, birds, pen-jars and arm-rests, whose character is so beautiful that they are much prized." A brush pot in the Palace engraved with his name and a horse rolling on the ground in slight relief is illustrated in the Ku Kung (plate 201).

2. Shih T'ien Chang (called Huan Wen). We are told that "he specialized in paintings on bamboo" and that he was a celebrated and a most remarkable bamboo carver. In the time of Yung Chêng (1722–1735) the Imperial Superintendent of Fine Arts allowed him to offer whatever he wished. The products of his shop were exceptionally fine, and he even produced two of the same kind at one time. In the days of Ch'ien Lung his careful and skilled work was remembered.

3. Feng Hsi Lu (called Yi Hou). "An excellent carver of bamboo figures, he carved these from bamboo roots copying figures of *bodhisattvas* and images of Buddha with marvellous accuracy. These strange figures were all so eccentric that, seeing them, men's hair would stand on end. The figure of the Immortal gathering herbs or the Heavenly Lady scattering flowers, have the appearance of those who have risen above all mundane affairs. Experts argue that if Yi Hou had not added colours his impressionist effects could have been obtained in carving the flowing garments by the skilful use of his knife alone. His flexible wrist moved like the wind and brought his art to perfection."

4. Shen Chien (called Liang Tzǔ) whose father Shen Han-ch'uan, we are told, learned bamboo carving from Chu Chih-chêng. He was the most celebrated carver in bamboo of the early Ch'ing period.

Among other Ch'ing carvers who might be mentioned are Yang Pao, who carved buttons in Ch'in and Han style, and Chou O, noted for his engraving of cursive script. Hou Hsiao-tseng imitated the ancient sacrificial vessels, such as the *tsun* and the *i* (plate 205).

R. SOAME JENYNS

[1] *Ku Kung*, Vol. 18, pl. 20, and Ferguson, *Survey of Chinese Art*, pl. 199.
[2] *Ku Kung*, Vol. 12, pl. 20. [4] *Ku Kung*, Vol. 11, pl. 5.
[3] *Ku Kung*, Vol. 18, pl. 13. [5] *Ku Kung*, Vol. 10, pl. 4.
[6] *Catalogue of Chinese Art Treasures from Taiwan*, 1961/62, pl. 227.
[7] Hirth and Rockhill, *Chau Ju Kua*, p. 215, footnote.
[8] S. Cammann, *Substance and Symbol in Chinese Toggles*.
[9] B. Laufer, *Insect musicians and cricket champions in China*, Field Museum of Natural History, Chicago 1927.
[10] B. Laufer, *op. cit.*
[11] A. de Sowerby, "Cricket Grounds and Culture in China", *China Journal*, Vol. 18, 1933, p. 157–162.
[12] *Illustrated Catalogue of Chinese Government Exhibits from the International Exhibition of Chinese Art*, London, Vol. IV, p. 115.
[13] Hirth and Rockhill, *Chau Ju Kua*, p. 216.
[14] *Catalogue of Exhibition of Chinese Art*, Burlington House, 1935/36, no. 2917.
[15] *Ku Kung*, Vol. 32, pl. 17.
[16] Ferguson, *Survey of Chinese Art*, p. 115.
[17] J. W. H. Grice, "Chinese Bamboo Carving", *Country Life*, May 1954.

197. BAMBOO BRUSH POT ▷

Ch'ing dynasty (1644–1912). Height 54 cm. Jenyns Collection, Bottisham, Cambridgeshire

The brush pot is carved with a design of a scholar, with two boy attendants, taking his ease under a pine tree. The carving is excellent; deep and strong, if a little coarse. It is unsigned.

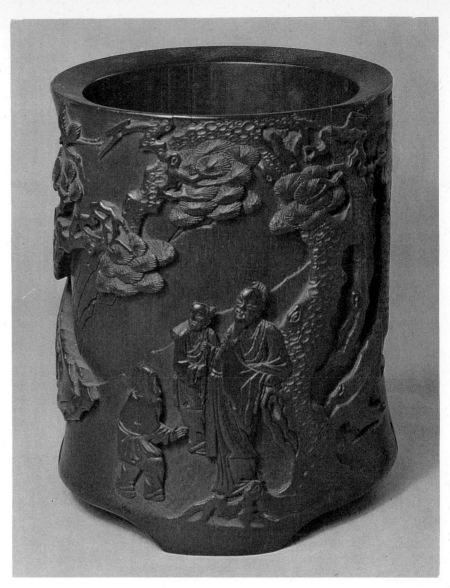

197

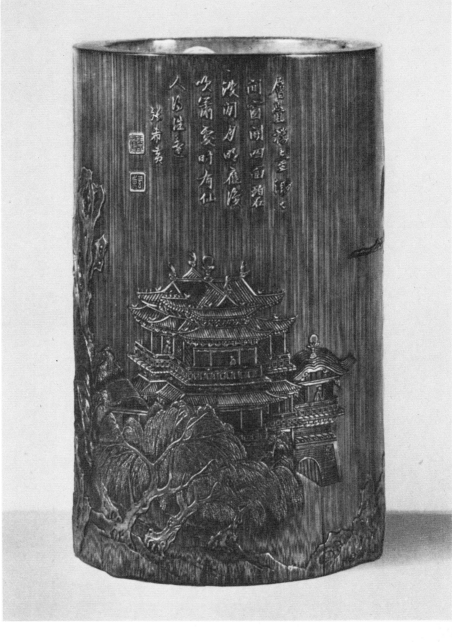

198. BAMBOO BRUSH POT SIGNED CHIANG HSI-HUANG

17th century. Height 13 cm. David Collection, London

This brush pot is carved with a landscape and a poem in low relief and signed Chiang Hsi-huang, with two seals. Chiang Hsi-huang was one of the five most famous bamboo carvers; he lived towards the close of the Ming period.

The landscape is of a pavilion standing on an island in a lake, beside a causeway lined with willows. The workmanship is most delicate and elegant. Sir Percival David also has a bamboo wrist-rest decorated with a landscape and poem by the same artist. (See *The Arts of The Ming dynasty*, Plate 102, Fig. 383.) For another brush pot carved with characters by the same hand, see the next plate.

199. BAMBOO BRUSH POT

Dated by a cyclical year either 1662 or 1672. Height 10 cm. The Fairhaven Collection, Anglesey Abbey, Cambridgeshire

This bamboo brush pot is signed by Chiang Hsi-huang (Chiang Tsung-yi) in the intercalary month of the cyclical year *Jen-Tzû* (i.e. 1662 or 1672) with two seals; the first reading Chiang Tsung-yi, and the second Hsi-huang.

It is engraved with a poem entitled *On Homecoming* by T'ao Ch'ien, written in 425. T'ao Ch'ien (365–427 A.D.) was magistrate of P'eng-tsê, in the modern province of Kiangsi, but held the post less than three months and then retired into private life occupying himself with poetry, music and the culture of flowers, especially chrysanthemums. This example of his style is considered one of the masterpieces of the Chinese language.

For the work of Chiang Hsi-huang, who lived in the 17th century, towards the close of the Ming, see also the previous plate.

200. BAMBOO BRUSH POT SIGNED CHU SAN SUNG ▷

Ming period. 16th century. Height 13.5 cm. Palace Museum, Taiwan

This brush pot is carved with figures of women in relief, separated by a background of incised birds and flowering trees. Chu Chih-cheng (San Sung) was the third of the three famous Chu's of Chiating, Kiangsu, who lived in the reigns of Lung Ch'ing (1567–1572) and Wan Li (1573–1619). The signature *San Sung* (literally "three pines") also appears on an ivory brush pot illustrated in the second volume of "Minor Arts".

201. BAMBOO BRUSH POT SIGNED WU CHIH-FAN ▷▷

Ch'ing period (1644–1912). Height 15.5 cm. Palace Museum, Taiwan

This brush pot is carved with a groom holding a rolling horse on a rope in slight relief. Only the horse is visible in the illustration. We know very little about Wu Chih-fan, except that he was a Taoist and famous for the characters he cut in relief on bamboo, and that he lived in the Ch'ing period during the reigns of Ch'ien Lung (1736–1796) and Chia Ch'ing (1796–1821).

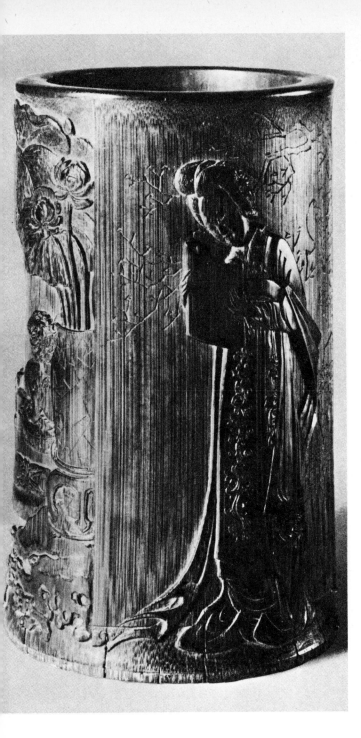

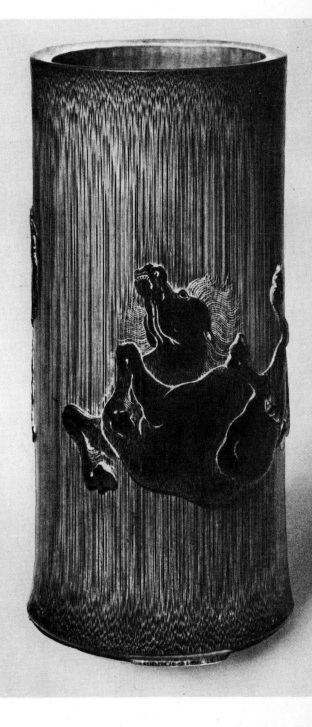

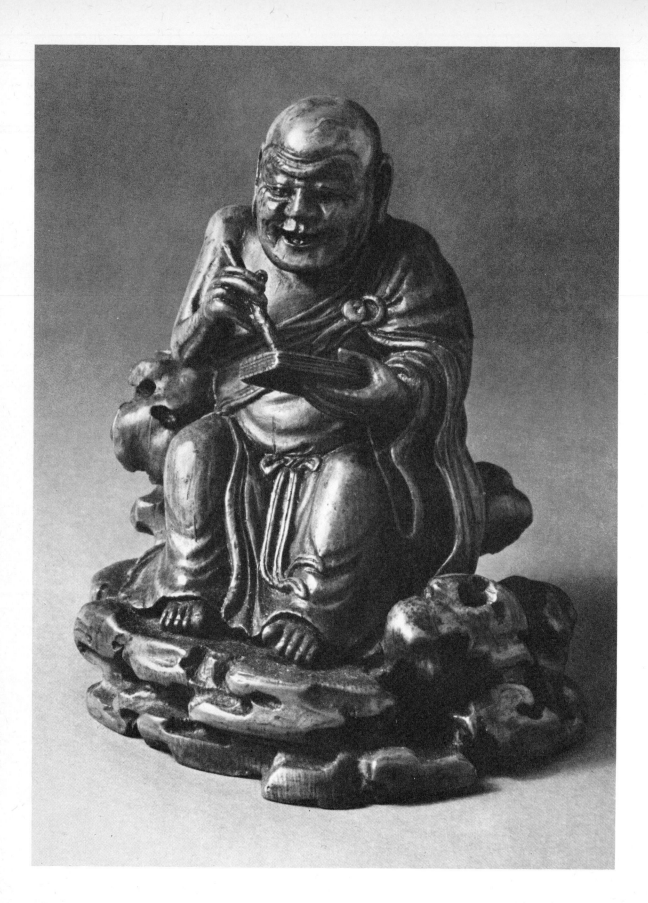

202. FIGURE OF A LOHAN, CARVED IN THE ROUND

Ch'ing dynasty (1644–1912). Height 7.2 cm. Jenyns Collection, Bottisham, Cambridgeshire

This bamboo Lohan is depicted seated. In his right hand he holds a writing brush and in his left an inkslab. The world Lohan is derived from *A-lo-han*, the Chinese way of expressing the Sanskrit word *Arhat*. The Lohan were the guardians of the Buddhist faith, who watched over and cared for the welfare of believers. The conception of a group of sixteen Lohan seems to have first appeared in the T'ang dynasty. Later this group was increased to eighteen, but in Japan, Korea and Tibet the number of sixteen has been retained.

This group of eighteen Lohan is represented in most Buddhist temples in a variety of poses. It is difficult to identify this particular figure.

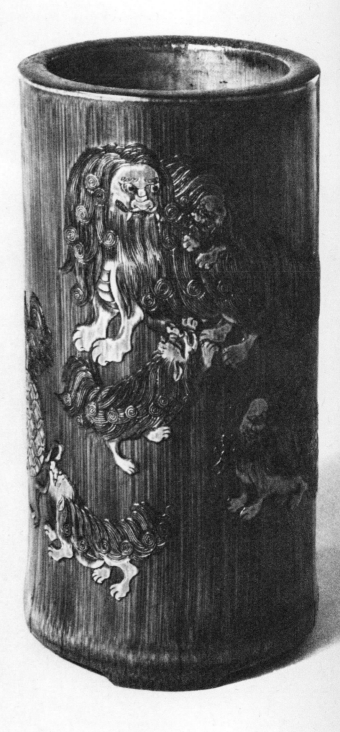

203. BAMBOO BRUSH POT

Ch'ing dynasty (1644–1912). Height 12.8 cm. Jenyns Collection, Bottisham, Cambridgeshire

This brush pot is carved with a group of Chinese lions by a process called *chu huang* (skin bamboo) in which the light surface of the skin of the bamboo is left to form a background to the carving. This technique was invented in the Ch'ien Lung period (1736–1796). The conventional lion of China, commonly called the dog of Fo (i.e. Buddha), as depicted by Chinese artists, seems more like a Pekingese dog than a lion.

The lion is not indigenous to China, although specimens may have reached China as tribute to various Emperors. It is not represented in Chinese art before the introduction of Buddhism, in which it figures as a defender of the law and a protector of sacred buildings.

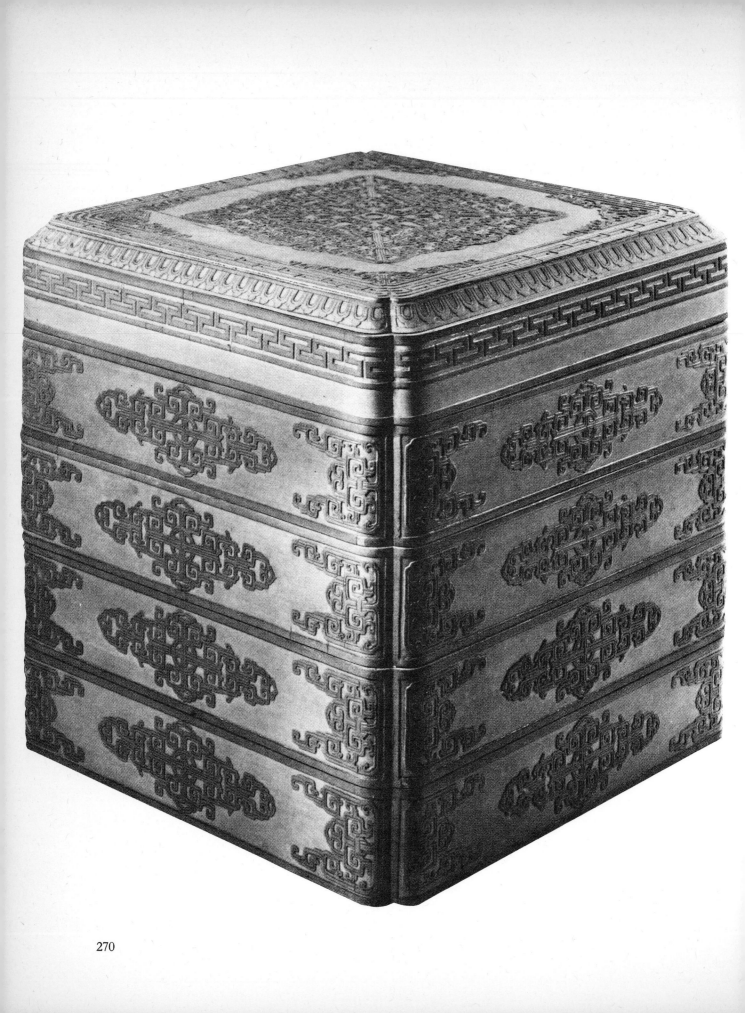

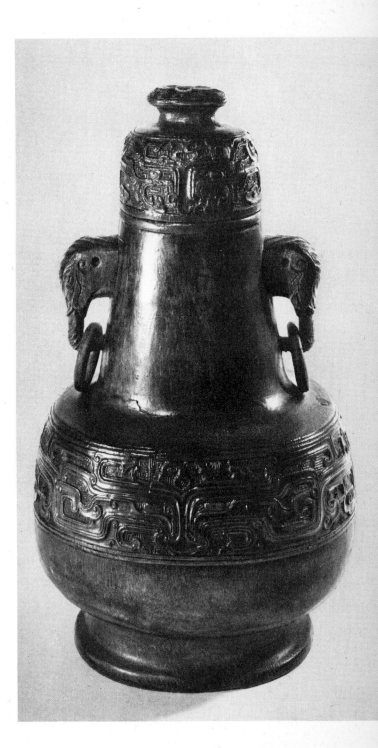

◁ 204. BAMBOO BOX IN FOUR TIERS

*Ch'ing dynasty (1644–1912). Height 20 cm. Formerly collection
Dr. Grice, Bognor Regis*

This box is a superb example of the technique of *chu huang*
(skin bamboo) already referred to (plate 203).
The sides of the box are decorated in conventional key-fret
and interlocking scroll pattern in slight relief. The carving is
precise and delicate, and the finished result is so elegant that
one imagines it must have come out of the Palace and have
been made in the Ch'ien Lung period (1736–1796).

205. BAMBOO VASE AND COVER

*Ch'ing dynasty (1644–1912). Height 19 cm. Formerly collection
Dr. Grice, Bognor Regis*

This vase is carved in imitation of a Chinese ritual bronze,
although it could not be said to resemble closely the bronzes
of any particular period. It is decorated with a girdle of con-
ventional archaic bronze pattern in the form of a *t'ao t'ieh* or
ogre mask in slight relief, and it has elephant head ring-han-
dles.
The Chinese carvers of bamboo specialized in brush pots
and wrist-rests, but they also made bamboo seals, incense
jars, figures, flutes and a number of vessels in imitation of
the antique. This is one of the last.

206. BOXWOOD BRUSH POT

Ch'ing dynasty (1644–1912). Height 12.5 cm. Palace Museum, Taiwan.

This brush pot is carved with a fascinating irregularity in its resemblance to the bole of a tree. It is decorated on one side, which is not shown, with a gnarled prunus branch and blossom, and some twigs of bamboo on which are perched two parakeets; and on the other (reproduced in this plate) with four gibbons plucking the Peaches of Immortality in slight relief. It is of beautiful workmanship, but unsigned.

A peach tree which grew in the gardens of the Palace of Hsi Wang Mu, the Queen of the Taoist fairyland, was said to yield the fruit of eternal life. Its peaches ripened once only in three thousand years. Hence the peach became a symbol of immortality in Chinese folklore. A monkey is supposed to have stolen some of these peaches and to have become immortal.

207. BOXWOOD WRIST-REST ▷

Ch'ing dynasty (1644–1912). Length 22 cm. Palace Museum, Taiwan

In this wrist-rest the carver has used his material to imitate the form of a segment of a rotten branch of a prunus tree, leaving a spray of prunus blossom on the hollow side. On the rounded surface of the wrist-rest are carved three poems; one in seal script, one in a clerical style and one in a running hand.

Each is accompanied by a signature and a simulated seal, but the writer has not been identified.

The commonest form of wrist-rest was carved in bamboo, but others were carved in ivory, or wood, like the one represented here.

208. WOOD ORNAMENT IN THE FORM OF A BEGONIA BLOSSOM ON A LEAF

Ch'ing dynasty (1644–1912). Length 6.5 cm. Jenyns Collection, Bottisham, Cambridgeshire

This little *bibelot* may have been carved from limewood. In the long list of flowers used by the Chinese as decoration the begonia is seldom included, nor does it figure in the list of special flowers for each month. But it does occur as a floral *motif* in Chinese painting, although usually not before the Ming period (see decoration on the bottom of the cupboard, plate 179, and enamel dish, plate 108).

209. WOODEN ORNAMENT IN THE FORM OF A
GROUP OF *LING CHIH* FUNGUS AND A NARCISSUS
BLOOM

*Ch'ing dynasty (1644–1912). Height 7 cm. Jenyns Collection,
Bottisham, Cambridgeshire*

It is difficult to say what wood has been used to carve this
little group of a narcissus plant, some *ling chih* fungus and
bamboo leaves for a scholar's table. The attraction the nar-
cissus held for the Chinese has been discussed in the text op-
posite plate 133.

The *ling chih* or *ju-i* (literally "as you wish") fungus is inti-
mately connected with Taoist folklore. It is said to grant
every wish, and it is to be seen in the hands of many Taoist
genii and in the mouths of deer, who symbolize prosperity.
The head of the *ju-i* is commonly used as a decorative bor-
der in Chinese art, and the *ju-i* headed sceptre was one of
the commonest presents made by the Emperor to his offi-
cials. These *ju-i* sceptres were made in great variety of mate-
rials including rhinoceros horn, ivory, gold, silver, rock-crys-
tal, sandalwood, cloisonné enamel and bamboo.

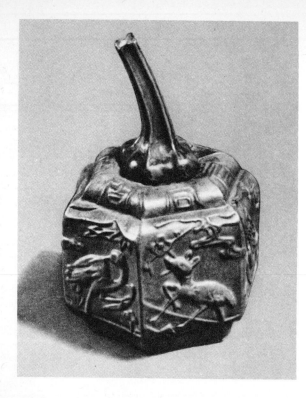

210. WATER-DROPPER

Mark and period of K'ang Hsi (1662–1722). Height 7.5 cm. British Museum, London

This delightful little water-dropper was made from a dried gourd *(lapenaria vulgaris)*. The gourd has been enclosed while it was growing in a patterned mould, so that as it grew it was pressed into the form of the mould; in this case, when it matured, it had taken on an hexagonal form exhibiting panels decorated with birds and animals in a finely embossed design beneath a border of *Shou* (long life) characters. The K'ang Hsi *nien hao* appears as if embossed in the same way on the base. The stem of the gourd has been put to delightful use as a stopper.

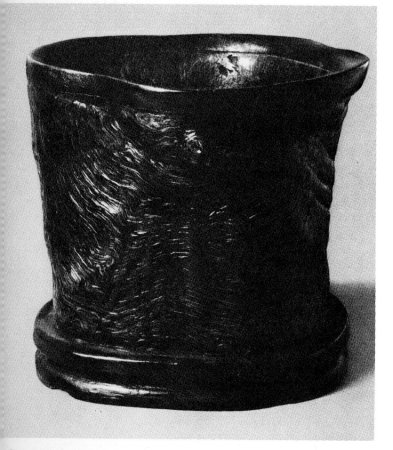

211. WOODEN BRUSH POT

Ch'ing dynasty (1644–1912). Height 10 cm. Jenyns Collection, Bottisham, Cambridgeshire

This brush pot is also (see plate 206) carved in the shape of the bole of a tree. But in this case the natural pattern of the grain of the wood is the only decoration. The result is remarkably effective. Unfortunately the species of tree has not been identified. This brush pot has a horn rim, and is in the scholar's taste.

Photographs by:

Kurt Ammann, Zurich: 134 137 164 165 171

Art Institute of Chicago, Chicago, Ill.: 37

Braun & Cie S.A., Mulhouse/France: 190

Brooklyn Museum of Art, Brooklyn, N.Y.: 53

Cleveland Museum of Art, Cleveland, Ohio: 127

A.C. Cooper, London: 57 143 172 193 198

Cowderoy & Moss, London: 192

Ives Debraine, Lausanne: 60 80 91 93 97

Olof Ekberg, Stockholm: 5 14 15 21 36

Fine Art Engravers, Ltd., London: 89 90 96 155 158 160 166 173

Freer Gallery of Art, Washington, D.C.: 1 10 13 16 19 38 52

Freer Gallery of Art, Washington, D.C. (by permission of the Palace and Central Museums of Taichung, Taiwan): 116 117 118 124 125 126 151 163 200 201 206 207

Fogg Art Museum, Harvard University, Cambridge, Mass.: 7 17 23

Erik Hansen, Copenhagen: 177 179 181 185 189

Helga Photo Studio, Inc., New York: 28 135 136 146 147 149 150 161 169 170 174 175

Hans Hinz, Basel: 2 4 6 18 20 22 29 40 41 42 43 44 45 46 47 49 50 62 63 65 66 67 69 70 73 74 75 76 77 81 82 86 88 92 94 103 104 109 113 133 140 141 142 152 153 154 157 159 162 168 176 199

Mallett & Son (Antiques) Ltd., London: 194 195 196

Metropolitan Museum of Art, New York: 54

Sotheby & Co., London: 99 100

John D. Schiff, New York: 148

Wilfrid Walter, London: 8 9 24 26 27 31 32 33 39 48 51 55 56 58 59 61 64 71 72 78 79 83 84 87 95 98 101 102 105 106 107 108 110 111 112 114 115 119 120 121 122 128 129 130 131 132 138 139 144 145 156 167 178 180 182 183 184 186 187 188 191 197 202 203 204 205 208 209 210 211

William Rockhill Nelson Gallery of Art, Kansas City, Mo.: 11 25 34

Ole Woldby, Stockholm: 123

Photographs placed at our disposal by the authors: 12 30 35 68 85

This book was printed in February 1981 by Orell Füssli Graphic Arts Ltd. Zurich
Filmsetting: Orell Füssli Graphic Arts Ltd. Zurich
Colour Lithography: Imprimeries Réunies S.A., Lausanne
Black-and-white lithography: Orell Füssli Graphic Arts Ltd. Zurich
Binding: Schuhmacher S.A., Schmitten-Bern
Editorial: Barbara Benson-Perroud
Design and Production: Claude Chevalley